SOURCES AND DOCU HISTORY OF ART SERIES

H. W. Janson, Editor

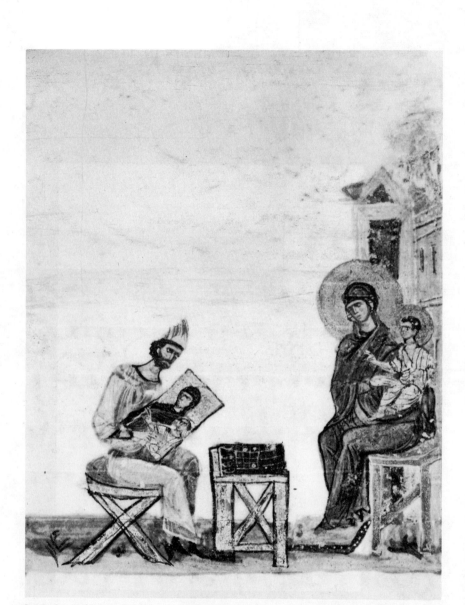

St. Luke Painting the Virgin and Child. *From* Gregory of Nazianzus, *Sermons,* *folio 106r, Jerusalem, Library of the Greek Patriarchate, Panagiou Taphou, 14.* *Photo Hirmer Fotoarchiv, Munich.*

The Art of the
Byzantine Empire

312–1453

SOURCES and DOCUMENTS

Cyril Mango

Dumbarton Oaks
Harvard University

PRENTICE-HALL, INC.
Englewood Cliffs, New Jersey

Library of Congress Cataloging in Publication Data

MANGO, CYRIL A. COMP.
 The art of the Byzantine Empire, 312–1453.

 (Sources and documents in the history of art series)
 Bibliography: p.
 1.–Art, Byzantine–History–Sources. I.–Title.
 II.–Series.
N6250.M25 709'.02 72-380
ISBN 0-13-047027-9

© 1972 by PRENTICE-HALL, INC., *Englewood Cliffs, New Jersey*

Printed in the United States of America

10 9 8 7 6 5 4 3 2 1

PRENTICE-HALL INTERNATIONAL, INC., *London*
PRENTICE-HALL OF AUSTRALIA, PTY. LTD., *Sydney*
PRENTICE-HALL OF CANADA, LTD., *Toronto*
PRENTICE-HALL OF INDIA (PRIVATE) LIMITED, *New Delhi*
PRENTICE-HALL OF JAPAN, INC., *Tokyo*

Contents

3. Justinian (527–65) *55*

4. From Justinian to Iconoclasm (565–726) *123*

Preface

The compilation of this anthology has proved a difficult task for two principal reasons. First, no book of this scope has ever been attempted before. It is true that there exist two rather old publications, identically but misleadingly entitled *Quellen der byzantinischen Kunstgeschichte,* the first by F. W. Unger (1878), the second by J. P. Richter (1897). Both of them, however, are concerned almost exclusively with the monumental history of Constantinople. A more recent collection of sources made by the Greek scholar K. D. Kalokyrês has not proved particularly helpful.

Certain periods covered by this book, such as those of the early Church Fathers, of Justinian, of Iconoclasm, as well as certain special topics, such as the iconography of Christ, have been surveyed with reference to texts bearing on the history of art. Other periods, however, and in particular the Middle and Late Byzantine ones have not been properly explored from this point of view. I have had, therefore, to rely to some extent on the accidents of my own reading and the helpful indications of colleagues.

The second difficulty has been caused by the language of the texts, a difficulty that can be fully understood only by those who have read Byzantine authors in the original. At one extreme of the scale we have the rhetorical texts—insufferably long-winded, precious, obscure, and imprecise. At the other extreme are certain humble documents, such as inventories, whose technical vocabulary cannot be fully elucidated with the help of any existing lexicon. In my own renderings I have attempted to be as accurate as possible at the expense of elegance. The format of this book did not allow me, however, to annotate at length all the passages of doubtful meaning. Serious students will wish, in any case, to go directly to the originals.

The translations from Greek, Latin and Slavic sources are my own. In the case of the last (as in several other respects) I have, however, benefited from the help of my colleague, Professor Ihor Ševčenko. For the few passages drawn from Syriac and Arabic sources I have had to rely on previous translations into modern European languages, but the renderings given here have been checked by Dr. Joseph Ghanem and Professor Irfan Shahîd. When, for the sake of clarity, I have had to add words that are not in the originals, I have placed them in square brackets.

In transliterating Greek words—I am here referring to the italicized words placed within parentheses—I have rendered *eta* by *ê*, *upsilon* by *u*, and *omega* by *ô*. With proper names and titles of works I have not aimed at complete consistency. Whenever there is a familiar English form, I have retained it: thus John Chrysostom rather than Ioannes (or Johannes) Chrysostomos; Andronicus Comnenus rather than Andronikos Komnenos. Unfamiliar names I have transliterated: thus Ioannes Diakrinomenos rather than John the Dissenter. Even this distinction, however, leaves many undecided cases. Are we to refer to John the Lydian, John Lydus or Ioannes Lydus? To Paul the Silentiary or Paulus Silentiarius? All I can say is that I have followed my instinct or my habit. Titles of works are usually given in their conventional Latin forms: thus *De aedificiis* (rather than *Buildings*), *Pratum spirituale* (rather than *Spiritual Meadow*), *Vita S. Stephani iunioris* (rather than *Life of St. Stephen the Younger*).

In addition to the gentlemen already named, I have received various kinds of help from the following: Mr. Michael Ballance, Professor Hans Belting, Mr. Alan Cameron, Mr. James Fitzgerald, Professor André Guillou, Miss Ann Moffatt, Mr. R. L. Van Nice, Mr. John Wiita. I should like to extend my thanks to all of them.

I am also grateful to the American Schools of Oriental Research for permission to reproduce, with a few changes, the translation by the Reverend D. J. Chitty of a passage from the *Testamentum Domini*; and to the Harvard University Press for permission to reprint some passages of my own translation of the Homilies of Photius.

Introduction

TYPES OF DOCUMENTS AND SOURCES

To the extent that a distinction can be drawn between documents and sources, it should be noted that the first category is very poorly represented in the written records of Byzantine art. It includes a number of imperial and ecclesiastical enactments as well as a few inventories, mostly monastic. Other types of documents, such as are familiar to us in Western Europe, e.g. the registers of guilds, financial accounts, contracts, letters of recommendation, artists' wills,[1] are totally lacking.

The bulk of our material may be loosely called literary and is drawn from a variety of sources: histories, chronicles, saints' lives, theological treatises as well as the accounts of foreign travellers. Of particular importance is a genre called the *ekphrasis,* i.e., the rhetorical description of a work of art. This is usually in prose, but may also be in verse (in epic hexameter in the case of Paul the Silentiary, in iambics in the case of Constantine the Rhodian); it may form an independent opuscule or be part of a larger work such as a book of history or even a sermon.[2] Procopius's famous work on the buildings of the emperor Justinian (*De aedificiis*) consists of a whole string of *ekphraseis.* In dealing with this genre, it should be borne in mind that it came into vogue in the Imperial Roman period and that it was governed by a set of conventions applicable to the standards of a naturalistic pagan art and understandable to an audience versed in the lore of Greek mythology. When it was pressed into the service of Christian subject-matter (and it continued to be practiced from the 4th century until the 15th), its language, its imagery and its clichés were not substantially modified. This resulted in a painful artificiality further aggravated by the reluctance to call anything by its "vulgar" technical name. A church could not be called a church (*ekklêsia*): it had to be a temple or a fane (*naos* or, even better *neós*), unless it was rendered by the poetic word for a house or a hall (*melathron*); a bishop (*episkopos*) became an *archimustês* or *mustipolos,* as if he presided over

[1] I have included in this anthology (p. 258) the will of a Cretan painter of the 15th century. This document, however, belongs to the Venetian rather than to the Byzantine sphere.

[2] On the history of this genre see the articles by G. Downey and A. Hohlweg quoted in the Bibliography.

the Eleusinian mysteries; a barrel vault, "a cylinder cleft in twain," and
so forth. This phenomenon was not peculiar to the *ekphrasis:* indeed, it
was shared by all "highbrow" Byzantine literature which was written in
classical, preferably Attic, Greek, i.e., a language that no one spoke at the
time. One consequence of this trend has to be noted here, namely the im-
precision of vocabulary. In medieval Greek a dome was called *troullos;*
but in sophisticated literature it may appear as a sphere or a hemisphere, a
circle, a crown, a peak, crest or a helmet; an arch, which was called *eilêma*
by the vulgar folk, is usually rendered by *apsis,* but sometimes by *antux,*
which is the Homeric word for the rim of a round shield and which was
also used for a variety of other curved elements; the term *stoa* could stand
for half a dozen different things.

Alongside the *ekphrasis* there flourished the epigram, also a classical
genre governed by its own rules. Since the epigram was usually a short
poem intended to be inscribed on the base of a statue, the entablature
of a building, the frame of an icon or the side of a sarcophagus, it rarely
contains a description of the object it was meant to accompany. Its value
to the art-historian often lies in the *lêmma,* i.e., its title containing the
attribution to this or that monument.

In selecting the contents of this anthology, I have tried to strike a
balance between different kinds of sources since, for reasons of space, no
one genre could be represented exhaustively. I have included much that
is familiar, but also a certain amount of material that may be new even to
specialists. I could not, however, avoid the "bunching" of testimony
around given geographical centers, such as Constantinople or Gaza, cer-
tain famous monuments, such as St. Sophia or the church of the Holy
Apostles, and certain periods, such as the reigns of Constantine the Great,
Justinian or Basil I.

To my regret, I have had to exclude altogether a number of sources
which, at first sight, might have claimed a place in a collection such as
this. Among them I may cite the Book of Ceremonies (*De cerimoniis*) of
Constantine Porphyrogenitus which is undoubtedly a document of ex-
ceptional importance for the study of the monuments of Constantinople,
especially those of the Imperial Palace. Unfortunately, however, it does
not readily lend itself to excerpting: the information it provides has to be
inferred and built up from separate accounts of various processions and
receptions. For example, it does not offer us a description of the famous
Golden Hall (Chrysotriklinos) of the palace: it tells us, incidentally and
in different passages, that it had eight arches and a conch turned to the
east, a dome pierced by sixteen windows, a cornice, a silver door, etc.[3]
I have also left out the entire category of artists' manuals: those of

[3] Among the many studies devoted to the Book of Ceremonies, that of
J. Ebersolt, *Le Grand Palais de Constantinople et le Livre des Cérémonies* (Paris,
1910) remains fundamental.

medieval date are of western origin, even if they contain material traceable to Byzantine sources (such as the *Compositiones Lucenses,* the *Mappae clavicula,* the *Schedula* of Theophilus and the *De coloribus* of Heraclius); the earliest Slavic manual, which goes under the name of bishop Nectarius, is of the end of the 16th century;[4] while the famous *Painter's Guide (Hermêneia)* by Dionysios of Fourna is a work of the 18th century.[5] I am aware of the fact that the latter, both in its technical and iconographic sections, often perpetuates genuine Byzantine practice; but to separate the Byzantine elements from later accretions is a task of considerable complexity.

GEOGRAPHICAL COVERAGE

The central tradition of Byzantine art is undoubtedly to be located at Constantinople, but to define its outer periphery is a matter of considerable delicacy. In this book I have, by and large, neglected the West for the reason that it has been covered in the companion volume on Early Medieval Art. I have, however, made an exception for Ravenna in the 6th and 7th centuries, since that city maintained close ties with the eastern capital, and its monuments are of crucial importance to every student of Byzantine art. The activity of Byzantine artists in western Europe, a highly complex problem,[6] has been left out.

Another area I have not attempted to cover, except for Eusebius' description of the Church of the Holy Sepulchre, is that of the Holy Land. There exists, of course, a vast body of material—mostly pilgrims' accounts[7]—relating to the Palestinian shrines, and I do not wish to deny

[4] See N. Petrov, " 'Tipik' o cerkovnom i o nastennom pis'me . . ." *Zapiski Imper. Russk. Archeol. Obščestva,* N.S., XI, 1/2 (St. Petersburg, 1899), 1 ff.

[5] The only halfway decent edition is that by A. Papadopoulos-Kerameus, *Hermêneia tês zôgraphikês technês* (St. Petersburg, 1909). The French trans. by Didron, *Manuel d'iconographie chrétienne* (Paris, 1845), which has served as the basis for further translations into other European languages, is often seriously misleading.

[6] See E. Müntz, "Les artistes byzantins dans l'Europe latine du V^e au XVI^e siècle," *Revue de l'art chrétien,* Ser. 4, IV (1893), 181–90; A. L. Frothingham, Jr., "Byzantine Artists in Italy from the Sixth to the Fifteenth Century," *American Journal of Archaeology,* IX (1894), 32–52. There is no up to date, detailed treatment of this subject. The well-known passage by Leo of Ostia concerning Byzantine artists and artefacts at Monte Cassino is readily available in E. G. Holt, *Literary Sources of Art History* (Princeton, 1947), pp. 4 ff.

[7] Basic collections: T. Tobler, *Itinera et descriptiones Terrae Sanctae,* I (Geneva, 1877), continued as *Itinera hierosolymitana et descriptiones Terrae Sanctae,* I/2 by T. Tobler and A. Molinier (1880); II by A. Molinier and C. Kohler (1885); T. Tobler, *Descriptiones Terrae Sanctae ex saec. VIII, IX, XII et XV* (Leipzig, 1874); P. Geyer, *Itinerae hierosolymitana saec. IV–VIII.*

that these monuments may have played an important part in the development of Byzantine art. A representative selection of this material, however, would have required more space than I could give it; little purpose would have been served by presenting a few snippets from Aetheria or Arculf.

With regard to the geographical extension of our source material there is a conspicuous difference between the period of the Christian Roman Empire (i.e., up to the middle of the 7th century) and the subsequent Byzantine period proper. The first is marked by a considerable number of urban centers that produced literature or are otherwise documented. Thus, some of our most interesting texts relate to Gaza; we know a good deal about the monuments of Antioch, and we have descriptions of churches at Tyre, Nazianzus, Nyssa, Edessa, etc. Surprisingly little, incidentally, is recorded of the Christian monuments of Alexandria. In the period after the 7th century and until the fragmentation of the Byzantine Empire in 1204 the situation changed radically: there was only one "city of culture," namely Constantinople, and practically all literary production was concentrated within its walls. The same applied to the reading public. As a result, our textual information is limited almost entirely to the monuments of Constantinople; we know next to nothing about the provinces.

BYZANTINE ART CRITICISM

Contemporary scholars have expressed some subtle views concerning the aesthetic values of Byzantine art: these, it is claimed, were influenced by philosophical, particularly neo-Platonic doctrines, which account for such phenomena as reverse perspective, radiating composition, disregard for scale and depth, etc.[8] Whatever value there may be in such theories, it is only fair to say that they receive little support from the texts. The "anagogical argument" (namely, that images serve to elevate our minds to immaterial realities), an argument derived from neo-Platonism via the pseudo-Dionysian writings, does, in fact, appear from time to time, but it is the exception rather than the rule. The prevailing view of Byzantine authors is that their art was highly true to nature. A perusal of the texts collected here will confirm this statement. The work

Corpus script. eccles. latin., XXXIX (1898); *Pravoslavnyj Palestinskij Sbornik*, I–LXIII (St. Petersburg, 1881–1917). Many of the more important texts may be found in English translation in the *Palestine Pilgrims' Text Society*, 13 vols. (London, 1897).

[8] See, e.g., A. Grabar, "Plotin et les origines de l'esthétique médiévale," *Cahiers archéologiques*, I (1945), 15–34; G. Mathew, *Byzantine Aesthetics* (London, 1963).

of painters is constantly praised for being lifelike: images are all but devoid of breath, they are suffused with natural color, they are on the point of opening their lips in speech.

There is an aspect of this phenomenon that is deserving of notice, namely the presumed resemblance not only between image and model, but also between image and supernatural vision. This provided a double verification. An image of, say, St. John the Evangelist was a true image because it followed the accepted iconographic type and bore an inscription identifying it as being St. John's. Furthermore, whenever St. John chose to appear in a vision to a saintly man, he looked exactly like his image, and was, in fact, recognized by virtue of this resemblance. We encounter this motif as early as the 5th century (see p. 40).

To us, such views appear rather perplexing, for we regard Byzantine art as being abstract rather than naturalistic, and we expect to find in the written sources some reflection of our judgment. We might think, furthermore, that Byzantine authors would have made some distinction between their own art and that of the Graeco-Roman period which they had before them. Yet this is not the case. Except for the difference in subject-matter (pagan in one case, Christian in the other), their aesthetic appreciation of both kinds of art is identical.[9]

We may attempt to explain this apparent lack of perception by saying that the Byzantines inherited from the ancient world their literary genres together with all the conventions that were, so to speak, built in. This in itself is undeniably true, as we have already remarked with respect to the *ekphrasis* and the epigram. To reproduce the artistic judgments of the classical authors was considered to be a mark of culture. It is also true that Byzantine authors did not write their *ekphraseis* and epigrams for nothing. They wrote them either as school exercises (in which case their aim was to follow their ancient models as closely as possible), or they wrote them for a patron, usually the person who had commissioned a given building or work of art. This last consideration may account for the total lack of adverse criticism. Every new church was the most beautiful that had ever been built, and it surpassed all previous churches; every painting, every icon was utterly lifelike, and expressed the very essence of its subject.

If the reader is not satisfied with such explanations, I can only add that we should not impose on Byzantine authors categories of thought and awareness that they did not possess.

[9] Cf. my remarks in "Antique Statuary and the Byzantine Beholder," *Dumbarton Oaks Papers*, XVII (1963), 65 ff.

Abbreviations

ASS

Acta Sanctorum, 3rd ed. (1863–).

BZ

Byzantinische Zeitschrift (1892–).

CSHB

Corpus scriptorum historiae byzantinae (Bonn, 1828–1897).

Janin, *CP byzantine*

R. Janin, *Constantinople byzantine,* 2nd ed. (Paris, 1964).

Janin, *Eglises*

La géographie ecclésiastique de l'Empire byzantin. I = *Le siège de Constantinople,* t. 3 = *Les églises et les monastères* by R. Janin (Paris, 1953).

Mansi

I. D. Mansi, *Sacrorum conciliorum nova et amplissima collectio* (Florence, Venice, 1759–1798).

PG

J. P. Migne, *Patrologiae cursus completus, Series graeca* (Paris, 1844–1866).

PL

J. P. Migne, *Patrologiae cursus completus, Series latina* (Paris, 1844–1864).

I

Constantine
(312–37)

Constantine attained the imperial dignity in 306. His espousal of the Christian religion, traditionally associated with the battle of the Milvian Bridge (312), provides, however, a more natural starting point for this chapter.

Like the Tetrarchic emperors before him, Constantine was a great builder in what may be called the 'public sector.' He was, moreover, faced with an entirely new challenge: having raised Christianity to the status of a privileged religion, of which he was in some way the High Protector, he wished to give it a suitable public image. This meant that churches had to be built in key cities, and they had to be as large and as sumptuous as possible. Since there was no previous tradition of Christian architecture to draw on, a new formula had to be devised: this was the basilica, adapted from a type of building that had long been used, mainly in the western provinces, for a variety of civic purposes.[1] Essentially, the Christian basilica was a timber-roofed, elongated structure having at one end an elevated dais for the bishop and clergy. It posed no difficult problems of engineering such as were inherent in vaulted or domed buildings—an important consideration at a time when qualified architects were in critically short supply; and it could be built very big. The essential dullness of the architectural shell could then be covered up with a rich placage of colored marbles, painting, and mosaic—this impressed the populace. The rather vulgar emphasis on everything that glittered—gilding, silver revetments, polished marble, hangings of purple—was very much in the spirit of the times,[2] and eventually became a permanent heritage of Byzantine art. This aspect is clearly reflected in the written sources.

In spite of the fact that the impetus for monumental church building came from the central government, Constantine's architects did not develop, as far as we can judge, a standardized type of basilica.[3] Moreover, many of the important foundations of this period were not simply houses of congregation, but had a commemorative function as well: such especially were the churches built in the Holy Land on the spots that had been hallowed by Christ's life or by earlier Biblical events.[4] In such martyria there was a focus towards which veneration was directed, be it the grotto of the Nativity or the Sepulchre, and this required a special architectural setting that was necessarily different in each case.

1 Among the numerous discussions of this topic, see especially J. B. Ward Perkins, "Constantine and the Origins of the Christian Basilica," *Papers of the British School at Rome*, XXII (1954), 69–90.

2 Cf. R. MacMullen, "Some Pictures in Ammianus Marcellinus," *Art Bulletin*, XLVI (1964), 435–55.

3 This is emphasized by R. Krautheimer, "Constantine's Church Foundations," *Akten des VII. Internat. Kongresses für Christliche Archäologie* (Trier, 1965), 237–55.

4 See the fundamental work of A. Grabar, *Martyrium*, I (Paris, 1946), 234 ff.

In this chapter we have collected the more important sources bearing on Constantine's building activity in the eastern provinces of the Empire. The description of the Church at Tyre[5] introduces us to the various features of a 4th century basilica (note that no mention is made of a pictorial decoration) while also providing for them a somewhat far-fetched and abstruse symbolical interpretation. The famous account by Eusebius of the Holy Sepulchre at Jerusalem, in addition to its architectural interest, shows us the administrative machinery that was set in motion for the execution of such a project. We obtain a glimpse, however brief, of the construction of Constantinople, with its imperial palace, its circus, its public buildings, and colonnaded streets. We are told all too laconically of churches at Constantinople and Nicomedia and of the octagonal church at Antioch. To illustrate a lower level of endeavor in this domain, that of the provincial bishop, we have included a short text bearing on the church of Laodiceia Combusta in Lycaonia.

In the realm of the figurative arts our documentation is decidedly meager. As regards the art of imperial propaganda, we have an interesting passage, also by Eusebius, describing a painting above the palace gate, presumably at Constantinople—a painting representing Constantine and his sons triumphing over the enemy of humankind (Licinius?). The Emperor's statues, his eyes gazing heavenward,[6] are also mentioned as evidence of his piety. But a specifically Christian pictorial art was as yet in its infancy. Sculptures of the Good Shepherd and of Daniel in the lion's den are described as decorating fountains, while a mosaic representing the cross was placed in the ceiling of the main hall of Constantine's palace. Portraits of Christ, of Peter and Paul were already in circulation, but Eusebius viewed them with disfavor as remnants of pagan custom. His vitriolic letter on this topic to the Empress Constantia is a locus classicus of the strict churchman's opposition to Christian portraiture, an attitude that we shall have occasion to encounter again and again in the subsequent period.

The Church of Tyre (c. 317)

Eusebius, Hist. eccles. X, 4, 37 ff. (*Panegyric of Paulinus, bishop of Tyre*): 37. Thus, then having enclosed a much larger space,[7] he [Paulinus] fortified the outer circuit by a wall which was to serve as a

[5] For the sake of accuracy, it should be noted that this church was built under the rule of Constantine's colleague, the pagan Licinius. It was only in 324 that Constantine made himself master of the entire Roman world.

[6] A tradition traceable back to Alexander of Macedon as portrayed by Lysippus. See H. P. L'Orange, *Apotheosis in Ancient Portraiture* (Oslo, 1947), pp. 19 ff.

[7] Than the one occupied by the previous church which had been destroyed during Diocletian's persecution.

secure bulwark of the whole [complex]. 38. Towards the rays of the rising
sun he spread out a vast and lofty entrance-gate (*propulon*) affording a
full view of what lay inside even to those who stood far away from the
sacred precinct. . . . 39. But when a man had come inside the gates, he did
not allow him straightaway to proceed to the inner sanctuary with impure
and unwashed feet, and so interposed a large space between the church
and the outer entrance. This space he enclosed in the form of a rectangle
and adorned all round with four porticoes (*stoai*) placed at right angles
to each other and uplifted on all sides by means of columns. The intervals
between the columns he closed off with latticed wooden barriers reaching
up to an appropriate height, while in the middle he left open to the sight
of heaven an atrium (*aithrion*) exposed to the beams of the sun and
affording excellent air. 40. Here he placed tokens of the sacred purifica-
tion by fitting out fountains right opposite the church; these flowed with
abundant water and provided cleansing to those proceeding farther into
the sacred precincts. This is the first halting-place for those that enter,
affording both beauty and splendor to everyone, and serving as an appro-
priate station for those who as yet lack the first initiation.[8]

41. After one has passed by this sight, he contrived open passages
into the church through several more entrance gates, having placed
towards the rays of the sun three gates in a row. Of these, he caused the
central one to surpass by far those on either side in both height and
breadth, and he decorated it sumptuously with iron-bound appliques
(*parapêgmata*) of bronze and carved ornaments, so that it was like a queen
escorted by her attendants. 42. In the same way, he disposed according to
the number of the entrance gates the porticoes on either side of the whole
nave,[9] and above these he contrived various openings into the church
[which admitted] much additional light and were adorned with finely
carved wood and decorated surrounds. And the basilica (*basileios oikos*)
he furnished with an abundance of rich materials, applying a plentiful
liberality in its expenses. 43. Here I find it superfluous to record the
length and breadth of the building, its gay adornments and its grandeur
surpassing description; or to detail the dazzling appearance of the [vari-
ous] works, the height [of the walls] reaching to heaven and the costly
cedars of Lebanon resting upon them. . . .[10] 44. . . . When he had thus
completed the church, he adorned it in fitting fashion with lofty thrones
in honor of the bishops and, in addition, with benches ranged in order
for the general [clergy].[11] Finally, he placed the sanctuary (*thusiastêrion*),

8 I.e. catechumens who have not received baptism.

9 I.e. the nave and two lateral aisles corresponded to the three entrance
doors in the east wall of the basilica.

10 The basilica was, therefore, roofed with timber.

11 The text is ambiguous. The persons described as being *kath'holou* were
either the inferior clergy or the congregation. The latter may have sat in church:
cf. p. 24.

i.e., the Holy of Holies, in the center, and so that this, too, should be inaccessible to the multitude, he fenced it off with wooden lattices perfectly fashioned with artful workmanship—an admirable sight to the beholder. 45. But not even the pavement was neglected by him, for this he embellished with every kind of splendid marble. Next he turned to the outside of the temple, skillfully constructing exedras and large buildings on each side, attached to the sides of the basilica and connected by means of passages to the central church. These also did our most peaceful Solomon, the builder of the temple of God, erect for those who yet need purification and ablutions by means of water and the Holy Spirit . . .[12]

There follows a symbolical interpretation of the various parts of the church.

63. Building, then, in righteousness[13] he duly divided the whole people according to their capabilities. For the sake of some he merely enclosed the outer circuit, thus fencing round the unerring faith (for great is the multitude of such people who are incapable of supporting any superior edification). For others he granted the entrance of the church, bidding them stand at the doors and guide the steps of those who enter and who, not unfitly, may be considered as the front gates of the temple. Others he supported by means of the first columns that describe a quadrangle round the outer court, i.e., guiding them by the first impact of the writ of the four Gospels. And others he sets round the basilica, on either side, men who are as yet catechumens, and in a state of growth and progress, yet not far distant and removed from the divine vision of the faithful within. 64. From among these having received the pure souls that have been washed like gold by the Divine bath,[14] some of them he supports by columns far superior to the external ones,[15] namely by the innermost mystical doctrines of Scripture, while others he illuminates by the windows that admit light. 65. The whole temple he adorned with one great entrance-gate, namely the glorification of the one and only God, the King of all, while to Christ and the Holy Ghost he ascribed the second light, on each side of the Father's sovereignty. As for the particulars of Truth, clear and brilliant as they are, he manifested them by the abundance and variety [of the elements] of the whole church. Gathering from all sides those who are alive, steady and firm in their souls, he chose them as building-blocks, and so constructed this great basilica. . . . 66. Also contained in this sanctuary are thrones and a multitude of benches, and seats, namely those souls upon which rest the gifts of the Holy Ghost, such as

12 I.e. a baptistery.
13 Isaiah, 54:14.
14 I.e. baptized Christians.
15 The columns separating the nave from the aisles must, therefore, have been bigger than those of the atrium.

were seen formerly by the companions of the holy apostles, unto whom appeared "cloven tongues as if of fire, and it sat upon each of them."[16] 67. And in the one of greatest authority,[17] perchance Christ Himself dwells in His fullness, while in those of secondary rank[18] He does so in the measure that each one of them has been apportioned the power of Christ and of the Holy Ghost. We may also compare the seats to the souls of those angels who have been assigned to instruct and guard each one of us. 68. And as for the holy, great and single altar *(thusiastêrion)*, what else can it be than the Holy of Holies, the pure soul of the universal Priest?

The Construction of Constantinople (324-30)[19]

Chron. Paschale I, 527–30: Under these consuls[20] the illustrious Emperor Constantine, having come from Rome and being resident at Nicomedia (the metropolis of Bithynia), paid repeated visits to Byzantium. He renewed the original walls of the city of Byzas and made many additions to them which he joined to the ancient walls,[21] and he called the city Constantinople. He also completed the Hippodrome[22] which he decorated with bronze statues and other embellishment, and made in it a *loge* for the emperor to watch [the games from] in imitation of the one in Rome. He built a big palace near the said Hippodrome and connected it with the *loge* of the Hippodrome by an ascending [staircase] called *cochlias.* He also constructed a big and very beautiful forum and set up in the center of it a tall column of purple Theban stone worthy of admiration. At the top of this column he set up a big statue of himself with rays on his head,[23] which bronze statue he had brought from Phrygia. The same Emperor Constantine removed from Rome the so-called Palladium and placed it in the forum that he had built underneath the column [bearing] his statue: this is stated by some inhabitants of Byzantium who have heard it by way of tradition. He also offered a bloodless sacrifice and conferred the name Anthousa on the Tyche of the city he had renewed.[24]

16 Acts 2:3.

17 I.e., presumably the bishop who occupied the central throne.

18 The clergy subordinate to the bishop.

19 An almost identical passage is to be found in Malalas, pp. 319–22. For an account from the pagan point of view see Zosimus II, 30–31 trans. J. J. Pollitt, *The Art of Rome,* Sources and Documents in the History of Art Series (Englewood Cliffs, N.J., 1966), pp. 212–13.

20 Januarinus and Justus (328). In fact, the construction of Constantinople was started in 324, immediately after the defeat of Licinius.

21 A more coherent account of the Constantinian walls is given by Zosimus.

22 Begun more than a century earlier by Septimius Severus.

23 Malalas, p. 320, specifies that there were seven rays.

24 Constantinople was dedicated with pagan rites and was therefore placed under the protection of a tutelary Fortune.

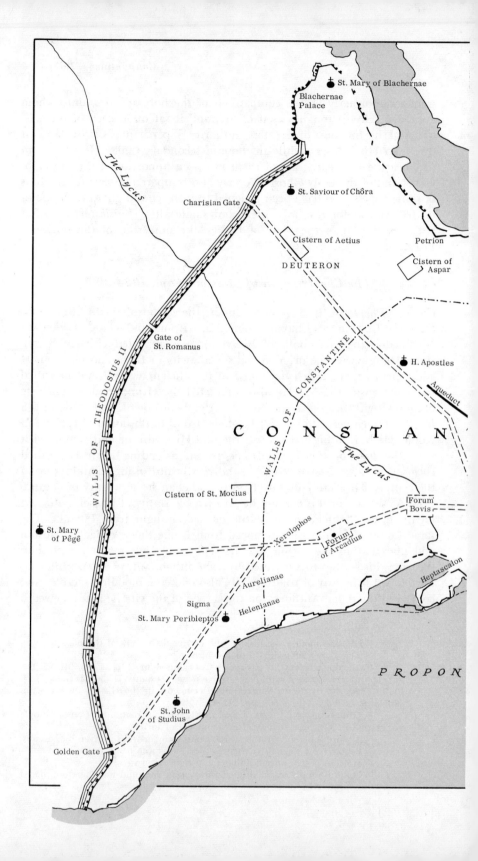

St. Mary of Blachernae

Blachernae
Palace

St. Saviour of Chôra

Charisian Gate

Cistern of Aetius

Petrion

Cistern of
Aspar

DEUTERON

Gate of
St. Romanus

H. Apostles

Aqueduct

WALLS OF THEODOSIUS II

WALLS OF CONSTANTINE

C O N S T A N

The Lycus

Cistern of St. Mocius

Forum
Bovis

St. Mary
of Pêgê

Xerolophos

Forum
of Arcadius

Heptascalon

Aurelianae

Sigma

Helenianae

St. Mary Peribleptos

P R O P O N

St. John
of Studius

Golden Gate

The Lycus

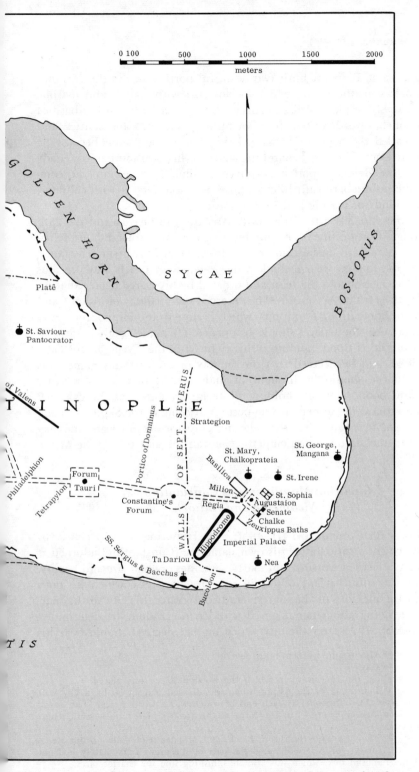

Figure 1. Plan of Medieval Constantinople.

The same Emperor built two beautiful porticoes from the entrance of the palace to the forum which he adorned with statues and marble, and he called the place of the porticoes Regia. Nearby he built a basilica with a conch, outside of which he set up huge columns and statues, and this he called the Senate. He named that place Augustaion because he had erected opposite [the Senate] the statue of his own mother, our Lady the Augusta Helena, upon a porphyry column. Furthermore, he completed the public bath called Zeuxippus[25] and decorated it with columns, different kinds of marble and bronze statues. . . .

In the year 301 after Our Lord's Ascension to heaven and the 25th of his reign, Constantine . . . having built an immense, splendid and felicitous city, named it Constantinople. . . . He conducted the first circus games and was the first to wear a diadem decorated with pearls and precious stones. He celebrated a big feast and ordered by his sacred decree that on this day, the 11th of Artemisios,[26] be observed the birthday of his city, and that the public bath of Zeuxippus (which is close to the Hippodrome and the Regia [and] the palace) should be opened. He made another statue of himself of gilded wood, holding in his right hand the Tyche of this City, also gilded, and he decreed that on the day of the birthday games this wooden statue should be brought in under escort of soldiers wearing cloaks and boots, everyone holding white tapers, and that the chariot[27] should go round the upper turning-post[28] and come to the Stama,[29] facing the imperial *loge*, and that the reigning emperor should arise and pay homage to the statue of the emperor Constantine and the Tyche of the City.

Christian Monuments at Constantinople, Nicomedia and Antioch

Eusebius, *Vita Constantini* III, 48 ff: 48. Honoring with special favor the city which is called after his own name, he [Constantine] adorned it with many places of worship and martyrs' shrines of great size and beauty, some in the suburbs and others in the city itself; by which he both honored the memory of the martyrs and consecrated his city to the martyrs' God. Being altogether inspired with divine wisdom, he determined to cleanse of all idolatry the city which he had decreed should bear his

25 Also begun by Septimius Severus.
26 May.
27 I.e. the chariot upon which the wooden statue was placed.
28 The arena of the Hippodrome was divided lengthwise by a low wall (Lat. *spina*, Gr. *Euripus*) at each end of which was a turning post (Lat. *meta*, Gr. *kampton* or *kamptêr*) in the form of three cones placed on a semicircular pedestal.
29 The text of both Chron. Pasch. and Malalas read *skamma*, but *stama* was the correct form. It designated the part of the arena immediately in front of the imperial box, which was also the finishing line for chariot races.

own name; so that there should nowhere appear in it statues of the supposed gods worshipped in temples, nor altars defiled by pollutions of blood, nor sacrifices burnt by fire, nor demonic festivals, nor anything else that is customary among the superstitious.

49. Instead, one could see upon the fountains placed in public squares images of the Good Shepherd, familiar to those who have a grounding in the Holy Scripture, as well as Daniel with the lions, made of brass and resplendent with gold leaf. Indeed, the Emperor's soul was seized by such intense love of God, that in the most pre-eminent building of the imperial palace itself he affixed on a large panel in the center of the gilded ceiling the sign of the Saviour's Passion composed of various precious stones set in an abundance of gold. This, in his love of God, he regarded as the phylactery of his very empire.

50. In this way, then, he beautified his own city. And likewise, he honored the capital of Bithynia [Nicomedia] by the offering of a very large and splendid church, out of his own treasure raising in that place, too, in honor of his Saviour a memorial of victory over his enemies and the adversaries of God. And he caused the most prominent cities of other provinces to be distinguished by the magnificence of their houses of worship, as in the case of the eastern metropolis that derives its name from Antiochus. Here, as it was the capital of the provinces in that region, he consecrated a church really unique in size and beauty. On the outside, he surrounded the entire church with enclosures of great extent, while the interior of the house of prayer he raised to an immense height. This was made in the form of an octagon ringed all round with chambers (*chôrêmata*) both on the upper and lower levels, and was decorated with a profusion of gold, brass and other costly materials.[30]

The Church of the Holy Sepulchre at Jerusalem (326–35)[31]

Eusebius, *Vita Constantini* III, 29 ff: 29. These things having been done,[32] forthwith the Emperor, by the injunction of pious edicts and [the provision of] ample grants, gave orders that a house of prayer worthy of God should be built round about the Cave of Salvation with rich and

[30] An almost identical description of the church at Antioch may be found in Eusebius' *Speech on the Tricennalia of Constantine*, IX, 15, ed. Heikel, p. 221. Its only significant deviation from the one quoted above is that it designates the spaces surrounding the central octagon not as *chôrêmata*, but as *oikoi* (which means just about the same) and *exedrai*.

[31] Among the numerous discussions of this passage, see esp. H. Vincent and F.–M. Abel, *Jérusalem*, II/1–2 (Paris, 1914), 155 ff.; E. Wistrand, *Konstantins Kirche am Heiligen Grab in Jerusalem* (Göteborg, 1952), pp. 4 ff.; K. J. Conant and G. Downey, "The Original Buildings at the Holy Sepulchre in Jerusalem," *Speculum*, XXXI (1956), 1 ff.

[32] The preceding chapters describe the discovery by Constantine of Christ's Sepulchre and the removal of the pagan temple that had been built on top of it.

[truly] imperial magnificence. This he had had in view for a long time, and had foreseen, by a superior providence, what was going to happen. To the governors of the peoples of the East he gave orders that by means of abundant and liberal grants they should make the work quite extraordinary in size and costliness; while to the bishop who at that time presided over the Church at Jerusalem he sent the following letter. . . .

We omit the preamble of Constantine's letter to bishop Macarius, but reproduce the main body of the letter which defines the bishop's responsibility in the erection of the church.

31. "It befits, therefore, your Sagacity to make such arrangements and such provision of every necessary thing, that not only shall this basilica be the finest in the world, but that everything else, too, shall be of such quality that all the most beautiful buildings of every city may be surpassed by this one. As regards the construction and decoration of the walls, know that we have entrusted that to the care of our friend Dracilianus, deputy to the Praetorian Prefects [i.e., Vicarius Orientis], and the governor of the province; for they have been instructed by My Piety to furnish forthwith by their providence both artificers and workmen and everything else that is necessary for the building after consulting with your Sagacity. Concerning the columns and marbles of whatever kind you consider to be most precious and serviceable, please inform us yourself in writing after an estimate has been made, so that we may learn from your letter what quantity and what kind are needed, and that these may be conveyed from every quarter: for it is fitting that the most wondrous place in the world should be adorned according to its worth. 32. As for the vault (*kamara*) of the basilica, I wish to know from you whether in your opinion it should be coffered or finished in some other fashion; for if it is to be coffered, it may also be adorned with gold. It remains for your Holiness to inform with all speed the aforementioned magistrates how many workmen and artificers and what expenditure of money are needful, and to report to me directly not only concerning the marbles and columns, but also concerning the coffering, if you should consider the latter to be preferable. May God guard you, beloved brother!"

33. These things did the Emperor write, and his instructions were at once carried into effect. Indeed, at the very memorial (*marturion*) of Salvation was the New Jerusalem built, over against the one so famous of old which, after the sacrilege of the Lord's murder, was given over to utter desolation in punishment of its inhabitants' impiety. Opposite the latter, the Emperor, thanks to his rich liberalities, reared the trophy of the Saviour's victory over death, this being perhaps the strange new Jerusalem proclaimed in prophetic oracles and sung in countless ways in long passages of divinely inspired prophecy.[33] And, first of all, he adorned

[33] Cf. Rev. 3:12, 21:2.

the sacred Cave which was, as it were, the head of the whole [work]. . . .
34. This first, as being the head of the whole, the Emperor's liberality
beautified with choice columns and with much ornament, decorating it
with all kinds of embellishments. 35. Next one passed to an enormous
space open to the clear sky, its ground adorned with a pavement of shin-
ing stone, and bounded on three sides by a long circuit of porticoes.
36. To the side opposite the Cave, which side faced the rising sun, was
joined the basilica (*basileios neôs*), an extraordinary work rising to an
immense height, and of great extent in both length and breadth. The
interior was covered with slabs of variegated marble, while the exterior
of the walls, adorned by the joining of dressed stones, one to another, pro-
vided a spectacle of surpassing beauty, no whit inferior to the appearance
of marble. As to the roof, the outside construction was covered with lead,
a sure protection against winter rains; while the inside, composed of
carved coffering, which, like a great sea, extended over the entire basilica
in a continuous intertwining, and being entirely overlaid with radiant
gold, made the whole church gleam with flashes of light.

37. On either side, extending the length of the church, were twin
aisles (*parastades*)[34] each consisting of a double range, an upper and a
lower, and also having their ceiling adorned with gold. The aisles facing
the nave were supported by enormous columns, while those that were
behind were raised on piers richly decorated on their faces. Three doors,
well placed towards the rising sun, admitted the entering crowds. 38.
Opposite these doors was a "hemisphere",[35] the main point of the whole
building, placed at the end of the basilica. This was encircled by twelve
columns, equal in number to the Saviour's apostles, and their summits
were adorned with great bowls of silver, which the Emperor himself gave
—a splendid offering—to his God. 39. Going on from there to the entrances
in front of the church, there was another atrium. Here were exedrae on
either side and a first court with porticoes, and finally the gates of the
court, following which, on the public square, was the porch of the whole
edifice, of exquisite workmanship, which afforded to the passers-by on the
outside a striking view of the interior.

40. This, then, was the church of Our Saviour's Resurrection which
the Emperor reared as a conspicuous memorial (*marturion*) and which he
adorned throughout in costly imperial fashion. He also embellished it
with numerous offerings of indescribable beauty, gold and silver and

34 The normal meaning of *parastás* is 'jamb' or 'pilaster.' In this context,
however, Eusebius can be thinking only of the lateral colonnades. Cf. Vincent
and Abel, pp. 160 ff.

35 The interpretation of the term *hemisphairion* (normally = 'dome') has
given rise to much discussion. Most scholars believe that Eusebius is referring
to an apse surmounted by a semidome, but other solutions have also been pro-
posed. Cf. A. Piganiol, "L'hémisphairion et l'omphalos des Lieux Saints," *Cahiers
archéologiques*, I (1945), 7 ff.

precious stones set in different materials; the skillful arrangement of which in regard to size, number and variety I have no leisure at present to describe in detail.

Theophanes, *Chronogr.*, A. M. 5828:[36] In this year [336/7] flourished[37] Eustathius, a presbyter of Constantinople, a man who embraced an apostolic way of life and attained to the summit of virtue; and the architect Zenobius who built the Martyrium at Jerusalem by Constantine's order.

The Church of Laodiceia Combusta in Lycaonia (c. 330)

Epitaph of Bishop Eugenius:[38] ... And having spent a short time in the city of the Laodiceans, I was made bishop by the will of Almighty God, and this bishopric I governed with much merit for a full twenty-five years, and I rebuilt the whole church from its foundations[39] with all the adornments around it, namely the porticoes (*stoai*), the *tetrastoa*,[40] the paintings, the mosaics (*kentésis*), the water-fountain, the porch (*propulon*), and all the works of the stone-masons.

Exemptions Conferred on Architects and Artisans

Cod. Theod. XIII, 4, 1 (Edict of Constantine to the Praetorian Prefect Felix, posted at Carthage in 334): There is need of as many architects as possible; but since there are none of them, Your Sublimity shall encourage to this study those men in the African provinces who are about eighteen years old and have had a taste of the liberal arts. In order to make this attractive to them, it is Our will that they themselves as well as their parents shall be immune from those services that are wont to be imposed on individuals, and that a suitable salary shall be appointed for the students themselves.

36 Ed. de Boor, I, 33.

37 Literally "was well known for his preeminence" (*diaprepôn egnôrizeto*). This passage has been strangely misinterpreted and misdated to 326 or 328 by modern commentators. As it stands, the text of Theophanes does not suggest that Eustathius had anything to do with the building of the Holy Sepulchre, as is normally assumed. It is true that in Jerome's translation of the Eusebian Chronicle (ed. R. Helm, *Griech. christl. Schriftsteller, Eusebius Werke*, VII, 1, [1913], 233f.), it is Eustathius who appears as the architect (*Eustathius Constantinopolitanus presbyter agnoscitur, cujus industria in Hierosolymis martyrium constructum est*), and the same is repeated almost word for word by Prosper of Aquitaine (PL 51, 576 C). The question remains whether it is Theophanes or Jerome who preserves more accurately the original source.

38 Ed. W. M. Calder, *Klio*, X (1910), 233; P. Batiffol, *Bull. d'ancienne littér. et d'archéol. chrét.*, I (1911), 25 ff.

39 The earlier church having presumably been destroyed during the Great Persecution. Cf. p. 4, n. 7.

40 I.e., the atrium surrounded by four porticoes. The plural form is perhaps used here for emphasis only.

Cod. Theod. **XIII, 4, 2 (Edict of Constantine to the Praetorian Prefect Maximus, 337):** We command that the practitioners of the arts enumerated in the appended list, whatever city they may live in, shall be exempt from all public services, on condition that they devote their time to learning their crafts. By this means they may desire all the more to become more proficient themselves and to train their sons.

[*Appended list of crafts:*] Architects, makers of panelled ceilings (*laquearii*), plasterers, carpenters, physicians, stonecutters, silversmiths, builders, veterinarians, stone-masons (*quadratarii*), gold-weavers (*barbaricarii*), makers of pavements (*scansores*), painters, sculptors, makers of perforated work (*diatretarii*), joiners (*intestinarii*), statuaries, mosaicists, coppersmiths, blacksmiths, marble-masons, gilders, founders, dyers in purple (*blattiarii*), makers of tessellated pavements, goldsmiths, makers of mirrors, carriage-makers (*carpentarii*), glass-makers, ivory workers, fullers, potters, plumbers, furriers.

Constantine's Coins and Effigies

Eusebius, *Vita Constantini* IV, 15: One may ascertain the power of that godly faith which sustained his soul by this consideration, namely that he had his image portrayed on gold coins in such a manner that he appeared to be gazing fixedly upward, as if praying to God. These effigies of his circulated throughout the Roman world. Furthermore, at the palaces of certain cities, the statues placed high up over the entrance represented him standing upright, gazing up to heaven and stretching out his arms in the manner of a man praying.[41]

A Painting at the Palace Gate

Eusebius, *Vita Constantini* III, 3: This, too,[42] he exhibited for everyone to see upon a panel placed high aloft at the vestibule of the imperial palace, having represented in painting the salutary symbol[43] above his head, while the enemy, that hostile beast which had laid siege to God's Church by the usurpation of the godless ones,[44] was in the shape of a dragon, falling into the abyss. Indeed, the books of God's prophets proclaimed him to be a dragon and a crooked serpent.[45] Wherefore the

[41] For a commentary on this passage see H. P. L'Orange, *Apotheosis in Ancient Portraiture,* pp. 93 f., who doubts that Constantine's statues actually represented the Emperor with uplifted arms.

[42] Constantine's explicit espousal of the Christian religion.

[43] I.e., the cross or the monogram of Christ.

[44] Referring presumably to the pagan Licinius whom Constantine defeated at Chrysopolis, on the shores of the Propontis, in 324.

[45] Isaiah 27:1.

Emperor, by means of waxen painting,[46] was showing to everyone, underneath his own feet and those of his sons, the dragon pierced by a dart in the middle of his body and cast down into the depths of the sea. He was hinting thereby at the invisible enemy of the human race whom he showed to have been precipitated into the depths of perdition by the power of the salutary trophy placed above his head.

After describing a bronze statue at Paneas reputed to represent Christ and the woman with an issue of blood, Eusebius comments as follows.

Christian Portraiture

Eusebius *Hist. eccles.* VII, 18, 4: It is not surprising that pagans who a long time ago received a benefit from our Saviour should have done this,[47] considering that I have examined images of the apostles Paul and Peter and indeed of Christ Himself preserved in painting: presumably, men of olden times were heedlessly wont to honor them thus in their houses, as the pagan custom is with regard to saviours.

Portraits of Patriarchs

Parast. syntomoi chronikai, 10:[48] This, too, is told by many persons, namely that images on boards of Metrophanes, Alexander, and Paul[49] were made by Constantine the Great, and that they stood at the Forum near the great status that is upon the column, on the eastern side; which images the Arians, upon taking power,[50] consigned to the flames at the Koronion Milion[51] together with the image of the Mother of God and of Jesus who became a babe in the flesh. . . .

Opposition to Christian Portraiture

Eusebius, *Letter to Constantia*:[52] You also wrote me concerning some supposed image of Christ, which image you wished me to send you. Now

46 Encaustic.

47 I.e., set up a statue of Christ.

48 Ed. Preger, p. 25. The accuracy of this passage as applying to the reign of Constantine may well be questioned, but it does provide some corroborative evidence for the manufacture of patriarchs' portraits in the 4th century. Cf. the text of St. John Chrysostom, p. 39f.

49 Patriarchs of Constantinople: Metrophanes (306/7–14), Alexander (314–37), Paul I (337–39, 341–42, 346–57).

50 Presumably in the reign of Constantius (337–61).

51 On the Milion see p. 141. The meaning of the epithet Koronion is not clear.

52 Sister of Constantine the Great. Text: J. B. Pitra, *Spicilegium Solesmense*, I (Paris, 1852) 383 ff.; PG 20, 1545 ff.

what kind of thing is this that you call the image of Christ? I do not know what impelled you to request that an image of Our Saviour should be delineated. What sort of image of Christ are you seeking? Is it the true and unalterable one which bears His essential characteristics, or the one which He took up for our sake when He assumed the form of a servant?[53]... Granted, He has two forms, even I do not think that your request has to do with His divine form.... Surely then, you are seeking His image as a servant, that of the flesh which He put on for our sake. But that, too, we have been taught, was mingled with the glory of His divinity so that the mortal part was swallowed up by Life.[54] Indeed, it is not surprising that after His ascent to heaven He should have appeared as such, when, while He—the God, Logos—was yet living among men, He changed the form of the servant, and indicating in advance to a chosen band of His disciples the aspect of His Kingdom, He showed on the mount that nature which surpasses the human one—when His face shone like the sun and His garments like light. Who, then, would be able to represent by means of dead colors and inanimate delineations (*skia-graphiai*) the glistening, flashing radiance of such dignity and glory, when even His superhuman disciples could not bear to behold Him in this guise and fell on their faces, thus admitting that they could not withstand the sight? If, therefore, His incarnate form possessed such power at the time, altered as it was by the divinity dwelling within Him, what need I say of the time when He put off mortality and washed off corruption, when He changed the form of the servant into the glory of the Lord God...?... How can one paint an image of so wondrous and unattainable a form—if the term 'form' is at all applicable to the divine and spiritual essence—unless, like the unbelieving pagans, one is to represent things that bear no possible resemblance to anything...? For they, too, make such idols when they wish to mould the likeness of what they consider to be a god or, as they might say, one of the heroes or anything else of the kind, yet are unable even to approach a resemblance, and so delineate and represent some strange human shapes. Surely, even you will agree that such practices are not lawful for us.

But if you mean to ask of me the image, not of His form transformed into that of God, but that of the mortal flesh before its transformation, can it be that you have forgotten that passage in which God lays down the law that no likeness should be made either of what is in heaven or what is in the earth beneath?[55] Have you ever heard anything of the kind either yourself in church or from another person? Are not such things banished and excluded from churches all over the world, and is it not common knowledge that such practices are not permitted to us alone?

[53] Phil. 2:7.
[54] 2 Cor. 5:4.
[55] Exod. 20:4; Deut. 5:8.

Once—I do not know how—a woman brought me in her hands a picture of two men in the guise of philosophers and let fall the statement that they were Paul and the Saviour—I have no means of saying where she had had this from or learned such a thing. With the view that neither she nor others might be given offence, I took it away from her and kept it in my house, as I thought it improper that such things ever be exhibited to others, lest we appear, like idol worshippers, to carry our God around in an image. I note that Paul instructs all of us not to cling any more to things of the flesh; for, he says, though we have known Christ after the flesh, yet now henceforth know we Him no more.[56]

It is said that Simon the sorcerer is worshipped by godless heretics painted in lifeless material. I have also seen myself the man who bears the name of madness[57] [painted] on an image and escorted by Manichees. To us, however, such things are forbidden. For in confessing the Lord God, Our Saviour, we make ready to see Him as God, and we ourselves cleanse our hearts that we may see Him after we have been cleansed. . . .

[56] 2 Cor. 5;16.
[57] Mani, the founder of Manichaeism.

2

From Constantine
to Justinian
(337–527)

Historically, the period covered by this chapter is marked by the successive waves of Germanic invasion and the downfall of the western half of the Roman Empire; theologically, by the crystallization of East Christian thought by the Cappadocian Fathers, and by the Monophysite controversy; artistically, by the almost complete elaboration of a specifically Christian art.

In the realm of church building, the basilica remained the dominant type and was progressively standardized. Today we are apt to regard the basilica as if it were an isolated building, but this was far from being the case: in fact, it was normally the focus of a large complex. The prescriptions contained in the Testamentum Domini give us some idea of the multiplicity of annexes surrounding an episcopal church. The archaeological exploration of Early Christian sites in many parts of the Roman Empire has shed much light on the nature of these complexes.[1]

In addition to the basilica, we have the martyrium, which originally designated a place of "testimony," and gradually came to mean a martyr's church. The growing importance of the cult of relics led, already in the fourth century,[2] to the custom of "translating" them, i.e., removing them from one place to another; and while a martyr's home town or the town in which he suffered martyrdom naturally had the strongest claim to having his martyrium, the migration of relics made it possible to build martyria in localities that had had no connection with the saint's earthly life. Particularly significant is the case of Constantinople which, at the time of its foundation, had practically no previous Christian associations, but which, with the passage of time, acquired the greatest collection of relics in all Christendom.

Architecturally, the martyrium assumed a "centralized" form (circular, polygonal, square, or cruciform). An excellent example is provided by the shrine at Chalcedon as described by Evagrius: here we have a basilical house of congregation and, attached to it, the circular martyrium of St. Euphemia containing the Saint's sarcophagus which emitted a miraculous stream of blood. St. Gregory of Nyssa describes in some detail his project for the construction of a cruciform martyrium which was to have an octagonal central space covered with a conical top of masonry. He also provides some valuable information on the employment of labor in central Asia Minor. At the Hebdomon, a suburb of Constantinople, we have an early example of a martyrium constructed for an imported relic, the head of St. John the Baptist.

[1] See J. Lassus, "Les édifices du culte autour de la la basilique," *Atti del VI Congresso Intern. di Archeologia Cristiana* (Ravenna 1962: published 1965), pp. 581–610.

[2] Thus, in 356 and 357 the relics of the apostles Timothy, Andrew, and Luke were brought to Constantinople and deposited in the church of the Holy Apostles.

The distinction between the elongated house of congregation and the "centralized" martyrium should not, however, be pressed too far. We have no evidence to affirm that Constantine's octagonal church at Antioch was a martyrium; or, for that matter, the octagonal church at Nazianzus. And we shall see that the cathedral of Gaza was cruciform. The passage describing the construction of the latter is one of particular interest. It tells us that there was at first a conflict of opinion as to the architectural form to be adopted, and that this conflict was resolved by the arrival of a ready-drawn plan—the cruciform one—dispatched from the court of Constantinople. The author goes on to describe in a particularly vivid manner how the outline of the walls was traced on the ground with chalk; how the bishop mobilized his volunteer labor force; how the columns of costly marble were sent a year later by the Empress Eudoxia, and how the people rushed to the shore to unload them from the ship that had brought them.³

In the realm of Christian pictorial art, the second half of the 4th century witnessed a momentous development. The "neutral" repertory of secular Graeco-Roman art—the pastoral, the scenes of hunting and fishing, the Nilotic landscape—was at first applied to church decoration, and perhaps some vague symbolic meaning could be read into it. Then there were the little vignettes familiar from catacomb painting, such as the Good Shepherd and the orant figure, and the great swirls of vegetal ornament that served as space fillers. All of this, however, proved inadequate for the mass of new Christian converts who had to be instructed in religious doctrine by means of explicit picture-stories drawn from the Old and New Testaments. The trend toward the decoration of churches with Biblical scenes is illustrated by the famous letter of St. Nilus to Olympiodorus; and soon thereafter we find such scenes (not all of them canonical) on the walls of Sta. Maria Maggiore in Rome (mid 5th century). At a later time—witness the passages from the Life of St. Pancratius (see p. 137)—an apostolic origin was claimed for this kind of didactic, Biblical iconography, as it was also claimed for icons.⁴

Simultaneously, picture stories illustrating the feats and sufferings of martyrs were created for the decoration of martyria. We have the detailed description by Asterius of the martyrdom of St. Euphemia in several scenes, as well as supplementary, if less specific, passages on Sts. Theodore and Barlaam.

3 Socrates, *Hist. eccles.* VII, 37, PG 67, 824 B, tells us that there was a special kind of broad ship, called *platē*, that was designed to carry big columns. A ship of this kind was built in the Troad, but was apparently so heavy that it could not be launched until the local bishop managed to budge it by supernatural power (c. 432 A.D.)

4 See *infra*, p. 40 for the icon of the Virgin painted by St. Luke. Cf. also the alleged letter of St. Basil to the Emperor Julian, PG 32, 1100 B, No. 360.

It is in the same period that the icon makes its hesitant debut. We have, of course, to be rather cautious in using this term because the distinction we draw today between an icon and a portrait is an artificial one and does not correspond to any reality of the Early Christian or medieval period. In Greek the word eikôn *means simply an image—any image;*[5] *and it is used, pretty much indiscriminately, along with other terms, such as* charaktêr, morphê, ektupôma, *etc. When St. John Chrysostom tells us that images of the bishop Meletius (d. 381) were set up in many people's houses, it is idle to ask whether these were "icons" or not. What we can observe is that the practice of displaying portraits of popular saints and bishops as well as of Biblical personages was slowly gaining ground, and that some degree of sacredness was attached to these portraits. The anecdote about the painter who dared to represent Christ in the likeness of Zeus is significant in this respect; so, in another way, is the statement that portraits of St. Symeon the Stylite were set up in workshops in Rome for "protection and security."*

The Eastern Church Fathers—the Cappadocians, St. John Chrysostom, St. Cyril of Alexandria—spoke with approval of Christian pictorial art which they regarded as a didactic and hortatory aid. St. Basil's famous dictum that "the honor shown to the image is conveyed to its model" became in the 8th and 9th centuries the slogan of the Iconodule party; although it is fair to add that in its original context it applies to imperial rather than to religious art (see p. 47). At the same time the puritan tradition opposing all kinds of Christian portraiture was kept alive by St. Epiphanius of Salamis, a theologian of unexceptionable orthodoxy; while somewhat later it found a ready reception in Monophysite circles, as exemplified by Philoxenus (Xenaias) of Mabbug and Severus of Antioch.

In the realm of secular art, sculpture in the round was steadily losing ground and became pretty much limited to statues of emperors, magistrates, and popular charioteers. Preserved monuments are few in number (e.g., the colossus of Barletta and the statues of magistrates from Ephesus and Aphrodisias), hence the importance of textual evidence. We have not attempted, however, to collect here all the references—they are usually very laconic—to this or that statue: the passages concerning the statues of the emperors Marcian and Anastasius and of the Quaestor Proculus may serve as examples. Triumphal arches and triumphal columns (such as

5 It is well to remember that the English word 'icon' in the sense of a religious image used by the Eastern Church is derived not from Greek, but from Russian usage: all the examples listed in the Oxford English Dictionary (none earlier than the 19th century) refer to the Slavic world. In Russian the term *ikona* carries the specific connotation of a religious picture, normally of a portable kind, but it is not legitimate to apply this connotation to the Byzantine period.

those of Theodosius I and Arcadius) continued to be erected, especially at Constantinople, as well as other huge public monuments like the Anemodoulion, a description of which will be found below. Portraits of the emperor were to be found everywhere and signified his omnipresence; so were pictures of him surrounded by his bodyguard and receiving the submission of his enemies. Public servants vied with each other in representing the glorious deeds of their emperor in painting or mosaic. These manifestations attest to the survival of traditional forms; what is rather more novel is the incipient interpenetration of secular and religious art. Christian symbols begin to appear on imperial monuments (e.g., on the base of the column of Arcadius); by the same token, imperial portraits could have a place in church decorations. The text describing the images of Leo I and his wife Verina in the church of the Blachernae, if it is trustworthy, is of interest in this connection.

Churches

The Ideal Church

Constitutiones apostolorum II, 57, 3 ff:[6] 3. First, let the church (*oikos*) be elongated (inasmuch as it resembles a ship), turned to the east, and let it have the *pastophoria* on either side, towards the east. 4. The bishop's throne is to be placed in the middle, and on both sides of him the presbyters shall sit, while the deacons stand by, trimly dressed, without any superfluous clothing, since they are like seamen or boatswains. It shall be the concern of the latter that the laity is seated in the other part [of the church] in a quiet and orderly fashion, the women sitting apart and observing silence. 5. The lector shall stand in the middle, on an eminence, and read the books of Moses and Joshua, son of Nun, of the Judges and the Kings.... 10. The janitors shall stand guard at the entrances [reserved] for men, and the deacons at those [reserved] for women, in the guise of ship's stewards: indeed, the same order was observed at the Tabernacle of Witness.... 12. The church is likened not only to a ship, but also to a sheepfold (*mandra*).... *The document goes on to state that just as in a fold various kinds of animals are placed separately, so the congregation shall be divided not only according to sex, but also according to age groups.*

 [6] Ed. F. X. Funk. *Didascalia et Constitutiones apostolorum*, I (Paderborn, 1905), 159 ff. The *Constitutiones* are believed to date from c. 375 and are based in part on the *Didascalia*, a work of the third century. The corresponding passage of the latter is less specific; it may be found in English trans. in R. H. Connolly, *Didascalia apostolorum* (Oxford, 1929), pp. 119–20.

Testamentum Domini I, 19:[7] I will tell you, then, how a sanctuary ought to be; then I will make known unto you the holy canon of the priests of the Church.

Let a church then be thus: with three entries in type of the Trinity. And let the diakonikon be to the right of the right hand entry, to the purpose that the Eucharists, or offerings that are offered, may be seen. Let there be a forecourt, with a portico running round, to this diakonikon. And within the forecourt let there be a house for a baptistery, with its length 21 cubits for a type of the total number of the prophets, and its breadth 12 cubits for a type of those who were appointed to preach the Gospel; one entry; three exits.

Let the church have a house for the catechumens,[8] which shall also be a house of exorcists, but let it not be separated from the church, so that when they enter and are in it they may hear the readings and spiritual doxologies and psalms.

Then let there be the throne towards the east; to the right and to left places of the presbyters, so that on the right those who are more exalted and more honored may be seated, and those who toil in the word, but those of moderate stature on the left side. And let this place of the throne be raised three steps up, for the altar also ought to be there.

Now let this house have two porticoes[9] to right and to left, for men and for women.

And let all the places be lit, both for a type and for reading.

Let the altar have a veil of pure linen, because it is without spot.

Let the baptistery also in like manner be under a veil.

And as for the Commemoration let a place be built so that a priest may sit, and the archdeacon with readers, and write the names of those who are offering oblations, or of those on whose behalf they offer, so that when the holy things are being offered by the bishop, a reader or the archdeacon may name them in this commemoration which priests and people offer with supplication on their behalf. For this type is also in the heavens.

And let the place of the priests be within a veil near the place of commemoration. Let the House of Oblation (*chorbanas*) and treasury all be near the diakonikon. And let the place of reading[10] be a little outside the altar. And let the house of the bishop be near the place that is called the forecourt. Also that of those widows who are called first in standing. That of the priests and deacons also behind the baptistery. And let the

7 Ed. Rahmani, pp. 22 ff. We have reproduced with a few changes the English translation by the Rev. D. J. Chitty from *Gerasa, City of the Decapolis,* ed. C. H. Kraeling (New Haven, 1938), pp. 175–76.

8 I.e., a narthex.

9 I.e., aisles.

10 I.e., the ambo.

deaconesses remain by the door of the Lord's house. And let the church have a hostel near by, where the archdeacon may be receiving strangers.

Dedication of St. Sophia, Constantinople, 360

Chron. Paschale I, 544: At the time of this council of bishops,[11] a few days after Eudoxius had been consecrated bishop of Constantinople, was celebrated the dedication of the Great Church of that city, more or less 34 years after its foundations had been laid by Constantine, the victorious Augustus. This dedication was carried out under the above consuls,[12] the 16th day before the Kalends of March, i.e., the 14th of the month Peritios.[13] At the dedication the emperor Constantius Augustus presented many offerings, namely vessels of gold and silver of great size and many covers for the holy altar woven with gold and precious stones, and furthermore, various golden curtains (*amphithura*) for the doors of the church and others of gold cloth for the outer doorways.

The Church at Nazianzus

Gregory Nazianzenus, Orat. XVIII, 39:[14] Since it was fitting that a memorial of his[15] magnanimity should be left to posterity, what was more suitable than this church which he erected both to God and ourselves, largely at his own expense (although, to a small extent, he availed himself of [the contributions of] the people)? It is a work that does not deserve to be passed over in silence, being bigger than many others and more beautiful than almost all [other churches]; made up of eight straight sides of equal length, and rising aloft by means of two stories of beautiful columns and porticoes, while the figures (*plasmata*) placed above them are true to nature.[16] At the top is a gleaming heaven[17] that illuminates the eye all round with abundant founts of light—truly a place wherein light dwells. It is surrounded on all sides with passages lying at equal angles,[18] made of

11 The council that condemned Macedonius, heretical bishop of Constantinople, and appointed Eudoxius in his stead (Jan. 27, 360).

12 Constantius XII (read X), Julian III.

13 February 14.

14 PG 35, 1037.

15 St. Gregory's father, also called Gregory, who was bishop of Nazianzus (d. 374).

16 It is not clear whether these were carvings or paintings or both. In any case, they were not statues as some scholars have supposed on the strength of the Latin translation in Migne's PG.

17 I.e. a dome having windows all round. A medieval scholion found in Cod. Vatic. Urbinas 15 (11th century) and published by A. Birnbaum, *Repertorium für Kunstwissenschaft*, XXXVI (1913), 192, states that the center of the ceiling was open to the sky, but that is probably a mistaken interpretation.

18 I.e. a perambulatory. Birnbaum, pp. 193, 195, reconstructs two concentric perambulatories, but such an arrangement is not borne out by the text.

splendid material, which enclose a vast central space, and it shines forth with the beauty of its doors and vestibules which greet the visitor from afar. I need not describe the exterior adornment, the beauty and size of the squared stones fitted together to a hair's breadth, the marble pedestals and capitals which occupy the corners,[19] and the local [stone] which does not yield [in quality] to the imported;[20] nor the bands carved with various forms that extend from base to pinnacle where the spectator's view is, to his distress, cut short.[21]

The Martyrium at Nyssa

St. Gregory of Nyssa, *Epist*. XXV *to Amphilochius, bishop of Iconium*:[22] By God's grace, my endeavours regarding the martyrium have, I am sure, come to a successful issue. If you so wish, the object of my concern will be attained by the power of God who is able to achieve anything in any manner He please. Seeing that, as the Apostle says, "He which hath begun a good work will perform it,"[23] be so kind as to become, in this as in other respects, the imitator of the great Paul and to realize our hopes in very deed by sending us as many artisans as are sufficient for the work. The extent of the whole work may become known to Your Perfection by means of a reckoning; for which reason I shall attempt to explain to you in writing the entire construction.

The church is in the form of a cross and naturally consists of four bays, one on each side. These bays come into contact with one another in a manner that is inherent in the cruciform shape. Inscribed in the cross is a circle cut by eight angles: I have called the octagonal shape a circle because it is rounded in such a way that the four sides of the octagon that are opposite one another on the main axes (*ek diametrôn*) connect by means of arches the central circle to the four adjoining bays. The other four sides of the octagon, which lie between the rectangular bays, do not extend in an even line towards the bays, but each one of them will encompass a semicircle having at the top a conch-like form leaning on an arch;

19 Gregory is referring to columns or pilasters placed against the exterior corners of the octagon. Only their capitals and pedestals were made of imported marble.

20 Local stone was evidently used for the shafts of the exterior columns as well as for the walls of the church.

21 The scholiast referred to in note 17 contributes the following interesting information: "The form of the church is octagonal, such as we see today in the church of St. John at Alexandria. Such also is the church of the Theotokos at Tyre." And further down, with reference to the two-storeyed porticoes (*stoai*): "There also exist three-storeyed *stoai*, as in the church of Dionysius at Alexandria."

22 Ed. G. Pasquali, pp. 79 ff. Cf. J. Strzygowski, *Kleinasien* (Leipzig, 1903), pp. 71 ff. (contribution by B. Keil).

23 Phil. 1:6.

so that, all together, there will be eight arches by means of which the squares and semicircles will parallel-wise be conjoined to the central space. Next to the inner side of the diagonal piers will be placed an equal number of columns for the sake of both adornment and strength, and these, too, will uphold arches constructed in the same manner as the outer ones. Above these eight arches the octagonal structure will be raised four cubits for the due proportion of the superimposed windows. From this point upward there will be a conical top, vaulted in such a way that the wide ceiling will terminate in a pointed wedge. The [interior] width of each of the rectangular bays will be eight cubits and their length greater by one half; as for the height, it will be proportioned to the width. The same will hold true of the semicircles, namely that the distance between the piers will amount to eight cubits, and the depth will be obtained by fixing the point of a compass in the center of the side and describing an arc through the end thereof. As for the height, here, too, it will be proportioned to the width. The thickness of the wall enclosing the entire structure will be three feet, i.e., in addition to the [above] internal measurements.

I have taken the trouble of inflicting all this verbiage on your kind self for this purpose, namely that by means of the thickness of the walls and the intervening spaces you may be able to reckon exactly the total number of feet; since your mind is surely skilled in applying itself successfully by God's grace to any subject you please, so making it possible for you by means of a detailed enumeration to reckon the sum of all the elements and despatch to us no more and no fewer masons than the task demands. Please take especial care that some of them should be expert in uncentered vaulting, for I have been informed that this is more stable than the kind that rests on supports. The scarcity of wood leads us to the idea of roofing the entire building with masonry because no roofing timber is available in these parts. Truthful as you are, you may believe that some local persons have contracted to provide me thirty artisans for squared masonry work to the *solidus*,[24] i.e., the prescribed food being supplied in addition. However, we have no [source of] stone, so that the material of construction will be clay brick as well as whatever stones happen to come our way; consequently, there will be no need for them to spend their time on dressing the face of the stones so that they fit one to another. Besides, I know that the men of your parts are more expert and easier to please with regard to their wages than our local men who are taking advantage of our need. As for the task of the stone-carvers, this

[24] I.e. per day. St. Gregory evidently considered this rate of pay too high, and tried to obtain cheaper labor from the region of Iconium. For laborers' wages see G. Ostrogorsky, "Löhne und Preise in Byzanz," *Byzant. Zeitschr.*, XXXII (1932), 295 ff.; A. H. M. Jones, *The Later Roman Empire* (Oxford, 1964), II, 858.

will concern not only the eight columns which are in need of adornment; it also requires altar-shaped pedestals[25] and sculpted capitals of the Corinthian order, as well as an entrance door of suitably decorated marble and the superimposed lintel (*thurômata*) beautified on the projecting cornice (*geision*) with the customary delineations (*graphai*).[26] For all of these we shall, of course, provide the material, while the shaping thereof will devolve on the craftsmen. In addition, there are the columns of the peristyle—not fewer than forty of them—which are surely stone-carvers' work.

Granted that our discourse has explained the task with sufficient accuracy, may Your Sanctity find it possible, knowing as you do our need, to set our mind at rest in every way with regard to the craftsmen. If a craftsman is to make a contract with us, let there be laid down, if possible, a clear measure of a day's work, lest having spent his time in idleness and having no work to show, he nevertheless demand his wage for having been in our employ for so many days. I realize that I may appear to many persons to be petty in examining the contract so minutely, but please be indulgent. For Mammon, who on so many occasions has been insulted by me, has finally removed himself as far as he could, being weary, I suppose, of the constant verbiage directed against him, and has sundered himself by an impassable gulf, i.e. by poverty, so that neither can he visit me nor can I cross over to him. For this reason I attach great importance to the good will of the craftsmen so as to enable me to fulfil my purpose without being hindered by poverty—that praiseworthy and desirable evil. In this I have been somewhat jocular; as for you, O man of God, conclude an agreement with the men according to custom and the best of your ability, and announce to them without hesitation both our good will and the full requital of their wages: we shall pay them everything without fail since, thanks to your prayers, God opens to us also His blessing hand.

The Martyrium of St. John the Baptist at the Hebdomon[27]

Patria Constant., § 145:[28] The round-roofed church that has conches was called Prodromos and was built by the elder Theodosius[29] because in his days the sacred head of the Forerunner was brought over, and the emperor, together with the patriarch Nectarius,[30] received it at the Hebdomon and deposited it in the church of [St. John] the Evangelist.

25 For the columns. St. Gregory refers to the kind of high pedestal that resembled an ancient altar (*bômos*).
26 I.e., carving.
27 A suburb of Constantinople, modern Bakīrköy.
28 Ed. Preger, p. 260.
29 Theodosius I (379–95).
30 Patriarch of Constantinople (381–97).

Rufinus the magister[31] prevailed on the emperor to build a church of the Forerunner so as to place in it his sacred head.

The Church of St. Euphemia at Chalcedon[32]

Evagrius, *Hist. eccles.* II, 3: Her church faces Constantinople and is beautified by the view of so great a city. It consists of three enormous structures. The first is open to the sky and is distinguished by an oblong court having columns all round; the second is nearly similar to the first with regard to width, length and columns, and is differentiated only by being covered with a roof.[33] On the north side of the latter, towards the rising sun,[34] is a circular building like a *tholos*, ringed inside with artfully made columns, all of the same material and size. Upon these, yet under the same roof, is raised a gallery so that one can, from there, too, pray to the Martyr and witness the service. Inside the *tholos*, to the east, is a beautiful sanctuary (*sêkos*) wherein the Martyr's sacred relics are deposited in an oblong tomb—some call this a sarcophagus (*makra*)—cunningly made of silver.... On the left side of this tomb is a small aperture secured by little doors through which they insert in the direction of the sacred relics a long iron rod having a sponge attached to it, and after rotating the sponge, they pull it back on the rod, full of blood and clots. When the people see this, they straightaway offer adoration to God. So great is the abundance of the effluvia, that the pious emperors and all the assembled clergy and the people receive generous portions thereof, and they are even sent out throughout the world to those among the faithful that are desirous of them.

The Cathedral of Gaza (402–7)

Mark the Deacon, *Life of Porphyry*, ch. 75 ff: 75. After the Marneion[35] had been completely burnt down and the city been pacified, the blessed Bishop[36] together with the holy clergy and the Christian people determined to build a church on the burnt site in accordance with the revelation he had had while he was at Constantinople: it was for this purpose that he had received money from the most pious empress Eudoxia.... Some persons urged that it should be built on the plan (*thesis*) of the

[31] Flavius Rufinus, *magister officiorum* under Theodosius I, promoted to Praetorian Prefect in 392, murdered in 395.

[32] Exact date of construction unknown, but the church certainly existed in the latter part of the 4th century. See R. Janin in *Echos d'Orient*, XXI (1922), 379 ff. and *below*, p. 37.

[33] Evagrius is referring to a basilica preceded by an oblong atrium.

[34] I.e., at the northeast corner of the basilica.

[35] Temple of Zeus Marnas, tutelary god of Gaza.

[36] Porphyry.

burnt temple. The latter had been a circular building encompassed by two concentric porticoes, while its middle part consisted of an inflated dome (*kiborion*) reaching up to a [great] height; and it had some other features suitable for idols and adapted to the foul and illicit rites of idolaters. Some persons, then, said that the holy church should be built according to this plan, while others contradicted them saying that the very memory of such a plan ought to be blotted out.... As for the holy Bishop, he said, "Let us leave this, too, to the will of God." And while the site was being cleared, there arrived a *magistrianos*[37] with imperial letters of Eudoxia of eternal memory. These letters contained greetings and a request for prayers on behalf of herself and of the Emperors, her husband and her son. On another sheet enclosed in the letter was the plan (*skariphos*) of the holy church in the form of a cross, such as it appears today by the help of God; and the letter contained instructions that the holy church be built according to this plan. The Holy Man rejoiced when he had read the letter and seen the plan.... Furthermore, the letter announced the despatch of costly columns and marbles.

76. When the ashes had been dug out and all the abominations removed, the holy Bishop ordered that the remaining debris from the marble revetment of the Marneion—these, they said, were sacred and pertained to a place into which access was forbidden, especially to women—would be used for paving the open space in front of the church so that they might be trodden on not only by men, but also by women, and dogs, and pigs, and cattle....

78. The holy Bishop had engaged the architect Rufinus from Antioch, a dependable and expert man, and it was he who completed the entire construction. He took some chalk and marked the outline (*thesis*) of the holy church according to the form of the plan (*skariphos*) that had been sent by the most-pious Eudoxia. And as for the holy Bishop, he made a prayer and a genuflexion, and commanded the people to dig. Straightaway all of them, in unison of spirit and zeal, began to dig crying out, "Christ has won!" ... And so in a few days all the places of the foundations were dug out and cleared.

79. And as the material of construction—namely enormous blocks from the hill called Aldioma to the east of the city as well as other material—had been made ready, the holy Man gathered the Christian people once again, and after performing on the spot many prayers and psalmodies, he, first of all, girded himself and began picking up stones and placing them in the foundations....

84. The following year the empress Eudoxia despatched the columns that she had promised—thirty-two big and admirable columns of

[37] A member of the corps of the *agentes in rebus* who were supervised by the *magister officiorum* (hence their name *magisteriani*) who acted as special couriers and secret agents.

Carystos marble[38] which now shine in the holy church like emeralds. As these arrived by sea . . . everyone, upon hearing the news, rushed to the shore. . . . They brought carts and, after loading the columns one by one, pulled them along and deposited them in the open space of the church. . . .

92. After a lapse of five years the construction of the holy great church was completed, and it was named Eudoxiana after the most pious Eudoxia. The most reverend Porphyry celebrated the dedication with great pomp on holy Easter, the day of the Resurrection. . . . Strangers came from all quarters to view the beauty and size of the said holy church, for it was said to be bigger than any other church of that time.

The Church of St. Symeon, the Elder Stylite (c. 476–90)[39]

Evagrius, *Hist. eccles.* I, 14: The structure of the church comprises four arms[40] in the form of a cross and is adorned with porticoes (*stoai*).[41] The porticoes have rows of columns of carved stone, beautifully made, which raise the roof to a considerable height. In the center is a court, open to the sky,[42] decorated with great skill. It is there that stands the pillar of forty cubits upon which he who was an incarnate angel on earth led his heavenly life. Near the roof of the said porticoes are small openings (some call them windows) which respond both to the aforementioned open court and to the porticoes.

On the left-hand side of the column I saw in one of those very openings (as did also the assembled crowd of peasants that surged round the column) an enormous shining star that travelled across the entire opening, not once or twice or three times, but repeatedly, often vanishing and then, suddenly, appearing again—something that occurs only at the memorial of this holy man.

Church Decoration

St. Nilus of Sinai, *Letter to Prefect Olympiodorus*:[43] Being, as you are, about to construct a large church in honor of the holy martyrs, you

[38] From the southern tip of Euboea. This marble comes in several shades of green and was extensively exported to Italy during the Roman Imperial period. On the ancient quarries see I. Papageorgakis in *Praktika tês Akadêmias Athênôn*, XXXIX (1964), 262-84.

[39] On Qalᶜat Simᶜān see esp. D. Krencker, *Die Wallfahrtkirche des Simeon Stylites in Kal'at Sim'an* (Berlin, 1939); J. Lassus, *Sanctuaires chrétiens de Syrie* (Paris,1947), 129 ff.; G. Tchalenko, *Villages antiques de la Syrie du nord*, I (Paris, 1953), 223 ff.

[40] Literally "sides."

[41] Referring to the four basilicas that radiate from the central octagon.

[42] The octagonal court was meant to be covered with a timber roof which was probably built and later collapsed because of some natural calamity. See discussion in Tchalenko, pp. 271 ff.

[43] PG 79, 577-80.

inquire of me in writing whether it be fitting to set up their images in the sanctuary inasmuch as they have borne testimony of Christ by their martyrs' feats, their labors and their sweat; and to fill the walls, those on the right and those on the left, with all kinds of animal hunts so that one might see snares being stretched on the ground, fleeing animals, such as hares, gazelles and others, while the hunters, eager to capture them, pursue them with their dogs; and also nets being lowered into the sea, and every kind of fish being caught and carried on shore by the hands of the fishermen; and, furthermore, to exhibit a variety of stucco-work so as to delight the eye in God's house; and lastly, to set up in the nave a thousand crosses and the pictures of different birds and beasts, reptiles and plants. In answer to your inquiry may I say that it would be childish and infantile to distract the eyes of the faithful with the aforementioned [trivialities]. It would be, on the other hand, the mark of a firm and manly mind to represent a single cross in the sanctuary, i.e., at the east of the most-holy church, for it is by virtue of the one salutary cross that humankind is being saved and hope is being preached everywhere to the hopeless; and to fill the holy church on both sides with pictures from the Old and the New Testaments, executed by an excellent painter, so that the illiterate who are unable to read the Holy Scriptures, may, by gazing at the pictures, become mindful of the manly deeds of those who have genuinely served the true God, and may be roused to emulate those glorious and celebrated feats. . . . And as for the nave, which is divided into many compartments of different kinds, I consider it sufficient that a venerable cross should be set up in each compartment; whatever is unnecessary ought to be left out.

Heterodox Painting

Theophanes, *Chronogr.*, A. M. 5999:[44] Anastasius[45] brought from Cyzicus a Manichaean painter who was a Syro-Persian[46] and pretended to be a presbyter, and who had the insolence to paint both in the palace of Helenianae[47] and at St. Stephen's of Aurelianae[48] certain fabulous [pictures] that were alien to the holy iconography of the Church: [This he did] at the behest of the Emperor who supported the Manichees. There occurred, as a consequence, a big popular uprising.

44 Ed. de Boor, I. 149–50. The date corresponds to 507.
45 The Emperor Anastasius (491–518).
46 I.e., a Syrian hailing from Persian territory.
47 Situated on the seventh hill of Constantinople.
48 A church built c. 400 A.D. and later restored by Basil I (see p. 193). It stood close to the Helenianae palace.

The Sacrifice of Isaac

St. Gregory of Nyssa, *De deitate Filii et Spiritus Sancti*:[49] I have
often seen this tragic event depicted in painting and could not walk by
the sight of it without shedding tears, so clearly did art present the story
to one's eyes. Isaac, kneeling down, his arms bent over his back, is set
before his father next to the very altar; the latter, standing behind the
bend [of Isaac's knee] and drawing with his left hand the lad's hair
towards himself, stoops over the face that looks piteously up to him as he
points the murderous sword grasped in his right hand. Already the edge
of the sword touches the body, when a voice sounds unto him from God
prohibiting the deed.

St. Cyril of Alexandria, *Epist*. XVI:[50] Imagine one of us wished to see
the story of Abraham painted on a panel (*pinax*): how would the painter
have represented him? Would he [have shown him] enacting all the afore-
mentioned things[51] simultaneously, or [shown] the same man [acting]
severally and differently, i.e., in different manners and in many places?
I mean, for example, that he would be mounted on his ass, accompanied
by the lad and followed by his servants; then again, after the ass and the
servants had been left below, and he had loaded the wood on Isaac, he
would be holding the knife and the fire in his hands; and then again the
same man, but in a different guise, after he had bound the lad on the
wood-pile, would be brandishing the knife in his right hand for the slay-
ing. Yet it is not a different Abraham that appears in different guises in
many parts of the painting, but he is the same man everywhere, the
painter's art being adapted to the actual requirements. For it would have
been neither reasonable nor possible to see him accomplishing at once all
the aforementioned things.

Votive Images

***Cod. Paris gr. 1447*, fols. 257–58**[52] After the demise of these men,[53] the
said emperor Leo and his most-pious spouse Veronica[54] honored in a fit-
ting fashion the holy garment[55] of Our Lady the Mother of God by dedi-

[49] PG 46, 572 C.

[50] PG 77, 220; Mansi, XIII, 12–13.

[51] Cyril had just quoted the story of the Sacrifice of Isaac from Gen. 22.

[52] Ed. A. Wenger, *Rev. des études byz.*, X (1952), 54 ff. The manuscript
is of the 10th century.

[53] The patricians Galbius and Candidus who, according to tradition, dis-
covered the Virgin's veil at Capernaum and brought it to Constantinople. This
is said to have taken place between 471 and 473.

[54] Leo I (457–74) and his wife Verina.

[55] This was called *pallium* or *omophorion* and appears to have been a veil
such as women wore to cover their head and shoulders.

cating to her a church with all glory and veneration and depositing therein the aforementioned casket which was of pure gold and precious stones . . . together with the glorious and most holy treasure [it contained]. Upon the lid of the reliquary (*soros*) they placed this inscription, namely that "Having offered this honor to the Mother of God, they have secured the might of the Empire."

The same emperors beloved of God and Christ set up in the ciborium of the reliquary (?)[56] an image, all of gold and precious stones, in which image [are represented] Our Lady the immaculate Mother of God seated on a throne and on either side of her Leo and Veronica, the latter holding her own son, the young emperor Leo,[57] as she falls before Our Lady the Mother of God, and also their daughter Ariadne. This image has stood from that time onward above the *bema* of the holy *soros.* . . .

We shall mention also the following . . . namely that in those days the aforesaid illustrious men[58] Galbius and Candidus dedicated with all glory and honor an enormous image of . . . Our Lady the Mother of God. To the right and left of her upon this image are two angels and, on either side, St. John the Baptist and St. Conon. The same Galbius and Candidus stand in an attitude of prayer and thanksgiving before God and Our Lady the Mother of God. This icon is set up in her venerable church between the two diaconica.[59] . . .

Pictures of Miracle

Theodore Lector, *Hist. eccles.* as excerpted by St. John Damascene:[60]

[498] *An Arian called Olympius went to the bath attached to the Helenianae palace at Constantinople and made an obscene remark about the Holy Trinity. He proceeded, as usual, from the* caldarium *to the* frigidarium *of the bath. The latter had a pool of water fed by a stream which had its origin in the church of St. Stephen. When he entered the pool, an angel appeared and poured boiling water over him so that his flesh fell from his bones and he died.*

When the event came to the attention of the emperor (who was Anastasius), he directed that the miracle should be painted on an image

56 The text, as printed by the editor, is meaningless. We have followed the variant reading of Cod. Palat. gr. 317 which suggests that the image in question was on the ciborium that was set over the reliquary. This was in the *bema* of a special chapel also known as the *soros.*

57 Leo II who reigned from Jan. to Nov. 474 was in fact the son of Ariadne and Zeno, hence the grandson of Leo I and Verina.

58 The title *illustris (endoxos)* was borne by all the chief officers of the Empire, both civil and military, and was more or less equivalent to the dignity of patrician.

59 Once again we follow the variant reading of the codex Palatinus.

60 PG 86, pp. 221 ff.

to be affixed above the water basin. A certain deacon John, who was *ekdikos*[61] of the aforesaid holy church of Stephen the First Martyr—a man who constantly showed his zeal on behalf of the doctrine of Consubstantiality—had another image painted, but not in plain form: for he wrote down [on it] the names of the men who were bathing and saw [the miracle], and where each of them resided, and also [the names] of the bath attendants. This image has lasted as a memorial down to the present, being affixed in the portico (*embolos*) of the *tetrastoon*[62] of the church we have repeatedly mentioned.

The author goes on to relate that the Arians suborned the administrator of the palace to remove the image from the bath on the pretext that it was being damaged by damp. The emperor, however, noticed its absence and had it reinstated. The administrator was stricken by a dreadful disease and died in front of the image.

Crosses not to be Trodden on

Cod. Just. I, viii, Edict of Theodosius II (427):[63] Since it is our diligent concern to observe by all means the religion of the highest God, we decree specifically that no one shall be permitted to carve or to paint the sign of Christ the Saviour upon the floor or the pavement or on marble slabs placed on the ground; nay, any such that are found shall be removed, and whoever attempts to contravene our statutes shall be punished by the gravest penalty.

Decoration of Martyria

St. Gregory of Nyssa,[64] ***Laudatio S. Theodori:***[65] When a man comes to a place like the one, where we are gathered today, wherein are the memorial and the holy relic of the Just one, he is at once inspired by the magnificence of the spectacle, seeing, as he does, a building splendidly wrought both with regard to size and the beauty of its adornment, as befits God's temple, a building in which the carpenter has shaped wood into the likeness of animals and the mason has polished slabs to the smoothness of silver. The painter, too, has spread out the blooms of his art, having

61 Legal representative of the church (*defensor ecclesiae*).

62 I.e., in one of the four porticoes surrounding the atrium of the church.

63 The prohibition of representing crosses on the floor lest they be trodden on was reiterated by the Quinisext Council in 692, Canon 73, Mansi, XI, 976.

64 Some doubt has been expressed concerning the authorship of the Laudation which must have been delivered at the martyrion of St. Theodore at Euchaita, near Amaseia in the Pontus.

65 PG 46, 737.

depicted on an image (*en eikoni*)[66] the martyr's brave deeds, his resistance, his torments, the ferocious faces of the tyrants, the insults, that fiery furnace,[67] the martyr's most blessed death and the representation in human form of Christ who presides over the contest—all of these he wrought by means of colors as if it were a book that uttered speech, and so he both represented the martyr's feats with all clarity and adorned the church like a beautiful meadow; for painting, even if it is silent, is capable of speaking from the wall and being of the greatest benefit. As for the mosaicist, he made a noteworthy floor to tread on.

Pseudo-Basil,[68] *Homilia XVII*, **In Barlaam martyrem:**[69] Arise now, O splendid painters of the feats of martyrs! Magnify with your art the General's mutilated appearance (*eikôn*).[70] Adorn with your cunning colors the crowned Athlete whom I have but dimly described. . . . May I behold the struggle between the hand and the fire,[71] depicted more accurately by you [than I have done]; may I behold the Wrestler, as he is represented more splendidly on your image. Let the demons weep. . . . Let the burnt yet victorious hand be shown to them once again. Let Christ, too, who presides over the contest be depicted on the panel.

Asterius of Amaseia, *Description of a painting of the martyrdom of St. Euphemia:*[72] 1. The other day, gentlemen, I was studying that marvellous author Demosthenes—I mean the work of Demosthenes in which he assails Aeschines with vehement arguments.[73] Having spent a long time on this speech, I became congested in my mind and had need of recreation and a walk so as to relax a little the strain of my spirit. So I left my chamber and after a short stroll in the marketplace in the company of friends, I proceeded to God's temple to pray in peace and quiet. When I arrived there and was walking down one of those roofed passages, I saw a painting that captivated me entirely—a work of art you might

[66] We have given a literal translation, although it appears that more than one image is meant.

[67] St. Theodore was burnt on a pyre.

[68] The attribution of this Homily to St. Basil of Caesarea is very ancient since it is already made by St. John Damascene. Some scholars have ascribed it to St. John Chrysostom. In any case, the Homily appears to have been delivered at Antioch at the martyrion of St. Barlaam. See H. Delehaye, *Analecta Bolland.,* XXII (1903), 132.

[69] PG 31, 489.

[70] Barlaam is believed to have suffered martyrdom at Antioch in the early 4th century during the persecution of Galerius and Maximinus Daia. The title *stratêgos* is applied to him figuratively: he was a general in Christ's army.

[71] Barlaam was forced to hold some incense and stretch his hand over the sacrificial fire. If he let the incense drop, he would have sacrificed to the pagan divinity; but he did not flinch and allowed his hand to be burnt.

[72] Ed. F. Halkin, pp. 4 ff.

[73] This could refer either to the speech *On the Embassy* or, more probably, to the famous speech *On the Crown*.

have ascribed to Euphranor[74] or another one of the ancients who raised painting to such great heights by making pictures that were all but alive. So, if you please,—and indeed we have time for a story—I shall describe the painting to you. For we, men of letters, can use colors no worse than painters do.

2. Once upon a time, when a tyrant was persecuting the true believers, a holy virgin called Euphemia who had consecrated her chastity to God willingly elected to suffer death. Her fellow-citizens[75] who shared the religion for the sake of which she died, in token of their admiration both for the courage and the sanctity of the virgin, built her a tomb near the church; there they deposited her coffin and honor her with a yearly festival that is frequented by all the people. The ministers of God's mysteries celebrate her memory in speech and act, and they studiously expound to the assembled crowds how it was that she accomplished her contest of endurance.[76] As for the painter, who was himself a believer, he artfully delineated the whole story on canvas (*en sindoni*) to the best of his ability and set up this sacred picture in proximity to the tomb. This is how the work of art is conceived.

3. High up on a throne sits the judge and looks at the virgin with bitter hostility: for art, when it so wishes, can convey the semblance of wrath even by means of inanimate matter. All round stand the government guard and many soldiers and secretaries holding tablets and stiluses; one of the latter, lifting up his hand from the wax, looks intently upon the accused, his face tilted, as if he were urging her to speak louder lest he make blameworthy mistakes, straining, as he does, to hear. The virgin stands dressed in a grey tunic and himation showing thereby that she is a philosopher,[77] and withal a comely one, for such was the artist's intention; but I see rather the virtue that adorns her soul. Two soldiers are leading her to the magistrate, one dragging her forward, the other urging her from behind. The virgin's appearance shows a mixture of modesty and firmness; for, on the one hand, she bows her head down as if ashamed of being gazed at by men, while on the other, she stands undaunted and fearless in her trial. Up to that time I used to appreciate other painters—for instance when I saw the incident of that woman of

[74] Famous painter, sculptor and art critic of the 4th century B.C.

[75] The reference is to Chalcedon. Asterius must have been residing in that town, across the water from Constantinople, when he composed his *Description*.

[76] I.e., her martyrdom. Like all Byzantine rhetoricians, Asterius uses cumbersome circumlocutions to avoid specifically Christian terms.

[77] By avoiding the use of bright colored garments Euphemia was showing her serious preoccupation with "philosophy," i.e. religion. On the Christian reinterpretation of the term "philosophy," see A.-M. Malingrey, *Philosophia* (Paris, 1961).

Colchis[78] who, being about to slay her children with the sword, divides her expression between pity and anger; and whereas one of her eyes manifests her wrath, the other denotes the solicitous and frightened mother. Now, however, I have transferred my admiration from that [artistic] concept to this painting; and I greatly prize the artist for his having blended so well the bloom of his colors, combining modesty with courage, two affections that are contradictory by nature.

4. The representation proceeds: a number of executioners, stripped down except for their short tunics, are beginning their work. One of them seizes the head and lays it down, thus preparing the virgin's face for punishment; another stands by and cuts out her pearly teeth. The instruments of torture are hammers and drills. But now tears come to my eyes and sadness interrupts my speech: for the artist has so clearly painted the drops of blood that you might think them to be trickling down in very truth from her lips, and so you might depart weeping.

Prison comes next. There, once again, is the holy virgin in her grey garments, sitting alone and stretching out her arms to heaven as she calls on God to help her in her distress. And while she prays, there appears above her head the sign which Christians are wont to worship and claim as their own, the symbol, I say, of the passion that was awaiting her.

Shortly thereafter, in another place, the painter has kindled a great fire and he has given substance to the flame by high-lighting it on this side and that with red color. In the midst of the fire he has set her, stretching her arms to heaven and far from showing any pain on her face, rejoicing that she was about to depart to the blessed life of the spirit.

At this point the painter stayed his hand[79] and I shall stay my speech. You may now, if you please, go and see the painting itself so as to judge exactly how far I have fallen short of it in my account.

Religious Portraiture

St. John Chrysostom, *Homil. encom. in Meletium*:[80] You have been so greatly affected not only by his name,[81] but even by his bodily traits. For what you have done with regard to names, you did also with regard to his image. Indeed, many persons have represented that holy image on

78 Medea. Asterius is referring to a famous painting by Timomachus of Byzantium (1st century B.C.). He could hardly have seen the original, which was in Rome (Pliny, *N. H.* XXXV, 136), but may have seen a replica of it. On the other hand, he may be simply reproducing from a literary source the standard appreciation of this painting: cf. *Anthol. graec.* XVI, 135–41.

79 In other words, the painting was made up of four scenes: (1) Interrogation before the magistrate; (2) Torture; (3) Prison; (4) Execution.

80 PG 50, 516. Meletius was bishop of Antioch, 360–81.

81 Meletius was so popular at Antioch that many parents gave his name to their children.

the bezel of their rings and on their seals (*en ektupômasi*)[82] and on bowls (*en phialais*) and on the walls of their rooms and in many other places so they might not only hear his holy name, but also see everywhere his physical traits, thus having a double consolation after his demise.

St. Nilus of Sinai, *Letter to Heliodorus Silentiarius*.[83] *Nilus recounts the following miracle of St. Plato of Ancyra. A man from Galatia became a monk on Mount Sinai together with his son. In the course of a barbarian raid the young man was taken into captivity together with other monks, while his father took refuge in a cave. Both addressed prayers to St. Plato who hastened to deliver the young man.*

Both of them had their prayers heard, the father in his cave on the mountain, the son in captivity, and, behold, our Plato suddenly appeared on horseback before the young man who was then awake, bringing along another horse without a rider. The young man recognized the Saint because he had often seen his portrait on images. Straightaway [Plato] ordered him to arise from among all the other [captives], and to mount the horse; his fetters fell apart like a spider's web, and he alone was delivered by virtue of his prayer. . . .

Theodorus Lector, *Hist. eccles.* I, 1 *as excerpted by Nicephorus Callistus Xanthopoulos*:[84] He [Theodore] says . . . that Eudocia[85] sent to Pulcheria[86] from Jerusalem an image of the Mother of God painted by the apostle Luke.

Theodorus Lector, *Hist. eccles.* I, 15 (*excerpt*):[87] At the time of Gennadius[88] was withered the hand of a painter who dared to paint the Saviour in the likeness of Zeus. Gennadius healed him by means of a prayer. The author[89] says that the other form of Christ, viz. the one with short, frizzy hair, is the more authentic.

Theodorus Lector, *as excerpted by St. John Damascene*:[90] A certain painter had his two hands withered while he was painting an image of Our Lord Christ. It was said that the commission of [making] the image was given to him by a pagan and that under the guise of the Saviour's name he painted the hair of the head parted so as to leave the face

82 Note variant reading *en ekpômasi* (Mansi, XIII, 8 D) = "on drinking cups," which may be preferable.

83 PG 79, 580–81; Mansi, XIII, 32–33.

84 PG 86, 165 A.

85 Wife of Theodosius II. She retired to Jerusalem in 443 and lived there until her death in 460.

86 Daughter of the Emperor Arcadius, she acted as regent from 414 to 416 and died in 453.

87 PG 86, 173. Cf. Theophanes, *Chronogr.*, ed. de Boor, I, 112.

88 Patriarch of Constantinople (458–71).

89 I.e., Theodorus Lector, the above passage being a paraphrase.

90 PG 86, 221.

[entirely] uncovered (for it is in this form that pagans delineate Zeus) so that bystanders would think that the veneration was directed to the Saviour.

Theodoret, *Hist. religiosa* XVI:[91] It is said that this man[92] became so famous in the great [city of] Rome that in the porches of all the work-shops they set up little images of him so as to obtain protection and security.

Opposition to Religious Art

Epiphanius of Salamis, *Testament*:[93] You may tell me that the Fathers abominated the idols of the gentiles, whereas we make images of saints as a memorial to them and worship these in their honor. It is surely on this assumption that some of you have dared to plaster walls inside the house of God and by means of different colors to represent pictures of Peter and John and Paul, as I see by the inscription of each of these false images, set down through the stupidity of the painter and according to his own incli-nation.[94] Now, first of all, let those who believe that by so doing they are honoring the apostles, learn that they are rather dishonoring them. For Paul, when he insulted the false priest, called him a plastered wall.[95] Surely then, let us by means of our virtue erect their commandments into images of them. But, you will say, we contemplate their images so as to be reminded of their appearance. Did they ever command you to do so? We have already convicted such men of laboring in vain, impelled as they are by ignorance. . . .

"We know," saith John, "that, when He shall appear, we shall be like Him."[96] Paul, too, has proclaimed the saints to be conformed [to the image] of the Son of God.[97] How is it then that you wish to see in an inglorious, dead and speechless position the saints who are destined to be adorned with glory, when the Lord saith of them that they shall be as the angels of God?[98]

Epiphanius of Salamis, *Letter to the Emperor Theodosius*:[99] Which of the ancient Fathers ever painted an image of Christ and deposited it in a church or in a private house? Which ancient bishop ever dishonored

91 Text: PG 82, 1473 A; Mansi, XIII, 73B.
92 St. Symeon the Stylite (d. 459).
93 Ed. G. Ostrogorsky, *Studien zur Geschichte des byzant. Bilderstreites* (Breslau, 1929), p. 67, Fr. 2. The authenticity of the Epiphanian fragments, though challenged by some critics, is now generally accepted.
94 Ed. Ostrogorsky, pp. 68–69, Fr. 6, 7.
95 Acts 23:3 ("whited wall" in the King James version).
96 I John 3:2.
97 Rom. 8:29.
98 Matt. 22:30.
99 Ed. Ostrogorsky, pp. 71–72, Fr. 23–27.

Christ by painting him on door curtains? Which one of them ever made an example and a spectacle of Abraham, Isaac, Jacob, Moses and the other prophets and patriarchs, of Peter, Andrew, James, John, Paul and the other apostles by painting them on curtains or on walls? . . .

Furthermore, they lie by representing the appearance of saints in different forms according to their whim, sometimes delineating the same persons as old men, sometimes as youths, [and so] intruding into things which they have not seen.[100] For they paint the Saviour with long hair, and this by conjecture because He is called a Nazarene, and Nazarenes wear long hair. They are in error, those who try to attach stereotypes to Him: for the Saviour drank wine, whereas the Nazarenes did not.

In this, too, they lie that they invent things according to their whim. These impostors represent the holy apostle Peter as an old man with hair and beard cut short; some represent St. Paul as a man with receding hair, others as being bald and bearded, and the other apostles as being closely cropped. If then the Saviour had long hair while His disciples were cropped, and so, by not being cropped, He was unlike them in appearance, for what reason did the Pharisees and scribes give a fee of thirty silver pieces to Judas that he might kiss Him and show them that He was the one they sought, when they might themselves or through others have known by the token of His hair Him whom they were seeking to find, and this without paying a fee? . . .

Seest thou not, O most God-loving emperor, that this state of things is not agreeable to God? Wherefore I entreat thee . . . that the curtains which may be found to bear in a spurious manner—and yet they do so—images of the apostles or prophets or of Lord Christ Himself should be collected from churches, baptisteries, houses and martyria and that thou shouldst give them over for the burial of the poor, and as [for the images] on walls, that they should be whitewashed. As concerns those that have already been represented in mosaic, seeing that their removal is difficult, thou knowest what to ordain in the wisdom that has been granted to thee by God: if it is possible to remove them, well and good; but if it proves impossible, let that which has already been done suffice, and let no one paint in this manner henceforth. For our fathers delineated nothing except the salutary sign of Christ both on their doors and everywhere else. . . .

Epiphanius, *Letter to John, bishop of Aelia*:[101] I have heard that certain persons have murmured against us [for the following reason]. As we were proceeding to the holy place of Bethel in order to join thy Honor, and when we came to the village called Anautha, we saw a lighted

100 Coloss. 2:18.
101 Ed. Ostrogorsky, pp. 74–75, Fr. 31. John II (386–417) was bishop of Jerusalem (Aelia Capitolina).

lamp and, upon enquiring, were informed that there was a church in that place. Having entered [the church] to perform a prayer, we found at the door a dyed curtain upon which was depicted some idol in the form of a man. They alleged that it was the image of Christ or one of the saints, for I do not remember what it was I saw. Knowing that the presence of such things in a church is a defilement, I tore it down and advised that it should be used to wrap up a poor man who had died. But they complained, saying, "He should have changed the curtain at his own expense before tearing this one down." And although I did promise that I would send another one in its stead, I have been slow in sending it because I have had to search for a suitable [article]. . . . Now, however, I have sent what I found. Please request the presbyter of the parish to receive the article that has been sent from [the hands of] the lector. . . .

Philoxenus of Mabbug

Theophanes, *Chronogr.*, A. M. 5982:[102] Xenaias, the servant of Satan, taught that images of the Lord and of the saints should not be accepted.[103] He was a Persian by extraction and, by station, a slave. Having fled from his master and being unbaptized, although he called himself a cleric, he was at the time of Calandion[104] perverting from the [true] faith the villages round Antioch. He was expelled by Calandion, but Peter the Fuller[105] consecrated him bishop of Hierapolis[106] and renamed him Philoxenus.

Joannes Diakrinomenos, Extract from *Ecclesiastical History*:[107] Xenaias used to say it was not lawful to endow angels with bodies since they were incorporeal, and to represent them in bodily human form or, for that matter, to deem that by confecting a painted image one was offering honor or glory to Christ; and that the only [image] acceptable to Him was worship in spirit and in truth.[108] And further down he[109] also says one ought to know this also, namely that it is an infantile act to represent the most-holy and venerable Ghost in the likeness of a dove seeing that the text of the Gospel teaches not that the Holy Ghost became a dove, but

102 Ed. de Boor, I, 134.

103 This passage is derived from the lost Ecclesiastical History by Theodorus Lector. A corresponding extract from the latter, ed. J. A. Cramer, *Anecd. graeca e codd. mss. Bibl. Reg. Parisiensis*, II (Oxford, 1839), 109, is phrased a little differently: "Xenaias, the same as Philoxenus, did not allow images of either Christ, our God, or of angels to be set up in churches."

104 Patriarch of Antioch (479–84).

105 A Monophysite who was either three or four times patriarch of Antioch, the last time from 485 to 489.

106 Mabbug in Euphratesia.

107 Mansi, XIII, 180–81.

108 John 4:23–24.

109 I.e., Joannes Diakrinomenos.

that it was once seen in the form of a dove, and that since this happened only once by reason of dispensation and not essentially, it was in no way fitting for believers to make for it a bodily likeness. Philoxenus not only taught these things, but he also practised his teaching: for he took down and obliterated images of angels in many places, while those representing Christ he secreted in inaccessible spots.

Severus of Antioch[110]

***Acts of the Council of 536*: Petition of the clerics and monks of Antioch against Severus (518):[111]** Nay, he [Severus] did not even spare the sacred altars and vessels: the former he scraped on the pretext they were impure, the latter he melted down and distributed [the proceeds] among his fellow-thinkers. This, too, he has daringly done, O blessed [Fathers]. He has appropriated, along with other things, the gold and silver doves representing the Holy Ghost that hung above the sacred fonts and altars, saying that the Holy Ghost should not be designated in the form of a dove.

John, Bishop of Gabala, *Fragment of a Life of Severus*:[112] He [Severus] used to stand in the *bema* and deliver long addresses, and he often attempted to persuade the multitude in the very church of the most-holy Michael that white vestments, not purple ones, were appropriate to angels.[113] He was not ignorant of the fact that the holy [angelic] host had no concern with vestments, but tried by this device to cause division and to urge against one another people who had this or that opinion.

Secular Art

A Monumental Weathervane at Constantinople[114]

Constantinus Rhodius, v. 178 ff: Let the fifth place among those incom-

110 Monophysite Patriarch of Antioch from 512 until 518, when he went into exile; d. 538.

111 Text: Mansi, VIII, 1039; XIII, 184A; Ed. M.-A. Kugener, *Patrologia Orientalis*, II/3 (1904), 342.

112 Text: Mansi, XIII, 184C.

113 In S. Apollinare in Classe, Ravenna, we have a contemporary instance of the representation of archangels in imperial, purple robes.

114 This was commonly known as the Anemodoulion, i.e., the Servant of the Winds. A shorter prose description, derived from that of Constantinus Rhodius, may be found in Cedrenus I, 565–66. The *Patria*, §114 (ed. Preger, II, 253) attributes the erection of this monument to Leo III (717–41), which is highly unlikely in view of its decoration. The same source says that it bore the figures of the twelve winds and that the "four big bronze sculptures" (the four sides of the pyramid?) had been brought from Dyrrhachium. The Emperor Andronicus I (1183–1185) conceived the strange idea of placing his own statue on top of the Anemodoulion (see p. 235).

parable marvels that soar to a great height [115] be assigned in our discourse to that brazen pedestal which represents, as it were, the shape of a towering pyramid or the complex crest of a Persian tiara. This exceptional work of sculpture, a four-legged marvel compacted of four bronze flanks, adorned on all sides with moulded forms (*zôa*)[116] filled with tendrils, fruit and pomegrantes, was erected by the elder Theodosius.[117] Naked Erotes, embroiled in the vine, stand there smiling sweetly and making fun from on high of those that walk below; while other youths, squatting down, blow upon the winds through brazen trumpets, one to the west, another to the south. Upon the summit, a brazen marvel with brazen wings is blown all round: it represents the shrill blasts of the winds that breathe upon the City. . . .

Nicetas Choniata, *De signis* 4, p. 856 f: And that four-sided bronze construction that soars into the air and almost vies in height with the great columns that rise in many parts of the City—who has not marvelled at the variety of its adornment once he has set his eyes upon it? Every kind of singing bird was represented there, warbling its vernal song; the labors of farmers were also depicted, their pipes and buckets, bleating sheep and gambolling lambs; underneath the sea was spread out and one could see schools of fish, some being caught, while others overcame the nets and freely fled back into the deep. In groups of two and three, unclothed Erotes were engaged in mutual combat, pelting each other with apples and shaking with sweet laughter. This four-sided [monument] terminated in a sharp point after the manner of a pyramid, upon which was set a female statue that revolved at the slightest gust of the wind; for this reason it was called Anemodoulion. And yet, this beatiful monument, too, was consigned by them[118] to the melting-pot. . . .

Imperial Statues

***Anthol. Graeca* IX, 802, *On an effigy of the Emperor Marcian*:** Thou seest this image (*morphê*);[119] it resembles a live horse, and Marcian bestrides it, the King of humankind. He has stretched out his right arm and he urges on his swift steed against the enemy who holds it up on his head.[120]

[115] As a prelude to his description of the church of the Holy Apostles, Constantine gives an account of the Seven Wonders of Constantinople.

[116] Referring presumably to a scroll filled with fruit.

[117] Theodosius I (379–95).

[118] The Crusaders in 1204.

[119] Presumably a statue.

[120] In other words, Marcian was represented trampling on the head of the vanquished enemy.

Malalas, pp. 400–401: The same John[121] melted down the bronze statues of the main street (*plateia*) of Constantinople which Constantine had collected for their excellence from all other cities and brought to Constantinople to serve as decoration. Having melted these, the said John made a statue of extraordinary size of the emperor Anastasius and erected it upon the great column that stood vacant at the Forum Tauri, as it is called.[122] This column previously carried a statue of the elder Theodosius, but the statue alone was thrown down by eathquake.[123]

Statues of Magistrates

***Anthol. Graeca*, XVI, 48:** I am Proclus, the son of Paul, a native of Byzantium, who was snatched in my flower by the Imperial court [and placed] in the hall of Justice that I may be the faithful spokesman of the mighty Emperor.[124] This bronze proclaims the reward of my labors. Father and son enjoyed similar [honors], yet the son surpassed his begetter by [winning] the consular staffs.[125]

Imperial Portraits

***Cod. Theod.* XV, 1, 44. *Decree of the Emperors Arcadius and Honorius addressed to the Prefect of Constantinople in 406*:** If it proves necessary at any time to repair either porticoes[126] or any other buildings that have been damaged by reason of their old age or some fortuitous cause, it shall be permitted, without consulting Our Clemency, but with due reverence, to take down Our images or those of former emperors. After the buildings have been repaired, these shall be brought back and set up once again in their proper places.

***Anthol. Graeca* IX, 799.** [Inscription] on the porphyry column which is at the Philadelphion:[127] Muselius[128] is devoted to the Emperor: his public works proclaim it, his deeds give mighty proof of it. He has given Rome[129]

121 John the Paphlagonian, *comes sacrarum largitionum,* appointed in 498.

122 Corresponding to modern Beyazit.

123 In 480.

124 Proculus, a man noted for his probity, was *quaestor sacri palatii* under Justin I. He died c. 526.

125 Proculus must have been made honorary consul since he does not appear in the *fasti* of ordinary consuls.

126 I.e., porticoes lining the main streets.

127 A quarter of Constantinople. Recent discoveries have established its position near modern Aksaray. See R. Naumann. "Der antike Rundbau beim Myrelaion," *Istanbuler Mitteilungen,* XVI (1966), 210.

128 Possibly the same as the Musellius who is recorded as Grand Chamberlain in 414 under Theodosius II.

129 I.e., Constantinople.

a Museum,[130] and within its halls he has depicted a marvellous image of the Emperor—an honor to the Muses' servants, an adornment for the City, the hope of youth, the instrument of virtue, and riches for good men.

St. Basil, *De Spiritu Sancto* **XVII, 44 f:**[131] For the Son is in the Father, and the Father is in the Son inasmuch as the former is like the latter, and the latter like the former, and in this lies their unity. So that by the peculiarity of their persons they are one and one, but in the community of their nature both are one. How then, if they are one and one, are there not two Gods? Because the imperial image, too, is called the emperor, and yet there are not two emperors: neither is the power cut asunder nor is the glory divided. And as the authority that holds sway over us is one, so the glorification that we address to it is one and not many, since the honor shown to the image is transmitted to its model. And what the image is down here by virtue of imitation, so the Son is over there by His nature. For just as in hand-made objects the likeness is by virtue of form (*kata tên morphên*), so in the case of the divine nature that is uncompounded the unity is in the communion of the Godhead.

St. John Chrysostom, *Ad illuminandos catech.* **II:**[132] As the painters do, so should you do now. For they put forth their boards and trace white lines all round, and sketch the images of emperors. And before applying the true colors, they erase certain things with complete freedom, and draw others in their place, thus correcting their mistakes and transposing what had been done faultily. But after having applied the paints, they are no longer able to erase or redraw anything, because that would damage the beauty of the image and such action would be blameworthy.[133] You, too, should do the same: consider your soul to be an image.

St. John Chrysostom, *In dictum Pauli, Nolo vos ignorare:*[134] What, then, is a shadow, and what is truth? Come, let us consider the images that painters delineate. You have often seen an imperial image covered with blue color.[135] Then the painter traces white lines and makes an emperor, an imperial throne, horses standing by, a bodyguard, and fettered enemies lying underneath. As you see these things being sketched (*skiagraphoumena*), you do not know the whole [composition], and yet you are not entirely ignorant of it, but you know faintly that a man and a horse are being drawn. Who the emperor is, and who the enemy, you do

130 I.e., some kind of educational auditorium. The following two epigrams (Nos. 800, 801) are devoted to the same building. They make it clear that the "Museum" was partly built anew, partly restored by Muselius.

131 PG 32, 149.

132 PG 49, 233.

133 This observation seems to apply to encaustic painting.

134 PG 51, 247.

135 Referring to the blue background which was applied first so as to cover the entire panel.

not know exactly until the true colors have been applied, making the image clear and distinct.[136]... In the same way you should consider the Old and New Testaments....

St. John Chrysostom, *In inscriptionem altaris* II:[137] Have you not observed this on imperial images, namely that the image itself representing the emperor is placed at the top, while underneath, at the foot (*choinix*), are inscribed the emperor's trophies, victories and achievements?

Deeds of Emperors

Joannes Lydus, *De magistr.* II, 20: [Constantine, Praetorian Prefect under Leo I (457–74)] built a magnificent forum (*agora*) which he named after Leo and represented there the latter's elevation in mosaic. Having, as I have said, constructed this at his own expense, and being resident in that neighborhood,... he assigned to his office[138] a modest house for the use of his successors....

***Ecclesiastical History* known as that of Zacharias Rhetor VII, 1:**[139] Marinus of Apamea, an able man, who was chartulary, depicted him [Justin I] in the public baths (*dêmosion*), as he had come from the *castrum* of Mauriana[140] in Illyricum to Constantinople, with all the history of his entry into Constantinople, and how he had been advanced from step to step until he became king. And, when this same Marinus was accused on this ground and came into danger, trusting in his astuteness, he readily rendered an answer, saying, "I have represented these things in pictures for the consideration of the observant and the understanding of the discerning, in order that magnates and rich men ... may not trust in their power and their riches ... but in God, who raises the poor man out of the mire and places him as chief over the people[141]...." And he was accepted, and escaped from the danger.[142]

136 There is here an untranslatable play on words: the sketch (*skiagraphia*) stands for the shadow (*skia*), i.e., the Old Testament, the veracity (*alêtheia*) of the colors for truth, i.e., the New Testament.

137 PG 51, 71.

138 Lydus explains that prior to this the Praetorian Prefect had no official residence.

139 Reproduced with a few changes from *The Syriac Chronicle known as that of Zachariah of Mitylene*, trans. F. J. Hamilton and E. W. Brooks (London, 1899), p. 189.

140 Presumably a mistake for Bederiana, Justin's native village.

141 Ps. 113:7–8.

142 Marinus, one of the most trusted advisers of the Emperor Anastasius, was twice Praetorian Prefect, the second time in 519, after the accession of Justin I.

Pictures of Charioteers

***Anthol. graeca* XVI, 380–37.** *The pictures described in the following anonymous epigrams may have been made during the lifetime of the charioteers represented, i.e. towards the end of the 5th century or the beginning of the 6th. The epigrams themselves are considerably later, as indicated by the lêmma.*

380. On Porphyrius of the Blue faction. The pictures of these men[143] were painted on the ceiling of the imperial box (*prokuptikon*).[144] These were charioteers of ancient times:

Having overcome on earth every other charioteer, Porphyrius, the wonder of the Blue faction, has been nobly carried up to race even in the air. This man, who has vanquished all the chariot-drivers of the world, mounts up that he may race with the Sun.

381. On the same:

Porphyrius, the son of Calchas, held the reins of the Blues when his cheeks were first covered with down. I am amazed how full of life the [artist's] hand has painted his horses. If he strikes them again, I am sure he will race once more to victory.

382. On Faustinus of the Green faction:

Observe the device of this building's architect: had he not covered it with a strong roof, Faustinus, the former glory of the Greens, would have risen to heaven, racing his horses as if he were alive. For take away the roof, and he will reach into the air.

383. On the same:

This is Faustinus, the charioteer of olden times. The Green faction found him and completely forgot how to be defeated at the races. He was, as you can see, an old man, but he had the strength of a youth and never lost.

384. On Constantine, charioteer of the Whites:

Constantine, who draws the reins of the Whites, had he not been confined by this solid building, would have reached first to heaven and beaten the other three. Dead as he is, you might have seen him travelling through the air, but art convinces me to see him as being alive.

385. On the same:

This was Constantine who in olden times drove with agility the quadriga of the White color. Ever since he has been snatched away by Charon, the sun of horse-racing contests has set, and gone are the pleasure and skill of the circus.

143 I.e., the four charioteers referred to in this group of eight epigrams.
144 In the Hippodrome of Constantinople.

386. On Julian, charioteer of the Reds:

The [artist's] hand is able to recreate those who died long ago. Indeed, Julian is as strong as before as he draws hither and thither the reins of the Reds. Painted as he is now, he stands high on his chariot; his hand awaits the signal: open his way to the winning-post!

387. On the same:

This is Julian who used to vanquish his opponents in the race when he had the chariot of the Reds. Had the painter endowed him with the gift of breath, this charioteer would have been ready once again to take the lead and win the crown.

Exemptions Conferred on Painters

Cod. Theod. XIII, 4, 4. Decree of the Emperors Valentinian, Valens and Gratian to Chilo, Vicar of Africa, issued at Trier in 374: It is Our pleasure that teachers of painting (*picturae professores*), provided they are free-born, shall not be liable to tax-assessment neither on their own heads nor on those of their wives and children.... They shall not be called to the tax payment of tradesmen on condition that they deal only in those wares that pertain to their art. They shall obtain rent-free sudios (*pergulas*) and workshops in public places, provided they exercise therein the practice of their own art.... They shall not be obliged by the magistrates to make sacred [i.e., imperial] images or to decorate public buildings without remuneration....

Minor Arts

Woven Garments

Asterius of Amaseia, *Homil.* I:[145] Then there are others whose mind is addicted to the same vanity—nay, who practice greater wickedness by not confining their stupid ideas to the above limits.[146] They have invented some kind of vain and curious broidery which, by means of the interweaving of warp and woof, imitates the quality of painting and represents upon garments the forms of all kinds of living beings, and so they devise for themselves, their wives and children gay-colored dresses decorated with thousands of figures.... When they come out in public dressed in this fashion, they appear like painted walls to those they meet. They are

145 PG 40, 165–68.

146 In the preceding paragraph Asterius inveighs against the use of silken stuffs and purple dye. The decoration of textiles with "the forms of various animals, figures of men, be they hunting or praying, and representations of trees" is mentioned by Theodoret, *De providentia orat.* IV, PG 83, 617 D.

surrounded by children who laugh among themselves and point their fingers at the pictures on the garments. . . . You may see lions and leopards, bears, bulls and dogs, forests and rocks, hunters and [in short] the whole repertory of painting that imitates nature. . . . The more religious among rich men and women, having picked out the story of the Gospels, have handed it over to the weavers—I mean our Christ together with all His disciples, and each one of the miracles the way it is related. You may see the wedding of Galilee with the water jars, the paralytic carrying his bed on his shoulders, the blind man healed by means of clay, the woman with an issue of blood seizing [Christ's] hem, the sinful woman falling at the feet of Jesus, Lazarus coming back to life from his tomb. In doing this they consider themselves to be religious and to be wearing clothes that are agreeable to God. If they accepted my advice, they would sell those clothes and honor instead the living images of God. Do not depict Christ (for that one act of humility, the incarnation, which he willingly accepted for our sake is sufficient unto Him), but bear in your spirit and carry about with you the incorporeal Logos. Do not display the paralytic on your garments, but seek out him who lies ill in bed. . . .

Church Furniture

Sozomen, *Hist. eccles.* IX, 1, 4: *In 414 the regency of the Empire was assumed by Pulcheria acting in the name of her brother, Theodosius II, who was then thirteen years old. Pulcheria decided at an early age to remain a virgin and persuaded her two younger sisters to do likewise.* To confirm her resolve, she wished to make God Himself, the clergy and all the subjects witnesses of her decisions. She, therefore, dedicated on behalf of her own virginity and her brother's rule a holy table to the church of Constantinople[147]—a marvellous object of gold and precious stones, most beautiful to behold—and upon the front of the table she wrote down these things that they may be known to everyone.

Carpentry

Theodoret of Cyrrhus, *Epist.* 38(34):[148] To the Sophist Isocasius:[149] I have despatched to Your Magnificence the excellent Gerontius, a very good carpenter who has learned the skill of carving in wood various animals and trees, and the quality of whose art is of the very highest. I had myself great need of his talents, but being of service to you takes precedence over my own interests. When I had learned from the most

147 Presumably St. Sophia.
148 Ed. Azéma, pp. 102–3. This document dates from ca. 425–450 A.D.
149 Isocasius, an influential professor, resided at Antioch. Cyrrhus was situated north of Aleppo, near the present Turkish border.

illustrious Eurycianus[150] that Your Eminence needed this man for the adornment of your house, I sent him immediately to Your Sagacity so that the work might be entrusted to the best member of the profession and that he might return to me as quickly as possible. . . .

[150] Eurycianus was a tribune. Theodoret wrote him a letter of consolation (*Ep.* XLVII) upon the death of the latter's daughter.

3

Justinian
(527–65)

The reign of Justinian may be regarded as representing both the culmination of Early Christian art and as the bridge linking the Early Christian period to the Byzantine Middle Ages. The emperor Anastasius had been a great builder;[1] Justinian, whose ambition it was to reconstitute the Roman Empire in its entirety, was an even greater one. Procopius' treatise, De aedificiis, has preserved for us the staggering catalogue of buildings that were erected during Justinian's reign in various parts of the Empire. A great part of these was defensive or utilitarian in character, but particular attention was also paid to public monuments and to churches. In Constantinople alone Justinian is said to have built or restored upward of thirty churches.[2]

In the excerpts given below we have concentrated our attention on three geographical areas: Syria-Palestine, Constantinople, and Ravenna. We begin with the cathedral of Edessa (modern Urfa in Turkey), a square building covered with a windowless dome, probably supported on corner squinches. The Syriac hymn that provides the description of this church is of particular interest in that it also offers a symbolical interpretation, partly cosmic, partly Biblical.[3] We pass on to Gaza, where two churches are described in considerable detail by the rhetor Choricius. St. Stephen's was a timber-roofed basilica provided with a gallery. Its decoration, like its architecture, was conservative: scenes of land and marine life on the western façade and Nilotic landscapes in the aisles. Only at the east end, perhaps on the triumphal arch, were holy personages represented: St. John the Baptist on the left, St. Stephen on the right, and, presumably, Christ in the middle. By contrast, St. Sergius' was a domed building with a square central bay, reduced by squinches to an octagon. The pictorial decoration was very elaborate: in the apse the Virgin Mary, attended by the patron saint and the founder of the church; in the vaults a lengthy New Testament cycle comprising at least twenty-four separate scenes, with particular emphasis on the miracles of Christ; in the drum of the dome the Prophets.[4]

We have devoted considerable space to St. Sophia at Constantinople since it represents the supreme creation of Byzantine architecture. The account of Procopius is the only one that describes Justinian's original church before the collapse of its dome in 558;[5] it also furnishes some

[1] The evidence is conveniently collected by C. Capizzi, L'imperatore Anastasio I, Orient. Christ. Analecta, CLXXXIV (Rome, 1969), 188 ff.

[2] Cf. G. Downey, "Justinian as a Builder," Art Bulletin, XXXII (1950), 262 ff.

[3] Cf. A. Grabar, "Le témoignage d'une hymne syriaque. . . ," Cahiers archéologiques, II (1947), 41 ff.

[4] Possibly the earliest recorded instance of Prophets in the drum of a dome. At a later period this became standard practice.

[5] G. Downey, "The Composition of Procopius, De aedificiis," Transactions of the American Philological Association, LXXVIII (1947), 181 ff. argues, uncon-

valuable information on the difficulties that were encountered in the process of construction. The rebuilding, completed in 562, which gave the church its present form, is explained by Agathias and by the Byzantine chronicles. Paul the Silentiary, writing immediately after the rededication in 562, gives a detailed description which, in spite of its poetic bombast, is remarkably accurate. He is also our best source for the chancel screen, the ciborium, the ambo, the lamps, the altar cloth—in short, the furnishings of the church. One feature deserving of comment is that, apart from a large mosaic cross in the center of the dome, we are not told anything of a pictorial decoration. Is this omission significant or accidental? The suggestion has been made that Justinian deliberately eschewed religious pictures, perhaps to placate his Monophysite subjects; yet, there were certainly images on the chancel screen and on the altar cloth.

With the passage of time, the "image" of St. Sophia grew to legendary proportions; and since it was precisely this legendary image that cast its shadow across the Middle Ages, well beyond the confines of the Byzantine Empire, we thought it necessary to reproduce the Narratio de S. Sophia, *a text that enjoyed an immense popularity, both in the original and in translation. The serious student may be disconcerted to find that the architect of St. Sophia is called Ignatius, that the first rebuilding is dated to the reign of Justin II (565–78), and that angels are constantly coming down from heaven to assist Justinian in his labors; yet he will discover in this text a number of valuable indications that are not available elsewhere.*

Next to St. Sophia, the second greatest church that Justinian built at Constantinople was that of the Holy Apostles. This was of cruciform shape, closely resembling St. John at Ephesus; S. Marco in Venice is a later copy of it. We have reproduced the account of Procopius, but have omitted for reasons of space those of Constantine Rhodius and Nicholas Mesarites which are extremely prolix.

For Ravenna, we naturally have to turn to Agnellus whose antiquarian zeal recorded whatever was left to see in that city in the early 9th century. In addition to his account of works of art that are still extant, like the procession of martyrs in S. Apollinare Nuovo, we may note the emphasis he places on precious furnishings, e.g., the silver ciborium of the Ursiana and those fabulous altar cloths on which were represented in gold and purple "the whole story of our Lord" and portraits

vincingly to my mind, that this work was composed in 559/60 and that Procopius deliberately omitted to mention the collapse of 558. The date of composition proposed by E. Stein (553–55) seems preferable to me: *Histoire du Bas-Empire,* II (1949), 837. However that may be, there can be little doubt that Procopius' description of St. Sophia refers to Justinian's original building.

of bishops. We have here an exact pendant to the furnishings of St. Sophia as described by Paul the Silentiary. Note also the precise figure (26,000 solidi)—the only one we have for this period—which Agnellus gives as the building cost of S. Vitale.

Among Justinian's secular buildings, we have singled out the vestibule of the imperial palace at Constantinople, the Senate House and the monumental column crowned by the Emperor's equestrian statue. This column came to be regarded as one of the wonders of Constantinople, and there exists a vast body of evidence concerning it, since every medieval visitor of the City—be he a Russian pilgrim, an Arab, or a Crusader—made a point of describing it for the benefit of "the folks at home." Even after the column had been pulled down by the Turks, it continued to be represented on Russian icons. We have reproduced two descriptions of this monument, the contemporary one by Procopius, and, the most detailed of all, by Pachymeres who saw it after the metal sheathing of the shaft had been removed, thus laying bare the construction.

We have also included in this chapter a number of epigrams from the Cycle *of Agathias. In fact the* Cycle *was published in the reign of Justin II,[6] but the bulk of its contents appears to date from Justinian's time. These epigrams bear witness to the wide prevalence of secular portraits usually done in encaustic—portraits not only of emperors and civil servants, but also of men of letters, professors, and even courtesans. We must remember that it is precisely in this milieu that the saint's portrait, i.e. the "icon," attained wide popularity,[7] of which more will be said in the next chapter.*

The Cathedral of Edessa[8]

1. O Essence which residest in the holy Temple, whose glory comes from Thee by nature,

Grant me the grace of the Holy Ghost to speak of the Temple of Edessa.

2. Bezaleel it was who, instructed by Moses, erected the tabernacle to serve us as a model,[9]

6 See A. and A. Cameron, "The *Cycle* of Agathias," *Journal of Hellenic Studies,* LXXXVI (1966), 6 ff.

7 Cf. A. Grabar, *Christian Iconography,* Bollingen Series XXXV, 10 (Princeton, 1968), 60 ff.

8 Syriac text ed. with German trans. by H. Goussen, *Le Muséon,* XXXVIII (1925), 117–136; second German trans. by A.-M. Schneider, *Oriens Christianus,* XXXVI (1939), 161–67; French trans. by A. Dupont-Sommer, *Cahiers archéologiques,* II (1947), 29–39. The Cathedral of Edessa was destroyed by flood in 524/5 and rebuilt soon thereafter. Like that of Constantinople it was called St. Sophia.

9 Exod. 31:2; 35:30; 36–38.

And now Amidonius,[10] Asaph and Addai[11] have built for Thee at Edessa this glorious Temple.

3. Verily, they have represented in it the mysteries of Thy Essence and Thy Dispensation,

And he who surveys it minutely is filled with admiration at its sight.

4. Indeed, it is an admirable thing that in its smallness it should resemble the great world,

Not in size, but in type: waters surround it,[12] as the sea [surrounds the earth];

5. Its ceiling is stretched like the heavens—without columns, vaulted and closed—

And furthermore, it is adorned with golden mosaic as the firmament is with shining stars.

6. Its high dome is comparable to the heaven of heavens;

It is like a helmet, and its upper part rests solidly on its lower part.

7. Its great, splendid arches represent the four sides of the world;

They also resemble, by virtue of their variegated colors, the glorious rainbow of the clouds.

8. Other arches are set all round like some outcrops of rock on the top of a mountain;[13]

It is on them, in them and by them that the entire roof is joined to the arches.

9. Its marble is like the Image not made by human hand,[14] and its walls are harmoniously covered therewith.

All polished and white, [this marble] is so shining that it gathers light within itself like the sun.

10. Its roof has lead upon it that it may not be damaged by rainfall;

It contains no wood whatever, and appears to have been cast in one piece [although it is] of stone.

11. It is surrounded by magnificent courts having two porticoes formed of columns;

These represent the Tribes of Israel that surrounded the Tabernacle of Witness.

10 Bishop of Edessa.

11 Presumably the architects of the Cathedral.

12 The Cathedral was situated between two lakes.

13 Referring probably to squinches that reduced to an octagon the square formed by the four main arches, and so facilitated the transition to a circular dome.

14 Referring to the famous Image of Edessa or *acheiropoietos*, the impression of Christ's face on a towel. This image was "invented" in 544. The point of the comparison is probably that the veinage of the marble, like the Image, was "not made by human hand."

12. On each side it has an identical façade, for the form of all three is the same,[15]

Just as the form of the Holy Trinity is one.

13. Furthermore, a single light shines in the choir through three open windows,

Announcing the mystery of the Trinity, Father, Son and Holy Ghost.

14. And on its three sides[16] light is produced by numerous windows

Representing the Apostles, and Our Lord, and the Prophets, and the Martyrs and the Confessors.

15. In the middle is placed a podium[17] after the model of the upper room of Zion,[18]

And underneath it are eleven columns like the eleven Apostles who were hidden therein.

16. Furthermore, the column behind the podium represents Golgotha by its form,[19]

And above it is affixed a luminous cross, like our Lord between the Thieves.

17. Furthermore, five doors open into it[20] after the likeness of the five Virgins,[21]

And through them the faithful enter with glory, like the [wise] Virgins, a splendid legion.

18. The ten columns that support the Cherubim of the choir[22]

Represent the ten Apostles who fled[23] at the time when our Lord was crucified.

19. The form of the nine steps that are placed in the choir as well as of the throne[24]

Represents the Throne of Christ and the nine orders of angels.

20. Exalted are the mysteries of this Temple concerning the heavens and the earth: in it is represented schematically

The sublime Trinity and the Saviour's Dispensation.

[15] I.e., the north, south, and west façades. The east façade must have had a projecting apse lit by three windows, and so was different.

[16] I.e., the north, south, and west sides of the nave.

[17] The ambo placed in the middle of the nave.

[18] Acts 1:13.

[19] The presence of such a column bearing a cross between the ambo and the choir is an element of local Oriental rather than Byzantine tradition.

[20] There could have been either five western doors or, say, three to the west, one to the north and one to the south.

[21] Matt. 25:1 ff.

[22] The ciborium placed above the altar table. This must have been decorated with images of Cherubim.

[23] Meaning uncertain.

[24] The nine steps of the synthronon and the bishop's throne in the middle of the apse.

21. The Apostles, who are His foundations in the Holy Ghost, the Prophets and the Martyrs are schematically represented in it.

May their memory abide in the heavens above by the prayer of the blessed Mother!

22. May the sublime Trinity that has given strength to them that built this Temple

Guard us against all evil and deliver us from injury!

St. Sergius at Gaza[25]

Choricius, *Laudatio Marciani* I, 17 ff:[26] 17. If, then, you walk to the north part of the city and turn left at the agora, you will stand before the vestibule [of the church] and will be unable to decide in your mind whether you should enjoy to the full [the sight of] the porch or proceed to the delights which, judging by the beauty of the exterior, must await you within. 18. Four columns of Carystian marble, adorned with their natural colors,[27] [are placed there, and they] surpass those of the agora colonnade by virtue both of their size and their position. The columns in the middle carry a single arch (*apsis*) surrounded by a design (*schêma*) of circles in relief,[28] harmoniously connected with smaller circles; the central one, which is placed at the top of the arch, bears aloft the symbol of the Saviour's Passion, the latter, too, consisting of a combination of circles.[29] 19. As to the arrangement of the roof, the middle bay consists of four arches forming a square; the space between them the architect has covered by means of four concave triangles.[30] Each of the end bays consists of a hollow sphere divided into half.

20. As you go up from here, you encounter a space delimited by four equal alleys, their columns being set at such a distance from the walls so as neither to reduce the width of the porticoes nor yet to diminish unduly the central area. These columns are placed all round; the ones that stand next to the entrances and are particularly subjected to [the weight of]

[25] This church was built in the early years of Justinian's reign, probably before 536, by Stephen, governor of Palestine, and Marcian, bishop of Gaza. On the chronology of the works of Choricius see W. Schmid, "Chorikios," Pauly-Wissowa, *Real-Enzyklopädie*, III (1899), 2425.

[26] Ed. R. Foerster and E. Richtsteig, pp. 7 ff. There exists a not altogether dependable English translation of this text by R. W. Hamilton, "Two Churches at Gaza, as described by Choricius of Gaza," *Palestine Exploration Fund. Quarterly Statement for 1930*, pp. 178 ff. containing an attempt at a reconstruction; better French version by F.-M. Abel, "Gaza au VI^e siècle d'après le rhéteur Chorikios," *Revue biblique*, XL (1931), 12 ff. Cf. also G. Millet, "L'Asie Mineure," *Revue archéologique*, Ser. 4, V/1 (1905), 99 ff.

[27] On Carystos marble see p. 32, n. 38.

[28] Or perhaps "conspicuous circles" (*kukloi periphaneis*).

[29] Perhaps a cross with flaring arms consisting of four segments of a circle.

[30] I.e., pendentives. The central bay of the porch was, therefore, covered with a dome like the two lateral ones.

arches have for aesthetic reasons no wooden ties connecting their capitals. 21. Each side of the roof is adorned in the middle with a segment of a cylinder, while the circuit (*kuklos*),[31] being open to the breezes, makes the fair season even pleasanter. 22. Passing by this [colonnade] on the right—the one turned towards the setting sun—you have, on the south, a place assigned to the salutation that is due to the legitimate bishop—an obligation we discharge all the more willingly because of his excellent character rather than because it is demanded by custom. To the north of this, you are drawn in by the long portico that is on the west side of the church: you are full of contentment, having a lovely breeze blowing from the westward atrium—for it does, indeed, blow sweetly and cools your body as it penetrates under the garments and lifts them up.

23. When you enter [the church], you will be staggered by the variety of the spectacle. Eager as you are to see everything at once, you will depart not having seen anything properly, since your gaze darts hither and thither in your attempt not to leave aught unobserved: for you will think that in leaving something out you will have missed the best. 24. . . . Exactly to the north of the portico which I have described as being long, is a building with columns all round it, reserved for the mystery [of baptism]; its floor is decorated with various shapes made of fine, densely-set mosaic. From the same portico and perpendicular to it two others take their origin, one on the south, the other on the opposite side, both being of the same length.[32] 25. The sides of the porticoes consist, on the one hand, of walls reveted with slabs which have been artfully joined in a uniform composition, and whose natural grain rivals the variety of painting; on the other hand, of columns which display a uniform harmony both in themselves and in their relation to each other,[33] and which, by the addition of arches, attain the height of the columns supporting the center of the church. The form of the latter is as follows. 26. Four arches confront each other, and another four take up a position in the opposite direction.[34] There being eight arches, each pair encloses within itself a concave roof which is extremely well decorated. You might say that even in architectural matters the bishop is a

[31] This sentence is not entirely clear. Choricius seems to mean that each side of the atrium portico had at its center a transverse barrel vault ("segment of a cylinder"). The *kuklos* seems to designate the portico itself which was naturally open.

[32] The long portico is presumably the narthex, while the two porticoes perpendicular to it are the lateral aisles of the church.

[33] I.e., the columns, of equal height, were evenly spaced.

[34] The central space which was square, as made clear in the sequel, appears to have been extended by means of four barrel vaults disposed crosswise. The four arches placed "in the opposite direction" would then have formed the abutment of these barrel vaults on the exterior walls of the church, except for the eastern side where, as Choricius explains, there was a semicircular apse.

guardian of equity, for nothing here outdoes its opposite, all the ele-
ments face each other in equal and symmetrical form, [except that] the
side turned towards the rising sun, wherein it is customary for the bishop
to sit, is, in the middle, hollowed out like a shell. 27. So as not to disdain
the art of the engineers (*mēchanopoioi*), we may say, as they would, that
a segment of a cylinder has been set up vertically on the ground and that
it is surmounted by the quarter of a hollow sphere. 28. The same wall is
adorned by two further forms[35] of similar shapeliness, one on each side.
These are equal to each other, while falling short as regards size of the
central [apse], and in decoration, too, they resemble each other, but differ
from the greater one. 29. The latter is adorned with gilded and silver
mosaic, and displays in the center the Mother of the Saviour holding on
her bosom her new-born Son; on either side stands a pious band. 30. At
the extreme right of these [groups] is a person who is in all respects like
an emperor, and who is worthy both of being included in the register
of God's friends and of bearing the name of the chief of God's deacons
of old:[36] this for many reasons and especially because, with the bishop
as partner of his labors, he has donated the church to his fellow-citizens,
knowing well that whereas other liberalities result only in the adornment
of the city, the construction of churches brings in not only beauty, but
a name for godliness besides. 31. He it is who, standing next to the
patron of the church,[37] asks him to accept the gift graciously; the latter
consents and looks upon the man with a gentle gaze as he lays his right
hand on the man's shoulder, being evidently about to present him to the
Virgin and her Son, the Saviour. 32. Such is the central picture. In the
aforementioned lateral [apses] there grow ever-burgeoning trees full of
extraordinary enchantment: these are luxurious and shady vines, and the
zephyr, as it sways the clumps of grapes, murmurs sweetly and peacefully
among the branches. . . . Most elegant of all is the vase containing, I
imagine, cool water:[38] the airiness of the church leads one to suppose
this. 33. The artist has rightly rejected the birds of the poets, the nightin-
gale and the cicada, so that not even the memory of these fabled birds
should intrude upon the sacred place; in their stead he has artistically
executed a swarm of other birds and, [in particular,] a flock of partridges.
He would, perhaps, have rendered even their musical sounds, had not
this hindered the hearing of divine things.

34. But let us return to the point where we digressed. Each of the four
inner arches (the description of which I have interrupted) is held on
either side by walls rising to the same height as the arches themselves
and supporting both diagonal walls and columns that reach up to the

35 I.e., lateral apses.
36 Stephen, the governor of Palestine.
37 St. Sergius. The composition described here must have been similar
to the one in the apse of the cathedral at Parenzo.
38 The cantharus out of which the vine motif was represented as growing.

contexture holding aloft the roof.[39] 35. Methinks, however, I have passed over the intermediate features: for beneath the junctures of this contexture are "pear trees, pomegranate trees and apple trees bearing splendid fruit,"[40] blossoming in all seasons alike. . . . 37. Nor has the artist forgotten that the poet calls the eagle "high-flying,"[41] for there they are with wings spread out, eager to soar aloft after plucking the nearest trees.

38. Amazed as I am at everything, I fairly marvel at the roof of the church. For within the contexture which is made up of four sides is fitted a shape consisting of eight sides, and this encloses a circle which holds aloft the roof—the greatest glory of all. 39. To gaze up at it you will require a neck accustomed to straining upward, so high is the roof above the ground, and with good reason, since it imitates the visible heaven. Such being the distance between the ceiling [and the ground], you would have to place upon the columns, tall as they are, another set of similar columns in order to reach the roof. 40. One might imagine that this [i.e., the roof] could not be surpassed, yet there is something of greater worth: for gold, as if it were gushing from an abundant golden fountain, has been poured round the eagles; gold blossoms over the arches, some of which it adorns entirely, while others it decorates in alternation with an admixture of blue, each setting off the beauty of the other.

41. Let someone enumerate to me the cities that pride themselves on the sumptuousness of the marble[42] [they bring forth]: Proconnesus, they say, takes joy in this respect; Lacedaemonia is propitious to the production of marble; Carystus, too, is famed for its suitability with regard to such produce. Then there are certain slabs which, they say, are named after the river next to which they are quarried. Caria, also, I am told, takes pride in the bloom of the stone that is cut there.[43] 42. All of

39 The arrangement described here recalls that of Alahan Manastīrī, except for the absence of galleries. Above the four main arches forming the central square there were four corner squinches supported on little columns, probably on jutting corbels. This produced an octagonal shape that was further reduced to a circle. Choricius does not, unfortunately, specify whether the dome was of masonry or timber, but he does make clear that it was circular in plan.

40 *Odyssey*, VII, 115; XI, 589.

41 *Iliad*, XII, 201, 219; *Odyssey*, XX, 243.

42 Literally "material" (*hulê*).

43 The marble of Proconnesus (today Marmara Adasī, the largest island in the Sea of Marmara) is white with a grey-blue vein. It is the commonest marble used in Byzantine buildings, and was widely exported in the 6th century. Lacedaemonian (also called Laconian or Spartan) marble is green porphyry. On the marble of Carystus see p. 32, n. 38. The marble "named after the river next to which it is quarried" may be the one called Sangarian or Sagarian, presumably after the river Sangarius in Asia Minor. Cf. A. K. Orlandos, *Hê xulostegos palaiochristianikê basilikê*, II (Athens, 1954), 248; R. Gnoli in *La parola del passato*, XXI (1966), 48–51, who describes it as "occhio di pavone rosso." Carian marble, quarried in the neighborhood of Iasos, is dark red with white bands. See Gnoli, pp. 51 f.

these places have contributed to the church gifts from [the product] in which they glory. Thessaly, too, has ministered to the church by providing both columns and plaques for the venerable spot where it is customary for the priest to be seated.[44] You may also see the altar-table made entirely of silver, supported on columns of equal worth. . . .

Choricius speaks next of the airiness and great size of the church. He then proceeds to give an account of its painted decoration. The art of painting, he says, is more valuable than the other arts because it imitates nature and strives to produce creations that are animate (empsucha).

47. If we attempted to describe the entirety of its work [i.e., of painting] which adorns the church all round, we would have to compose a speech altogether too long for this festive occasion. Hence, I shall set aside the pictures (*historiai*) that are on the walls, and shall pass up to the ceiling.

48. A winged being has just descended from heaven in the painter's [fancy] and comes to her who will be a mother without a husband;[45] she is not yet a mother as he finds her modestly spinning and greets her with the good tidings. He is represented as if he were conversing with her, but even if the painter had endowed him with speech, it would have been difficult to hear him, so great is the intervening distance. 49. Startled by the unexpected vision, she suddenly turns round in her confusion and nearly lets fall the purple from her hand, the joints of her fingers weakened by fear. Her female sex and the innocence of her years —she was a maiden of marriageable age—trouble her and make her suspicious of the salutation. 50. The angel, having accomplished his mission, has flown away. She now goes out of her chamber to visit a kinswoman and friend, and is about to tell her what has happened; the latter anticipates her through premonition and falls on the maiden's breast. Indeed, she strives to go down on her knees, but the Virgin, in her humility, holds her up.[46] 51. Let that be. But what is the intent of this next painting? Here are an ass and a cow, a manger, an infant and a maiden who is lying down on a couch, her left hand placed under her right elbow, her cheek resting on her right hand.[47] What is the meaning of this representation? We need not be perplexed, for this is the same virgin

44 I.e., the apse. Thessalian marble (green serpentine) is that used, e.g., in the main colonnades of St. Sophia. On the quarries, near the modern village Chasabali, see D. Jung in *Praktika tês Akadêmias Athênôn*, XXXVI (1961), 149–55.

45 The Annunciation. On the description of the New Testament cycle that follows cf. J. Reil, *Die altchristlichen Bildzyklen des Lebens Jesu* (Leipzig, 1910), pp. 112 ff.

46 The Visitation.

47 The Nativity.

whom we left a while ago with the wool in her hand: now is the time of her delivery, and she has given birth to a child without recourse to union with a man. 52. Her face is not altered with the pallor of one who has just given birth, and, indeed, for the first time; deemed worthy of a supernatural motherhood, she was justly spared its natural pains. Why then the manger? What are we to say of the cow and the ass? These, we are told, had been prophesied by sages of yore, and so it came to pass. 53. Their ears ringing with a sound from heaven, the shepherds have let their animals stray; they have left their sheep grazing on the sward, by the spring, and, entrusting to their dog the protection of the flock, they raise their necks to heaven and strain their ears in the direction of the sound, each standing in whatever pose he finds most comfortable and easiest.[48] Some of them have dispensed with their crooks, but one, though not using his for the flock, is resting his left arm upon it, while raising his right arm, I suppose, because he is astonished by the cry. 54. A second call, indeed, was not needed: sight, they say, is surer than hearing, and, as you see, an angel has come to meet them and is showing them the direction of the babe. The sheep, because of their innate stupidity, do not even turn towards the vision: some of them are bending down towards the grass, while others are drinking from the aforementioned spring. The dog, however, being an animal hostile to strangers, appears to be looking intently at the extraordinary apparition. 55. Such are the details the painter has set down. Meanwhile the shepherds are guided on their way by a star, dimly reflected in the spring whose waters are stirred up by the sheep. 56. So much for the shepherds. As for that holy man, bowed down by the infirmity of his age,[49] I would have pitied him greatly had he not lived long enough to see the advent of the infant. The mother, too, is present holding the child in her arms. He, like the old man he is, has trouble in walking, yet does so with joyful countenance.

57. I see you are desirous of the banquet and preoccupied with the guests. It was a wedding, and the bridegroom was entertaining the Saviour's followers whom he had invited. In the middle of the dinner the fear arose that a shortage of wine would both spoil the enjoyment of the dishes and bring the banquet to a shameful conclusion.[50] 58. The Protector of the universe, who had been invited along with His Mother, changes on her suggestion the nature of water into wine suitable for a wedding. So one of the servants lifts up a jar of water and makes it his task to fill the amphoras, while another fills the bowl and offers it round to the guests, beginning at the usual place. It seems the wine has a fine bouquet,

[48] The Annunciation to the shepherds, apparently a separate scene. Note that the Magi were apparently omitted.

[49] Zachariah. The scene in question is the Presentation in the Temple.

[50] The marriage feast at Cana.

for the man who has just drunk it betrays his pleasure by his flushed appearance. Such is the incidental token of His love of man.

59. Further on, He attends a woman consumed by a lingering disease.[51] One of His disciples had married her daughter, and, at this man's request, He heals the woman, neither by using incantations nor "laying on soothing ointments,"[52] but simply by stretching out His hand.

60. Next to this is a man with a withered hand, whose disease had baffled the learning of physicians. Scarcely able to stand for pain, he prays to be cured and at once his prayer is fulfilled.[53]

61. But who is this mournful man? What suffering prompts his supplication? A trusted servant has run life's allotted course and has nearly reached the end. It is a terrible misfortune for the master that a good servant should unexpectedly be departing. Leaving him at home, the master has come to plead on his behalf. He [Christ] listens and promises to dispel the trouble: without dispute the disease yields to His word.[54]

62. Next, there is a woman who had placed all her hopes in an only son, had reared him to the flower of his youth in the expectation of being supported by him, but, by a common fate, was cheated of her hope. The youth is being carried to his grave, accompanied by wailing women. 63. These are crowded together so as to partially obscure each other, but if you were to separate them, you might imagine that each one of them was painted entire. Perhaps they were standing apart before the miracle took place, but when they saw the Saviour bring the youth back to life, they rushed together to look, and now their rejoicing naturally exceeds the measure of their sorrow at his death: for a man's death is to be expected, but for a dead man to come back to life is more than one can hope.[55]

64. These [miracles] chasten a woman of loose life. She renounces the great wickedness of her ways and comes to scorn her soft raiment, her wonted golden ornaments, the fashioning of her hair, since beauty is no longer of importance to her. Instead, she venerates and honors Him with the riches she has, by pouring ointment over His feet.[56]

65. Endowed with so much power, He has even the winds under His control. The boat is tossed about; the onset of the waves does not allow it to maintain an even keel and drags one side down. But He rebukes the raging winds and, immediately, they tremble at His threats.[57] For no longer "doth the crash of waves beset my ears."[58]

[51] The healing of Peter's mother-in-law.
[52] *Iliad*, XI, 830.
[53] The healing of the man with the withered hand.
[54] The healing of the centurion's servant (Matt. 8:5; Luke 7:2).
[55] The raising of the widow's son at Nain (Luke 7:12).
[56] The sinning woman's faith (Luke 7:37).
[57] The stilling of the storm.
[58] *Iliad*, X, 535.

66. It is not surprising that He should walk over the sea and gradually save His companion. The latter is shown incomplete in the painting, i.e., the half of him that is hidden is meant to be under water, while the part that emerges is as yet in safety.[59]

67. Here is a youth who is not in his right mind, yet neither servant, nor friend nor kinsman dares to tame him. He has a frenzied expression and it is clear that he is looking round the bystanders intending to do some harm to one of them. The painting has put fetters on him which do not allow him to walk, but he is trying to force his bonds. He is not very conscious of the pain caused by his violence since madness is insensitive to suffering. 68. Observe here the painter's skill: intending to represent a madman who is made sane, he shows the insanity by means of disorderly movement, and the cure—he is painted as if sinking from exhaustion—by the expulsion of the demon.[60] 69. I pity your suffering, boy, but deem you fortunate as much as I pity you: for the cure of grave diseases causes great joy.

70. Do you see that woman touching the hem of His garment? This is another form of healing. For, wasted away as the woman's strength was by the incessant discharge of blood, He, without even turning round, stays the morbid outflow of her force.[61]

71. After that comes a second struggle with death and a second victory. A man who was very dear to Him had lately died. In pity of the weeping women, He effects his return to life. At this the women loudly manifest their joy, being as they are wont to cry readily at the sight of a prodigy. One of them points [the event] to her neighbor; the latter is transported with delight.[62]

72. Art knows how to represent God in human disguise. For this reason it has not exalted Him by His achievements, but has placed Him at table with the same companions. He is foretelling, I should judge, the impending plot.[63] 73. The meal having come to an end, one of the company, caring little for salt and table, embraces his Master—this was the signal for the betrayal—and surrenders Him, as you see, to impious men whose vileness equals his own. These take Him and lead Him away: they convert their passionate envy into an accusation against Him.[64] 74. The governor at the time knew the falseness of their charges, but altogether lacking the judgment of a ruler, he found it difficult to restrain an irritated mob bent on accomplishing, once and for all, whatever it

[59] Christ and Peter walking on the sea.
[60] The healing of the demoniac.
[61] The healing of the woman with the issue of blood.
[62] The raising of Lazarus.
[63] The Last Supper.
[64] The Betrayal; possibly also Christ before Caiaphas. The description of the Passion cycle is so condensed that it is difficult to tell how many separate scenes are involved.

pleased. So he is persuaded to surrender Him to those that will take Him away and, thinking somehow to wipe away the sacrilege and pass it on to the guilty, he orders his servant to bring him some water and washes his hands.[65] 75. After heaping many outrages on Him or rather upon themselves—since it is forbidden to insult God—they have finally consigned Him to the most shameful kind of death, between two thieves.[66] 76. They also set guards next to His tomb, but He, making mock of their guard, regains His immortality and, after appearing to the women about His Mother, is borne up to His dwelling-place escorted by a heavenly choir.[67] And so He has not belied the ancient prophets who compass about the central part of the ceiling.[68]

St. Stephen at Gaza[69]

Choricius, *Laudatio Marciani* II, 28 ff:[70] 28. Follow me then to the eastern gate of the city. If you go downhill from there and turn left, you will need no guide to show you the way: the church is visible from afar and is itself a sufficient guide. 29. All along the way are booths which afford a certain attraction, but this is incidental. When you have reached the porch and mounted a great number of steps (the church being built on an eminence), you see a summer retreat[71] which, thanks to a gentle breeze, mitigates the heat of the season. 30. Cooled by light winds, securely defended like a fortress by means of two towers which flank the entrance,[72] it is adorned with a handsome atrium (*protemenisma*) boasting four porticoes, each side being of equal length. 31. The squareness of the plan is indicated by the columns which are equal in number [on each side] and evenly spaced: they all come from the same city,[73] have the

[65] The judgment of Pilate.

[66] The Crucifixion.

[67] The guard at the tomb; the Resurrection; Christ appearing to the women; the Ascension. Note the Virgin's presence in the scene of Christ's appearing to the women: on this see J. D. Breckenridge, "Et prima vidit," Art Bulletin, XXXIX (1957), 9 ff.

[68] Prophets were, therefore, represented in the drum of the dome.

[69] Choricius's speech was delivered between 536 and 548, presumably at the dedication of the church.

[70] Ed. Foerster and Richtsteig, pp. 35 ff. In addition to the translations by Hamilton and Abel (above, p. 60, n. 26), §§ 37–46 have also been translated by G. Downey in E. Baldwin Smith, *The Dome* (Princeton, 1950), pp. 155 ff.

[71] I.e., the atrium.

[72] The use of a tower or two flanking towers attached to the structure of a church (often to the west façade) is frequent in the Christian architecture of Syria and Palestine. It has been suggested that, like the Moslem minarets, they were used to call the faithful to prayer. See H. C. Butler, *Early Churches in Syria* (Princeton, 1929), pp. 210 f.; J. Lassus, *Sanctuaires chrétiens de Syrie* (Paris. 1947), pp. 235 ff.

[73] I.e., from the same quarry or locality.

same form, and gleam "whiter than snow," as the poets say.[74] Those, however, that face east surpass the others in height by the same measure that the latter rise above the ground:[75] it being, I suppose, proper that the columns nearest the church should have some pre-eminence. 32. At this moment the fabric of the colonnades serves a purely aesthetic purpose, but at the other feast of the Martyr which is celebrated in the winter,[76] they serve to protect visitors from being drenched if rain happens to be falling. 33. The colonnade that is in front of the church gives access, on the right, to a building used by the servitors of the sacred ministry, and, on the left, to a space reserved for the bishop's salutation,[77] where, as Homer would have said, are "shrill winds blowing,"[78] Boreas and Zephyr, vines and clear water and all kinds of plants; where the good priest, with voice flowing sweeter than Nestor's (according to Homer),[79] greets the entrants with open heart and smiling countenance. 34. These things the colonnade offers you on right and left, while on its eastern wall you may see everything the sea brings forth and all the tribute of the earth: there is hardly anything you could look for that is not included, and a great deal that you would not expect to see.[80] How faithful to nature is this art! What splendid, what charming execution! This rich adornment befits a sanctuary of such golden opulence

35. Starting at this colonnade, the church stretches far to the east. Its width is such as the length requires, its length is dictated by the width, and the height of the roof proportionate to both. This, namely the proportion of the fabric, is its first and greatest glory; the second consists in the contribution made by all the famous marble-bearing countries. 36. A double benefit accrues from these marbles: [they provide] the church [with material] for decorous workmanship and are a source of honor to the cities that sent them, since a man who has seen them and admired them at once praises the donor. Among the columns, the most remarkable are the four, dyed by nature with the color of imperial raiment,[81] which define the area forbidden to those who are not members of the holy ministry.[82]

37. But the east side, with its elaborate craftsmanship, has drawn me in rather too quickly, not allowing me to dwell on the exterior

[74] *Iliad,* X, 437.

[75] In other words, the eastern colonnade of the atrium was twice as tall as the others.

[76] The feast of Stephen is celebrated by the Eastern Church on December 27.

[77] Cf. p. 61.

[78] *Odyssey,* IV, 567.

[79] *Iliad,* I, 249.

[80] Presumably a mosaic representing various kinds of marine and land life.

[81] I.e., made of porphyry.

[82] I.e., the presbytery.

[features], and has rightly attracted me to itself before I had gone through the other parts. From the floor up, the wall is distinguished by a varying concavity whose lower part maintains a constant width up to the arch that rests upon its corners; the remainder gradually contracts in width in a degree corresponding with the arch.[83] 38. Two holy personages are [represented], one on either side, each carrying his usual insignia: the one on the spectator's right is the patron of the church, while to the left you may see the Forerunner.[84] 39. The lower part [of the apse] gleams with different kinds of marble. In the center is a window, wide and tall in proportion, entirely encompassed by a single kind of stone, though diversified by art, which completes the revetment along both edges of the window and adorns the walls on either side. It does not cease here, but mounts up on both sides and reaches the band, itself of the same [kind of] stone, that lies above the window.[85] 40. In this way, bands of well-fitting marble cover the wall. They are so joined together as to appear to be a work of nature, and so variegated with their natural colors as to resemble altogether a hand-painted picture. Indeed, painters whose business it is to select and copy the most beautiful objects there are, should they need to represent columns or gorgeous plaques—and I have often seen that sort of thing in paintings—will find plenty of excellent models here.

41. On top of one of the bands—I refer to the uppermost—is placed a novel form (*schêma*). I have heard it called in geometrical terms the 'half cone'; the following is the origin of the term. . . . *Choricius goes on to explain that cones grow on pine-trees and the pine* (pitus) *in Greek mythology had been a maiden of whom Boreas was enamored.* . . . So much I can tell you by way of comparison, but if you desire a full account, this is what it is like. 43. A carpenter [has taken] five circles of the material given him by his craft[86] and cut each of them into two equal parts. Joining nine of these segments to each other by their tips, and by their middle points to the band which I have just called the uppermost, he has placed upon them an equal number of concave timbers which start out wide at the bottom and, gradually tapering to

[83] This unduly complicated sentence seems to describe a normal apse of semicircular plan.

[84] This representation was probably on the triumphal arch. The person on the right is described as *ho men to temenos echôn*: I understand this to mean "he who owns the church," i.e., St. Stephen, rather than "he who bears the church in his hand." The latter description would be appropriate to the image of the founder, i.e. bishop Marcian, but the absence of St. Stephen would be surprising. The central element of the composition may have been the picture of Christ mentioned in § 45 below.

[85] In this passage Choricius uses the word 'band' (*zônê*) in two different senses to designate (1) A band of marble revetment; (2) the cornice which in § 41 is more specifically called the 'uppermost band.'

[86] I.e., wood.

a sharp point, are curved sufficiently so as to fit the concavity of the wall. By drawing together the extremities of all these [pieces] into one, and bending them gently, he has produced a most pleasing sight. 44. But while there were five circles cut in half, I have described the function of only nine of the segments, and I perceive that you are naturally asking about the remainder of one circle. 45. Well, this part has been again divided into two halves and each of them placed on either side of the nine, and upon the two of them rests an arch of the same material, hollowed out in front, and having by way of additional ornament a picture of the Ruler of the universe painted at its center. Gold and other colors give brilliance to the whole work.[87]

46. So much for that arrangement. As for the two colonnades, since it was proper that they should have some distinction at their eastern end, yet not so much as the middle,[88] they are beautified with all the other forms (*schêmata*) except for the cone decoration[89] that I have described. 47. That the female congregation should not be mingled with the men, though there is room enough on the ground for both without crowding, you[90] have constructed a double women's gallery (*gunaikônitis*), its length and width equal to those of the aisles below, but somewhat inferior in height to the extent that the columns supporting the roof are shorter than the ones beneath them.

48. Let us now evaluate the height of the church roof from the ground. Lofty columns; an architrave (*sundesmos*) connecting their capitals; above it, a wall reveted with marble; [a] second [range of] columns; another stretch of masonry decorated with animal figures; windows of arched form—these, added together, make up the height [of the church.] 49. The curious observer may look high and low in search

[87] Baldwin Smith and Downey (pp. 38 ff., 155 ff.) have argued that Choricius is here describing a wooden dome of pine cone shape, flanked by two half-domes, all three elements being placed over the crossing of the church. Such an interpretation is not, however, warranted by the text. In our opinion, Choricius is probably referring to the semidome of the apse which may have been slightly pointed at the top so as to suggest the form of a cone cut vertically in half (surely not a truncated cone as Smith and Downey would let us believe). The halfcone rested on the cornice and consisted of two elements, viz. a framework of nine semicircular ribs and, placed upon these, nine wooden gores, whose apices met at the crown of the apse. If Choricius is correct in stating that the ribs were joined to each other by their tips, one can only conclude that they were disposed like an accordion. Such an arrangement would have called for a median brace resting on the cornice, a feature also mentioned by Choricius. The two wooden quadrants were probably affixed to the face of the apse, but their function as well as the nature of the 'hollowed out' arch that they supported are not clear to us.

[88] I.e., not so much as the apse.

[89] Or, as Downey renders this phrase, "the variety given by the cones." Choricius may be trying to say that the two colonnades did not have any special feature at their eastern end such as exedras covered by halfdomes ('cones').

[90] Presumably the bishop.

of a spot bare of either marble or gold: he will not find one here. Those who are embarrassed by [so much] gold and marble, and seek relief in stones and masonry, will be able to study the latter on the outside.

50. I had nearly forgotten the Nile. The river itself is nowhere portrayed in the way painters portray rivers,[91] but is suggested by means of distinctive currents and symbols, as well as by the meadows along its banks. Various kinds of birds that often wash in that river's streams dwell in the meadows. 51. This charming sight is offered by the walls of the aisles which, furthermore, are well ventilated, there being two breezes that blow into them from two directions and, through them, into the middle [of the church] thanks to the many large windows that everywhere let in the light.

52. Seeing that so much zeal has been expended here, let us invite men who have examined the shrines of many cities, each one an expert in a different kind of work, and, in the presence of such judges, let our church be tried as in a court against the famous temples of the world. 53. For example, let one man be a connoisseur of painting, not only the kind that uses colors, but also of mosaic which imitates the former; let another be a judge of marbles, be they named after the place where they are quarried or after their color; another an expert on capitals; let another clearly evaluate the amount of gold, in case there is either deficiency or excess—both errors of taste. Let someone else carefully observe the roof, unless he renounces to do so because of its height: for here are costly timbers covered with coffering (*kalathiskoi*) for the sake of both strength and beauty. 54. When all the judges have come together, each one being assigned to decide on the aspect he happens to know better than the others, our church will unanimously be declared the victor.

St. Sophia, Constantinople (532–37)

Procopius, *De aedif.* I, i, 23 ff: The Emperor, disregarding all considerations of expense, hastened to begin construction and raised craftsmen from the whole world. It was Anthemius of Tralles, the most learned man in the discipline called engineering (*mêchanikê*), not only of all his contemporaries, but also as compared to those who had lived long before him, that ministered to the Emperor's zeal by regulating the work of the builders and preparing in advance designs of what was going to be built. He had as partner another engineer (*mêchanopoios*) called Isidore, a native of Miletus, who was intelligent in all respects and worthy to serve the Emperor Justinian. . . .

So the church has been made a spectacle of great beauty, stupendous

[91] I.e., in the form of a personification.

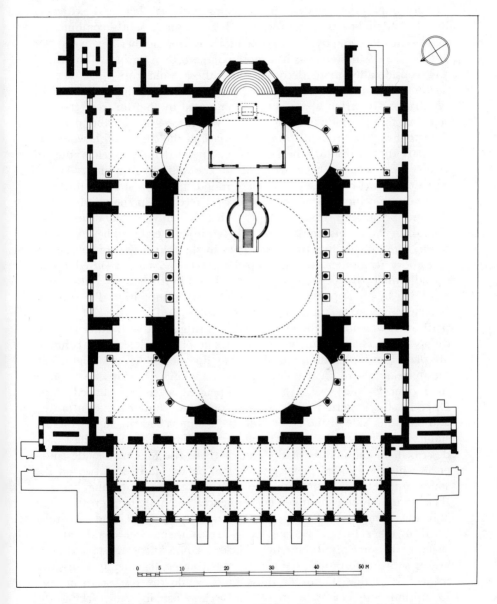

Figure 2. St. Sophia, Constantinople, ground plan. Indications of Ambo, Chancel screen, Ciborium, and Synthronen are hypothetical.

to those who see it and altogether incredible to those who hear of it. . . .
Its breadth and length have been so fittingly proportioned that it may
without impropriety be described as being both very long and extremely
broad. And it boasts of an ineffable beauty, for it subtly combines its
mass with the harmony of its proportions, having neither any excess nor
any deficiency, inasmuch as it is more pompous than ordinary [buildings]
and considerably more decorous than those which are huge beyond
measure; and it abounds exceedingly in gleaming sunlight. You might
say that the [interior] space is not illuminated by the sun from the out-
side, but that the radiance is generated within, so great an abundance of
light bathes this shrine all round. The face of the church—this would be
the part turned towards the rising sun, intended for the celebration of
God's mysteries—has been wrought in the following fashion. A con-
struction of masonry rises from the ground, not in a straight line, but
gradually drawing back from its sides and receding in the middle, so as
to describe a semi-circular shape which is called a half-cylinder by
specialists, and this towers to a precipitous height. The extremity
(*huperbolê*) of this structure terminates in the fourth part of a sphere,[92]
and above it another crescent-shaped form (*mênoides*)[93] is lifted up by
the adjoining parts of the building, wonderful in its beauty yet altogether
terrifying by the apparent precariousness of its composition. For it seems
somehow not to be raised in a firm manner, but to soar aloft to the
peril of those who are there; and yet, it is supported with quite extraor-
dinary firmness and security. On either side of these [elements] columns
are placed on the ground, and these, too, do not stand in a straight line,
but retreat inward in a half-circle as if making way for one another
in a dance,[94] and above them is suspended a crescent-shaped form.
Opposite the eastern wall is another one that contains the entrances,
and on either side of the latter both the columns and the superstructure
stand in a half-circle, in a manner very similar to what has been
described. In the middle of the church there rise four man-made emin-
ences which are called piers (*pessoi*), two on the north and two on the
south, opposite and equal to one another, each pair having between
them exactly four columns. The eminences are built to a great height
and are composed of big stones, carefully selected and skillfully
fitted together by the masons. As you see them, you could suppose
them to be precipitous mountain peaks. Upon these are placed four
arches so as to form a square, their ends coming together in pairs and
made fast at the summit of those piers, while the rest of them rises
to an immense height. Two of the arches, namely those facing the
rising and the setting sun, are suspended over empty air, while the others

[92] The semidome of the apse.
[93] The eastern semidome.
[94] Procopius is here referring to the colonnades of the exedras.

have beneath them some kind of structure (*oikodomia*) and rather tall[95] columns. Above the arches the construction rises in a circle: it is through this that the first light of day always smiles. Indeed, I believe it towers above the whole earth, and the structure has gaps at short intervals,[96] being intentionally interrupted so that the openings corresponding to the divisions in the masonry are channels of constant illumination. And since the arches are joined together on a square plan, the intervening construction assumes the form of four triangles.[97] The bottom end of each triangle, being pressed together by the conjunction of the arches, causes the lower angle to be acute, but as it rises it becomes wider by the intervening space and terminates in the arc of a circle, which it supports, and forms the remaining [two] angles at that level. Rising above this circle is an enormous spherical dome which makes the building exceptionally beautiful. It seems not to be founded on solid masonry, but to be suspended from heaven by that golden chain[98] and so cover the space. All of these elements, marvellously fitted together in mid-air, suspended from one another and reposing only on the parts adjacent to them, produce a unified and most remarkable harmony in the work, and yet do not allow the spectators to rest their gaze upon any one of them for a length of time, but each detail readily draws and attracts the eye to itself. Thus the vision constantly shifts round, and the beholders are quite unable to select any particular element which they might admire more than all the others. No matter how much they concentrate their attention on this side and that, and examine everything with contracted eyebrows, they are unable to understand the craftsmanship and always depart from there amazed by the perplexing spectacle. So much, then, for this.

It was by means of many devices that the Emperor Justinian and the engineers Anthemius and Isidore gave stability to the church, suspended as it is in mid-air. Most of these are beyond my comprehension and I find it impossible to express them in words; one device only I shall describe here in order to demonstrate the strength of the whole work. It is as follows. The piers which I have just mentioned are not built like ordinary masonry, but in this fashion. Courses of stone have been laid in a four-square shape[99]; they are hard by nature, but worked smooth, and those of them that were intended to form the lateral projections of the piers have been cut at an angle, while the ones that were assigned an

95 I have adopted here the reading of *cod. Vaticanus 1065*, *kionas makrous* in preference to *kionas mikrous* ("small columns") as printed in the Teubner and Loeb editions. The original form of the north and south tympana is not known exactly, but it would be reasonable to assume an arrangement similar to that of the great west window which is divided by tall mullions.

96 The windows of the dome.

97 The pendentives of the dome.

98 *Iliad*, VIII, 19.

99 Strictly speaking, the main piers are not rectangular (see plan).

intermediary position have been made rectangular. These were joined together not with lime which they call unslaked, nor with asphalt, the pride of Semiramis in Babylon, nor with any other similar substance, but with lead poured into the interstices, which has penetrated into all the intervening spaces and having hardened in the joints, binds the stones together.[100] This, then, was built in the above manner; but let us now proceed to the remaining parts of the church.

The entire ceiling has been overlaid with pure gold which combines beauty with ostentation, yet the refulgence from the marble prevails, vying as it does with that of the gold. There are two colonnades (*stoai*), one on each side, not separated from the church by any structural element, but actually adding to the measure of its width and extending to its whole length, while their height is less than that of the building. They, too, have a vaulted ceiling (*orophē tholos*) adorned with gold. One of these colonnades is assigned to men for their devotions, while the other is used by women for the same purpose. However, there is no difference or any distinction between the two, but their very equality and similarity contribute to the beauty and adornment of the church. But who could describe the galleries (*huperôa*) of the women's part (*gunaikônitis*) or enumerate the many colonnades and columned courts (*peristuloi aulai*) by means of which the church is encompassed? Who could recount the beauty of the columns and the marbles with which the church is adorned? One might imagine that one has chanced upon a meadow in full bloom. For one would surely marvel at the purple hue of some, the green of others, at those on which the crimson blooms, at those that flash with white, at those, too, which Nature, like a painter, has varied with the most contrasting colors. Whenever one goes to this church to pray, one understands immediately that this work has been fashioned not by human power or skill, but by the influence of God. And so the visitor's mind is lifted up to God and floats aloft, thinking that He cannot be far away, but must love to dwell in this place which He himself has chosen. . . . And as for the treasure of this church—the [vessels of] gold and silver and precious stones which the Emperor Justinian has dedicated here—it is impossible to give an exact account of all of them. I shall allow my readers to form an estimate by means of a single example. That part of the church which is especially sacred and accessible to priests only—it is called the sanctuary (*thusiastêrion*)—exhibits forty thousand pounds of silver.

So the church of Constantinople, which men are wont to call the Great Church... has been wrought in this fashion by the Emperor Justinian. It was not by money alone that the emperor built it, but with toil of the mind and the other qualities of the soul, as I am about to

[100] Lead, of course, was laid in sheets, not poured.

relate. One of the arches that I have just mentioned (engineers call them *lôroi*),[101] namely the one to the east, had already been raised on either side, but had not been completed in the middle, and was still waiting. The piers on top of which the structure was being built, unable to bear the mass that was pressing down on them, somehow or other suddenly started to break away and seemed to be on the point of collapsing. So the staff of Anthemius and Isidore, terrified at what had happened and having lost confidence in their skill, referred the matter to the emperor. And the emperor, impelled by I know not what, but, I suppose, by God (since he is not an engineer), immediately commanded them to complete the curve of that arch. "For," he said, "when it is supported by itself, it will no longer need the piers (*pessoi*) beneath it."[102] If this story were unwitnessed, I am sure it would seem to be a piece of flattery and altogether incredible, but since there exist many witnesses of what happened at that time, we need not be reluctant to tell the rest of the story. So the craftsmen carried out the orders, and he entire arch was securely suspended, thus confirming by experiment the validity of his idea. This, then, was finished in the above manner; but in the case of the other arches, namely those turned toward the south and the north, the following chanced to happen. The so called *lôroi*, swelled out by the masonry of the church,[103] were already in the air, but everything beneath them was suffering under their weight and the columns that are there were shedding little flakes as if being scraped.[104] Once again the engineers became dispirited by what had happened and reported their plight to the emperor. And once again the emperor solved the problem by the following device. He commanded that the extremities of the parts that had suffered, namely what came in contact with the arches, should be immediately removed and inserted much later, at such time when the

101 From Lat. *lorum* meaning a thong. The *lôros* was also the name of a long ceremonial scarf worn by consuls and emperors.

102 This passage is not altogether clear. The meaning, I believe, is not, of course, that the arch, once completed, will no longer need the piers, but rather that it will not be making such heavy demands on the piers. In the Loeb ed. (p. 31) it is suggested that Procopius is using the term *pessoi* in two different senses: (1) 'piers,' (2) the props of the wooden centering. I find it difficult to accept this explanation. There can be no doubt that the eastern arch was built on a centering; what happened, however, is that as the voussoirs were being laid, the piers started tilting laterally. Justinian would have been guilty of a *non sequitur* if he had said that the arch, when completed, would not have needed the centering any longer: no arch does.

103 I have given a literal translation of this somewhat obscure phrase. The 'swelling' in question may refer to the pendentives which, naturally, would have exerted added weight on the arches. Procopius seems to be saying that the north and south tympana were erected simultaneously with the arches and that the latter, being still damp and therefore in the process of settling, weighed down heavily on the underlying masonry.

104 This is an accurate description of the behavior of marble when subjected to great pressure.

moisture of the masonry had sufficiently abated. They followed these precepts, and thereafter the structure survived secure. From this work the emperor enjoys a kind of added testimonial.

The Rebuilding of St. Sophia (558–62)[105]

Agathias, *Hist.* V, 9, 2–5: He [Justinian] showed particular concern for the Great Church of God which he rebuilt in a conspicuous and admirable form from the very foundations after it had been burnt down by the populace, and endowed it with exceedingly great size, a majestic shape and an adornment of various quarried materials. He compacted it of baked brick and mortar, and in many places bound it together with iron, but made no use of wood so that the church should no longer prove combustible. The architect and creator of all these things was that Anthemius whom I mentioned not long ago. When, as a result of the earthquake,[106] the church had lost the central part of the roof—the part that towers over all the others—the emperor repaired it in a more secure fashion and raised it to a greater height. Since Anthemius had long been dead, Isidore the Younger and the other engineers reviewed among themselves the former design and, by reference to what had remained, they judged the part that had fallen down, i.e., its nature and its faults. They left the east and west arches as they were in their former places, but in the case of the north and south ones they extended inward that part of the construction which lies on a curve and gradually increased its width so as to make them [the north and south arches] agree more closely with the others and observe the harmony of equal sides. In this way they were able to reduce the unevenness of the void and to gain a little on the extent of the space, i.e., that part of it which produced a rectangular figure. Upon these [new] arches they set up once again that circle or hemisphere (or whatever alse they call it) which dominates the centre of the building. As a result, the dome naturally became more even and well-curved, conforming altogether to the [correct geometrical] figure. It was narrower and steeper so that it did not strike spectators with as much amazement as before, but it was far more securely set up.

Theophanes, A.M. 6051, pp. 232–33:[107] On May 7th of this year [558], a Tuesday, in the 5th hour, while the dome of the Great Church was

[105] Cf. G. Millet, "La coupole primitive de Ste. Sophie," *Revue belge de philologie et d'histoire*, II (1923), 599 ff.; K. J. Conant, "The First Dome of St. Sophia and its Rebuilding," *Bulletin of the Byzantine Institute*, I (1946), 71 ff.

[106] The earthquake occurred in December 557, and the collapse of the dome in 558.

[107] This passage probably derives from the complete Chronicle of Malalas, now lost. It also appears, with minor variations, in the abbreviated Malalas, CSHB, pp. 489 f. and in other chronicles. Cedrenus, CSHB, I, 676 f. adds: "He

being repaired—for it had been cracked by the preceding earthquakes—and while the Isaurians[108] were at work, the eastern part of the vault (*prohupostolê*) of the holy sanctuary fell down and crushed the *ciborium,* the altar-table and the *ambo.* The engineers were censured because, avoiding the expense, they had not made the suspension [secure] from below, but had tunnelled the piers upholding the dome, and for this reason they had not held. Having grasped this, the most-pious emperor erected new piers to receive the dome,[109] and so the dome was built and raised by more than twenty feet in height as compared to the original structure.

Malalas, p. 495: In the same indiction [562/3][110] took place the second consecration of the most-holy Great Church. As compared to its old form, the dome was made thirty feet higher[111] and they also made two additional arches (*kamarai*), i.e., the northern and the southern one.

St. Sophia after the Rebuilding

Evagrius, *Hist. eccles.* IV, 31: He [Justinian] erected unto God and the saints many beautifully adorned churches at Constantinople. [In particular,] he built an incomparably great pile such as has never been recorded—I mean the Great Church that is so beautiful and glorious as to exceed the power of speech. Yet I shall attempt to the best of my ability to describe the particulars of this temple. The divine palace consists of a dome lifted up on four arches (*psalides*) and rising to so great a height that those who behold it from the ground are at a loss to comprehend how the cupola (*hêmisphairion*) was completed,[112] while it would be a bold man indeed who, once he was at the top, would attempt to gaze down to the bottom. The arches rise free from the ground to the roof-covering. Beside them, on right and left, columns of Thessalian marble are set out in a row, supporting, by means of other, similar columns, galleries (*huperôa*) which enable anyone who so wishes to look down upon the service; it is from there that the empress, when she attends celebrations, witnesses the performance of the holy mysteries. The arches that face the rising and the setting sun have been left open, so that nothing stands in the way [of the contemplation] of these wonderfully great proportions.

[Justinian] also made outside the church the four spiral ramps opposite the interior piers. These he planted in the ground and raised as far as the dome so as to buttress the arches. At the same time he made the altar-table, an incomparable work."

108 Cf. C. Mango, "Isaurian Builders," *Polychronion: Festschrift F. Dölger* (Heidelberg, 1966), pp. 358 ff.

109 Incorrect.

110 The reconsecration was celebrated on December 24, 562.

111 Cf. the previous passage ("more than twenty feet").

112 Literally "find it difficult to arrive at the termination of the cupola."

The porticoes (*stoai*) of the said galleries, by means of columns and little arches complete this huge edifice from the bottom upwards.[113]

In order to make clearer the wonderful qualities of this building, I have resolved to set down in feet its length, width and height, as well as the opening and height of the arches, which are as follows: the length from the door facing the holy conch (wherein the bloodless sacrifice is celebrated) to that conch itself is 190 feet; the width from north to south is 115 feet; the height[114] from the summit of the cupola to the ground is 180 feet; the width of each arch is . . . feet;[115] the breadth from east to west is 260 feet; the width of their opening (*emphôton*) is 75 feet.[116] There are, furthermore, two other remarkable porticoes[117] in the direction of the setting sun and beautifully adorned open courtyards on all sides. He, too, it was [118] that wrought the incomparable church of the Holy Apostles wherein emperors and priests are given the burial that is due to them.

Paulus Silentiarius, Descr. S. Sophiae. *This poem was recited early in 563 soon after the second consecration of the church on December 24, 562*: [186] Now the wondrous curve (*antux*) of the half-sphere, although resting on powerful foundations, collapsed[119] and threw down the entire precinct of the sacred house. . . . [198] Yet, the broad-breasted fane did not sink to the foundations, . . . but the curve (*keraiê*) of the eastern arch slipped off and a portion of the dome was mingled with the

113 The exact meaning of this sentence is not clear to me.

114 Literally "depth."

115 Lacuna in text.

116 Evagrius's figures raise some difficulties. The total interior length of the nave from east to west (including the apse) is 80.24 m. which gives us 260 ft. if 1 ft. = 30.9 cm. We obtain precisely the same result for the height of the dome, 55.75 m = 180 × 0.309. So far, we are on the right track: the dome of St. Sophia is laid out within a square of 30.95 m., i.e., exactly 100 ft. Evagrius's north-south measurement cán apply only to the width of the nave. Measured from one colonnade to the other (which is the maximum width), this amounts to 32.88 m., i.e., about 106 ft. instead of the 115 that Evagrius gives. The discrepancy is considerable, unless one supposes that there has been a scribal error and that the original figure was 105. The distance from the west door to the "conch" (190 ft.) makes sense only if by "conch" we understand the chancel-barrier; if this is so, we have a valuable indication of the position of the chancel-barrier. But what are we to make of the *emphôton*, the width of which is given as 75 ft., i.e., 23.175 m.? This cannot apply to the opening of the major arches which, as we have just seen, is 100 ft. We can only conclude that Evagrius has in mind the east-west distance between the major piers which amounts to 22.25 m., i.e., 77.5 ft. On the Byzantine foot see P. A. Underwood, "Some Principles of Measure in the Architecture of the Period of Justinian," *Cahiers Archéologiques*, III (1948), 64–74; E. Schilbach, *Byzantinische Metrologie* (Munich, 1970), pp. 13–16.

117 The two narthexes.

118 I.e., Justinian.

119 In 558. See p. 78.

dust: part of it lay on the floor, and part—a wonder to behold—hung in mid-air as if unsupported. . . .

Paul goes on to describe how Justinian was roused to action; how he visited the ruins of the church and praised the skill of the architect Anthemius; how the church was rebuilt and re-consecrated.

[352] To the east there open the triple spaces of circles cut in half, and above, upon the upright collar of the walls, springs up the fourth part of a sphere: even so, above his triple-crested head and back does a peacock raise his many-eyed feathers. Men of the craft in their technical language call these crowning parts conches. . . . [362] The middle one is girded by the priestly seats and steps ranged in a circle: the lowest part of them is drawn close together round a center on the ground, but as they rise, they widen out little by little until they reach the stalls of silver,[120] and so in ever-increasing circles they wheel round the curved wall *(keraiê)* that stands above them. This conch is followed by an arch resting on strong foundations, rectangular in plan and curved at the top, not in the form of a sphere, but in that of a cylinder cleft in twain.[121] Two other columned conches, one on each side, extend westward like bent arms stretched out to embrace within these mansions the band of singers.[122] These conches are lightened by columns speckled with purple bloom, ranged in half circle, holding aloft on golden capitals an overwhelming burden—columns which were once produced by the sheer (?)[123] crags of Thebes on the Nile. Thus on either side are the bases of each arcade upheld on twin columns, and along the traces of the three-fold conch skilled workmen did bend from below smaller arches cut in half,[124] under whose springing the columns have set their capitals, bound with bronze, carved, overlaid with gold, driving away all fear. Upon the porphyry columns stand others from Thessaly, splendid flowers of verdant stone. Here are the fair galleries for the women, and they have the same form that may be seen below, except that they are adorned not with two columns, but with six Thessalian ones. One may wonder at the resolve of the man who upon two columns has bravely set thrice two, and has not hesitated to fix their bases over empty air. All the spaces between the Thessalian columns he has fenced with stone closures upon which the women may lean and rest their laborious elbows.

[120] I.e., the silver seats of the bishop and clergy which occupied the topmost tier of the synthronon.

[121] The rectangular space of the bema directly in front of the apse.

[122] The two eastern exedras.

[123] Literally, the "well-greaved crags." The adj. *euknêmis* is regularly applied by Homer to the Achaeans; it does not appear to be very suitable for the crags of Thebes.

[124] Literally "half-finished" *(hêmiteleis)*. I do not understand the use of this epithet here if Paul is speaking, as he seems to be, of the three arches subtended by the two porphyry columns in each exedra.

[398] Thus, as you direct your gaze towards the eastern arches, you behold a never-ceasing wonder. And upon all of them, above this covering of many curves, there rises, as it were, another arch borne on air,[125] spreading out its swelling fold, and it rises to the top, to that high rim upon whose back is planted the base of the divine head-piece of the center of the church.[126] Thus the deep-bosomed conch springs up into the air: at the summit it rises single, while underneath it rests on triple folds; and through fivefold openings pierced in its back it provides sources of light, sheathed in thin glass, through which, brilliantly gleaming, enters rosy-ankled Dawn.

[417] And towards the west one may see the same forms as towards the dawn, though there is a small difference. For there in the central space it is not drawn in a curved arc as it is at the eastern end, where the priests, learned in the art of sacrifice, preside on seats resplendent with an untold wealth of silver; at the west is a great, richly-wrought portal, not a single one, but divided into three at the boundary of the temple.

[425] By the doors there stretches out a lengthy porch receiving those that enter beneath wide gates. It is as long as the wondrous church is broad; this space is called *narthex* by the Greeks. Here through the night there rises a melodious sound pleasing to the ears of Christ, giver of life, when the psalms of God-fearing David are sung with alternate voice by the sacred ministers. . . . [438] Into the porch there open wide seven holy gates inviting the people to enter; one of these is on the narrow face of the narthex facing south, and another on the northern wing; the rest on their groaning pivots are opened by the warden in the west wall which marks the end of the church.

Whither am I driven? What wind, as upon the sea, has carried away my roaming speech? The center of the church, the most renowned place, has been neglected. Return, my song, to behold a wonder scarcely to be believed when seen or heard.

[448] Next to the eastern and western circles—those circles cut in half—next to the twin Theban columns, are four sturdy piers *(toichoi)*, bare in front, but on their sides and powerful backs they are bound by supports from opposite directions. The four of them rest on strong foundations, fixed on solid stones. In their midst the workman has mixed and poured the dust of fire-burnt stone,[127] thus binding them together by the builder's art. Above them are bent arches of measureless size like the many-colored rounded bow of Iris: one turns towards the wing of Zephyr, another to Boreas, another to Notus, another rises upright towards fiery Eurus. Each arch joins its unshaken foot to that of the neigh-

125 The main eastern arch.
126 The dome.
127 Presumably crushed brick, which was a regular component of Byzantine mortar. Cf. p. 111 and n. 280.

boring curve at either end, and so they are fixed together on the edge, but as each rises in the air in bending line, it slowly separates from its former fellow. Now, the space between the arches is filled with a fair construction. For where they bend away from one another according to the laws of art, and would have shown empty air, there springs up a wall in the shape of a triangle,[128] sufficiently curved so as to join the arms on either side by the common yoke of a circular rim. On four sides these walls creep over and spread out, until they are united and run up on the back of the circle like a crown. The middle portion of the arches, as much as forms the curved rim, the builder's art has compacted of baked bricks, while the ends of the bows are made of construction stone.[129] In the joints they have put sheets of soft lead lest the stones, pressing as they do upon one another and adding rude weight to weight, should have their backs broken; but with the lead inserted, the stone foundation is gently compressed.

[481] A stone rim, rounded on all sides, has been fastened upon the backs [of the arches], where the base of the hemisphere comes down; there, too, are the winding curves of the last circle[130] which the workmen have set like a crown upon the backs of the arches. Under this projecting adornment suspended stones have fashioned a narrow path like a fringe upon which the lamplighter may fearlessly walk round and kindle the sacred lights.

[489] Rising above this into the immeasurable air is a helmet rounded on all sides like a sphere and, radiant as the heavens, it bestrides the roof of the church. At its very summit art has depicted a cross, protector of the city. It is a wonder to see how [the dome], wide below, gradually grows less at the top as it rises. It does not, however, form a sharp pinnacle, but is like the firmament whicn rests on air....[131]

[506] At the very navel the sign of the cross is depicted within a circle by means of minute mosaic so that the Saviour of the whole world may for ever protect the church; while at the base of the half-sphere are fashioned forty arched windows through which the rays of fair-haired Dawn are channelled....[132]

[532] Now, towards the east and the west, you will see nothing beneath the arches: all is air. But towards the murmuring south wind and the rainless north there rises a mighty wall up to the chin of the rounded

128 I.e., a pendentive.
129 Paul is probably trying to say that the arches, which are of brick, rest upon the stone piers.
130 Meaning not entirely clear. Paul may be thinking of the ribs of the dome.
131 Verses 497–505 are badly mutilated in the manuscript.
132 Paul goes on to say that the church was roofed in brick since no timbers were big enough for the purpose—a purely poetic digression.

arch, and it is illuminated by twice four windows.[133] This wall rests below on stone props, for, underneath it, six Haemonian columns,[133a] like the fresh green of the emerald, hold up a tireless sinewy juncture (it is there that the women have their seats). These in turn are heaved upon massive heads by four columns fixed immovable on the ground, glittering jewels of Thessalian marble graced with locks of golden hair.[134] They separate the middle mansion of the glorious church from the lengthy aisle *(aithousa)* that lies alongside. Never were such columns, high-crested, blooming like a grove with bright flowers, cut from the land of Molossis.

[550] But in the midst of the aisle, too, Anthemius of many crafts assisted by the wisdom of Isidorus (for both of them, serving the will of the industrious Emperor, have built this prodigious church) have set up four more columns, shorter in measure than their neighbours, but as bright with verdant bloom, being as they are from the same quarry. Their goodly feet are not planted in the ground all in a row: instead, they are set on the pavement in facing pairs, and upon their heads, a vault *(keraiê)*, wound on fourfold arches, supports the underside of the women's abode. Close by, in the direction of the north wind is a door that leads the people to the pure founts that cleanse human life and drive away the grievous scars of sin.[135]

[567] Following these four graceful Thessalian columns, on either side, namely towards dusk and dawn, pierced cylindrical vaults are poised on the divinely built walls along the length of the aisle and serve for passage. Towards the north wind they open into double doors, whereas towards the south, over against the doors, are well-wrought spaces like chambers.[136] And again towards the day and night stand two other columns from the Haemus and two pillars *(stêmones)* with lofty crests from famous Proconnesus, set close to the doors. Towards the east there is but one door, while towards the abode of black night the people enter through a double portal.[137]

[133] The form of the tympana was altered at a later period. Now each of them has twelve windows.

[133a] Same as Thessalian.

[134] The four verd antique columns on the ground floor.

[135] This surely refers to the baptistery. Paul's indication is deserving of notice, since the building generally regarded as the baptistery of St. Sophia is situated to the south of the church.

[136] This is not very clear. I think that Paul is referring to the arched passages between the main piers and the pier-buttresses. The latter are pierced by tunnel vaults which must indeed have been provided with doors. Today the tunnel in the northeast pier-buttress is entirely blocked up; that in the northwest pier-buttress forms an enclosed room without exit, but that, too, represents a later alteration.

[137] This is quite correct if one envisages the west bay of the aisle as a rectangle without its curved prolongation towards the longitudinal axis of the church.

[580] On the south you will find a long aisle altogether similar to the northern one, yet it has something in addition: for it contains a space separated by a wall, reserved for the Ausonian emperor on solemn festivals. Here my sceptered king, seated on his customary throne, lends his ear to [the reading of] the sacred books.[138]

[586] And whoever mounts up will find that the women's aisles on either side are similar to those below; but the one that runs above the narthex, to the west, is not like the other two.

[590] Now on the western side of this divine church you will see a court encompassed by four aisles:[139] one of these is joined to the narthex, while the others are open wide, and various paths lead to them. At the prized center of the wide court stands a spacious fountain, cleft from the Iasian peaks;[139a] from it a burbling stream of water, forced by a brazen pipe, leaps into the air—a stream that drives away all suffering, when the people, in the month of the golden vestments,[140] at God's mystic feast, draw by night the unsullied waters in vessels....

[605] Upon the carved stone wall[141] curious designs glitter everywhere. These have been produced by the quarries of sea-girt Proconnesus. The joining of the cut marbles resembles the art of painting for you may see the veins of the square and octagonal stones meeting so as to form devices: connected in this way, the stones imitate the glories of painting.

And outside the divine church you may see everywhere, along its flanks and boundaries, many open courts. These have been fashioned with cunning skill about the holy building that it may appear bathed all round by the bright light of day.

[617] Yet who, even in the thundering strains of Homer, shall sing the marble meadows gathered upon the mighty walls and spreading pavement of the lofty church? Mining [tools of] toothed steel have cut these from the green flanks of Carystus[142] and have cleft the speckled Phrygian stone, sometimes rosy mixed with white, sometimes gleaming with purple and silver flowers.[143] There is a wealth of porphyry stone, too, besprinkled with little bright stars that had laden the river-boat on the broad Nile. You may see the bright green stone of Laconia and the glittering marble

138 This space was known as the *mêtatorion (mutatorium)*.

139 The atrium. Paul treats the so-called exonarthex as forming one of the four porticoes of the atrium.

139a I.e., made of Carian marble on which see p. 63, n. 43.

140 January, when the consuls in their golden ceremonial robes entered on their year of office. The "mystic feast" is Epiphany.

141 It is not clear whether Paul is referring here to the walls of the atrium or to the fountain that stood at its center.

142 See p. 32 and n. 38.

143 Also mentioned by St. Gregory of Nyssa, PG XLIV, 653D, 657B, this was probably the same as Docimian or Synnada marble, which came in a variety of colors.

with wavy veins found in the deep gullies of the Iasian peaks, exhibiting slanting streaks of blood-red and livid white; the pale yellow with swirling red from the Lydian headland; the glittering crocus-like golden stone which the Libyan sun, warming it with its golden light, has produced on the steep flanks of the Moorish hills; that of glittering black upon which the Celtic crags, deep in ice, have poured here and there an abundance of milk; the pale onyx with glint of precious metal; and that which the land of Atrax[144] yields, not from some upland glen, but from the level plain: in parts vivid green not unlike emerald, in others of a darker green, almost blue. It has spots resembling snow next to flashes of black so that in one stone various beauties mingle.

[647] Before one comes to the glitter of cut mosaic, the mason, weaving together with his hands thin slabs of marble, has figured upon the walls connected arcs laden with fruit, baskets and leaves, and has represented birds perched on boughs.[145] The twining vine with shoots like golden ringlets winds its curving path and weaves a spiral chain of clusters. It projects gently forward so as to overshadow somewhat with its twisting wreaths the stone that is next to it.[146] Such ornament surrounds the beauteous church. And above the high-crested columns, underneath the projecting stone edge, is deployed a tapestry of wavy acanthus, a wandering contexture of spiky points, all golden, full of grace.[147] It encompasses marble shields—discs of porphyry glittering with a beauty that charms the heart.

[664] The hills of Proconnesus have gladly offered their back to the life-giving Queen[148] to cover the entire floor, while the polish of Bosporus stone[149] shimmers gently, black with an admixture of white.

[668] The roof is compacted of gilded tesserae from which a glittering stream of golden rays pours abundantly and strikes men's eyes with irresistible force. It is as if one were gazing at the midday sun in spring, when he gilds each mountain top.

[673] Indeed, our emperor, who has gathered all manner of wealth from the whole earth, from barbarians and Ausonians alike,[150] did not deem a stone adornment sufficient for this divine, immortal temple in which Rome has placed all its proud hopes of joy. He has not spared,

144 Thessaly.

145 This applies to the *opus sectile* decoration in the spandrels of the gallery colonnade.

146 In fact, this decoration is very nearly flat.

147 Referring to the spandrels of the main colonnade on the ground floor.

148 Meaning, presumably, the church.

149 Bosporus marble is mentioned once again in the *Description of the Ambo, below*, p. 93, where it appears to be the same as Proconnesian (white with blue veins), but this cannot be so here. There was a black Bithynian marble, the same that is now quarried at Adapazarī.

150 I.e., his own Roman subjects.

too, an abundant enrichment of silver. The ridge of Pangaeus[151] and the cape of Sunium[152] have opened all their silver veins, and many a treasure-house of our lords has yielded its stores.

[682] For as much of the great church by the eastern arch as was set apart for the bloodless sacrifice is bounded not with ivory or cut stone or bronze, but it is all fenced under a cover of silver. Not only upon the walls which separate the priest from the choir of singers has he set plates of naked silver, but the columns, too, six sets of twain in number, he has completely covered with the silver metal, and they send forth their rays far and wide. Upon them the tool wielded by a skilled hand has artfully hollowed out discs more pointed than a circle,[153] within which[154] it has engraved the figure of the immaculate God who, without seed, clothed himself in human form. Elsewhere it has carved the host of winged angels bowing down their necks, for they are unable to gaze upon the glory of God, though hidden under a veil of human form—He is still God, even if He has put on the flesh that removes sin. Elsewhere the sharp steel has fashioned those former heralds of God[155] by whose words, before God had taken on flesh, the divine tidings of Christ's coming spread abroad. Nor has the artist forgotten the images of those who abandoned the mean labors of their life—the fishing basket and the net— and those evil cares in order to follow the command of the heavenly King, fishing even for men and, instead of casting for fish, spread out the nets of eternal life.[156] And elsewhere art has depicted the Mother of Christ, the vessel of eternal life, whose holy womb did nourish its own Maker. And on the middle panels of the sacred screen which form a barrier round the sanctified priests, the carver's tool has incised one symbol that means many words, for it combines the names of the Empress and Emperor: It is like a shield with a boss in whose middle part has

151 In eastern Macedonia. This is a literary allusion and does not indicate that the gold and silver mines of Pangaeus, famous in antiquity, were exploited in Justinian's time.

152 In Attica. The mines were at Laurium.

153 I.e., oval. S. G. Xydis, "The Chancel Barrier, Solea, and Ambo of Hagia Sophia," *Art Bulletin,* XXIX (1947), 8 f. proposes a textual emendation, namely *oxutorous* [instead of *oxuterous*] *kukloio . . . diskous,* i.e. "sharply chased circular discs." He does so on the grounds that oval or ellipsoid frames were rarely used in Early Christian art.

154 Or "in the midst of which." I fully agree with Xydis that the discs, whether oval or circular, must have been on the entablature, and not on the columns of the chancel screen, and that the figure of Christ occupied the central disc above the chancel door. Several examples of entablatures decorated in this manner have recently come to light in Asia Minor. They usually comprise figures of Christ, the Virgin Mary, and John the Baptist, forming a central group, flanked symmetrically by angels, apostles and other saints.

155 The prophets.

156 The apostles.

been carved the sign of the cross.[157] And the screen gives access to the priests through three doors. For on each side the workman's hand has made a small door.[158]

[720] And above the all-pure table of gold[159] rises into the ample air an indescribable tower, reared on fourfold arches of silver. It is borne aloft on silver columns on whose tops each of the four arches has planted its silver feet. And above the arches springs up a figure like a cone, yet it is not exactly a cone: for at the bottom its rim does not turn round in a circle, but has an eight-sided base, and from a broad plan it gradually creeps up to a sharp point, stretching out as it does so eight sides of silver. At the juncture of each to the other stand long backbones which seem to join their course with the triangular faces of the eight-sided form and rise to a single crest where the artist has placed the form of a cup. The lip of the cup bends over and assumes the shape of leaves, and in the midst of it has been placed a shining silver orb, and a cross surmounts it all. May it be propitious! Above the arches many a curve of acanthus twists round the lower part of the cone, while at the top, rising over the edge, it terminates in upright points resembling the fragrant fruit of the fair-leaved peartree, glittering with light.[160] Now where the sides of the base are fitted to each other are fixed silver bowls, and in each bowl is set a candelabrum like a candle that burns not, expressing beauty rather than giving light; for these are fashioned all round of silver, brightly polished. Thus the candle flashes a silver ray, not the light of fire. And on columns of gold is raised the all-gold slab of the holy table, standing on gold foundations, and bright with the glitter of precious stones.

[755] Whither am I carried? Whither tends my unbridled speech? Let my bold voice be restrained with silent lip lest I lay bare what the eyes are not permitted to see. But ye priests, as the sacred laws command you, spread out with your hands the veil dipped in the purple dye of the Sidonian shell and cover the top of the table. Unfold the cover along its four sides and show to the countless crowd the gold and the bright designs of skilful handiwork. One side is adorned with Christ's venerable form. This has been fashioned not by artists' skilful hands plying the knife, nor by the needle driven through cloth, but by the web, the

157 I.e., the parapet slabs of the chancel screen were decorated with the monogram of Justinian and Theodora. Note that the latter had died in 548. It is not entirely clear whether this monogram was itself constructed in the form of a cross or whether it accompanied an ordinary cross.

158 The chancel projected into the nave, so that it had three enclosed sides with a door in each.

159 The altar-table.

160 This sentence is rather obscure.

produce of the foreign worm,[161] changing its colored threads of many shades. Upon the divine legs is a garment reflecting a golden glow under the rays of rosy-fingered Dawn, and a chiton, dyed purple by the Tyrian seashell, covers the right shoulder beneath its well-woven fabric; for at that point the upper garment has slipped down while, pulled up across the side, it envelops the left shoulder. The forearm and hand are thus laid bare. He seems to be stretching out the fingers of the right hand, as if preaching His immortal words, while in His left He holds the book of divine message—the book that tells what He, the Lord, accomplished with provident mind when His foot trod the earth. The whole robe shines with gold: for on it gold leaf has been wrapped round thread after the manner of a pipe or a reed, and so it projects above the lovely cloth, firmly bound with silken thread by sharp needles.[162] On either side stand two of God's messengers: Paul, replete with divine wisdom, and the mighty doorkeeper of the gates of heaven who binds with both heavenly and earthly bonds.[163] One holds the book pregnant with holy ordinance, the other the form of the cross on a golden staff. And both the cunning web has clothed in robes woven of silver; while rising above their immortal heads a golden temple enfolds them with three noble arches fixed on four columns of gold.[164] And on the hem of the veil shot with gold, art has figured the countless deeds of the Emperors, guardians of the city: here you may see hospitals for the sick, there sacred fanes.[165] And elsewhere[166] are displayed the miracles of heavenly Christ, a work suffused with beauty. And upon other veils you may see the monarchs joined together, here by the hand of Mary, the Mother of God, there by that of Christ, and all is adorned with the sheen of golden thread.

[806] Thus is everything clothed in beauty; everything fills the eye with wonder. But no words are sufficient to describe the illumination in the evening: you might say that some nocturnal sun filled the majestic temple with light. For the deep wisdom of our Emperors has stretched from the projecting stone cornice, on whose back is planted the foot of

161 Literally the "barbarian ant," i.e., the silkworm. It may be recalled that the silkworm was introduced into the Byzantine world in 552, probably from Sogdia. At the time when Paul the Silentiary was writing silk was still for the most part imported from Persia.

162 This is an accurate description of the kind of broidered stuff that was called *sólénoton*. Cf. p. 156.

163 Cf. Matt. 18:18.

164 In other words, the figures of Christ, Peter and Paul were enclosed within a triple arcade.

165 I.e., hospitals and churches that had been founded by Justinian. As has often been pointed out, this description provides a remarkable analogy to the Daniel and St. Peter Egyptian textiles, now in Berlin, on whose borders are represented various churches and miracles of Christ. See J. Strzygowski, *Orient oder Rom* (Leipzig, 1901), pp. 91 ff.

166 Probably on the same altarcloth.

the temple's lofty dome, long twisted chains of beaten brass, linked in alternating curves by many hooks. From many points on a long course these fall together to the ground, but before they reach the floor, their lofty path is checked and they form an even choir. And to each chain he has attached silver discs, suspended circle-wise in the air round the central confines of the church. Thus, descending from their lofty course, they float in a circle above the heads of men. The cunning craftsman has pierced the discs all over with his iron tool so that they may receive shafts of fire-wrought glass[167] and provide pendent sources of light for men at night. Yet not from discs alone does the light shine at night, for in the [same] circle you will see, next to the discs, the shape of the lofty cross with many eyes upon it, and in its pierced back it holds luminous vessels.[168] Thus hangs the circling choir of bright lights. You might say you were gazing on the effulgent stars of the heavenly Corona close to Arcturus and the head of Draco.

[834] Thus the evening light revolves round the temple, brightly shining. And in a smaller, inner circle you will find a second crown bearing lights along its rim, while in the very center another noble disc rises shining in the air, so that darkness is made to flee.

[839] By the aisles, too, next to the columns on either side, they have placed in sequence single lamps, one apart from the other, and they go through the whole length of the far-stretching church. Beneath each they have placed a silver vessel resembling a balance pan, and in the center of this rests a cup of burning oil. There is not, however, one equal level for all the lamps, but you will see some high, some low, in lovely curves of light as they glitter step-wise on their aerial path, suspended from twisted chains. In this manner does the twin-pointed Hyas shine, fixed in the parted forehead of Taurus. One may also see ships of silver bearing a luminous freight; suspended, they sail through the bright air instead of the sea, fearing neither the south wind nor late-setting Boôtes.[169] And down on the floor you will see elegant beams running between two-horned [supports] of iron, upon which extends a row of lights, servitors of the temple, connected by straight rods of red color.[170] Some of these are on the floor, where the elegant columns have set their bases, while others are above the capitals, following the long path of the walls.[171]

167 I.e., narrow glass beakers.

168 I.e., cross-shaped *polukandéla*. The "eyes" are for the insertion of the little glass lamps. Objects of this kind form part of the recently discovered and as yet unpublished silver treasure from Kumluca in southern Turkey.

169 For a bronze lamp in the form of a ship, see *Handbook of the Byzantine Collection* [at Dumbarton Oaks] (Washington, D.C., 1967). No. 107.

170 Paul is describing here some kind of floor lamp, but its exact nature is not clear to me.

171 I.e., in the galleries.

[862] Neither has the base of the deep-bosomed dome been left without light, for along the projecting stone of the curved cornice the priest[172] has lit single lamps attached to bronze stakes. Just as a king, cherishing his virgin daughter, might place round her neck a lovely chain glowing like fire with rubies set in gold, so has our Emperor fixed round the cornice a revolving circle of lights that run along the whole base.

[871] There is also on the silver columns,[173] above their capitals, a narrow path of access for the lamplighters, a path full of light, glittering with bright clusters; these one might compare to the mountain-reared pine tree or to the cypress of tender foliage. Pointed at the summit, they are ringed by circles that gradually widen down to the lowest curve that surrounds the base of the trunk; and upon them have grown fiery flowers. Instead of a root, bows of silver have been affixed beneath these trees of flaming vegetation. And in the center of this beauteous grove, the form of the divine cross, studded with bright nails, blazes with light for mortal eyes.

[884] Countless other lights, hanging on twisted chains, does the church of ever-changing aspect contain within itself; some illumine the aisles, others the center or the east and west, others shed their bright flame at the summit. Thus the bright night smiles like the day and appears herself to be rosy-ankled. . . .

The Ambo of St. Sophia

Paulus Silentarius, *Descr. ambonis* v. 50 ff: In the center of the wide church, yet tending rather towards the east, is a kind of tower, fair to look upon, set apart as the abode of the sacred books.[174] Upright it stands on steps,[175] reached by two flights, one of which extends towards the night, the other towards the dawn. These are opposite to one another; but both lead to the same space that is curved like a circle; for here a single stone circumscribes a space that resembles a circle, but is not altogether equal to a complete curve, for it contracts a little and so draws out the outline of the stone.[176] And towards the west and east the stone forms a neck projecting from the circle and resting upon the steps. Up to the height of a man's girdle our divine Emperor has erected beauteous walls, crescent-shaped, sheathed in silver.[177] For he has not

[172] Surely, priests would not have been employed to light the lamps along the dome cornice.

[173] Of the chancel screen.

[174] I.e., intended for the reading of the sacred books.

[175] Greek text uncertain.

[176] In other words, the platform of the ambo consisted of a single stone slab of oval shape.

[177] Referring to the parapet of the platform.

bent the silver right around the stone, but the silver slabs unfold into glorious curves in the middle and form a wall. The skilful craftsman has opened the curve sufficiently on either side so as to provide access to the flights of steps.[178] Nor does fear seize those who descend the sacred steps because their sides are unfenced; for walls of shining marble have been artfully reared here, and they rise above the steps to such height as is needed to guide a man's hand. By grasping them, a man eases his toil as he mounts upwards. So, in a slanting line, these [parapets] rise on either side together with the steps that are between them and come to a stop.

[76] This stone, too,[179] is not devoid of worth; for it was to some purpose that they quarried the wild summits of steep hills to have a far-stretching boundary of the long flights. The whole of it is adorned with skilful workmanship and glistens with the many hues of the natural stone. Its surface is covered, as it were, with eddying whirlpools, in places resembling an infinity of circles, while in others they stray from under the circles into winding curves. In parts is seen a rosy bloom mingled with pallor, or the fair brightness of human fingernails;[180] in other places the brilliance turns to a soft white like the color of boxwood or the lovely semblance of bees-wax which men wash in clear mountain streams and lay out to dry under the sun's rays: it turns silver-white, yet not completely altering its color, it shows traces of gold. So, too, does ivory, tinged by the passage of long years, turn its silvery color to quince-yellow. In places it has a dark sheen, yet marvellous Nature did not allow this livid color to spread, but has mixed cunning patterns into the stone, and a changeful silvery light flashes over it: sometimes it flows over a wide expanse tinged with the choicest hue of dark crocus-yellow, sometimes it has a paler glow, like the light that creeps round the pointed horns of the new-born moon. Near a stony crag stands the sacred city [Hierapolis] which has given its famous name to this marble.[181]

[105] That whole fair construction of stone, whence the precepts of divinely wise books are read out,[182] has been artfully fixed on eight cunningly wrought columns. Two of these are towards the north, two towards the south wind, two towards the east, and two towards the abode of night. Thus [the structure] is heaved up, and underneath the stone there is, as it were, another chamber, wherein the sacred song is raised

[178] This passage has caused much difficulty to editors and translators, and various textual emendations have been proposed. The meaning is, however, sufficiently clear: The parapet (silver slabs) does not go right round the oval platform, but forms two crescents, separated by an opening to the east and another to the west.

[179] I.e., the marble of the parapets.

[180] Note that onyx owes its name to its resemblance to the human nail.

[181] This was evidently a kind of alabaster. See R. Gnoli in *La parola del passato*, XXI (1966), 54, n. 33.

[182] Literally "carried up."

by fair children, heralds of wisdom.[183] What is roof for those below is a floor for those above; the latter is like a spreading plain, made level for the feet of mortals, while the underside has been cut out and hollowed by the mason so that it rises from the sacred capitals, curving over with artful adornment, like the bent back of the hard-shelled tortoise or the oxhide shield which the agile warrior holds over his helmet when he leaps in the Pyrrhic dance. The rough face (*metôpon*) of this whole stone has been girded all round with silver, and upon it the skilful craftsman has traced with the point of his iron tool various trees and fair flowers, interspersed by the soft leaves of ivy, with its clusters and budding shoots.

[126] To provide an unshakable foundation for the entire [structure]—the steps, the floor and the columns themselves—the skilled craftsman has raised underneath it a stone base, the height of a man's foot above the ground. And with a view to broadening this footing of the structure, they have placed on either side, round the belly (*gastêr*) in the middle, half-circles of stone, and the space that has been thus cut off they surrounded with separate columns erected in semicircular formation. Thus the whole belly is widened by means of four rich columns on either side, to north and to south, and the cavern[184] is, like a house, protected on all sides by an encircling fence of stone. The lovely columns have been cut[185] by the masons' strong picks in the Phrygian land, by the Mygdonian heights; and when a man beholds the bloom of the stone, he would say that white lilies have been mingled with rose cups and the soft petals of the short-lived anemone. In places the marble is rosy with a tinge of white, in others it is mostly white with a tinge of fiery red; here and there the veins are traversed by fine sinews and, mingling together, they flush with purple, like the blood of the Laconian shell.[186]

[148] First then they laid round about, at the bottom, the cunningly wrought plinth (*krêpis*) resplendent with twisting curves, and upon it they firmly set up stone pedestals (*bômoi*)[187] cut from the rich quarries of the Bosporus.[188] They gleam white, but on their white skin a blue vein winds a scattered path. The mason has beautifully carved the eight sides of each pedestal, while the steel carving-tool has bound its round neck [with a collar] so that the column should rest securely upon the circular [top of] the pedestal that is affixed underneath. Throughout

183 Literally, "wherein the heralds of wisdom [i.e., the priests] raise the propitious song that is rich in fair children." Paul surely means to say that a choir of boys was stationed beneath the platform of the ambo.
184 I.e., the hollow space under the platform of the ambo.
185 Literally "raised."
186 See, p. 85, n. 143.
187 Cf. p. 29, n. 25.
188 See, p. 86, n. 149.

the space of the church shines the glory of each column set on its po-
lished base, like a white cloud tinged by the ruddy rays of the sun rising
above the horizon.

[163] In this manner was the half-circle ringed with four columns;
and the other half was surrounded with another four columns, thus
fashioning a fair mantle of stone round the well-wrought cavern (antron).
Observing that there were three intervals between the four columns, the
skilful mason made a fence for them of marble from the Sacred City,[189]
right upon the plinth (krêpis) and he gently curved this [fence of] fair
stone. It was indeed proper that this crown of stone on the goodly floor
of the undefiled fane should bear a sacred name. And in the outermost
interval he inserted a stout door, slightly curved, through which the
man entrusted with the holy books enters the precinct of the cave. Now
the form of the cavern is identical both towards Garamas on the south[190]
and towards the Arimaspian wind[191] as regards the columns, the plinth
and the fence. The doors, however, the workmen have not fixed in the
same place, but one they have set westwards and the other eastwards—
the western one to the north, while the southern door faces east. More-
over the fence-walls do not stand to the same height as the columns, but
they rise above the beauteous pavement as much as to hide the men in
the depths of the cave. But the eight columns with their deeply carved
capitals project above the fence-wall, even though both [columns and
fence] are firmly planted upon one and the same level foundation plinth.
The gilded capitals shine all round with a brilliant glow, like high peaks
which the golden-rayed disc of the sun strikes with its arrows.

[191] And all the capitals that rise aloft are crowned above in
circled order by an embracing rim of beams,[192] which binds the columns
together in one curve, though each is separate from the other. Fixed
upon the rim you may see trees with fiery clusters, glittering afar with
flowers of flame from their silver branches. Nor does each sapling shoot
up at random, but it rises in the form of a regular cone with many loops
covered with lights: starting with a wide circle, it gradually diminishes
until it comes to a sharp point. And the fair girdle you see—the one that
forms the rim[193]—is colored on all sides with sapphire dust and crowned
with golden ivy-leaves. Towards the home of Zephyr and towards fiery-
winged Eurus,[194] there are fixed upon the rim two silver crosses, one on

189 Hierapolis in Phrygia.

190 The Garamantes were an African tribe.

191 I.e., north. The Arimaspi were a Scythian people.

192 I.e., an architrave. Paul surely does not mean to say that this was
wooden, as some commentators have supposed.

193 Meaning, once again, the architrave which had a design of gold ivy
leaves on a blue ground.

194 I.e., west and east.

each side, bent in the form of a shepherd's crook, upon which many a nail with curved head picks up the countless lights of the lamps.[195]

[209] With such beauties is adorned the ambo of double access.[196] It bears this name because it is ascended *(ambatos)* by holy paths, and here the people direct their attentive eyes as they listen to the immaculate mysteries of the divine word.

[213] And even for the steps they have used not ordinary cut stone, but one on whose white surface you may see thin veins of a beautiful deep red color like true purple. Using unpolished stones, the mason has made rough the easy treads of the stairs, a secure support for the feet of men, lest any one on the descending path slip down from above and fall unsteady to the floor. Thus, in orderly succession, one stone, as it rises above another, recedes from it, as much as to allow a man ascending to support his steps in turn.

[224] And as an island rises amidst the waves of the sea, adorned with cornfields, and vineyards, and blossoming meadows, and wooded heights, while the travellers who sail by are gladdened by it and are soothed of the anxieties and exertions of the sea; so in the midst of the boundless temple rises upright the tower-like ambo of stone adorned with its meadows of marble, wrought with the beauty of the craftsman's art. Yet, it does not stand altogether cut off in the central space, like a sea-girt island, but it rather resembles some wave-washed land, extended through the white-capped billows by an isthmus into the middle of the sea, and being joined fast at one point it cannot be seen as a true island. Projecting into the watery deep, it is still joined to the mainland coast by the isthmus, as by a cable.

[240] Such, then, is the aspect of this place; for, starting at the last step to the east,[197] there extends a long strait *(aulón)*[198] until it comes near the silver doors and strikes with its lengthy plinth the sacred precinct. On either side it is bounded by walls. They have not used lofty slabs for this fence-wall, but of such a height as to reach the girdle of a man standing by. Here the priest who brings the good tidings passes along on his return from the ambo, holding aloft the golden book; and while the crowd strives in honor of the immaculate God to touch the sacred book with their lips and hands, the countless waves of the surging people break around. Thus, like an isthmus beaten by waves on either side, does this space stretch out, and it leads the priest who descends

195 In other words, the upper arm of each cross was bent in a curve so as to form Christ's monogram ☧ on the "nails," whose form is not entirely clear to me, cf. p. 91.

196 I.e., having two flights of stairs.

197 I.e., the lowest step of the eastern staircase of the ambo.

198 This was called *sólea,* and corresponds to the western *schola cantorum.* See S. G. Xydis in *Art Bulletin,* XXIX (1947), 11 ff.

from the lofty crags of this vantage point[199] to the shrine of the holy table. The entire path is fenced on both sides with the fresh green stone of Thessaly, whose abundant meadows delight the eye. And next to each Thessalian slab stands a post of equal height, yet in form not rounded like a cylinder. A man versed in figures would say that these posts had the shape of an elongated, as opposed to an equal-sided cube. To join the Molossian slabs together, the masons have wedged one stone into another;[200] and it is from the Phrygian hills that the stone-cutter has quarried these posts. When, to soothe your sorrows, you cast your eyes there, you might see snake-like coils twining over the fair marble, in beauteous wavy paths; there fiery red and white are set next to each other, and there is a color intermediate between the two, their lines bending in alternating coils, as they roll round on their convoluted path. And in other places you may see the natural markings of the stone that resemble in their changeful lines the moon and the stars. And on the upper rim of the fence-wall they have fixed another long stone produced by the same craggy hill, so that the Thessalian slabs, firmly fixed as they are on the foundations of the plinth below, should also be held at the top by another stone attachment, while their sides are bound together by the square posts, and so fixed immovable on the pavement.... [294] And at the eastern end, by the holy fence-walls of the altar, they have cut off the isthmus, so as to afford a speedier path to those who pass from side to side.

Such works as these has our bountiful Emperor built for God the King. And in addition to his glorious gifts, he has dedicated, beyond the much-praised temple, a shining [image] of his Serenity that protects the city,[201] a live token of honor, set up with divine counsel, to the Governor of the world, Christ the universal King....

The Construction of St. Sophia: A Semi-Legendary Account

Narratio de S. Sophia, 7 ff: 7. There were a hundred master craftsmen (*maistores*), and each one whom had a hundred men, so that all together there were ten thousand, Fifty master craftsmen with their people were building the right-hand side, and the other fifty were likewise building the left-hand side, so that the work would proceed quickly, in competition and haste.

8. The shape of the church was revealed to the emperor by an angel of the Lord. The master-builder was the engineer (*mêchanikos*)

199 I.e., the ambo.

200 To put it more accurately, the closure slabs of verd antique fitted into the upright posts which probably had vertical slots on either side.

201 Probably referring to Justinian's equestrian statue, on which see p. 110 ff.

Ignatius,[202] a man possessed of great wisdom and experienced in the building of churches. Barley was cooked in cauldrons, and its juice, instead of water, was mixed with lime and [crushed] brick, this juice being sticky, good for mixing and adhesive. They also cut to pieces the bark of elms and put it in the cauldrons together with the barley. They made square masses, fifty cubits long and fifty cubits wide and twenty cubits thick, and they placed these in the foundations, and they used [the mixture] neither hot nor cold, but lukewarm because that way it would be adhesive. And above the mass they placed big stones, equal in length and width, and they could be seen to hold like iron.

9. When the foundation was raised two cubits above the ground—as stated by the aforementioned Strategius, the emperor's adopted brother, who kept the accounts[203]—there had been expended 452 *kentênaria*[204] of gold. Every day silver pieces *(miliarêsia)* were brought from stones received one silver piece per day so they would not lose heart or the palace and placed at the Horologion,[205] and those who carried up the curse.... When the piers had been raised and the great columns (both those of Roman stone[206] and the green ones) had been set up, the emperor did not sleep in the afternoon, but showed much solicitude and zeal in observing the stone-carvers, masons, carpenters and other builders....

10. When they had erected the arches of the right-hand and left-hand galleries and roofed them over with vaults [?],[207] the emperor decreed that on a Saturday silver pieces should be brought from the palace.... [208]

11. When the builders had reached the second gallery[209] and had erected the upper columns and the vaults, and roofed everything all round, the emperor was dispirited because he did not have a [sufficient] quantity of gold.... [210]

12. When he was about to complete the holy presbytery *(thusiastêrion)* and light it by means of glazed windows *(stoai)*, he ordered the engineer that the apse *(muax)* should have one arched opening; but then he changed his mind and ordered that it should have two lights, i.e.,

202 The architects of St. Sophia were, of course. Anthemius of Tralles and Isidore of Miletus.

203 Strategius, a rich Egyptian landowner, was *comes sacrarum largitionum* (533–538). There is no indication that he was Justinian's adopted brother.

204 *Kentênarion* = 100 lbs.

205 At the south-west corner of St. Sophia, where there was a monumental clock.

206 I.e., porphyry.

207 The Greek form, *kephalikas* (variant reading *skaphikas*) *apsidas*, is not entirely clear.

208 There follows the famous legend about the guardian angel of St. Sophia.

209 There is only one gallery in St. Sophia.

210 Follows a story about the miraculous invention of a treasure of gold.

two arches so as to reduce the weight, inasmuch as they had not set up a centering (*kriômata*) there, just as [they had not done so] in the narthex and on the sides of the church.[211] But as the other craftsmen objected, saying that one arch would light the presbytery [sufficiently], the master-builder was at a loss what to do, since sometimes the emperor said that there should be one arch, and at other times two; and as he stood there in distress (it was a Wednesday, in the fifth hour), there appeared to him an angel of the Lord in the likeness of Justinian, wearing imperial vestments and red buskins, and said to the craftsman: "I wish that you make me the apse with three lights by means of three arches, in the name of the Father, the Son and the Holy Ghost." . . .

13. All the piers, both inside and out, are held by iron tie-rods set in solder (?) so as to be firm and unmoving. The rendering (*emplasis*) of all the piers was of oil [mixed] with lime, and upon this they set up the variegated marble revetments.

14. The emperor despatched Troilus the chamberlain, Theodore the prefect and Basilides the quaestor to the island of Rhodes and there they made out of clay enormous bricks of equal weight and size which they stamped with these words: "God is in the midst of her, and she shall not be moved. God shall help her, and that right early."[212] And counting their number, they shipped them to the emperor. The weight of twelve such bricks is equal to that of one of our bricks because that clay is very light, spongy and of a white color. Hence a popular tale has spread abroad that the dome is made of pumice, but it is not so, except that it is light. With these bricks they built the four enormous arches and as they started to round off the dome, they would set up to twelve bricks,[213] and between each twelve the priests made a prayer for the establishment of the church. Every twelve bricks the builders made a hole and they inserted in the holes sacred relics of different saints; [this they did] until they finished the dome. Boldly, it stood straight up.

15. After they had finished the beautiful marble revetments, [the emperor] gilded the joints of the revetment, the column capitals, the panels [?][214] and the cornices of the second and third storeys. All of these he gilded with pure gold two fingers thick. And as for the entire ceiling, i.e., of the galleries and the aisles and all round, and of the four narthexes,[215] he gilded them with gleaming gold glass,[216] all the way to

211 The "sides" are presumably the aisles. The vertical wall of the apse is lit by two rows of three windows each. It is difficult to see any connection between the number of windows and the absence of centering.

212 Ps. 45(46):5.

213 Perhaps twelve courses of brick.

214 Perhaps simply "carvings." The term used is *lakariká* (variant form *lagariká*) from Lat. *laquearia*.

215 I.e., the two narthexes and, presumably, the two wings of the atrium.

216 I.e., gold mosaic.

the surrounding forecourts. The pavement of the church he decorated with various costly marbles which he polished and laid down; as for the outer sides and surrounding areas, he paved them with very big, costly slabs of white marble.

16. The holy presbytery [he made] of shining silver. The parapets and columns he sheathed entirely in silver together with their doors— all of silver plated with gold. He set up in the presbytery four silver tables on columns, and these, too, he gilded. He also gilded the seven steps on which the priests sit, together with the bishop's throne and the four silver columns erected two on each side, by the entrance to the tunnel *(eilêma)* called *kuklion,* which is underneath the steps;[217] this he called the Holy of Holies. Furthermore, he erected big silver-gilt columns together with the ciborium and the lilies. The ciborium he made of silver and niello *(arguroenkauston).* On top of the ciborium he set up a globe of pure gold weighing 118 lbs. and golden lilies weighing 4 lbs. [each], and above these a golden cross with precious and rare stones, which cross weighed 80 lbs. of gold.

17. He also adopted the following device. Wishing to make the altar table much costlier than gold, he called in many specialists and told them so. They said to him: "Let us place in a smelting-furnace gold, silver, various precious stones, pearls and mother of pearl, copper, electrum, lead, iron, tin, glass and every other metallic substance." Having ground all of these in mortars and bound them up, they poured them into the smelting-furnace. After the fire had kneaded together these [substances], the craftsmen removed them from the fire and poured them into a mould, and so the altar-table was cast, a priceless mixture. In this way he set it up, and underneath it he placed columns of pure gold with precious stones and enamels *(chumeusis);* and the stairs all round upon which the priests stand to kiss the altar-table he made of pure silver. As for the *thalassa*[218] of the altar-table, he made it of priceless stones and gilded it. Who can behold the appearance of the altar-table without being amazed? Who indeed can comprehend it as it changes color and brilliance, sometimes appearing to be gold, in other places silver, in another gleaming with sapphire—in a word, reflecting seventy-two hues according to the nature of the stones, pearls and all the metals?

18. He also made doorways below and above to the number of 365. At the first entrance [coming] from the atrium *(loutêr)* he made doorways of electrum, and in the narthex matching doors [also] of electrum. In the second narthex he made three ivory doors on the left side and three on

217 A semicircular tunnel of this kind, running underneath the synthronon, may still be seen, e.g. at St. Irene, Constantinople, and St. Nicholas at Myra.

218 A basin, probably on a stand, for the ritual ablutions of the clergy. See D.I. Pallas, *Hê 'thalassa' tôn ekklêsiôn* (Athens, 1952), Collection de l'Institut Français d'Athènes, 68.

the right, and in the middle three doorways,[219] namely two matching ones and one very big, of gilded silver, and all the doors he gilded. Inside these three doors, instead of ordinary wood, he placed wood from the Ark. . . .

21. The ambo and the *solea*[220] he made of sardonyx, and he set in the gold columns precious stones, crystal, jasper and sapphire; and he laid much gold on the upper part of the *solea*. [The ambo] had a golden dome with pearls, rubies and emeralds. The cross of the ambo weighed a hundred pounds of gold and it had pendants of rubies and pear-shaped pearls. Up above, instead of parapets, the ambo had awnings of pure gold. . . .

23. He also made golden vessels, those for the twelve feasts[221] and others, namely holy Gospel books,[222] basins, pitchers, chalices[223] and patens: all of these he made of pure gold with stones and pearls, and the number of holy vessels was one thousand; three hundred corrugated[224] gold altar-covers with precious stones and one hundred crowns[225] so that there should be different ones for each feast day; one thousand chalice-covers and paten-covers, all of gold with pearls and priceless stones; twenty-four Gospel books, each weighing two *kentênaria*;[226] thirty-six golden censers with [precious] stones, two hundred golden lamps each weighing 40 lbs., six thousand golden *polykandêla* and lamps in the form of a vine *(botrudia)* for the narthex, the ambo, the bema and the two women's galleries. . . .

24. He made five crosses of gold, each weighing one *kentênarion*, and decorated them with various costly stones so that they are valued eight *kentênaria* each; two golden *manualia*[227] with [precious] stones and huge pearls which have been valued at five *kentênaria* of gold; two other very large *manualia* of carved crystal having feet of pure gold, each worth one *kentênarion* of gold. He also made four golden candle-sticks *(phatlia)* with [precious] stones, each worth one *kentênarion*, to

[219] The Greek text is corrupt at this point. I have followed Preger's emendation: see apparatus on p. 96 of his ed.

[220] See p. 95 and n. 198.

[221] The codification of the Twelve Feasts is generally regarded to have achieved a canonical form at a relatively late date (11th/12th century). They are enumerated as follows by John of Euchaita (11th century): Annunciation, Nativity, Circumcision, Presentation in the Temple, Baptism, Transfiguration, Raising of Lazarus, Entry into Jerusalem, Crucifixion, Resurrection, Ascension, Pentecost.

[222] The mention of Gospel books appears to be out of place here.

[223] *Diskopotêria*, i.e., sets of chalice and paten.

[224] *Endutai sôlênôtai*. This kind of decoration consisted in tubular striations encased in gold thread. The corresponding Latin term was *vestis rugata*. Cf. p. 156.

[225] These were "votive" crowns for suspension.

[226] The indication of weight is certainly excessive.

[227] Candlestands or lampstands *(candelabrum manuale)*.

be placed upon the golden and crystal *manualia;* another fifty large *manualia* of silver and two hundred of a man's height, also of silver, to stand in the choir.

25. Upon the ambo he expended a year's taxes received from Egypt alone, i.e., 365 *kentênaria;* this is what he expended on the ambo and the *solea.* . . . The entire church, together with its outer surroundings, but without the holy vessels, other furnishings and donations made from all parts of the Empire, represents all together an outlay of 3200 *kentênaria* of minted gold.

26. Justinian alone began the church and he alone finished it with no help from anyone else with regard to building. Wonderful to behold were the beauty and variety of the church, for all around it shone with gold and silver. And the floor, too, made visitors marvel for it appeared like the sea or the flowing waters of a river thanks to the great variety of its marble. The four strips *(phinai)*[228] of the church he called the Four Rivers that flow out of paradise, and he decreed that persons excommunicated for their sins should stand upon them, one by one. In the atrium *(phialê)* he made twelve conduits and stone lions that spouted water for the ablutions of the common people. On the right-hand side of the right women's gallery *(gunaikitês)*[229] he made a pool *(thalassa)* in which water collected to the depth of one span, and a gangway for the priests to walk over the pool. Facing the pool he set up a cistern of rain water, and he carved twelve lions, twelve leopards, twelve deer, twelve eagles, twelve hares, twelve calves and twelve crows, out of whose throats water flowed by means of a mechanism for the ablution of the priests alone. He called this place Leontarion. There, too, he constructed the *mêtatorion,*[230] a beautiful chamber covered with gold, so that he might rest there whenever he went to the church. Who can relate the excessive beauty of this church, sheathed in gold and silver from floor to ceiling?

27. Having completed the church and the holy offerings, on the 22nd of December, he came out of the palace in procession, sitting on a chariot drawn by four horses. . . .

28. The dome that was boldly built by Justinian, the precious and glorious ambo worthy of all admiration, the *solea* and the variegated floor of the church lasted seventeen years. After Justinian's death, his nephew Justin became ruler, and in the second year of his reign, on a Thursday, in the sixth hour of the day, the dome fell down[231] and

228 Referring presumably to strips of marble in the pavement. The term *phina* (Lat. *finis*) denoted any kind of boundary, such as the finishing line in the Hippodrome of Constantinople.

229 This must refer to the south aisle.

230 The emperor's changing-room *(mutatorium)* situated in the easternmost bay of the south aisle.

231 In fact, the dome collapsed on 7 May, 558, while Justinian was still emperor.

crushed the wonderful ambo and the *solea* with all their sardonyx, sapphires, mother of pearl, pearls, the gold and crystal parapets, the silver columns and the precious pavement. The four arches, however, the columns and the remaining structure stood unshaken. The emperor called in the engineer who had labored there and who was still alive and asked him what had happened to cause the destruction of the dome. He replied: "Your uncle was too hasty in removing the wooden supports that were in the dome so as to cover it quickly with mosaic, and he made it [too] high so as to be seen from everywhere. Also, when the workmen cut down the scaffolding they threw down [the timbers] and from their weight the foundations were shattered, and so the dome fell down." The men of the craft spoke to the emperor and told him this: "If you wish, O Lord, that the dome be made flat like a cymbal, send emissaries to the island of Rhodes, as your uncle did, and let them bring bricks of the original size, made of the same clay and bearing the same stamp." The emperor so ordered, and they brought the bricks from Rhodes as they had done before. In this manner the dome was vaulted. They reduced its former height by five fathom[232] and made it in the shape of a drum. Fearing lest it fall down again in a short time, they left the timbers and the supports in place for a year until they were satisfied that the dome had set. As for the ambo and the *solea*, he was unable to make them as lavish and precious [as before], and so he made the ambo cheaply out of stones and columns covered with silver, parapets, curtains and surrounds (*peripherion*) also of silver, and he did the same for the *solea*. He did not wish to make a cupola for the ambo because of the great expense, as he said. For the floor he was unable to find slabs of such great size and variety, and so he sent Manasses, patrician and praepositus, to Proconnesus to cut slabs that would denote the earth, while the green ones signify the rivers that flow into the sea.

29. When they cut down the scaffolding of the dome and were about to take the timbers down, they filled the church with water to a depth of five cubits and threw the timbers down and these floated in the water[233] and did not shatter the foundations. In this manner the church was completed: wherefore some people say that Justin built it, but this is untrue.

The Church of the Holy Apostles at Constantinople

Procopius, De aedif. I, iv, 9 ff: There was from olden times a church at Byzantium dedicated to all the apostles, but already it had been shaken

[232] In fact, the dome was heightened by more than 20 ft. Cf. p. 79.
[233] Meaning of Greek text uncertain.

by the lapse of time and was not expected to stand much longer. The emperor Justinian demolished it entirely, being eager not merely to restore it, but to make it more remarkable with regard to size and beauty. He carried out his intention in the following manner. Two straight arms were made, intersecting each other in the middle after the fashion of a cross, the longitudinal one running east and west, while the transverse one was turned to north and south. These were fenced in all round by walls, while on the inside they were bordered by columns that stood both on the ground and the upper [floor]. At the junction of the two straight arms, i.e., at their very center, a place has been consecrated that is inaccessible to those who do not perform the mysteries: this is fittingly called the sanctuary (*hierateion*). The transverse arms on either side of the sanctuary are equal to each other, while on the longitudinal axis the western one is that much longer than the other as to form the shape of a cross. The part of the roof that is above the sanctuary, as it is called, has been made to resemble that of the church of Sophia—at any rate, as regards the middle—except that it happens to be smaller than the latter. The arches, four in number, are suspended and bound together in the same manner [as in St. Sophia]; likewise, the circular ring (*to kukloteres*) that rests upon them is divided by windows, and the dome that curves above seems to be somehow hovering in the air and not standing on solid masonry, although it is perfectly secure. The central part of the roof is therefore constructed in this fashion; and as for the arms which, as I have said, are four in number, their roof[234] is of the same dimensions as the one in the middle, but lacks this one feature, namely that underneath the circular curvature the masonry is not pierced by windows.

The Church of the Virgin of the Pêgê[235]

De sacris aedibus Deiparae ad Fontem, ASS Nov. III, 879: *Justinian was allegedly healed from a disease of the kidneys by drinking the water of a fountain known simply as Pêgê (modern Balīklī) outside the walls of Constantinople.* In gratitude to his Benefactress [the Virgin Mary] and in repayment of his debt he erected from the foundations this great church in the name of Our Lady, which he cleverly compacted by means of only four arches and wrought it in a circle so that it seemed to hang in the air—a smaller dome on earth similar to the greater one of heaven. [This church] having suffered through [the passage of] time and fallen down was restored by the Emperor Basil [I].

234 I.e., each arm of the cross was surmounted by a dome equal in diameter to the central one, but lacking windows.
235 Cf. Procopius, *De aedif.*, I, iii, 6.

The Church of the Virgin Katapolianê in Paros[236]

Nicetas Magister, *Vita S. Theoctistae Lesbiae*, ch. 3 f., ASS Nov. IV, 226. *The author, who took part in the Byzantine expedition against Arab-occupied Crete in 911, describes a visit he paid en route to the island of Paros.*[237] . . . We sailed to Paros so as to explore, by the way, the territory of the island and to behold the church of Our Lady, the Mother of God, that is there. . . . This was quite admirable, preserving, as it did, the remnants of its ancient beauty. It was built symmetrically, supported all round by means of numerous columns of imperial marble (*basilikos lithos*),[238] and having all its walls reveted with sawn marble of the same kind as that of the columns. So delicately did the craftsman finish the stone, that the wall seemed to be clothed with purple fabric, while the glitter of the stone exhibited such liquid refulgence as to surpass the brilliance of pearls. . . . 4. When we beheld, inside the door, the ciborium (*orophion*) that surmounted the holy table, we were amazed by its beauty. This piece of carving did not seem to be made of stone or to have been artfully cut by manual labor and iron [tools], but to have been, as it were, kneaded out of fresh milk and poured into the shape of a roof. I had once seen this kind of stone in [a statue of] Selênê driving a chariot drawn by oxen. The ciborium had been broken, and lay in pieces. . . .

The author goes on to relate (p. 227) that an Arab admiral called Nisiris (Nasir) had attempted to remove the ciborium to Crete. He assured himself by measurement that it would go through the door of the church, but when he tried to take it out, it kept expanding. Unable to get the ciborium through the door, the Arab was filled with anger and broke it to pieces.

Ravenna

Agnellus XXIV, *De Ecclesio* cc. 57, 59: In his [Ecclesius's] time the church of the blessed martyr Vitalis was founded by Julianus Argentarius[239] together with the bishop himself. . . . As I have said above, the

236 This church, which is still extant, appears to date from about the middle of the sixth century. See H. H. Jewell and F. W. Hasluck, *The Church of Our Lady of the Hundred Gates . . . in Paros* (London, 1920).

237 On the historical circumstances see A. A. Vasiliev, *Byzance et les Arabes*, II. pt. 1 (Brussels, 1968), 208 f. Cf. also H. Delehaye, "La Vie de sainte Théoctiste de Lesbos," *Byzantion*, I (1924), 191 ff.

238 The author is evidently referring to porphyry. The present columns of the church are, however, described by Jewell and Hasluck, p. 35, as being of cipollino marble.

239 A banker, as shown by his appellation, he took part in the erection of four other churches at Ravenna and Classis. He is believed to be represented in the apse of S. Vitale between Justinian and bishop Maximian. It is generally held that S. Vitale was founded in 526 and dedicated in 548.

church of the blessed martyr Vitalis was built in his time by Julianus Argentarius. No other church in Italy resembles it with regard to construction and architectural design (*in mechanicis operibus*). As we have found in the laudation recording the holy memory of the founder Julianus,[240] 26,000 gold solidi were expended for the aforementioned church of the martyr Vitalis. When this most-blessed man [Julianus] died, he was buried in the church of the blessed martyr Vitalis, below the *monasterium* of St. Nazarius,[241] in front of the altar. . . .

Agnellus XXVI, *De Victore* c. 66: He [Victor] also made a silver ciborium of wonderful workmanship above the altar of the holy Ursiana church, so named after the person who built it.[242] Some say that he did this in conjunction with the people, while others say that the orthodox emperor Justinian, the elder,[243] acting on a suggestion, decided that he should do such a work and offered his help. Moved by charity, he bestowed upon the blessed Victor the entire tax-revenue of Italy for one year.[244] When he [Victor] had received this, he removed the old wooden ciborium and made the one you see now, constructed of 2,000 lbs. of silver, accurately weighed. Upon the arches of the ciborium are written the following verses: "This vow Victor the priest together with his flock absolved unto Christ; Victor who by his love increased the faith of the people" From the remainder[245] he made various vessels for the bishop's table, some of which remain to the present day. He also made for the altar of the holy Ursiana church a cloth (*endothim*)[246] of pure gold and silken thread, very heavy, having a shell (*cocca*) in the center. Among the five images that are on it we recognised his own, while under the representation of the Saviour's feet the following inscription is woven in purple: "Victor the bishop, servant of God, offered this adornment for the day of the Resurrection of Our Lord Jesus Christ, in the fifth year of his ordination."[247]

Agnellus XXVII, *De Maximiano* cc. 72–73: He [Maximian] built here, at Ravenna, a church of the blessed Stephen, levite and martyr, not far from the postern of Ovilio;[248] [he built it] from the foundations, wonderfully big, and decorated it most beautifully. In the vault of the tribune

240 I.e., presumably, his epitaph.

241 This *monasterium* has been identified with the prothesis of S. Vitale.

242 The basilica Ursiana was the cathedral of Ravenna. It was part of a great complex built by bishop Ursus (late fourth or early fifth century) of which only the Orthodox Baptistery remains today.

243 To distinguish him from Justinian II.

244 This is obviously a legendary element.

245 I.e., with the remainder of the money given by Justinian.

246 From the Greek *endutē*.

247 Rasponi, in his ed. of Agnellus, p. 185, argues that this altarcloth was dedicated on Easter Day (April 5) 543.

248 Close to S. Vitale.

is set up his own portrait made of variegated mosaic cubes, and all round
there is wonderful glass decoration.[249] He deposited there relics of many
saints' bodies whose names you will find written down as follows:[250] "In
honor of the holy and most-blessed first martyr Stephen and with his
help, the bishop Maximian, slave of Christ, built this basilica from the
foundations and dedicated it on the third day before the Ides of Decem-
ber, indiction XIV, the ninth year after the consulship of Basilius the
younger."[251] He joined to the sides of this basilica small *monas-
teria*,[252] all of which shine wonderfully with new gilded mosaic cubes
and others of different colors, set in plaster. On the capitals of all the
columns is carved Maximian's name.[253] In the *monasterium* which is on
the men's side[254] you will find six letters of inlaid stone (*lithostratas*).
The ignorant interpret them incorrectly, while the learned understand
that what is written there is MU.SI.VA.[255]

73. Some people claim that on a given day the bishop summoned
the *archiergates*, i.e., the chief foreman, and asked him why he was not
completing the structure of the said church. The man replied "While
you, my Lord, were travelling in the parts of Constantinople, the mortar
and bricks gave out, nor do we have enough stones that we may continue
working." On the bishop's order so much material was brought together
in one night, namely lime and tiles, stones and bricks (*bisales*), marbles
and timber, columns, slabs and sand—all of this, as I have said, was made
ready by the carriers in one night—that they could hardly make use of it
all in eleven months.[256]

Agnellus XXVII, *De Maximiano* c. 80: He [Maximian] made two
vessels for chrism, one of which was wonderfully carved and weighed
fourteen pounds, but it recently perished, before the time of the arch-
bishop Petronacius,[257] the other, which is beautifully worked, exists to
this day and upon it is written: "The archbishop Maximian, slave of
Christ, made this chrismatory for the use of the faithful."

He also ordered to be made a precious purple altarcloth (*endo-
thim*), the like of which we have never been able to see elsewhere; it is of

249 I.e., mosaic.
250 The saints' names are not actually contained in the inscription.
Agnellus lists them further down, in a passage we have omitted.
251 The date is December 11, 550.
252 I.e., chapels.
253 Presumably in the form of a monogram as are the names of Julianus
and bishop Victor on the impost blocks of the capitals of St. Vitale.
254 I.e., on the right hand side of the church.
255 This sentence is not very clear. Agnellus may have seen a fragmentary
inscription recording the setting up of the mosaic decoration.
256 St. Stephen's was built in eleven months as stated in the dedicatory
inscription reproduced by Agnellus, c. 72. The rest of the story about the chief
foreman is clearly legendary.
257 Bishop of Ravenna from some time before 819 until after 827.

needlework and contains the whole story of Our Lord. On the holy day of Epiphany it is placed on the altar of the Ursiana church. However, he did not complete it; one part of it was finished by his successor.[258] Who has ever seen anything like it? The images, the birds and beasts that are represented on it can be described only [by saying] that they are alive in the flesh. The portrait of Maximian himself is beautifully made in two places: one is bigger and the other smaller, but there is no other difference between the two. By the smaller one is an inscription conceived like this: "Glorify the Lord with me that He has raised me from the dung." He made another altarcloth of gold on which he ordered to be woven in gold [the images of] all his predecessors. He made a third one and a fourth one with pearls on which is written: "Spare Thy people, O Lord, and remember me, the sinner, whom Thou didst raise from the dung in Thy reign."

He also ordered to be made a great gold cross which he adorned with very precious gems and pearls, namely aquamarine, amethyst, carnelian and emerald, and beneath the gold, at the center of the cross, he hid a particle from the wood of our holy Cross of redemption upon which the Lord's body did hang. The weight of the gold is very considerable.

Agnellus XXVIII, *De Agnello* cc. 86, 88: This most-blessed man [Agnellus], therefore, re-united[259] all the churches of the Goths, i.e., those that had been built at the time of the Goths and [in particular] by king Theoderic, and which were held by the perfidious Arians. . . . The most-blessed bishop Agnellus re-united the church of St. Martin the Confessor[260] in this city, which church had been founded by king Theoderic and is called the Golden Heaven. He decorated the tribunal and both walls with mosaic images of martyrs and virgins walking in procession. He also affixed panels of stucco (*metala gipsea*) which he covered with gold, and he reveted the walls with different kinds of marble and made a wonderful pavement of inlaid stone (*lithostratis*). If you look at the inside of the front wall, you will find portraits of Justinian Augustus and bishop Agnellus decorated with golden mosaic cubes.[261] No other church or building is like this one with regard to ceiling panels (*laquearia*) and beams. After he had consecrated the church, he gave a banquet at the Confessor's episcopal palace.[262] Now, if you look carefully in the tribunal, you will find above the windows the following inscription in stone letters: "King Theoderic built this church from the foundations in the name of Our Lord Jesus Christ." . . . 88. This, too, you may see on the

258 See p. 108.
259 I.e., annexed.
260 S. Apollinare Nuovo.
261 Of this composition only the bust of Justinian remains.
262 I.e., at the palace attached to the church of St. Martin.

wall. As I have said,[263] two cities are represented there. On the men's side, the martyrs are proceeding out of Ravenna and going towards Christ, while the virgins are proceeding out of Classis towards the holy Virgin, and in front of them walk the Magi offering gifts. Why is it, however, that they are depicted in different garments, and not all in the same kind? Because the painter has followed divine Scripture. Now, Caspar is offering gold and wears a blue (*iacintino*) garment,[264] and by his garment he denotes matrimony. Balthasar is offering frankincense and wears a yellow garment, and by his garment he denotes virginity. Melchior is offering myrrh and wears a variegated garment, and by his garment he denotes penitence. He who was before all time is dressed in a purple robe and by this He signifies that He was born a King and that He suffered. The one who is offering a gift to the newborn in a variegated robe signifies at the same time that Christ heals all those that are sick, and that He is to be flagellated by the Jews with various insults and lashes. For it is written of Him: "He hath borne our infirmities and carried our sorrows, yet we did esteem Him as if he were a leper," etc. And further down: "He was wounded for our transgressions and affixed for our iniquities."[265] He who makes his offering in a white garment[266] signifies that after the resurrection he will dwell in divine light. Just as these three precious gifts contain a divine mystery, i.e. that by gold is meant kingly wealth, by frankincense the priestly form, by myrrh death, so by all of these it is shown that He is the one who has taken men's iniquities upon Himself, namely Christ; thus also, as I have said, these three gifts are contained in their garments. Why is it that just three came from the East, and not four, or six, or two? That they may signify the perfect plenitude of the entire Trinity.

On account of his love for them, the most blessed Agnellus adorned with the story of the Magi that part of the purple altar cloth, mentioned above, which his predecessor Maximian had not completed. His portrait, of marvellous needlework is inserted there (*mechanico opere aculis inserta est*).

Secular Buildings at Constantinople

Procopius, *De aedif.* I, x, 5 ff: There is in front of the Palace a square bordered by colonnades which the people of Byzantium call Augustaion. . . . To the east of this square stands the Senate House, a work of

263 In fact, Agnellus had not previously referred to the two cities.
264 Caspar's cloak is actually purple, Melchior's green with yellow highlights, and Balthasar's white with black spots.
265 Isaiah 53:4–5 slightly paraphrased.
266 This sentence does not refer to the Magi. It is either of general applicability or refers to the processions of martyrs in the same church.

the emperor Justinian surpassing description by reason of the magnific-
ence of its entire construction. . . . Six columns stand in front of it, two of
which have between them the wall of the Senate House that faces west,
while the other four are set slightly forward; all of them are white in
appearance, while as regards size, they are, I believe, the biggest columns
in the whole world. The columns form a portico (*stoa*), the roof of which
curves into a vault (*tholos*), while the whole upper part of the portico is
decorated with beautiful marble of the same kind as the columns and is
wonderfully set off by a multitude of statues that stand above it.

Not far from this square is the residence of the Emperor. Nearly
the whole Palace has been constructed anew by the Emperor Justinian,
but it is impossible to describe it in words. . . . We know the lion by his
claw, as the proverb has it; so also will my readers know the impressive-
ness of the Palace from its vestibule. This vestibule, then, which is called
Chalkê [the Bronze Gate], is of the following kind. Four straight walls,
as high as heaven, are set in a rectangle, and they are in all respects
similar to one another, except that the two facing south and north,
respectively, are slightly shorter than the others. Near each corner there
projects an eminence[267] of carefully worked stones, rising together with
the wall from the ground to the top, and while being four-sided, it is
joined to the wall on one of its sides; far from breaking up the beautiful
space, it adds a kind of adornment thanks to the harmony of similar
proportions. Above these [elements] rise eight arches, four of them sus-
taining the central part of the roof which curves into the form of a
suspended cupola, while the others, two to the south and two to the
north, lean onto the adjoining walls and lift up the vaulted roof (*tholos*)
that hangs between them. The entire ceiling prides itself on its pictures,
affixed here not by means of wax poured on in melted form,[268] but com-
posed of tiny mosaic cubes adorned with various colors. These simulate
all kinds of subjects including human figures. I shall now describe the
nature of these pictures. On either side are war and battle, and numerous
cities are being captured, some in Italy, others in Libya. The Emperor is
victorious through his lieutenant, the general Belisarius, who returns to
the Emperor, his whole army intact, and offers him booty, namely kings
and kingdoms and all other things that are prized by men. In the center
stand the Emperor and the Empress Theodora, both seeming to rejoice
as they celebrate their victory over the kings of the Vandals and the
Goths,[269] who approach them as captives of war being led into bondage.
They are surrounded by the Roman Senate, one and all in festive mood.

267 I.e., a pilaster.
268 I.e., encaustic painting.
269 Gelimer, king of the Vandals was brought captive to Constantinople in
534, Witigis, king of the Goths, in 540. The latter date provides a *terminus post
quem* for the decoration of the Chalkê. The Empress Theodora died in 548.

This is indicated by the mosaic cubes which on their faces take on a joyful bloom. So they smile proudly as they offer the Emperor divine honors because of the magnitude of his achievements. The whole interior up to the mosaic of the ceiling is reveted with beautiful marbles, not only the upright surfaces, but the entire floor as well. Some of these marbles are Spartan stone resembling emerald,[270] others imitate the flame of fire. Most of them, however, are white in color, not plain, but having at intervals a tracery of wavy blue lines.[271]

Justinian's Pillar and Equestrian Statue

Procopius, *De aedif*. I, ii, 1 ff: In front of the Senate House there happened to be a public square; this square the people of Byzantium call Augustaion. Here seven courses of stone are laid in a square, all joined together in sequence, but each course receding and falling short with regard to the one beneath it in such a way that each stone set in a projecting position becomes a step and the people who gather there can sit upon them as on seats. At the top of the stones there rises a pillar of extraordinary height, not all of one piece, but composed of large blocks in circular courses, cut at an angle on their inner faces and joined to one another by the skill of the masons.[272] Finest bronze, cast into panels and wreaths, encompasses the stones on all sides, both binding them securely together and covering them with adornment, and simulating the form of a column nearly throughout, but especially at the top and base.[273] This bronze is in color softer than pure gold, while in value it does not fall much short an equal weight of silver. At the summit of the column stands a huge bronze horse turned towards the east, a most noteworthy sight. He seems to be about to advance and to be vigorously pressing forward. Indeed, he lifts up his left front foot as if about to step on the ground before him, while the other is planted on the stone above which he stands as though to take the next step. The hind feet he draws together so as to have them in readiness when it is time to set them in motion. Upon this horse is mounted a bronze image of the Emperor like a colossus. And the image is clad like Achilles, for that is how they call the costume he wears.[274] He is shod in ankle-boots and has no greaves on his legs. Furthermore, he wears a cuirass in heroic fashion and his head is

[270] The same as Lacedaemonian marble, on which see p. 63, and n. 43.

[271] Proconnesian marble.

[272] The shaft appears to have been actually made of brick (cf. p. 111).

[273] The wording is rather unclear. Procopius is probably trying to say that the bronze revetment made the pillar appear monolithic (which it was not), and that is covered both the base and the capital.

[274] Cf. G. Downey, "Justinian as Achilles," *Trans. Amer. Philol. Assoc.*, LXXI (1940), 68–77.

covered with a helmet which gives the impression of swaying,[275] and a kind of radiance flashes forth from there. One might say in poetic style that this was the Autumn star.[276] He gazes towards the rising sun, steering his course, I suppose, against the Persians. In his left hand he holds a globe, by which the sculptor has signified that the whole earth and sea were subject to him, yet he carries neither sword nor spear nor any other weapon, but a cross surmounts his globe, by virtue of which alone he has won the kingship and victory in war. Stretching forth his right hand towards the regions of the East and spreading out his fingers, he commands the barbarians that dwell there to remain at home and not to advance any further.

Georg. Pachymeres, *Ekphrasis of the Augusteôn*:[277] From ancient times this holy temple [St. Sophia] has had a courtyard fenced in by public buildings, in the midst of which stands the Augusteôn, i.e. the statue of Justinian Augustus, set up in his honor soon after he had returned from his Persian toils. A foundation supports the column from the ground, and this foundation consists of stairs numbering seven steps of white marble, wider at the base and tapering towards the top (the three lowest steps are buried under the earth; so times have changed). These steps are not on one side only, but on all [four] sides, on a square plan, so that one may mount them from any direction. One then reaches a platform, altogether level except that a structure of baked brick and mortar is set upon it. This is contained between four columns placed at the equal angles [of the pedestal] as well as columns placed opposite, as many as there are to be seen. A surface contexture of marble slabs covers the brick within, as may be observed in one spot where, by the effect of time, a slab has been lost. This structure is fashioned in the shape of a cube, four of whose six sides are adorned with arcades, one on each side. Above this is another base of white marble, and a second, and a third, and on top of them a fourth zone of marble: the first three taper in width, while the superimposed zone is curved and so provides a suitable base for the shaft. At this point is placed the shaft which, in olden times, as we are told, was covered with variegated Temesian copper,[278] and if we are to believe our author,[279] this copper was not much inferior to silver [in value]. Today, however, the shaft appears quite bare so that one may count the number of stones it is composed of, and observe that they are of the fire-resisting kind,[280] and how they are fitted together. It also has,

[275] The swaying effect was due, of course, to the plumes on the helmet.
[276] *Iliad,* V, 5.
[277] Ed. along with Nicephorus Gregoras, CSHB, II, 1217 ff.
[278] A reference to *Odyssey,* I, 184.
[279] Procopius, *De aedif.,* I, ii, 4.
[280] I.e., brick. By an excess of pedantry, Pachymeres refers to baked brick as "fire-fighting stone."

like a reed, zones of the same white stone—as many as ten of them, spaced at equal intervals,[281] From there on are further zones of white marble, but these are consecutive, a second on the first, and a third on the second, and so forth to the number of nine; these are not of the same size, but fan out so as to provide a wide base for that which lies upon them, namely a tenth course so that this part, too, should not fall short of the perfection of number. This [course of] stone is square in form, but it sags in the middle, with the result that its lines break, and the breaks are marked with stones, which stones (and these alone) are completely covered with brass all round. At this point the architect has contracted the structure and placed a thick stone and upon it another one which is narrower still, but affords a sufficient base for the steed. Indeed, the column required not only width for the safety of its load, but also narrowness so that the work of art that is placed upon it should be all the more conspicuous. This work of art is a brass steed of admirable form: it deserves not to be missed by the public, even if one happens to pass by several times a day. As you behold this steed, you imagine it to be striving to run against the wind in an easterly direction: for so is the head lifted up and slightly inclined towards the north; so are the mane and the other hairs that grow on the head ruffled, instead of being well combed, as they play in the wind. If at the same time you observe the left front leg, which is bent at the knee and held aloft, while the others are planted in the ground, you may be tempted to say that even inanimate objects can move. Granted also that the steed had a bit in its mouth (which a careful observer would infer it to have had in olden times), one of two explanations may be assumed: either that being pressed by the rein and constrained it was stamping its front foot, or that it was being let go and was hastening its trot so that the front foot did not touch the ground while the rear ones did. The flanks of the animal, as shown by their swelling, are expanded by a vital breath suited for swift motion. And as for the luxuriant tail, it does not droop as normally, but first it rises and then falls to the ground close to the [rear] legs. Observe now the rider who has the appearance of a swift horseman and who sits astride [his mount]. Even if he is wearing buskins, you may suppose that on his proud steed he would be capable of running the race he wanted without spur or goad; and so casually is he holding his legs that they seem to be supported by themselves, thanks to his vital force, instead of being upheld by stirrups, as is usual. Bravely then does he sit on his mount, a youthful rider high up in the air, and he seems to be gazing into the distance: a man not inclined to hirsuteness as regards the beard and having his hair cut over his forehead and, in the back, not even

281 I.e., the shaft was made of brick except that single courses of white stone were let in at fairly wide intervals. This is a form of construction typical of Justinian's period at Constantinople.

reaching down to his neck, so that he appears to be taking pleasure in the cropping of hair.[282] How strange, too, is the helmet[283] on his head which does not cover anything, but only adorns the wearer! For it does not lie in width,[284] nor is it fashioned in a circle, but, where it touches the head, it appears to be a diadem, evenly surrounding the temples and the brow; from here upwards it gradually extends in width and reaches to a great [height] assuming the shape of golden feathers for the head. This object had lasted intact to my own times; once, however, there blew a wind of extraordinary violence so that two of the feathers fell down and these appeared to be very much larger than they are seen [from the ground] adorning [the statue's] head. These [two feathers] are preserved to this very day in the treasury of the Church. The rider is not clothed with any superfluous undergarments but with such that might be worn by a properly equipped horseman, namely, with regard to the upper part, terminating at the elbow, and, with regard to the lower part, at the knees. Over this is fastened a cloak, a garment that is called Achillean;[285] which covers part of his body, is thrown over his left shoulder and reaches down to the horse's loins, where it envelops a good portion of the rear and falls down loose. The statue's hands are not occupied with the horse, not even with steering it, as horsemen do; but the right hand he holds upraised in a martial and courageous spirit as if he were severely threatening the enemy, except that this is not indicative of folly or senseless rashness. For the left hand removes such a grievous interpretation and justifies the man sufficiently. Indeed, he holds in it, at a short distance from his body, a gilded orb of brass upon which stands a cross made of the same material, and he seems to be showing—he who has stretched out his other arm in a threatening gesture—what it is that he trusts in as he is threatening: for the orb represents the world and it is by the power of the cross that he, the master of the whole earth, has been emboldened to grasp it.

Religious Painting

When the inhabitants of Apamea in Syria heard of the destruction of Antioch by the Persians in 540, they implored their bishop, Thomas, to exhibit publicly their most venerated relic, a particle of the True Cross.

[282] Byzantine men wore beards and long hair. Judging by numismatic portraits, the last emperor to have shaved his beard according to Roman usage was Maurice (582–602).

[283] Procopius, whose text Pachymeres had before him, had described the statue's headdress as a helmet (*kranos*). Originally, it most probably was a helmet with a diadem at the base and a tuft of peacock feathers at the top. In the 9th century, however, the helmet fell down and was incompetently patched up, with the result that the *calotte* seems to have been discarded.

[284] I.e., it does not have a broad brim.

[285] The same term is used by Procopius, *De aedif.*, I, ii, 7 (see above, p. 110).

Thomas did so, and as he carried the relic through the church, a miraculous flame followed him. This was interpreted as presaging the preservation of the city from the Persians.

A Fresco at Apamea

Evagrius, *Hist. eccl.* IV, 26: An image [of the miracle] was set up in the ceiling of the church to make known these events by means of painting to those who were ignorant of them. This remained until the Persian invasion of Adaarmanes, when it was burnt together with God's holy church and the whole city.[286]

The date of the mosaic at Bethlehem is unknown. Its attribution to the Empress Helena is certainly false; it may have been made in connection with the restoration of the basilica of the Nativity by Justinian.[287]

A Mosaic at Bethlehem

***Epist. synod. patr. Orient.* VII, 8:**[288] Indeed, the blessed Helena ... erected the great church of the Mother of God at the holy and glorious [town of] Bethlehem, and on its outer western wall she depicted in mosaic the holy Nativity of Christ, with the Mother of God holding the lifegiving Infant on her bosom and the adoration of the gift-bearing Magi. When the godless Persians devastated all the cities of Romania[289] and Syria, and burnt to ashes the holy city of Jerusalem[290] ... they came to the holy town of Bethlehem, and when they beheld the images of their fellow countrymen, i.e., of the Persian Magi versed in astronomy, they respected the persons represented as if they were alive, and out of reverence and love towards their ancestors, left the great church unharmed and free of any damage. . . .

The Camuliana Image of Christ

***Eccles. Hist.* known as that of Zacharias Rhetor, XII, 4:**[291] And she said to him,[292] "How can I worship Him, when He is not visible and I do not know Him?" And after this one day, while she was in her garden ... in

[286] In 573.
[287] Cf. H. Vincent and F.-M. Abel, *Bethléem* (Paris, 1914), p. 127.
[288] Ed. Duchesne, p. 283.
[289] I.e., the Byzantine Empire.
[290] In 614.
[291] Reproduced with a few changes from *The Syriac Chronicle Known as that of Zachariah of Mitylene,* trans. F. J. Hamilton and E. W. Brooks (London, 1899), pp. 320 f.
[292] The beginning of the chapter is lost.

a fountain of water which was in the garden she saw a picture of Jesus our Lord, painted on a linen cloth, and it was in the water. And on taking it out she was surprised that it was not wet. And, to show her veneration for it, she concealed it in the head-veil which she was wearing, and brought it and showed it to the man who was instructing her; and on the head-veil also was imprinted an exact copy of the picture which came out of the water. And one picture came to Caesarea[293] some time after our Lord's passion, and the other picture was kept in the village of Camulia,[294] and a temple was built in honor of it by Hypatia who became a Christian. But some time afterwards another woman from the village of Diyabudin[295] ... in the jurisdiction of Amaseia, when she learned these things, was moved with zeal, and somehow or other brought one copy of the picture from Camulia to her own village; and in that country men call it *acheiropoiêtos*, i.e., "not made by hand." And she, too, built a temple in honor of it. . . . In the 27th year of the reign of Justinian, indiction III,[296] a marauding band of barbarians came to the village of Diyabudin, and burnt it and the temple. . . . And certain earnest men, natives of the country, informed the serene Emperor of these things, and begged him to give a contribution. . . . But one of the men attached to the Emperor's person in the palace advised him to have the picture of the Lord carried on a circular progress through the cities by these priests, and a sum of money sufficient for the building of the temple and the village collected. And from indiction III until indiction IX[297] they have been conveying it about.

Other Images

***Anthol. graeca* I, 34 (by Agathias):** On an image of the archangel Michael at Platê:[298] The wax, greatly daring, has represented the invisible, the incorporeal chief of the angels in the semblance of his form. Yet it was no thankless [task] since the mortal man who beholds the image directs his mind to a higher contemplation. His veneration is no longer distracted: engraving within himself the [archangel's] traits, he trembles as if he were in the latter's presence. The eyes encourage deep thoughts, and art is able by means of colors to ferry over [to its object] the prayer of the mind.

[293] In Cappadocia.

[294] Also known as Camuliana, northwest of Caesarea. The famous image was brought to Constantinople in 574.

[295] Perhaps Dioboulion, a village in the province of Pontus. See E. von Dobschütz, *Christusbilder*, Texte und Untersuchungen, N.F., III (1899), 5**, no. 8.

[296] 554/5.

[297] I.e., until 560/1.

[298] A quarter of Constantinople rather than the small island, one of the Princes' Islands, bearing the same name.

Anthol. ***graeca*** **I, 35 (by Agathias):** To the same at Sosthenion:[299] Aimilianus the Carian and with him John, Rufinus of Alexandria and Agathias of Asia,[300] having been admitted, O chief of the angels, to the fourth year of juridical studies, have dedicated their painted image to thee, O blessed one, asking thee for continued success. Mayest thou sustain their hopes for their future life.

Justification of Religious Images

Hypatius of Ephesus, ***Fragment of "Miscellaneous Enquiries" addressed to his suffragan bishop Julian of Atramytion:***[301] Then you say that those who set up in sanctuaries [representations of] holy and venerable things in painting or carving alike are upsetting the Divine Tradition; that you clearly understand Scripture to forbid such a practice, and that not only does it forbid the making [of representations], but even bids us to destroy them when they are being made or are already in existence.

It is necessary to examine the reason why Scripture says such things, and to understand at the same time why it is that the moulding of sacred objects is allowed. Inasmuch as some people believed (as Holy Writ says) that "the Godhead is like unto gold and silver and stones and the tracing made by man's device;"[302] inasmuch as they invented unto themselves material gods according to their fancy and "worshipped the creature more than the creator;"[303] [for this reason] it says: "Destroy and cut down their altars and burn with fire their graven images,[304] and take good heed of your souls, for ye saw no similitude on the day that the Lord spake unto you on the mount of Horeb out of the midst of the fire, lest ye corrupt yourselves and make you a graven similitude."[305] For no existing thing is similar or equal or identical to the Trinity that is good and divine above all beings, and is the creator and cause of all beings. For "who is like unto thee, who shall be likened to thee?"[306] as we hear the divines sing.

299 I.e., to the archangel Michael, whose church at Sosthenion, on the European side of the Bosphorus, had been rebuilt by Justinian (Procopius, *De aedif.*, I, viii, 2 ff.). The epigram evidently describes a votive group portrait of the kind known to us through the mosaics of St. Demetrius at Thessalonica.

300 I.e., the Roman province of Asia in western Asia Minor. Agathias was a native of Myrina.

301 Ed. F. Diekamp, *Analecta Patristica,* Orient. Christiana Analecta, CXVII (Rome, 1938), 127–29.

302 Acts 17:29.

303 Rom. 1:25.

304 Deut. 7:5, 25.

305 Deut. 4:15, 16.

306 Ps. 70:19; 82:2 (Septuagint).

This being so, you say, "We allow venerable paintings[307] in sanctuaries, but in forbidding, as we often do, carving in wood and stone, we do not regard the latter as being free from sin, except on doors.[308]

But, O, my reverend friend, we neither confess nor set down in writing that the Divine essence (whatever it may be) is similar or identical or equal to any existing thing. And as for the inexpressible and incomprehensible love of God towards us men,[309] and the holy patterns set by the saints,[310] we ordain that these should be celebrated in sacred writings, since, for our part, we take no pleasure whatever in any sculpture or painting. However, we permit simple folk, inasmuch as they are less perfect, to learn such things in an introductory manner by means of sight, which is appropriate to their natural development, having found on many occasions that even the old and new ordinances of God[311] may be brought down to the level of the weaker for the sake of their spiritual salvation. Indeed, even the holy prophet Moses, who made the above legislation at God's prompting, set up in the Holy of Holies golden images of the Cherubim of beaten work. And in many other cases we see the divine wisdom through its salutary love of men sometimes relaxing its strictness for the sake of souls that are as yet in need of guidance....

For these reasons we, too, permit material adornment in the sanctuaries, not because God considers gold and silver, silken vestments and vessels encrusted with gems to be precious and holy, but because we allow every order of the faithful to be guided in a suitable manner and to be led up to the Godhead, inasmuch as some men are guided even by such things towards the intelligible beauty, and from the abundant light of the sanctuaries to the intelligible and immaterial light....[312]

Secular Images

Anthol. graeca, XVI, 62, 63: 62. On a statue of the Emperor Justinian in the Hippodrome:[313] O Emperor, slayer of the Medes, these gifts does Eustathius, the father and son of thy Rome,[314] bring unto thee: a

307 Or "paintings to be worshipped."

308 This paragraph is obscure, possibly because the text is corrupt.

309 Probably referring to the Incarnation of Christ.

310 Meaning doubtful.

311 I.e., the ordinances contained in the Old and New Testaments.

312 On the interpretation of this difficult text see N. H. Baynes, "The Icons before Iconoclasm," *Harvard Theological Review*, XLIV (1951), 93 ff.; P. J. Alexander, "Hypatius of Ephesus," *ibid.*, XLV (1952), 177 ff.

313 This was not the equestrian statue of the Augustaion, as several commentators of the Anthology have supposed, but one placed near the Kathisma (imperial box) of the Hippodrome. See *Parast. synt. chron.*, § 61.

314 This must mean that Eustathius, a native of Constantinople, was also Prefect of the City.

steed for thy victory, a second Victory holding a wreath,[315] and thyself
seated on this steed that is as swift as the wind. May thy might, O
Justinian, stand high, and may the defenders of the Medes and Scythians
remain forever chained to the ground.[316]

63. Another [epigram] on the same [statue]: Bronze from the
Assyrian spoils[317] has fashioned, all at once, a steed, an emperor and
Babylon destroyed. It is Justinian, and Julian, who bears the yoke of the
East,[318] has set him up as a witness to the slaying of the Medes.

Anthol. graeca I, 36 (by Agathias): On an image at Ephesus of
Theodore, *illustris,*[319] twice proconsul, on which he is represented receiv-
ing his insignia from the Archangel: Graciously deign to be represented,
O Archangel: for even if thy visage is invisible, yet this is a mortal's gift.
It is thanks to thee that Theodore has his *magister's* belt,[320] and has
twice served the Crown as proconsul. This painting is a witness of his
gratitude: by means of colors he has faithfully reproduced thy favor.

Anthol. graeca, XVI, 37 (by Leontius Scholasticus): Thou seest Peter[321]
in golden garments. The magistracies beside him *(hai de par' auton
archai)* bear witness to his successive labors: first [the Prefecture] of the
East, then the purple shell [i.e., the consulate], and, once again [the
Prefecture] of the East.[322]

Anthol. graeca, XVI, 41 (by Agathias): On an image set up in the
palace of Placidia[323] by the members of the new chancery *(skrinion)*:

315 The Emperor was probably holding a globe on which was perched a
little Victory with a wreath in her hand.

316 These may have been represented by little figures lying prostrate on
the ground (cf. p. 45). The reference to the Scythians probably has to do with
Justinian's military operations in the Caucasus area.

317 I.e., booty taken from the Persians.

318 This probably means that Julian was Praetorian Prefect of the East,
and a person of that name and rank is in fact recorded in 530/1. If this attri-
bution is correct, the statue must have been set up to commemorate Justinian's
first Persian War (527–31). A difficulty, however, remains. According to the
lêmma, epigrams 62 and 63 refer to the same monument. If this is correct, are
we to assume that Julian and Eustathius were the same person who served
successively as Prefect of Constantinople and Praetorian Prefect, or was the
statue dedicated by two officials?

319 Honorific title of the highest government officials.

320 The belt *(cingulum)* was the distinctive badge of the *magister officio-
rum*. A Theodore bearing that office is recorded in 579.

321 Peter Barsymes, honorary consul and Praetorian Prefect of the East
from 543 to 546 and from 555 to 562 or later. The poem cannot, therefore, be
earlier than 555. See A. and A. Cameron, "The *Cycle* of Agathias," *Journal of
Hellenic Studies,* LXXXVI (1966), 15.

322 It seems that Peter was flanked on this picture (whose exact nature
cannot be determined) by symbolical figures representing the magistracies he
had held.

323 A palace at Constantinople built by Galla Placidia, daughter of
Theodosius I. This was an imperial domain administered by a *curator.*

Those who serve in the new division have dedicated [a picture of] Thomas, the great Emperor's blameless Curator, close to [that of] the divine Pair,[324] so that even in his image he should have a place next to the Ruler. For he has exalted the throne of the divine palace by increasing the treasure, yet did so in a righteous manner. This work [i.e., portrait] is a token of gratitude: for what can the brush (*graphis*) offer other than the memorial that is owed to good men?

***Anthol. graeca*, XVI, 36 (by Agathias):** On an image of a professor at Pergamon set up for him on account of a civic embassy: Mayest thou forgive [that we have not erected for you] images, long overdue, for thy speeches and agile eloquence. Now, however, because of thy labors and concern on behalf of the city, we have set up this painting (*graphis*) of thee, O Heraklamôn. If the honor is too small, do not blame us: for in this manner we are wont to reward our good men.

***Anthol. graeca*, XVI, 80 (by Agathias):** I have been a courtesan in Byzantine Rome and offered my love for sale to all comers. I am crafty Callirhoe. Smitten by passion, Thomas has set up this, my portrait (*graphis*), showing all the ardor he has in his breast; for like wax is his heart melting.[325]

324 I.e., a portrait of the emperor and empress, who were either Justinian and Theodora or Justin II and Sophia.

325 The portrait must have been in encaustic. There are several other contemporary epigrams on portraits of courtesans and dancing girls, e.g., *Anthol. graeca*, XVI, 77, 78, 277, 278, 283 ff.

4

From Justinian
to Iconoclasm
(565–726)

For a few decades after Justinian's death some effort was made to continue the architectural and artistic manifestations of the central government. Justin II was an active builder; Tiberius and Maurice tried to do likewise, but, it would seem, on a smaller scale. Then, at the very beginning of the 7th century, things came to a grinding halt. The Empire was falling apart: the loss of the Balkan peninsula to the Avars and the Slavs was followed by the Persian occupation of the eastern provinces, the Avaro-Persian siege of Constantinople (626), the rise of Islam, and the permanent conquest by the Arabs of Palestine, Syria, Egypt, and the entire North African coast. Byzantium was engulfed by its Dark Ages which were to last until the beginning of the 9th century, i.e. until the Arab menace had been effectively contained. In these two hundred years of constant warfare, building activity (other than works of fortification) virtually stopped, and the complex organization that had sustained artistic production, such as the quarrying of marbles, the manufacture of mosaic cubes, the government control of silverware, appears to have been disrupted. Note the statement of Tabari (see p. 132) that when Justinian II sent a consignment of mosaic cubes to the Caliph Walid I, he had them collected from ruined cities. For the supply of materials the Empire was being obliged to live off its own wreckage—a phenomenon that persisted, to a greater or lesser extent, until the close of the Middle Ages.

In the post-Justinianic period the icon assumes an ever increasing role in popular devotion, and there is a proliferation of miracle stories connected with icons, some of them rather shocking to our eyes. We have reproduced a few examples of such stories.[1] The need for the realistic, "physical" representation of holy personages gradually drove out the last vestiges of Early Christian symbolism: the famous 82nd canon of the Quinisext Council set the seal of ecclesiastical approval on this trend by prohibiting the depiction of Christ in the guise of a lamb.

Of the mural decoration of churches during this period we cannot speak with any assurance. There is some reason to suspect, however, that the elaboration of a standard scheme, such as we find from the 9th century onward, may have started before Iconoclasm. The testimony of the Life of St. Pancratius of Taormina is indicative in this respect. The "standard scheme," consisting of a condensed biblical cycle and a selection of holy personages, was also geared to a symbolical interpretation of the various parts of the church. Attempts at such an interpretation were made, as we have seen, already in the 4th century, but they were marked by great diversity, not to say fancifulness: nor is there anything very explicit in the influential Mystagogia of St. Maximus the Confessor (d. 662).[2] But in the Historia mystagogica of Germanus, whose attribu-

[1] For a survey of the subject see E. Kitzinger, "The Cult of Images in the Age before Iconoclasm," *Dumbarton Oaks Papers* VIII (1954), 83 ff.

[2] Text in PG 91, 657 ff.

tion to the early 8th century has been confirmed by recent research,[3] we find what was to become the traditional Byzantine interpretation: the church building being not the image of the physical universe, but a paradigm of Christ's invisible Church and of His life on earth. Since theory and practice usually go hand in hand, we may assume that Germanus had before him the kind of decoration which his symbolism called for.

Justin II (565–78)

Theophanes, Chronogr. A.M. 6058, pp. 241–42: Being a pious man, he [Justin] added to the adornment of the churches that had been built by Justinian, namely, the Great Church, that of the Holy Apostles as well as other churches and monasteries, and he donated to them vessels and ample revenues.[4]

Theophanes, Chronogr. A.M. 6062–64, pp. 243 f.: In the same year [568–69] he [Justin II] began building the palace of Sophianae named after his wife Sophia,[5] on the pretext that before he had become emperor and was yet *curopalatês*,[6] his son Justus was buried in the church of the Archangel [Michael] which is there, and this he now adorned with various costly marbles. . . .

In this year [569/70] the Emperor Justin began building the Deuteron palace[7] on the estate which he had before he became emperor. And likewise another at the harbor of the island of Prinkipo,[8] which was also

3 See R. Bornert, *Les commentaires byzantins de la divine liturgie* (Paris, 1966), pp. 125 ff.

4 This passage has been taken to mean that Justin II added pictorial cycles to the churches that had been built by Justinian, but the wording is too indefinite to warrant such a specific interpretation. Cf. C. Mango, *Materials for the Study of the Mosaics of St. Sophia at Istanbul* (Washington, D.C., 1962), p. 93.

5 On the Asiatic shore of the Bosphorus. Theophanes' date is incorrect: we know from the contemporary evidence of Corippus that this palace was built not later than 566/7. See A. Cameron, "Notes on the Sophiae, the Sophianae and the Harbour of Sophia," *Byzantion*, XXXVII (1967), 11 ff.

6 Chief of the palace guard.

7 Rather than "the second palace" (*to palation to deuteron*). A section of northwest Constantinople bore the name Deuteron, and there was a palace there: Janin, *CP byzantine*, 131. This is clearly the one referred to by John of Ephesus, a contemporary source: "For having formed the idea of erecting a palace upon the site of his former dwelling in the northwestern suburb of the city, he razed a great number of houses there to the ground, and built a hippodrome, and laid out extensive gardens and pleasure grounds, which he planted with trees of all kinds; and gave orders also for the erection of two magnificent statues of brass in honour of himself and Sophia. But scarcely had they been set up, before a violent storm of wind occurred, which overturned them, and they were found deeply imbedded head foremost in the ground." (*Ecclesiastical History*, III, 24, trans. Payne Smith, 204 f.).

8 The biggest of the Princes' Islands.

his estate; and the church of the holy Anargyroi [Cosmas and Damian] in the quarter of Darius.[9] He also restored the public bath of Taurus[10] and called it Sophianae after his wife Sophia. . . .

In this year [571/2] Justin began building the church of the holy Apostles Peter and Paul at the Orphanage,[11] and that of the holy Apostles at the Triconch[12] which had been burnt in the reign of Zeno.[13] He also added to the church of the holy Mother of God at Blachernae the two arches (*apsides*), the northern one and the southern one, i.e., in the big church, which he made cruciform.[14]

John of Ephesus, *Eccles. Hist.* III, 24:[15] He [Justin II] next determined upon building unto himself a pharos, i.e., a huge pillar in the eastern part of the city on the seashore, in what is called the Zeuxippus. Within it a staircase was constructed, so broad and spacious that the workmen could mount it up with loads of massive hewn stone; which were cramped together with bars of iron and strongly cemented with lead. While the pillar was being built, some citizens wrote an inscription and fixed it upon a tablet there, as follows:

> Build, build aloft thy pillar,
> And raise it vast and high;
> Then mount and stand upon it,
> Soaring proudly in the sky:
> Eastward, south, and north, westward,
> Wherever thou shalt gaze,
> Nought thou'lt see but desolations,
> The work of thy own days.

9 On this church cf. the epigram in *Anthol. graeca*, I, 11. The quarter of Darius lay to the west of the imperial palace.

10 I.e., at the forum Tauri, modern Beyazit.

11 Situated somewhere near the Acropolis (Seraglio Point) of Constantinople. See Janin, *Eglises*, pp. 413 f.

12 Situated near the Capitol. See Janin, *Eglises*, pp. 414 f.

13 A fire is recorded in 475: A. M. Schneider, "Brände in Konstantinopel," BZ, XLI (1941), 384.

14 This work is commemorated by two epigrams, *Anthol. graeca*, I, 2, 3. The church of the Blachernae was of basilical shape. It was built c. 450 and rebuilt in the reign of Justin I (518–27): Procopius, *De aedif.*, I, iii, 3. Justin II appears to have added a transept. Restored once again in the 11th century, the famous church was finally burnt down in 1434. There is an interesting desription of it by Isidore of Kiev, ed. G. Mercati, "Due nove memorie di S. Maria delle Blacherne," *Atti della Pont. Accad. Rom. di Archeol.*, *Memorie*, I/1 (1923), 28 f. A manuscript note, published by Mercati, p. 26 f. states that the church of the Blachernae "was measured and found to be 68 common feet in width and 146 of the same feet in length. As for the sacred church of the most holy Mother of God at Thessalonica [called] Acheiropoietos, this, too, was measured and found to be 53 common feet in width." Unfortunately, there is some error in these figures, since the total interior width of the Acheiropoietos is 28.30 m. and that of its nave alone 14 m. For the length of the Byzantine foot, see above, p. 80, n. 116.

15 Trans. P. Smith, pp. 205 f., corrected by comparison with Latin trans. by E. W. Brooks, *Corpus Script. Christ. Orient.*, *Script. Syri.*, III, 3, Versio, 111 f.

Before its completion, however, Justin died, and it is said that the question who would finish it led to a quarrel between Tiberius and Sophia: for she bade him undertake it; but he said, "I shall do nothing of the sort; for it is your duty to finish it." And she, supposing that at all events he would complete it and place his own statue upon it, said, "If you will not do it in honor of him who began it, do so for yourself." At which he was angry, and vowed that his statue would stand neither on this pillar nor another. Subsequently, when he saw that the great loads of stone employed in it would be useful for the buildings he had commenced in the palace, he had it entirely taken down, and all the stones removed to the palace and to the church of the Forty Martyrs which he was building for a long time. It was said that many hundreds of pounds of gold had been spent on this pillar.

***Vita S. Marthae*, ASS, May V, 415 ff.** *Martha died c. 560 and was buried in her son's monastery of the Wondrous Mountain near Antioch. At first, her tomb was placed in a small conch to the right of the Stylite's pillar. Her cult proved, however, very popular, and a few years later, a special trefoil martyrium was built for her as described in the following passage.*[16]

For several days he [Symeon] kept seeing the tomb of the blessed woman [Martha], together with the conch wherein this tomb was placed, being moved before his eyes to the south side of the first church he had built. ... From that time onward nearly the whole brotherhood was given no respite: the blessed Martha appeared to them by means of [various] signs and demanded insistently that a chapel be made for her and that her body together with the tomb be transferred to this chapel. ... And while all the brethren were reporting the glorious prodigies they had seen in various ways, there came forward also that monk who had had the first revelation four months prior to her death[17] ... and he said, "Lo, the great Lady [Martha] has appeared to me with joyful countenance three or even four times, bringing me peace from the Lord and showing me the plan (*skariphos*) of a chapel having three conches, namely one to the east, and one to the right and one to the left. She explained to me the entire arrangement of the structure and enjoined on me to report this to all of you...." ... The Slave of God [Symeon] said to them: "You are not to concern yourselves with this, but if the Lord so wishes, I shall receive from Him a notice concerning this request also. For, if this is

16 For the remains of the monastery, see W. Djobadze, *Istanbuler Mitteilungen*, XV (1965), 228 ff.

17 This revelation is described on pp. 403C–404D of the same Life. The nameless monk saw Martha transformed into a luminous cross, only her face showing above it.

pleasing to Him, He will assemble once again, through the Holy Spirit, masons from the land of Isauria,[18] and what is agreeable to His eyes shall be done as He wishes it." ... And on the holy day of the Lord [Sunday] God's servant Symeon ... directed that [the outlines of] the triconch chapel be traced in accordance with the form that had been delineated by the Blessed Woman and shown to him. And while they were tracing it, lo, there assembled a throng of masons from the land of Isauria and other places, men afflicted by various diseases and infirmities, who, after coming before the Saint with great faith and being cured by him, asked to be allowed to do the work. When they had started to build the great eastern conch and the two smaller ones on either side, the Blessed Woman appeared in a vision to one of the brethren and, taking charge of the work, ordered that a vault (*prohupostolê*)[19] be constructed in front of the two smaller conches. The monk reported this to the Saint in the presence of all the brethren, but a man called Angoulas, who was also a member of the brotherhood, strenuously opposed this course of action: he had secretly directed Theodore Apothetês, who was one of the builders, to start work in accordance with his own design, not according to the plan (*akariphos*) that had been indicated by St. Martha. But soon thereafter Angoulas was confounded for the impudent notions he held. ... For the Blessed Woman appeared in a nocturnal vision to one of the masons called Neon ... calling Angoulas a bad master-builder and saying clearly that Theodore surnamed Apothetês should not carry out the work inasmuch as he was an infidel. A day after Neon had related these things, Apothetês was seized by a spirit of trepidation and departed without anyone's knowledge. And behold, a certain Paul, an experienced builder who was a native of the land of Isauria, and had been cured by the Saint of various diseases. .. came to the monastery. Taking charge of the work, he begged the Slave of God [Symeon] to be allowed to construct a vault (*prohupostolê*) in front of the two smaller conches. The Saint said to him: "As it pleased the Lord to suggest it to you, so you shall do it." And everyone was astonished. .. since nobody had said anything to the newly arrived builder.

The entire structure of the church having been finished and the roof placed upon it, a few years later it was decorated ... and so the relics of God's holy Slave [Martha] together with her tomb were transferred to this church

[18] Symeon's monastery was built largely by Isaurian masons who evidently used to come to the region of Antioch in search of work.
[19] Probably a barrel vault. Cf. p. 79.

Tiberius (578-82)

John of Ephesus, *Hist. eccles.* III, 23:[20] While King Tiberius, who is also called Constantine, was Caesar,[21] and Justin [II] was alive and occupied the Great Imperial Palace (*authenticum*), scanty apartments were assigned to him in one of the wings; and even after Justin's death, his wife Sophia remained in the Imperial Palace, and Tiberius was unable to eject her, nor would she permit him to reside therein. And after he had been made Emperor, he was in great straits, especially when he had been joined by his wife and two daughters. As he was unwilling to use constraint against queen Sophia so as to take up his residence in the Great Palace, he was obliged to remodel the whole of the northern side and build a palace for himself. For which purpose he demolished many spacious buildings and destroyed a beautiful garden which had existed in the middle of the palace and been a great pleasure to former kings. After pulling these down on all sides, he erected larger and more magnificent buildings, including a splendid bath which he built anew, and spacious stabling for his horses at the upper end of the palace, and many other things.

Leo Grammaticus, *Chronogr.* pp. 137-38:[22] He [Tiberius] built and decorated the public bath of the Blachernae, and he restored many churches and hospices. He also splendidly decorated the so-called Chrysotriklinos[23] in the palace which had been built from the ground up[24] by Justin [II].

Maurice (582-602)

Theophanes, *Chronogr.* A. M. 6079, p. 261: Maurice built the Karianos portico at the Blachernae[25] and he had painters depict in it his deeds from his childhood up to his becoming emperor. He also completed the public bath which is at the portico.

20 Trans. Payne Smith, pp. 203 f. modified in accordance with the Latin trans. by Brooks, p. 111. On this passage see my remarks in *Art Bulletin*, XLII (1960), 69.

21 Tiberius became Caesar on December 7, 574, and Emperor on September 26, 578.

22 Parallel text: Cedrenus, I, 690, where these activities are dated to the 4th year of Tiberius.

23 On the famous Golden Hall of the imperial palace see J. Ebersolt, *Le Grand Palais de Constantinople* (Paris, 1910), pp. 77 ff. Cf. below, p. 184.

24 Literally "from the foundations," an expression by which Byzantine authors designate an entirely new building as distinct from a restored one.

25 The northwest corner of Constantinople. The portico probably had columns of Carian marble.

Theophanes, *Chronogr*. A. M. 6088, p. 274: In this year [596] the Emperor built the round terrace of the Magnaura,[26] and in the middle of the courtyard he set up his own statue and he made an armory there.[27]

The Ciborium of St. Demetrius at Thessalonica

This story, which is set in the troubled reign of Phocas (602–610), concerns an unnamed relative of a Prefect of Illyricum who had a vision described in the following passage.

***Miracula S. Demetrii*, §§ 82 ff.[28]** 82. Then, it seems, he entered the church and, after saying his prayers, saw that sacred and beautiful construction which is set up in the midst of the church on the left hand side:[29] it is hexagonal in plan, having six columns and as many partitions, shaped out of carved, assayed silver.[30] Its roof is likewise held up all round by the six sides and terminates in a circular conjunction from the base up. At the top it bears a silver sphere of no small size, its lower part surrounded by the shoots of lilies. At the very summit flashes forth the trophy that is victorious over death: by its silver composition it amazes our corporeal eyes, while by bringing Christ to mind, it illuminates with grace the eyes of the intellect—I mean the life-giving and venerable cross of God our Savior.

83. Having beheld in his dream this God-given structure that is in the church—the one we call the sanctified ciborium—he seemed to be asking those around him, "What, O brethren, is this wonderful work that rises in the middle of the church's length?" They replied, "We have been told by our fathers that the most glorious martyr Demetrius reposes there in divine fashion." The man said, "I should like to see its inside." So they pointed out to him the attendant that stood by the silver doors saying that without him no one could penetrate within. . . .

84. When the attendant had opened the doors, our man, even before he had entered, saw the little silver couch that is set up in the

26 A reception hall in the imperial palace.

27 According to another tradition, the armory was established by Phocas (602–10). Leo Grammaticus, p. 146: "The same Phocas [built] the armory which is near the palace of Magnaura, and he set up in the middle of it a column of masonry with his own statue at the top."

28 PG 116, 1265 ff.

29 The base of this ciborium was discovered in 1917: see G. A. and M. G. Sotêriou, *Hê basilikê tou Hagiou Dêmêtriou Thessalonikês* (Athens, 1952), pp. 100 f. and pl. 26a. The ciborium described here appears to have been made after the destruction of the original one by the Avars c. 580. See *ibid.*, pp. 10 ff.; N. Theotoka, "Peri tôn kibôriôn tôn naôn tou Hagiou Dêmêtriou," *Makedonika*, II (1941–52; published 1953), 395 ff.

30 This should be understood to mean that the ciborium was reveted with embossed silver.

middle[31]—as we may see it also—and at the head of it a splendid throne made of gold and precious stones upon which sat Christ's most glorious martyr Demetrius in the same form as he is depicted on icons, while at the foot of the couch was another splendid throne made entirely of silver on which he saw seated a woman of beautiful and decorous aspect[32]. . . .

Phocas (602–10)

Chron. Paschale I, 698 f., 703: In this year [609] was completed the composite column[33] which was built by the Emperor Phocas together with the cistern to the east of the church of the Forty Saints near the Brazen Tetrapylon[34]. . . .

In this year [612] the venerable cross was affixed at the top of the composite column which is to the east of the church of the Forty Saints. . . .

Ravenna

Agnellus XXVI, De Reparato c. 115: He was already an old man [when he became bishop], and his emaciated likeness used to be in the church of the blessed Peter[35]. . . . At the time of Constantine, the elder emperor, father of Heraclius and Tiberius,[36] he proceeded to Constantinople and he obtained everything he requested of the emperor. . . . He ordered that their portraits as well as his own, decorated with mosaic-cubes of different colors, should be depicted in the tribunal of the apse of the blessed Apolenaris, and that underneath their feet should be inscribed a metrical distich conceived as follows:

> "That he may be their partner by his merits, Reparatus, burning with eternal zeal, has made new raiment for the church."

31 Elsewhere described as a *krabbation* on which was represented the Saint's portrait (PG 116, 1217D), this appears to have been a reliquary in the shape of a silver couch. See G. A. and M. G. Sotêriou, p. 17; A. Grabar, "Quelques reliquaires de S. Démétrios," *Dumbarton Oaks Papers* V, (1950), 8 ff.

32 This was the Lady Eutaxia symbolizing law and order.

33 I.e., a column of masonry as opposed to a monolithic one.

34 This monument was situated somewhere near modern Beyazit. On the church see Janin, *Eglises,* p. 501.

35 At Classe.

36 Agnellus is here confusing the Emperors Constans II (641–68) and his son Constantine IV (668–85) whose brothers were Heraclius and Tiberius. Reparatus was bishop from 673 until 679; in 666, while still a deacon, he obtained from the Emperor, then residing at Syracuse, the *autokephalia* (independence from Rome) of the church of Ravenna. The mosaic at S. Apollinare in Classe probably represents, however, not the granting of the *autokephalia,* but that of certain fiscal exemptions for the clergy of Ravenna which Reparatus obtained from Constantine IV.

Above the emperors' heads you will find the following:

"Constantine, the elder emperor, Heraclius and Tiberius, emperors."[37]

Agnellus XXXVII, *De Theodoro* c. 119: In his time[38] was built the monastery of the blessed Theodore the deacon by the patrician Theodore[39] not far from the place called Chalchi,[40] next to the church of the blessed Martin the Confessor[41]. . . . The aforementioned patrician and exarch made three golden chalices for the holy Church of Ravenna which remain to this day. He used to resort every day to the monastery of St. Mary called Ad Blachernas . . . and there he reposes together with his wife Agatha. Above the altar of the Virgin he made a most precious casket *(theca)* [covered] with genuine purple cloth *(ex blacta alithino)* having upon it a picture-story of how God created heaven and earth and the animals and Adam with his progeny. Who has ever seen anything like it? By God's favor it remains to this day.

Justinian II (First reign, 685–95)

Theophanes, *Chronogr.* A. M. 6186, pp. 367–68: Justinian busied himself with the buildings of the palace. He built the hall *(triklinos)* which is called Justinian's[42] and the circuit-wall of the palace. . . . The Emperor demanded that the patriarch Callinicus[43] offer a prayer so that he might demolish the church of the holy Mother of God *tôn mêtropolitou*,[44] which was near the palace, wishing to set up on its site a fountain and to build steps for the faction of the Blues who would receive the Emperor there.[45] The Patriarch replied, "We have a prayer for the construction of a church, but none for the demolition of a church." As the Emperor was pressing him and demanding the prayer at any cost, the Patriarch said, "Glory be to God who is always long-suffering, now and for ever and ever. Amen." When they heard this, they pulled down the church and made the fountain. And they built the church *tôn mêtropolitou* at the Petrion.[46]

37 The inscriptions, as visible today, are a modern restoration based on the text of Agnellus.

38 Theodore was bishop from 679 to 693.

39 Governor of the Exarchate of Ravenna.

40 Also mentioned by Agnellus c. 94, this was the vestibule of Theodoric's palace, built in imitation of the Chalkê of Constantinople, on which see p. 109.

41 S. Apollinare Nuovo.

42 On this hall see Ebersolt, pp. 95 ff. It was later decorated with mosaics by Theophilus: see below, p. 165.

43 Patriarch of Constantinople, 694–706.

44 Name of a city quarter.

45 On the fountains of the Blue and Green factions and the ceremonial receptions that took place there see Ebersolt, pp. 100 ff.

46 A quarter of northwest Constantinople overlooking the Golden Horn.

Artistic Relations with the Arabs

Theophanes, *Chronogr.* A. M. 6183, p. 365: Abimelech[47] sent men to build the temple at Mecca, and he wished to remove [for this purpose] the columns from holy Gethsemane.[48] However, Sergius, son of Mansour, a most Christian man, who was general logothete[49] and very intimate with Abimelech, as well as Patricius . . . surnamed Klausus begged him not to do so, but to persuade Justinian [II] through their plea to send another set of columns; and this was done.

al-Tabarī, *Annals* II, 1194:[50] We began to pull down the mosque of the Prophet [at Medina][51] in Safar 88 [January 707]. Al-Walīd had sent to inform the Lord of the Romans that he had ordered the demolition of the mosque of the Prophet, and that he should aid him in this work. The latter sent him 100,000 *mithqāls*[52] of gold, and sent also 100 workmen, and sent him 40 loads of mosaic cubes; he gave orders also to search for mosaic cubes in ruined cities and sent them to al-Walīd. . . .

al-Maqdisī in *Bibl. geogr. Arab.* III, 158: And it is said that for building it [the mosque of Damascus] al-Walīd gathered the skilled workmen of Persia, India, al-Maghrib,[53] and Byzantium and spent on it the tax revenue of Syria for seven years as well as the gold and silver load of eighteen ships that had sailed from Cyprus,[54] let alone the implements and the mosaic cubes which the King of the Romans had sent him as a gift.[55]

Secular Painting

A Portrait of Agathias

***Anthol. graeca* XVI, 316 (by Michaelius):** In recognition of Agathias, both orator and poet, and of the double form of his eloquence, the City,[56]

47 The Caliph 'Abd al-Malik (685–705).
48 I.e., the church of the Agony. Cf. B. Meistermann, *Gethsémani* (Paris, 1920), pp. 98 ff.
49 I.e., finance minister.
50 Trans. H. A. R. Gibb, *Dumbarton Oaks Papers*, XII (1958), 225.
51 I.e., so as to rebuild it.
52 I.e., solidi.
53 I.e., North Africa west of Egypt.
54 Variant reading: "together with the gold load of a ship which had come from Cyprus."
55 Variant reading: "let alone the precious stones and the implements which the King of the Romans and the Muslim governors had sent him as a gift." I owe the translation of the passage from al-Maqdisī to Prof. Irfan Shahîd.
56 Probably Myrina in Asia Minor, Agathias' birthplace.

acting as a mother would towards her son, has offered this image, a token of her love and of his wisdom. Together with him she has set up his father Memnonius and his brother, representatives of a most distinguished family.

Portraits of Bishops

John of Ephesus, *Eccles. Hist.* I, 36:[57] The name of the synod[58] was written up, and proclaimed in them [i.e., in monasteries], and the pictures of all the orthodox [i.e., Monophysite] fathers taken down, and those of John himself[59] everywhere set up. But as he had done, so was he requited of God. For after his bitter and painful death, and the succession of Eutychius, his predecessor, upon the throne, his pictures in all places were utterly destroyed, and those of Eutychius fixed up in the churches in their stead.

A Portrait of Philippicus Bardanes (711–13)

***Parast. syntomoi chronikai* § 82:[60]** The painted image (*stêlê*) in the ancient bath, i.e., that of Zeuxippus, is of the gentle Philippicus who erred out of ignorance,[61] and it is reported that it is exactly like its model. Indeed its painter was greatly praised by other painters because the emperor's likeness did not depart from its archetype.

Religious Painting

Eustratius Presbyter, *Vita S. Eutychii* § 53.[62] *This is one of the miracles performed by Eutychius, Patriarch of Constantinople, while in exile at Amaseia in Pontus (565–77).*

A young man who professed the craft of the mosaicist was working in that capacity at the house of Chrysaphius of pious memory in that same city of Amaseia. As he was removing the old mosaic from the wall representing the story of Aphrodite (for the said man intended to convert his house into a chapel of the archangel [Michael] since it stood in a high position, and its big lower storey into a chapel of our immaculate Lady the Mother of God, for ever virgin—which indeed was done); when, therefore, the mosaicist had cut out the picture of the unclean Aphrodite,

57 Trans. Smith, pp. 71 f.; cf. Latin trans. by Brooks, p. 32.
58 The Council of Chalcedon, 451.
59 John III Scholasticus, Patriarch of Constantinople, 565–77.
60 Ed. Preger, p. 71.
61 The error in question is probably his espousal of the Monothelete heresy.
62 PG 86, 2333 ff.

the demon that resided in it struck his hand which became inflamed and swollen. . . . Seeing himself in great danger, he chose the better course and visited the Saint so as to obtain God's help through him. The latter said a prayer over the man and anointed his right hand (for this was the injured one) with holy oil. He did this for three days, and the [right] hand was made healthy like the other one by God's assistance. By way of thanksgiving and as a reminder of the miracle that had been performed, the man who had been healed set up the Saint's image in that very house where he had been injured: with the same hand that had received healing he depicted his godly physician.

Vita S. Symeonis iunioris ch. 118.[63] *A woman of Rhosopolis in Cilicia by the name of Theotekna had been married twenty years, but remained childless. Furthermore, she was possessed by a demon. She sought the help of St. Symeon who drove the demon out of her. Thereafter, she returned home and bore a child.*

After . . . returning home, the woman, impelled by her faith, set up an image of the Saint in the inner part of her house. This worked miracles, being shadowed over by the holy spirit that dwelled in the Saint, so that demoniacs were cleansed there, and persons afflicted with various diseases were healed. Among them was a woman who for fifteen years had had a constant discharge of blood. She came to see the image with much faith, and forthwith her discharge ceased. For she had said to herself, "If only I see his likeness, I shall be saved."

Vita S. Symeonis iunioris ch. 158.[64] *An artisan of Antioch was freed by St. Symeon of a demon that had possessed him for many years.*

Having returned to his house, this man, by way of thanksgiving set up an image of him [Symeon] in a public and conspicuous part of the city, namely above the door of his workshop. Upon seeing the image honored with lights and curtains (*vela*), some infidel persons were filled with ardor and roused a number of troublemakers of their own ilk, so that a crowd collected and shouted tumultuously, "Kill the man who has done this, and let the image be thrown down!". By God's dispensation, it happened that the man was not then in his house, for they intended to put him to death. . . . Being, then, unable to contain their frenzy, they let a soldier climb a ladder so as to throw down the image. But when he had climbed up and stretched out his hands to carry out what he had been ordered to do, he immediately fell to the ground, and there was great noise in the crowd. In their ardor, they made a second

63 Ed. P. Van den Ven, p. 98. Quoted in the Acts of the Seventh Ecumenical Council, Mansi, XIII, 73 ff.

64 Van den Ven, pp. 140 f.; Mansi, XIII, 76; also quoted by St. John Damascene, *De imaginibus oratio* III, PG 94, 1393 ff.

man go up, and he, too, stretched out his hands to pull down the image, but likewise fell to the ground. . . . Those infidels, getting frenzied all the more, put a third man to the task, and he also, when he stretched out his hands to throw down the image, collapsed to the ground. Then great fear came over the Christians who stood round. . . .

John Moschus, *Pratum Spirituale* ch. 81:[65] The same monks[66] told us the following story: "In our times a pious woman of the region of Apamea dug a well. She spent a great deal of money and went down to a great depth, but did not strike water. So she was despondent on account both of her toil and her expenditure. One day she sees a man [in a vision] who says to her: 'Send for the likeness of the monk (*abbas*) Theodosius of Skopelos and, thanks to him, God will grant you water.' Straightaway the woman sent two men to fetch the Saint's image, and she lowered it into the well. And immediately the water came out so that half of the hole was filled. The men who had conveyed the image brought to us some of that water, and we drank it and gave praise to God."

Sophronius of Jerusalem, *Miracula SS. Cyri et Ioannis* ch. 36.[67] *This story, which is set in Alexandria, concerns a certain Theodore, a heretic of the Julianist sect. This man was afflicted with the gout and sought the help of SS. Cyrus and John who, however, refused to assist him until he had joined the Catholic Church. After some hesitation, Theodore consented to take Catholic communion.*

Let us now describe briefly the healing of his body. A few days later he was again asleep and saw the Martyrs standing by, ordering him to follow them. This he did readily since he knew that he would profit by following the Saints. "So we[68] came to a perfect temple, awesome and most splendid in appearance and, in height, reaching up to the very heavens. Once within it, we saw an enormous and wonderful image: in the middle it had Our Lord Christ depicted in colors, to the left of Christ Our Lady the Mother of God, Mary for ever Virgin, and to the right John the Baptist. . . .[69] And furthermore some members of the glorious choir of apostles and prophets and of the company of martyrs;

65 PG 87[ter], 2940A–B.

66 The monks of the monastery of Skopelos, a mountain near Rhosus, in Cilicia.

67 PG 87[ter], 3557 ff. This passage is quoted by St. John Damascene, PG 94, 1413 ff. and in the Acts of the Seventh Ecumenical Council, Mansi, XIII, 57 ff.

68 The narrative is now given in the first person as if Theodore were the speaker.

69 This is the composition known to modern scholarship as the Deêsis on which see C. Walter, "Two Notes on the Deësis," *Revue des études byzantines*, XXVI (1968), 311 ff. Sophronius surely means that the Virgin Mary was on Christ's left from the spectator's viewpoint.

among the latter were present the martyrs Cyrus and John who, standing [now] in front of the image, fell to their knees before the Lord, bowed their heads to the ground, and prayed for the healing of the young man. . . .

They repeated their prayer three times and, on the third attempt, won Christ's approval.

'Lo,' they said to me, 'God has granted the favor. Now proceed to Alexandria and go to sleep on an empty stomach in the great Tetrapylon. Take a small quantity of oil from the lamp that burns there, high up, in front of the Saviour's image, put it in a little flask and, still on an empty stomach, come back here. When you have anointed your legs with this oil, you will receive the gift of health.'[70]

Theodorus, ep. Paphi, *Vita S. Spyridonis* ch. 20.[71] *The author relates a tale according to which St. Spyridon (4th century) was able by the force of his prayers to overthrow a pagan idol at Alexandria.*

A memorial of this amazing miracle remains to this day in the city of the reverend Father, namely Trimithous, above the central gateway; i.e., the Noble Door (*archontikê thura*) of the church, at the spot where the precious body of our holy father Spyridon lies—an image depicting this whole story as well as others that have not been recorded in this work. This story was not known to any of the inhabitants of the aforesaid Christ-loving city until the present narration was read in that very same holy church of God on the memorial day of our holy father Spyridon, this 14th indiction, in the 15th year of our Christ-loving and most pious emperor Constantine and the second year of his most pious son Constantine, crowned by God.[72] After the perusal of the present text, some of the Christ-loving men who were there—also present were Sergius, the most-holy archbishop of Constantia in Cyprus and Paul the most-holy archbishop of Crete. . . .[73]—saw this delineation and reported the matter to the aforesaid blessed men and to my humble self. . . . Certain persons after the reading expressed doubts concerning this miracle, i.e., whether the story was true, on the grounds that it was not contained in the Saint's Life that is composed in iambic verse.[74] But when the aforesaid Christ-loving men examined the painted image and found that the delineation

[70] Note that at the Council of 787, after the reading of this passage, Thomas, the vicar of the Oriental patriarchs said: "This image in the Tetrapylon of Alexandria, O reverend Fathers, is still standing to this day and cures diseases of all kinds" (Mansi, XIII, 60 C).

[71] Ed. Van den Ven, pp. 88 ff.

[72] December 14, 655.

[73] There follow the names of several other prelates.

[74] This earlier life of St. Spyridon is lost.

was made understandable by the story that had been read, everyone was overjoyed and gave praise to God on this account.

Vita S. Pancratii. *The scene in the following passage is set in Pontus, where the apostle St. Peter builds a church and appoints a bishop.*[75]

Having spoken these words, the blessed apostle Peter sent for the painter Joseph and said to him: "Make me the image of Our Lord Jesus Christ so that, on seeing the form of His face, the people may believe all the more and be reminded of what I have preached to them." So the painter took waxen (*enkêrotata*) colors and painted the image of Our Lord Jesus Christ. And the apostle said: "Paint, O child, also mine and that of my brother Pancratius so that those who use them for remembrance may say, 'This was the apostle Peter who preached the word of God among us;' and concerning my brother Pancratius, 'He is the one who built the tower of the sacristy (*skevophulakion*).'" So the young painter made these also and wrote on each image its own name. This is what the apostles did in all the cities and villages from Jerusalem as far as Antioch. And having taken thought, Peter made the entire picture-story (*historia*) of the incarnation of Our Lord Jesus Christ, beginning with the angel's crying 'Hail' to the Virgin,[76] and ending with the Ascension of Our Lord Jesus Christ, and he commanded that churches should be decorated with this story. From this time onward these things were given earnest attention by everyone and they were depicted on panels and parchment (*chartia*), and were given to bishops who, upon completing the construction of a church, depicted them both beautifully and decorously, and enjoined [on the people] to honor them with great fear and reverence as if they were beholding the actual subject of the pictures (*tôn historiôn tous tupous*). . . .

St. Peter sends Pancratius and a preacher named Marcian to the West that they may spread the Gospel there, and provides them with the equipment needed for setting up a church (pasan ekklêsiastikên katastasin), to wit:[77]

. . . two Gospel books, two books of Acts composed by the divine apostle Paul, two sets of silver paten-and-chalice (*diskopotêria*), two crosses made of cedar boards, and two volumes (*tomoi*) of the divine picture-stories (*historiai*) containing the decoration of the church, i.e., the pictorial story (*eikonikê historia*) of the Old and New Testaments,

75 Ed. Veselovskij, p. 73, and Usener, p. 418. I have also had before me, through the kindness of Mr. James Fitzgerald, the text of cod. Lavra △ 58. There are considerable differences between the various manuscripts of the Life.
76 I.e., the Annunciation.
77 Veselovskij, p. 75.

which volumes were made at the command of the holy apostles.... And again he said to them. "I want you, when you build churches, to decorate them as follows." And taking the pictures (*pinakes*) that had been painted by Joseph, he opened them,[78] and said as he pointed to them, "First, put the Annunciation, then the Nativity, then how He was baptized by the Forerunner, the Disciples, the Healings, the Betrayal, the Crucifixion, the Burial, the Resurrection out of Hades, and the Ascension. Portray all of these in the church so that the crowds of visitors may see the subject of the portraits (*tou charaktêros ton tupon*) and, being reminded of the Lord's incarnation, should be inspired and so assume a more ardent faith."

After the death of Pancratius, a martyrium was built at the place of his burial. The author of the Life, who calls himself Evagrius and claims to have been the disciple of Pancratius, speaks here in the first person.[79]

After the site had been measured with a cord (*spartion*), the diggers set to work, and when they had dug the trench for the foundations, I performed the rite of the fixture of the cross (*stauropêgia*), and construction began. When the church (*oikos*) had been completed, I made a forecourt and a fountain of water and small houses on either side.... A year having elapsed, I decorated the entire church with the story of the Old Testament, starting with the Creation of heaven and earth by Our Lord God, according to the book of Genesis, and down to [the creation of] man. In another place I made the picture-story of the New Testament. Furthermore, I depicted the portrait of my master Pancratius on an image, exactly as he was, and when I see him in the image, I think that he is alive and that I am in his company.

Miracula SS. Cosmae et Damiani, miracle 13.[80] *This story concerns a military man called Constantine who, coming from Constantinople, was posted at Laodicea Trimitaria in Phrygia.* Whenever he was sent abroad, he used to take along, out of faith and for his own protection, a representation (*ektupôma*) of the Saints [Cosmas and Damian] in the form of a picture.

At Laodicea he married a woman who soon thereafter developed a pain in her jaw. Forgetting that he had the icon with him, Constantine

[78] The author seems to be referring here not to panel pictures, but to pictures in a book as indicated by the verb "opened" or "unfolded" (*anaptuxas*). In another passage these are referred to as *pinakes chartôoi*, i.e., pictures on parchment (Veselovskij, p. 77, n. 2).

[79] Cf. Veselovskij, p. 110, who does not, however, give the full Greek text of this passage. I have followed the Lavra codex, fol. 230ʳ.

[80] Ed. Deubner, pp. 132 ff.; quoted in the Acts of the Seventh Ecumenical Council, Mansi, XIII, 65.

was at a loss what to do. The following night she fell asleep and saw
these great and awesome physicians... Cosmas and Damian standing by
her bed in the form in which they are depicted and saying to her, "Why
are you afflicted? Why are you causing distress to your husband? We are
here with you. Do not worry...." When she awoke, she questioned her
husband, wishing to learn from him the appearance *(ta schêmata)* of the
glorious Saints Cosmas and Damian, i.e. how they are depicted and in
what manner they manifest themselves to the sick. The husband ex-
plained to her their appearance and related the blessings they confer....
The story made him remember that he had in the wallet he carried
under his arm a representation of the Saints on an image and, taking it
out, he immediately showed it to his wife. When she saw it, she offered
obeisance and realized that indeed the Saints were present with them as
they had said.

Miracula SS. Cosmae et Damiani, miracle 15.[81] *This story concerns a
woman who had been healed of various diseases by Sts. Cosmas and
Damian.* She depicted them on all the walls of her house, being as she
was insatiable in her desire of seeing them....

*The woman then develops a bad case of colic and happens to be
left alone in her house.* Perceiving herself to be in danger, she crawled
out of bed and, upon reaching the place where these most wise Saints
were depicted on the wall, she stood up leaning on her faith as upon a
stick and scraped off with her fingernails some plaster. This she put into
water and, after drinking the mixture, she was immediately cured of
her pains by the visitation *(epiphoitêsis)* of the Saints.[82]

Quinisext Council (692), Canon 82:[83] On some venerable images is
depicted a lamb at whom the Forerunner points with his finger: this has
been accepted as a symbol of Grace, showing us in advance, through the
Law,[84] the true Lamb, Christ our Lord. While embracing the ancient
symbols and shadows inasmuch as they are signs and anticipatory trac-
ings handed down to the Chuch, we give preference to the Grace and
the Truth which we have received as the fulfilment of the Law. Con-
sequently, in order that the perfect *(to teleion)*[85] should be set down
before everybody's eyes even in painting, we decree that [the figure of]
the Lamb, Christ our God, who removes the sins of the world, should
henceforward be set up in human form on images also, in the place of

[81] Deubner, pp. 137 f.; quoted in the Acts of the Seventh Ecumenical
Council, Mansi, XIII, 68.

[82] In other words, the ingestion of some plaster from the image of the
Saints was considered to bring about in some way their actual presence.

[83] Mansi, XI, 977 ff.

[84] The Law *(nomos)* denotes the Old Dispensation of which John the
Baptist was the last representative.

[85] I.e., Truth in its fullest manifestation.

the ancient lamb, inasmuch as we comprehend thereby the sublimity of the humiliation of God's Word, and are guided to the recollection of His life in the flesh, His Passion and His salutary Death, and the redemption which has thence accrued to the world.

Justification of Religious Painting

John, bishop of Thessalonica, Mansi XIII, 164–65: The pagan said, "Do you not in the churches paint images of your saints and worship them, and not only of saints, but also of your God? In the same manner you may consider that when we cherish our idols, we do not worship these, but the incorporeal forces to whom we do service through them."

The Saint answered, "We, however, make images of men who have existed and have had bodies—the holy servants of God—so that we may remember them and reverence them, and we do nothing incongruous in depicting them such as they have been. We do not invent anything as you do, nor do we exhibit the physical portraits of certain incorporeal beings. Besides, as you have said, in our act of worship we glorify not the images, but the persons represented through painting, and these not as gods (far from it!) but as genuine slaves and friends of God who have the facility to intercede on our behalf. And as of God, we make images of Him—I mean of Our Lord and Saviour Jesus Christ—such as He was seen on earth and lived among men: Him we depict, and not as He is conceived in His divine nature. . . . "

The pagan said, "Granted that you represent God the Logos incarnate, what say you of the angels? For them, too, you paint in human form and worship them, and that although they are not men but are said to be, and indeed are, spiritual and incorporeal beings. You may interpret in the same manner the worship we accord to our gods through their statues; i.e., that we do not act absurdly just as you do not either in painting angels."

The Saint answered, "Concerning angels and archangels and the holy Powers that are above them—and I shall add our human souls—the Catholic Church recognizes them to be spiritual, but not altogether incorporeal and invisible, as you pagans say; rather as having a fine body of an aerial or fiery nature, as it is written: 'Who maketh his angels spirits, his ministers a flaming fire'. . . . [86] The Godhead alone is truly incorporeal and uncircumscribable, whereas the spiritual creatures are not entirely incorporeal and invisible like the Godhead. Hence they are localized and admit of circumscription. . . . True, compared to us, they are invisible; yet they have often been seen sensually by many persons in the form of their own bodies—seen by those whose eyes God has

[86] Ps. 103(104):4.

opened. Being furthermore circumscribed as to place, they are proved to be not altogether incorporeal like the Divine nature. Hence we are not in error in painting and honoring the angels, not as gods, but as spiritual creatures, God's ministers who are not incorporeal in the full sense of the word. As for painting them in human form, this is so because they have been consistently seen as such by those to whom they had been sent by the only God."

Images as Propaganda

Agathon the Deacon, Mansi XII, 192 ff. *This passage concerns the Emperor Philippicus Bardanes (711–13) who, as a Monothelite, attempted to expunge all memory of the Sixth Ecumenical Council (680–81)*: Using his imperial might and authority even before his entry [into Constantinople] he ordered the destruction of the image of the Holy Sixth Council which several years previously had been set up between the Fourth and the Sixth Schola in the vestibule of the imperial palace;[87] for, he said, he would not deign to enter the palace (which was not his) unless this had been done. He also issued this further arbitrary command that the names of Sergius, Honorius and their followers (who had been expelled and anathematized by the same holy Ecumenical Council)[88] should be proclaimed in the sacred diptychs of the holy churches, and that their images should be set up again in their proper places....

Agathon proceeds to describe the deposition of Bardanes and the accession of the orthodox emperor Anastasius II.

After the destruction of the aforementioned conciliar image, he who had ordered this lawless deed—I mean that insane scoundrel Bardanes—decreed that in the vault of the so-called Milion the five holy Ecumenical Councils, and they alone, should be represented on a picture and he had himself together with Sergius portrayed standing upright in the middle of it. These two personages were now necessarily and quite appropriately removed, and the holy Sixth Ecumenical Council was depicted there together with the other five.

Symbolism of the Church Building

Hist. mystagogica (attributed to Patriarch Germanus I):[89] 1. ... The church is a heaven on earth wherein the heavenly God "dwells and

[87] The Scholae were the quarters of a corps of palace guard called Scholarii. These were divided into seven companies, each one of which had its own barracks. See Ebersolt, pp. 28 ff.

[88] Sergius I, Patriarch of Constantinople (610–38), attempted to bridge the gap between the Orthodox and Monophysite positions by the doctrine of a single energy in Christ. He won the support of Pope Honorius I of Rome (625–38).

[89] Ed. Brightman, pp. 257 ff.

walks."[90] It typifies the Crucifixion, the Burial and the Resurrection of Christ. It is glorified above Moses' tabernacle of testimony,[91] on which were the mercy-seat and the holy of holies. It was prefigured by the Patriarchs, foretold by the Prophets, founded by the Apostles and adorned by the Hierarchs.

2. The conch is after the manner of the cave of Bethlehem where Christ was born, and that of the Cave where He was buried as the Evangelist saith, that there was a cave "hewn out of the rock, and there laid they Jesus."[92]

3. The holy table is the place where Christ was buried, and on which is set forth the true bread from heaven,[93] the mystic and bloodless sacrifice, i.e., Christ.... It is also the throne upon which God, who is borne up by the cherubim, has rested. At this table, too, He sat down at His last supper in the midst of His apostles and, taking bread and wine, said unto them, "Take, eat and drink of it: this is my body and my blood."[94] It was prefigured by the table of the Law[95] on which was the manna which cometh down from heaven,[96] i.e., Christ.

4. The ciborium (*kibourion*) stands for the place where Christ was crucified: for the place of His burial was nigh at hand[97] and in an underlying position (*hupobathron*).[98] ... It is also after the manner of the ark of the covenant of the Lord[99] ... where God ordered to be made two cherubim of beaten work,[100] one on each side: for *kib-* stands for the ark (*kibôtos*), while *-ourin* is the illumination or light of the Lord.[101]

5. The place of sacrifice (*thusiastêrion*)[102] is after the manner of Christ's tomb where Christ hath given Himself in sacrifice[103] to God the Father by the offering of His body,[104] like a sacrificial lamb, but also as a high priest and as the Son of Man who offers Himself and is offered.... The place of sacrifice is so named after the spiritual one in heaven, and the spiritual and immaterial hierarchies of the heavenly host are represented

90 2 Cor. 6:16; cf. Lev. 26:12.
91 Ex. 27:21.
92 Mark 15:46; John 19:42.
93 John 6:32.
94 Cf. Matt. 26:26–28.
95 I.e., of the Old Testament.
96 Cf. John 6:50.
97 John 19:42.
98 I.e., just as the ciborium stands over the altar-table, so the place of the Crucifixion was close to and higher than the place of the Burial.
99 Num. 10:33.
100 Ex. 25:18.
101 False etymology: the Urim ("lights") were the stones on the breastplate worn by the high priest.
102 I.e., the presbytery.
103 Eph. 5:2.
104 Heb. 10:10.

by the material priests on earth who stand by and worship the Lord continuously. . . .

6. The *bêma* is a place like a footstool (*hupobathros topos*) and like a throne in which Christ, the universal King, presides together with His apostles, as He saith unto them, "Ye shall sit upon a throne to judge Israel."[105] It also signifies the Second Coming at which He shall come to sit upon the throne of His glory to judge the world. . . .

7. The cornice (*kosmitês*)[106] denotes the holy order (*kosmion*) of the world (*kosmikon*), and shows the seal of the crucified Christ and God, adorned (*kosmoumenon*) with the cross.

8. The cancelli (*kangella*) denote the place of prayer, and signify that the space outside them may be entered by the people, while inside is the holy of holies which is accessible only to the priests. . . .

9. The ambo denotes by its form the stone of the holy Grave which the angel rolled back from the door and sat upon it[107] announcing the resurrection of the Lord to the women who brought unguents

Carving and Minor Arts

Vita S. Symeonis iunioris § 108:[108] Thanks to St. Symeon's prayer a spirit of wisdom was granted to one of his disciples, a monk named John, as it had been to Bezaleel[109] to carve various designs upon the column capitals of the church that had been built by the Saint and dedicated to the Holy and life-giving Trinity. For he said to his master, "Father, lay your holy hand upon my heart, and I shall begin carving as the holy spirit that is in you inspires me." Now, this man was wise in spirit, but had no experience of stonecarving, and it is only through faith that he acquired this gift. So the Servant of God laid his hand upon the monk's breast and said, "God will make you wise in stone-carving, too." He then started to carve the capitals of the columns and completed them.[110]

Georgius presbyter, *Vita S. Theodori Syceotae*, ch. 42:[111] As by God's grace, the monastery[112] was growing, but lacked as yet the use of silver vessels (those in service being made of marble), St. Theodore despatched his archdeacon to the imperial city of Constantinople with a view to

105 Cf. Matt. 19:28.
106 Probably the entablature of the chancel-screen.
107 Matt. 28:2.
108 Ed. Van den Ven, pp. 88 ff.
109 Bezaleel and Aholiab were the architects of the Tabernacle: Ex. 31:2, 6.
110 Some of these capitals are still preserved in the ruins of St. Symeon's monastery about 12 miles southwest of Antioch.
111 Ed. Ioannou, pp. 399 ff.; cf. English translation by Dawes and Baynes, pp. 117 f.
112 At Sykeon in Galatia.

purchasing a silver chalice-and-paten (*diskopotêrion*) to serve the un-
defiled mysteries. This man departed and purchased from a banker[113] an
object that was clean and well-made as regards the assay of the silver and
the quality of workmanship, and this he brought to the monastery. The
next day, as the service was approaching, the archdeacon brought the
chalice-and-paten to the *diakonikon* and uncovered it as so to show it to
the Saint and make the oblation (*prothesis*) in it. He, however, having
seen it, recognized by his discerning eye the blameworthy nature of its
use, and condemned it as being useless and unclean. As the archdeacon
could perceive only what was on the surface and not what was concealed,
and kept exhibiting the perfection of the work and the assay mark of five
stamps,[114] believing he could thereby convince the Saint, the latter said
to him, "I too, know, my child, that in appearance this is a most beautiful
specimen (*exemplion*) and that the assay of silver is evident from the
superimposed stamps, but another hidden cause is spoiling it. I believe
this has happened because of unclean use. If you doubt it, say the verse
for our prayers, and you will be convinced." The archdeacon having said
the verse of the Invocation, the Saint bowed down his head and prayed,
and when he had finished, the chalice-and-paten turned black like silver
that has been withdrawn from a fiery furnace. When the brethren saw
this, they glorified God who made secret things known through His
Servant. The archdeacon removed the objects to a safe place, whereupon
they regained the appearance of pure silver; he then went to Constanti-
nople and returned them to the banker, to whom he explained the cause.
The latter questioned his shop-manager (*harmaritês*) and the silversmith
he had under contract,[115] and discovered that the objects had been made
from a prostitute's chamber-pot. This sinful mistake he announced to
the archdeacon, begging forgiveness and, at the same time, marvelling at
the holy man's discernment. He gave the archdeacon other vessels that
were pure and very beautiful, and these the latter conveyed to God's holy
Servant. He explained to him [Theodore] and to the brethren the story
of the first set of vessels, and they gave thanks to God.

Passio S. Procopii 4.[116] *The story is set during Diocletian's persecution
of the Christians. A pagan young man called Neanias (later renamed
Procopius), a native of Jerusalem, is invested by the emperor with a mili-
tary command at Alexandria. On his way there he sees a vision of the*

113 The term *arguropratês*, equivalent to Latin *argentarius*, denoted both
the banker and the dealer in precious metals and jewels.

114 On this topic see E. Cruikshank Dodd, *Byzantine Silver Stamps* (Wash-
ington, D.C., 1961). Our passage is discussed on p. 27.

115 Tentative translation of *suntaktitês argurokopos*. The term *suntak-
titês* is not found in the lexica.

116 Ed. Papadopoulos-Kerameus, pp. 5 f.; quoted in the Acts of the
Seventh Ecumenical Council, Mansi, XIII, 89. On the *Passio* see H. Delehaye,
Les légendes grecques des saints militaires (Paris, 1909), pp. 82 ff.

cross. Filled with great joy and faith, Neanias took courage . . . and he came to Scythopolis.[117] He convened secretly the whole guild of goldsmiths and silversmiths and asked them, "Can you make me an object such as I shall order?" Frightened by the man's stern looks, they consulted with each other and introduced before him their best craftsman, called Mark, saying, "He will fulfill your wish, Sir."

Neanias then indicates to Mark the object he has in mind, namely a cross. Mark at first refuses to make it because he is afraid of the emperor, but Neanias reassures him by the promise of not revealing the matter to anybody. Having been persuaded, he [Mark], all alone and in secret, made the cross at night out of silver and gold, and it so happened that when the cross was finished and raised up, there appeared on it three images designated by names written in the Hebrew tongue, namely on the top arm "Emmanuel", and on the lateral arms "Michael" and "Gabriel". Becoming suspicious, Mark tried to erase them, but was unable to do so, for his hand was paralysed. When the cock had crowed, the *dux*[118] Neanias came to Mark's house to take the cross, and when he saw it, he did obeisance to it and said to Mark, "What are these figures, and what is the inscription?" He answered, "Sir, at the time when the work was finished, these three images appeared, and I do not know whose they are or what the inscription is."

[117] The Biblical Bethshan, west of the Jordan.
[118] Military governor.

5

The Period
of Iconoclasm
(726–842)

In the preceding chapters we have noted repeated instances of opposition to a Christian figurative art; we have also observed that the cult of the icon assumed an ever-growing importance in Christian devotion from about the middle of the 6th century onward. In 726 (or 730)[1] iconoclasm became the official doctrine of the Empire and remained in force until 780; it was revived once again in 814 and lasted until 842. Two remarks are worth making here. First, iconoclasm was not a purely Byzantine phenomenon, but extended into the Semitic and Caucasian worlds—in fact, the origin of Byzantine iconoclasm is attributed in our sources to the Arab court in Syria. Second, the adoption of iconoclasm by the Emperor Leo III occurred at a time when the fortunes of the Empire were at their lowest ebb, only a few years after the Arab siege of Constantinople in 717. There can be little doubt that the Emperor and his advisers attributed Byzantine reverses to the wrath of the Almighty caused by the growth of idolatry in the Christian Church.

It is difficult to determine how much Early Christian art perished in the 8th and 9th centuries. Judging by our meager sources, the period of serious destruction coincided with the reign of Constantine V (741–75), but even the Iconoclastic Council of 754 expressed serious reservations on this score, while prohibiting the manufacture of images in the future. In offering an alternative form of church decoration, the iconoclasts reverted to the "neutral" repertory of the 4th and 5th centuries, i.e., crosses and swirls of vegetation enlivened by birds and fruit. At the same time, the tradition of secular art (imperial victories, hippodrome scenes, and so on) was maintained and encouraged.

The brief restoration of icon-worship under the Empress Irene is very poorly documented. We should not, I think, imagine that there was much artistic activity at this time; and it is worth observing that the one important monument surviving from Irene's reign, the apse mosaics of St. Sophia at Thessalonica, appear to have been non-figurative.

During the second period of iconoclasm and, in particular, during the reign of Theophilus (829–42) the increasingly favorable position of the Empire led to a resumption of building activity. Our information is concerned primarily with palace architecture and mobilier, and shows an influx of Islamic models and of expensive gadgetry, such as those golden trees on which mechanical birds warbled. There must have been a considerable resemblance between the court of Theophilus and that of Harun al-Rashid.

To the historian of Byzantine art the most interesting contribution of the Iconoclastic period lies in the precise formulation of a theory of religious images. The writings of the iconoclasts have been consigned to

[1] The exact date of the promulgation of the first iconoclastic edict is in doubt.

the flames, but a few important fragments are preserved in the works of their adversaries where they are subjected to detailed refutation: the Questions (Peuseis) of Constantine V,[2] and the Definitions of the Iconoclastic councils of 754 and 815 have come down to us in this way. The writings of the Orthodox polemicists, on the other hand, fill many volumes. Of the two parties, the Iconoclasts held the cruder view concerning the nature of figurative art; to them, a true image had to be "consubstantial" with its model ("prototype"), a kind of magical double. From this they drew the conclusion that the only genuine image of Christ was the consecrated bread and wine of the eucharist. The Orthodox were clearly on more solid ground when they argued that an image was a symbol (tupos) which, by reason of resemblance, reproduced the "person" (prosôpon), but not the substance (ousia or hupostasis) of the model. Yet, in their appeal to the tradition of the Church—and this formed an important part of the argument—the Iconoclasts were closer to historical truth than their opponents in affirming that the early Christians had been opposed to figurative art.

In perusing the vast amount of literature generated by the Iconoclastic controversy, the modern reader cannot help making two observations. First, that for all the subtlety shown on both sides, there was very little originality: practically all the arguments pro and contra had been anticipated in the preceding centuries.[3] Second, that the discussion was conducted almost entirely in theological and scholastic terms without reference to the basic artistic problem that any serious theory of images must take into account, viz. what constitutes a likeness. How do we know that an image of Christ looks like Christ? Neither the Iconoclasts nor the Orthodox appear to have asked this fundamental question. They were satisfied that the image represented the "person" of the model, and to prove the matter there was the accompanying inscription.[4] Once a picture was labelled "St. Peter," it was obviously a portrait of St. Peter. This simplistic attitude tells us a great deal about the Byzantine understanding of figurative art.

The Beginning of Iconoclasm in Syria

Acts of Seventh Ecumenical Council (787)[5] The following account of the origin of Iconoclasm was given by the presbyter John, vicar of the

2 Text in G. Ostrogorsky, Studien zur Geschichte des byzantinischen Bilderstreites (Breslau, 1929), pp. 8 ff.

3 Cf. the excellent studies by N. H. Baynes, "Idolatry and the Early Church" and "The Icons before Iconoclasm" in Byzantine Studies and Other Essays (London, 1955), pp. 116 ff., 226 ff.

4 Cf. Nicephorus, Antirrheticus I, 38, PG 100, 293 B: the inscription authenticates the veracity of the image.

5 Mansi XIII, 197B–200B.

Oriental Patriarchs. When Omar[6] had died, he was succeeded by Yazid,[7] a frivolous and fickle man. Now, there was in Tiberias a certain leader of the lawless Jews, who was a sorcerer and the instrument of soul-destroying demons, called Tessarakontapêchys [Forty Cubits High] Being informed of the frivolity of the ruler Yazid, this wicked Jew went up to him and attempted to make some prophecies. Having in this manner gained the tyrant's favor, he said: "I wish, O Caliph, on account of the good will I have towards you, to suggest to you a certain method, easy to accomplish, by means of which you will win an extension of your life and will remain here to rule for thirty years, if you put what I say into effect." Won over by the promise of longevity . . . the senseless tyrant replied: "Anything you suggest to me I shall readily do. . . ." Whereupon, the Jewish sorcerer said to him, "Give an order without delay or postponement that an encyclical letter be issued throughout your dominions to the effect that every kind of pictorial representation, be it on boards or in wall-mosaic or on holy vessels or altar-cloths, or anything else of the sort that is found in all Christian churches should be obliterated and entirely destroyed; not only these, but also all the effigies that are set up as decoration in the marketplaces of cities." It was a devilish plot on the part of the false prophet to have added "all effigies" because he tried to avoid the suspicion of being hostile to us [Christians]. The wicked tyrant was easily persuaded by him and sent out emissaries throughout his dominions to pull down the holy icons and other images. And in this fashion he denuded God's churches . . . before this plague had reached our country.[8] And since the God-loving Christians took to flight so as not to destroy holy icons with their own hands, the Emirs who had been charged with this task imposed it on accursed Jews and miserable Arabs. And so they burnt the holy icons, and some churches they whitewashed, while others they scraped down. When the unworthy bishop of Nacoleia[9] and his followers heard of this, they imitated the lawless Jews and infidel Arabs and set about insulting the churches of God. . . .

The most-holy bishop of Messene[10] said: "I, too, was a boy in Syria when the Caliph of the Saracens was destroying images."

The First Period of Iconoclasm (726–80)

Theophanes, *Chronogr.* A. M. 6218, p. 405 (726): The populace of the

[6] Omar II (717–20); for a discussion of this text see A. A. Vasiliev, "The Iconoclastic Edict of the Caliph Yazid II, A.D. 721," *Dumbarton Oaks Papers,* IX/X (1956), 25 ff.

[7] Yazid II (720–24).

[8] I.e., before the introduction of iconoclasm into the Byzantine Empire.

[9] Constantine, bishop of Nacoleia in Phrygia, was one of the chief ecclesiastical advisers of Leo III.

[10] Messina in Sicily.

Imperial City, being greatly distressed by the new doctrines, planned to attack him [Leo III], and they killed some of the Emperor's men who had taken down the image of our Lord that was over the great Bronze Gate.[11] As a result, many of them underwent punishment for the sake of true religion, namely mutilation, scourging, banishment and fines. . . .

Theophanes, *Chronogr*. A. M. 6218, pp. 405 f. *This passage refers to the siege of Nicaea by the Arabs in 727.* After a long siege and a partial destruction of the walls, they [the Arabs] did not capture it [Nicaea] thanks to the intercession, acceptable to God, of the Holy Fathers[12] who are honored there and in whose church are, to this day, set up their portraits which are venerated by those who share their beliefs. A certain Constantine, who was the equerry of Artabasdus,[13] on seeing an image of the Mother of God, threw a stone at it and broke it; and after it had fallen down, he trampled on it. And he saw our Lady appearing to him in a vision and saying, "See what a brave deed you have wrought against me! Verily, you have done this upon your head." And the next day, as the Saracens attacked the walls . . . that miserable man rushed to the wall like a brave soldier and was struck by a stone discharged by a siege engine, and it broke his head. . . .

Vita S. Stephani iun., col. 1112–13. *This passage refers to the time of the Iconoclastic Council of 754.* In every village and town one could witness the weeping and lamentation of the pious, whereas, on the part of the impious, [one saw] sacred things trodden upon, [liturgical] vessels turned to other use, churches scraped down and smeared with ashes because they contained holy images. And wherever there were venerable images of Christ or the Mother of God or the saints, these were consigned to the flames or were gouged out or smeared over. If, on the other hand, there were pictures of trees or birds or senseless beasts and, in particular, satanic horse-races, hunts, theatrical and hippodrome scenes, these were preserved with honor and given greater lustre.

Vita S. Stephani iun., col. 1120: The tyrant [Constantine V] scraped down the venerable church of the all-pure Mother of God at the Blachernae, whose walls had previously been decorated with pictures of God's coming down to us, and going on to His various miracles as far as His Ascension and the Descent of the Holy Ghost. Having thus suppressed all of Christ's mysteries, he converted the church into a storehouse of fruit[14] and an aviary: for he covered it with mosaics [represent-

11 The Bronze Gate (Chalkê) formed the entrance of the Imperial Palace. Cf. p. 109.

12 The 318 Fathers who attended the First Ecumenical Council at Nicaea in 325.

13 Son-in-law of the Emperor Leo III.

14 Cf. Ps. 78(79):1.

ing] trees and all kinds of birds and beasts, and certain swirls of ivy-leaves [enclosing] cranes, crows and peacooks, thus making the church, if I may say so, altogether unadorned.

Vita S. Stephani iun., col. 1172: Having gone out of the palace, the tyrant [Constantine V] proceeded to that part of the public street that is called Milion. At that public spot the Six holy Ecumenical Councils had been depicted by the pious emperors of olden times[15] and were conspicuously displayed so as to proclaim the orthodox faith to country folk, foreigners and the common people. These the new Babylonian tyrant had at that time smeared over and obliterated, and portrayed in their stead a satanic horse-race and that demon-loving charioteer whom he called Ouranikos [heavenly]—so much he loved him, he who was unworthy both of heaven and earth, that he honoured him more than he did the holy Fathers [of the Church].

Nicephorus, *Breviarium* p. 76: At the same time [768/9] Nicetas the bishop of the City[16] restored certain structures of the episcopal church (*katholikê ekklêsia*)[17] that had been damaged by [the passage of] time. In the reception rooms that are there, which the Romans call *secreta*—both in the small building and the big one—he scraped off the images of the Saviour and the saints made of golden mosaic and melted wax.

Epiphanius Monachus, *Vita S. Andreae*, col. 220. *Epiphanius relates that the apostles Peter and Andrew visited Sinope in Pontus. Because of the hostility of the local Jewish population, they remained outside the city, on the deserted tip of the peninsula jutting out into the Black Sea.* I, the monk and presbyter Epiphanius, and the monk James came to this place and we found an oratory of St. Andrew the apostle and [in it] two monks who were also presbyters, Theophanes and Symeon, and a most admirable image of St. Andrew painted on marble.[18] Theophanes, who was more than seventy years old, showed us the seats of the apostles and their stone couches. He said that at the time of Cabalinus[19] there came some iconoclasts who wanted to scrape off the image. They tried very hard, but their efforts came to nothing: indeed, their hands were held back. There is a tradition that this image was painted in the apostle's lifetime. It performs many cures.

Acts of the Seventh Ecumenical Council (787)[20] Demetrius, the God-loving deacon and sacristan said: "When I was promoted sacristan at

15 Cf. p. 141.
16 Iconoclastic patriarch of Constantinople (766–80).
17 St. Sophia.
18 *eis marmaron hulographoumenê*. The term *hulographia* denotes any kind of painting, whether in encaustic or tempera.
19 Constantine V (741–75).
20 Mansi XIII, 184D–185A, 189C.

the holy Great Church of Constantinople,[21] I examined the inventory (brebion) and found that two silver-bound illuminated books (êrgurô-mena dia eikonón) were missing. Having searched for them, I discovered that the heretics had thrown them in the fire and burnt them. I found another book by Constantine the Chartophylax[22] which dealt with the holy icons. The leaves containing passages on icons had been cut out by these deceivers. I have this book in my hands, and I am showing it to the Holy Synod." The same Demetrius opened the book and showed to everyone the excision of the leaves.

Leontius, the pious secretary (a secretis), said: "There is, O Fathers, another astonishing thing about this book. As you can see, it has silver plates (ptuches) and on either side of them it is adorned with the images of all the saints. Letting these be, I mean the images, they cut out what was written inside about images, which is a sign of utter folly."

The holy Synod said: "Anathema to the plotters who cut out [leaves]."

Leo, the most-holy bishop of Phokia,[23] said: "This book has lost its leaves, whereas in the city in which I live they have burnt more than thirty books." . . .

Tarasius, the most-holy Patriarch, said: "They have scraped not only holy icons, but also Gospel books[24] and other sacred objects. . . ."

Acts of the Seventh Ecumenical Council, col. 356. *Here the iconoclast emperors are rebuked for their misguided intervention in religious affairs: they ought, instead, to have confined themselves to their proper sphere.* Having rejected the [kind of] praise that is fitting and proper to emperors, they have ascribed to themselves that which refers to Christ our God.[25] They ought instead to have recounted their manly deeds, their victories over the foe, the subjection of barbarians which many have portrayed on panels and on walls so as to consign their narration to memory and to arouse the love and zeal of spectators.

Cedrenus II, p. 497. *This passage refers to a restoration of the Blachernae church by Romanus III in 1031.* He adorned the capitals of the Great Church [St. Sophia] and of the most-holy Mother of God of Blachernae with silver and gold. And being about to restore the presbytery of the Blachernae, he found an old hanging icon which he ordered to be renovated. He saw that the wall revetment was covered with

21 The appellation Great Church was applied both to St. Sophia and to the Patriarchate of Constantinople.

22 An author of the 6th or 7th century.

23 I.e., Phokaia, a city of western Asia Minor, northwest of Smyrna.

24 I.e., illuminated ones.

25 In claiming to have suppressed idolatry, whereas "in fact" idolatry had been abolished by Christ.

silver,[26] and he directed that it should be taken down and made anew. When the revetment had been removed, there appeared a painted icon (*hulographikē*) on a small panel of the Mother of God holding our Lord God on her bosom. This had remained unharmed since the times of Copronymus[27] until this day, i.e., over a lapse of three hundred years.

Ignatius Monachus, *Narr. de imag. Christi in monast. Latomi*, 6 ff.[28]
This legendary account is of interest, first, because it provides a description of an important work of art that is still in existence, the mosaic of the monastery, tôn Latomôn (also known as Hosios David) at Thessalonica,[29] and secondly, because it records the protective concealment of this mosaic, which probably took place during the Iconoclastic period, although the text says otherwise. The legend relates that the Emperor Maximian, who persecuted the Christians, resided at Thessalonica, and that he had a daughter called Theodora who secretly embraced the Christian religion. She then requested her father to build for herself a palace and a bath in the northern part of the city, and she converted the bath into a church.

When this had been done, she ordered that a painter be fetched immediately so as to paint the pure Mother of God ... in the eastern apse. So this image was being painted and the work was nearly finished when, the following day, the painter came along intending to complete the picture ... and saw not the same painting, but a different one, indeed one that was altogether dissimilar, namely that of our Lord Jesus Christ, in the form of a man, riding and stepping on a luminous cloud and on the wings of the wind, as the divine David sings.[30] And at the four corners of this cloud there appeared four forms completely alien to our nature, endowed with wings and holding books in their hands, namely at the top, the forms of a man and an eagle, and at the bottom, of a lion and a bull. Anyone who wishes to liken these to heavenly powers will not be in want of examples, as this is clearly explained by the learned theologian Dionysius.[31] Furthermore, an inscription was found under the feet of this holy figure and another on the book which he carried in His left hand (for the right hand He held up, as if pointing to heaven) conceived exactly as follows: the one under the feet: "This most-holy house is a fountain of life; it receives and feeds the souls of the faithful.

26 Presumably behind the hanging icon.

27 Constantine V.

28 Ed. Papadopoulos-Kerameus, pp. 107 ff. Cf. V. Grumel, "La mosaïque du 'Dieu-Saveur' au monastère du 'Latome' à Salonique," *Echos d'Orient*, XXIX (1930), 157 ff.

29 The basic publication is by A. Xyngopoulos in *Archaiologikon Deltion*, XII (1929; publ. 1932), 142 ff. The mosaic has been variously dated between the late 5th and the 7th century.

30 Ps. 17:11.

31 Pseudo-Dionysius the Areopagite.

I prayed and my prayer was granted. Having attained my wish, I executed [this work] in fulfilment of a vow, I whose name is known to God."[32] The inscription on the book [read as follows]: "This is our God in whom we placed our hope and joy for our salvation. He shall bring rest to this house."[33] Furthermore, two prophets—they are called Ezekiel and Habakkuk—stood on either side, outside the cloud, amazed by the vision....*Theodora directed the painter to leave the miraculous image untouched. This event, however, was reported to her mother, the empress, who questioned her on her behaviour. Theodora denied everything and, to escape suspicion, had the image covered.* She directed her servants to bring a cowhide together with mortar and baked bricks, and she securely covered the image of the God-man so as to cause it no harm and to avoid all suspicion and insinuation. *Even so, Theodora was convicted of being a Christian and put in prison, where she died. Maximian ordered that her house and bath be burnt, but the image escaped injury under its protective covering. Much later, in the reign of Leo the Armenian (813–20) the image was miraculously revealed so as to confute the iconoclastic heresy. It happened in this way. An Egyptian monk called Senouphios wished to behold the form of Christ in which He would come to judge the earth. A divine vision directed him to proceed to Thessalonica, to the monastery* tôn Latomôn. *This he did, but at first he could not find what he was seeking. In a second vision he was told to persevere, and he took a cell in the monastery.* Then, I say . . . the old man having for some reason been left alone in the church, there occurred a storm and an earthquake and, in addition, a shattering thunder-clap, so that the very foundations of the church seemed to shake. And directly the revetment of mortar and baked brick and that cowhide that overlay, as has been said above, the sacred image of the Lord fell to the ground, and that holy figure of Christ appeared gleaming like the sun in the midst of the cloud. When the old man, who was standing in the middle of the church, saw this, he cried out loudly, "Glory be to God, I thank thee!" and he gave up his blessed soul.

The Restoration of Images under Irene (780–802)

De sacris aedibus Deiparae ad Fontem p. 880. *During her joint reign with her son, Constantine VI, the Empress Irene was healed of a haemorrhage by drinking from the miraculous fountain of the Pêgê.* In gratitude for which she, together with her son, dedicated [to the church] veils woven of gold and curtains of gold thread (the kind commonly called

32 This inscription is, for the most part, preserved.
33 Adapted from Isaiah 25:9–10. The inscription is still in existence.

sôlênôta)[34] as well as a crown and vessels for the bloodless sacrifice deco-
rated with [precious] stones and pearls. She also ordered that, as a lasting
memorial, their portraits should be executed in mosaic on either side of
the church [representing them in the act of] handing over the offerings
that have been enumerated so as both to express their faith and to pro-
claim for all time the miracle [of the healing] of the haemorrhage through
the setting up [of the portraits] and the offering of the gifts.

The Second Period of Iconoclasm (814–42)

Scriptor Incertus de Leone pp. 352, 354–55: And about the month of
December [814] Leo [V] declares to the Patriarch [Nicephorus]: "The
people are offended on account of the icons, saying that we do wrong in
revering them and for this reason the aliens are victorious over us. Make,
therefore, a little concession by way of a compromise with the people, and
let us remove [the images] that are near the ground. But if you do not
wish to do so, convince us of the reasons why you revere them, seeing that
Scripture nowhere contains an explicit statement [on this subject]. . . ."

He [Leo] also had some impious collaborators through whose agency
he engineered his secret treacheries. By their help he caused the impious
soldiers to stone the image which was at the palace gate called Chalkê.[35]
And so they started to throw stones and clay at the image, and to utter
words filled with stupidity and impiety, calling it Hades and the Devil
and other things which it would be improper to mention here. Then the
tyrant [Leo] said to the people, "Let us take the image down from up
there, lest the soldiers dishonor it"—imitating in this Leo the Isaurian
because he wanted to reign as long as the other had done.[36] Above the
image was the inscription, "This which aforetime the Emperor Leo took
down, Irene has restored here," and it was that Leo who removed the
image which had existed since the foundation of the City.

**Letter of the Emperors Michael II and Theophilus to Louis the
Pious (824):[37]** This, too, we declare to your Christ-loving Affection that
many clerics and laymen, alienating themselves from apostolic traditions
and not observing the definitions of the Fathers, have become originators
of evil practices. First, they expelled the venerable and life-giving crosses
from the holy churches and in their stead they set up images, in front of
which they placed lights and burnt incense, and held them in the same
esteem that is due to the venerable and life-giving cross upon which

34 Cf. p. 100, n. 224.
35 Cf. p. 109.
36 Leo III reigned 24 years (716–40).
37 Text: *Monumenta Germaniae historica, Leges, Sect.* III, ii/2 (1908),
478 f.

Christ, our true God, deigned to be crucified for the sake of our salvation. They sang hymns to these images and worshipped them and asked help of them. Many people wrapped cloths round them and made them the baptismal godfathers of their children.[38] Others, who were desirous of taking the monastic habit, did not have recourse to persons more advanced in the religious life, who formerly would have been wont to receive the hairs of their head, but, using images, allowed their hairs to fall, as it were, into the bosom of the same. Certain priests and clerics scraped the paint of images and, mixing this with the eucharistic bread and wine, let the communicants partake of this oblation after the celebration of the mass. Others again placed the Body of the Lord in the hands of images and made the communicants receive it therefrom. Others yet, spurning the Church, used panel images in the place of altars, and this in ordinary houses, and over them they celebrated the holy ministry, and they did in the churches many other illicit things of this kind that were contrary to our faith and appeared to be altogether unseemly to men of learning and wisdom.

Wherefore, the orthodox Emperors and most-learned bishops decreed that a local council be convened so as to examine these matters, and they came together under the inspiration of the Holy Ghost.[39] By common decision they forbade such practices in any place whatever, and caused images to be removed from positions near the ground lest they be worshipped by ignorant and weak persons; on the other hand, they allowed those images that had been placed higher up to remain in place, so that painting might fulfil the purpose of writing, but they did not permit[40] either lamps to be lit before them or incense to be burnt. Such also is our belief and conviction, and we reject from Christ's Church those who cling to the above wicked inventions.

Theophanes Continuatus pp. 99 f.: Of his [Theophilus's] predecessors—these were Leo and Theophilus's father Michael—the latter decreed that on no image, wherever it may be depicted, should the word "holy"[41] be inscribed, since he conceived the wrong opinion that this epithet was appropriate to none but God.... "This is what he decreed," quoth he [Theophilus], "while the other, i.e., Leo, that [images] should not even be venerated. As for me, [I decree] that they should not even be depicted with colors. Inasmuch as they are lowly, one ought not to be excited

38 Cf. p. 174.
39 The Iconoclastic Council of 815.
40 Actually, the text says "they did not prohibit" (*sed neque eis lucernas accenderent, neque incensum adolerent, prohibuerunt*), but this appears to be the opposite of the required meaning.
41 In Greek the word *hagios* means both "saint" and "holy."

about them, but to look up to Truth alone." For this reason holy pictures were taken down in all churches, while in their stead beasts and birds were set up and depicted, thus evidencing his beastly and servile mentality. For this reason, too, were holy vessels profaned in the marketplace by impure hands, being, as they were, thrown down on the ground and burnt, so that those venerable objects that had holy figures carved upon them came to be regarded as profane.

The Painter Lazarus

Theophanes Continuatus pp. 102 ff.: Inasmuch as the tyrant [Theophilus] had resolved that all painters of sacred images should be done away with, or, if they chose to live, that they should owe their safety to having spat upon [these images], and thrown them to the ground as something unclean, and trodden upon them; so he determined to bring pressure on the monk Lazarus who at that time was famous for the art of painting. Finding him, however, to be above flattery and not amenable to his will, and having been reproved by him not once or twice, but several times, he subjected him to such severe torture that the latter's flesh melted away along with his blood, and he was widely believed to have died. When he [Theophilus] heard that Lazarus, having barely recovered in prison, was taking up his art again and representing images of saints on panels, he gave orders that sheets of red-hot iron should be applied to the palms of his hands. His flesh was thus consumed by fire until he lost consciousness and lay half-dead. Yet he was destined to be preserved by Grace as a spark of light for the following generation. For when he [Theophilus] was informed that Lazarus was on his deathbed, he released him from prison thanks to the supplication of the Empress and some of his closer associates, and Lazarus took refuge at the church of the Forerunner called *tou Phoberou*[42] where, in spite of his wounds, he painted an image of the Precursor that exists to this day[43] and performs many cures. These things happened at that time; when, however, the Tyrant had died and True Faith shone forth once again, it was he who with his own hands set up the image of the God-man Jesus Christ at the Brazen Gate.[44] Invited by the illustrious Theodora to grant and seek forgiveness for her husband, he replied, "God is not so unjust, O Empress, as to forget our love and labors on His behalf, and attach greater value to that man's hatred and extraordinary insanity." But that was later.

[42] On the Asiatic shore of the Bosphorus, near the mouth of the Black Sea. See R. Janin in *Echos d'Orient*, XXXVII (1938), 344 ff.
[43] I.e., in the middle of the 10th century.
[44] On the previous destruction of this image see pp. 152, 157.

Buildings of Theophilus (829–42)

Theophanes Continuatus pp. 94 f.: He [Theophilus] likewise showed his diligence by devoting himself to works of construction. He rebuilt from the foundations [those parts of] the walls [of Constantinople] that were fairly low, and having, so to speak, obliterated the effects of age, made them high and beautiful and altogether inaccessible to the enemy. These walls still exhibit his name written upon them.[45] Furthermore, he expelled the prostitutes from their houses and having cleansed that whole area, he constructed a hospice bearing his own name, a building of great beauty and size, airy and attractive. . . . In addition, he erected at great expense a house and a palace for his daughters in the locality called *ta Karianou*,[46] of which some remains are still extant today, a monument to their memory.

Theophanes Continuatus pp. 98 f. *In 830 John the Synkellos (later patriarch of Constantinople) was sent on an embassy to Baghdad and was greatly impressed by the splendor of the Arab capital.* Having come back to Theophilus and described to him the things [he had seen] in Syria [*sic*], he [John] persuaded him to build the palace of Bryas[47] in imitation of Arab [palaces] and in no way differing from the latter either in form or decoration. The work was carried out according to John's instructions by a man named Patrikês who happened to be also adorned with the rank of patrician. The only departure he made [from the Arab model] was that he built next to the bedchamber a church of Our most-holy Lady, the Mother of God, and in the courtyard of the same palace a triconch church of great beauty and exceptional size, the middle part of which was dedicated to the Archangel [Michael], while the lateral parts were dedicated to women martyrs.

Leo Grammaticus p. 215: Being a lover of adornment, Theophilus caused to be made by the master of the mint (a most cultivated man who was related to the patriarch Anthony) the Pentapyrgion[48] and the two

45 Theophilus restored the walls along the Sea of Marmara and those along the Golden Horn. Many of his inscriptions are still in existence: cf. C. Mango, "Byzantine Inscriptions of Constantinople," *American Journal of Archaeology,* LV (1951), 55 ff.

46 Cf. p. 128.

47 Near Bostancī, an Asiatic suburb of Constantinople. The substructures of this palace have been plausibly identified by S. Eyice, "Bryas Sarayī," *Belleten,* XXIII (Ankara, 1959), 79 ff.

48 This was a piece of furniture, some kind of a vast cupboard crowned by five towers. It was kept in the Chrysotriklinos and was used for exhibiting various precious objects. See J. Ebersolt, *Le Grand Palais de Constantinople* (Paris, 1910), p. 82.

enormous organs of pure gold which he decorated with different stones and glasses, as well as a golden tree in which were perched birds that warbled musically by means of some device.[49] He also renovated the imperial vestments which he adorned with gold embroidery.

Theophanes Continuatus pp. 139 ff.: In this way he [Theophilus] ended his life, and so we shall take our leave of him and turn our attention to his remaining buildings which are in the palace, buildings that are very remarkable and worthy of mention. You will find them facing you directly as you enter [the palace] by the [church of the] Lord. Indeed, the Karianos, which is so named because it has in its staircase (*gradôsis*)[50] a broad stream, so to speak, of Carian marble,[51] and is today used as a *vestiarium* for storing away silken vestments, is a work due to his solicitude, as is also the neighboring Triconchos (so named after its shape) which has a gilded roof. The latter rises up in three conches, one of which is built towards the east and is supported on four columns of Roman stone [i.e., porphyry], while the other two are transverse, facing north and south respectively. The western part of the building is borne on two columns and has three doors leading out. The middle door is made of silver, while those on either side are of burnished bronze. The exit leads into the Sigma, so named because of its resemblance to the letter,[52] the walls of which bloom with as much beauty as those of the Triconchos, for both are reveted with slabs of variegated marble. The Sigma has a firm and splendid roof supported on fifteen columns of Docimian stone.[53] If you go down the staircase to the basement, you will find it to be similar in shape [to the Sigma] and to be supported on nineteen columns: its ambulatory is paved with speckled marble (*piperaton*). Next to this ambulatory, further in towards the east, the builder has erected a kind of *tetraseron*[54] which also comprises three conches after the likeness of the Triconch that lies above it, except that whereas one of them faces east, the other two are directed towards the west and the south respectively. The northern bay of the *tetraseron* has, separated off by two columns of speckled porphyry, a *mystêrion* which has received this appropriate name for the following reason: just as resonant caves transmit to the listener the complete echo of sounds, so likewise if one approaches the wall of the eastern or the western conch and says something in secret to oneself, another man standing diametrically opposite is able to hear those secret

49 This tree as well as two golden lions, two golden griffins, and a gold organ, weighing a total of 20,000 lbs. of gold, was later melted down by Michael III and minted into coin: Theophanes Continuatus, p. 173.

50 Meaning doubtful.

51 On Carian marble see p. 63.

52 I.e., a building in the shape of a lunate C.

53 From Docimion in Phrygia. This marble, which is still quarried, comes in several colors: it may be pure white, yellowish, or it may have a purple vein.

54 I.e., a building of four bays (three conches plus the central bay).

sounds by applying his ear to the wall. Such is the extraordinary thing that happens here.

This building adjoins the peristyle of the Sigma, which we have already mentioned, so that the two form a kind of unit. The latter [i.e., the peristyle of the Sigma] gives on to an open terrace in the middle of which is a bronze fountain having a rim crowned with silver and a gilded cone. This is called the Mystic Fountain of the Triconch on account of the adjoining buildings, namely the Mysterion and the Triconch. Next to the fountain are set up steps of white Proconnesian marble, and in the middle of the said steps is a marble arch supported on two columns slender as reeds. There, too, next to the long side of the Sigma have been erected two bronze lions with gaping mouths. These spouted water and flooded the entire hollow area of the Sigma, thus providing no small amount of pleasure. At the time of receptions the fountain was filled with pistachios and almonds as well as pine nuts, while spiced wine flowed from the cone for the enjoyment of all those that stood there and were desirous of partaking, i.e., all the performers and those who played the organs and those who sang in a choir. The demes and the citizens together with the suburban contingents[55] stood on the steps and performed the order of the imperial ceremony, having at their center, i.e., under the said marble arch, both the *domestici* of the Schools and the Excubita, if they happened to be on hand, and the demarchs of the two factions, the Green and the Blue. . . .[56] The emperor, who sat on a gold throne encrusted with gems, watched these proceedings and took great pleasure in them; in fact, he did not arise, as laid down in the books of rules (*taktika*) and imperial ceremonial, until he had enjoyed the spectacle of those dances and leaps performed by the citizens. It was for this purpose that these [constructions] were made by Theophilus, and he took such great joy in them that he performed at the Triconch both the conduct of his normal affairs and the daily processions.

Facing the silver door of the Triconchos is a structure whose roof is borne aloft by four columns of Thessalian, i.e., green marble. Directly opposite the latter and close to the aforementioned steps, i.e., to the west of the Sigma, are a number of halls that were built by Theophilus. The first, which has a low position, is called Pyxites; the second, which is

55 The demes of Constantinople were civic groups whose function, by the 9th century, was limited to conducting games in the hippodrome and appearing at various celebrations and processions. There were four demes assimilated to the four circus factions (Blues, Greens, Whites, Reds) and each was divided into an urban and a suburban section. The suburban sections had a military organization.

56 The urban sections of the demes were headed by two demarchs, that of the Blues (and Whites) and that of the Greens (and Reds). The suburban (*peratic*) sections were governed by the chiefs of the palace guard, the domestic of the Schools (or Scholae) and that of the Excubita.

higher up and serves as the residence of the imperial clergy, has no name. On the side of the Pyxites are carved verses, the composition of Stephen *a secretis*, surnamed Capetolites. As for the verses carved in the ambulatory of the Sigma, they are by Ignatius, the university professor. On the left side, i.e., to the east of the Sigma, is another hall, called Eros, which served as Theophilus's armory. For this reason, one sees on its walls pictures of nothing but shields and all kinds of weapons. So much then for the buildings that were put up starting with the Triconchos and going in a westerly direction. Now, on the eastern side you may see the hall named Margarites, which was also built entirely by Theophilus. Its roof is supported on eight columns of mottled pink marble, its walls are decorated with different kinds of pictures, while the floor is paved with Proconnesian marble and *opus sectile*. The attached bedchamber has a domed ceiling speckled with gold; this is upheld by four columns of Bathy marble (*bathuinos*),[57] while the porches on the east and south sides are held up each by four columns of Thessalian marble. The walls and the floor are splendidly reveted in the same fashion as the Margarites. Theophilus used to reside in this bedchamber from the spring equinox until the autumnal one and even later; as, however, the winter solstice approached he used to move to another bedchamber, next to the hall named Karianos, which was also built by him with a view to being exposed to the strong gusts of the south wind. The latter chamber now serves as the residence of the chief janitor. One should also observe the terrace that was set up there by Theophilus in a northerly direction, from which terrace one could see the old polo-grounds: the latter occupied the area upon which the glorious Emperor Basil [I] erected the New Church, the two fountains and the enclosed garden.[58] Such then are the buildings of Theophilus on the eastern side.

As for the southern side, first he extended the terraces, as we have already said, and laid out the gardens which are still extant. In addition, he built there a number of chambers, namely the Kamilas, as it is called, and next to it a second chamber, and then a third which today houses the wardrobe of the Empress. The ceiling of the Kamilas is speckled with gold and is upheld by six columns of Thessalian, i.e., green marble. The lower part of the walls is reveted with slabs of the same marble, while the upper part has gold mosaic representing figures picking fruit. The floor is paved with Proconnesian marble. Attached [to the Kamilas] is a chapel containing two altars, one dedicated to Our most-holy Lady, the Mother

57 The nature of this marble is unknown to me. Du Cange, *Glossarium mediae graecitatis*, s.v. explains the term as meaning "dark," but I suspect it is a toponymic, perhaps after a river called Bathys ("deep"), of which there were two in Asia Minor, one on the Black Sea Coast, the other near Dorylaion in Phrygia.

58 On these see pp. 194 ff.

of God, the other to the archangel Michael. Underneath this is a mezzanine which has a window with a marble grille overlooking the Chrysotriclinos; this has been converted into a library by Constantine [VII] Porphyrogenitus, the Christ-loving Emperor. There, too, is a dining room, its walls decorated with slabs of Bathy marble and its entire floor with *opus sectile* of different colors. The second chamber after the Kamilas has a similar ceiling supported on four columns of Docimian marble, while its floor is paved with Proconnesian marble; on its walls are mosaics whose background is entirely gold, while the rest consists of trees and green ornamental forms. Below this is a mezzanine which serves as the residence of the eunuchs to whose care the ladies' quarters are entrusted. The third chamber, which is now used for the Empress's wardrobe, has a ceiling similar to the other two and a floor likewise paved with white Proconnesian marble; all its walls were later decorated with [religious] images by Michael [III], the son of Theophilus. The basement which is joined to this chamber has its roof supported on seven columns of Carian marble, five to the south and two to the east, and is enclosed by two walls adorned with slabs of Roman, Pêganusian[59] and Carian marble as well as strips of green Thessalian marble. This building is called Mousikos on account of the precise joining of its marbles; its pavement likewise consists of various beautiful stones forming different shapes. When you see this building, you think it is a meadow abounding in various flowers. Joined to the west side [of the Mousikos] is another chamber which exhibits the beauty of marbles and has its roof upheld by five columns of Carian stone, three to the south and two to the west. At the foot of this building is another one which adjoins the Empress's chamber and is divided into two rooms. Leo [VI], the Christ-loving Emperor, built there a chapel of St. Anne whose roof is likewise upheld on four columns of Bathy marble, while its floor is reveted with Proconnesian white and its walls with slabs of Bathy marble. This, as we have said, is close to the Empress's chamber; while the one to the west of the Mousikos has a staircase leading down into the aforementioned chamber and an entrance of the same kind; it also opens on to the Kainourgion (which is a hall and a bedchamber built by Basil the illustrious Emperor)[60] and on to the porch of the Pentacubiculon in which is an oratory of St. Paul set up by the same illustrious Emperor Basil.

Such then are the buildings that were erected within the palace, on the north and south sides, by Theophilus, and we have consigned [an account of] them to our history because, with a view to revealing the conduct of his life, we did not wish any of his deeds to be forgotten. It was he also who decorated with golden mosaics the two halls—I mean the

[59] See p. 206, n. 123.
[60] On this see p. 196.

one called Lausiacos and the hall of Justinian [II]—and he transferred to the Lausiacos the coffering from the palace of the usurper Basiliscus. He also built another hall along with four splendid chambers, of which two—these adjoin the mezzanine of the second chamber following the Kamilas—have their golden ceiling supported by four arches and are close to the Porphyra (so named because according to an old tradition the Empress distributes purple cloth there among the noblewomen at the time of the Brumalia);[61] whereas the other two are close to the Lausiacos and overlook the latter. Theophilus paved these with Proconnesian marble and adorned their walls not with marble but with paint; they have been, however, destroyed by fire. Thecla, the eldest daughter of Theophilus, also built a very beautiful chamber at the Blachernae, at the spot where there is a church of St. Thecla, the first martyr. She ended her days there, being then bed-ridden.

The Iconoclastic Position

Definition (Horos) *of the Iconoclastic Council of 754.*[62] *This document begins with a brief account of the Creation; the corruption of man by Lucifer, the inventor of idolatry; the Incarnation, which liberated man from idol-worship; the renewed introduction of idolatry under cover of Christianity; and the first six ecumenical councils which established the doctrine of Christ's two natures and single hypostasis.*

After examining these matters with much care and deliberation . . . we have found that the illicit craft of the painter was injurious to the crucial doctrine of our salvation, i.e., the incarnation of Christ, and that it subverted the six ecumenical councils that had been convened by God,[63] while upholding Nestorius who divided into two sons the one Son and Logos of God who became man for our sake;[64] yea, and Arius, too, and Dioscorus and Eutyches and Severus who taught the confusion and mixture of the one Christ's two natures.[65]

[61] A pagan Roman festival in honor of Bacchus which, in spite of ecclesiastical opposition, continued to be celebrated at the court of Constantinople between late November and mid-December.

[62] Text in Mansi, XIII, 208 ff. This document was read out piecemeal at the Seventh Ecumenical Council (787), each passage being followed by its refutation. See M. V. Anastos, "The Argument for Iconoclasm as Presented by the Iconoclastic Council of 754," *Late Classical and Mediaeval Studies in Honor of A. M. Friend, Jr.* (Princeton, N.J., 1955), pp. 177 ff.

[63] Mansi XIII, 240 C.

[64] *Ibid.*, 241 E. Nestorius, Patriarch of Constantinople (428-31), was condemned, rightly or wrongly, for dividing Christ into two persons.

[65] *Ibid.*, 244 D. These, except for Arius, were Monophysites condemned by the Council of Chalcedon (451) for teaching that Christ had only one nature. Arius is included in this heretical group as having been in some way its precursor.

Wherefore we have considered it proper to demonstrate in detail by the present Definition the error of those who make and reverence [images]....[66] How senseless is the notion of the painter[67] who from sordid love of gain pursues the unattainable, namely to fashion with his impure hands things that are believed by the heart and confessed by the mouth![68] This man makes an image and calls it Christ: now the name "Christ" means both God and man. Hence he has either included according to his vain fancy the uncircumscribable Godhead in the circumscription of created flesh,[69] or he has confused that unconfusable union ... and in so doing has applied two blasphemies to the Godhead, namely through the circumscription and the confusion. So also, he who reveres [images] is guilty of the same blasphemies. Both deserve the same condemnation in that they have erred together with Arius, Dioscorus, Eutyches and the heresy of the Acephali.[70]

When they are condemned by the right-minded for having attempted to delineate the incomprehensible and uncircumscribable divine nature of Christ, they resort forsooth to another base excuse, namely that "We paint the image of the flesh alone, which we have seen and touched and with which we have lived;" which is an impiety and an invention of the evil genius of Nestorius.[71] *The bishops go on to state that the flesh of Christ is the flesh of the divine Logos, and the two cannot be separated; the same applies to Christ's soul.*

Granted, therefore, that at the Passion the Godhead remained inseparable from these [i.e., Christ's body and soul], how is it that these senseless men ... divide the flesh that had been fused with the Godhead and [itself] deified, and attempt to paint a picture as if it were that of a mere man? In so doing they fall into another abyss of lawlessness, namely by severing the flesh from the divinity, and by attributing to the flesh a separate hypostasis and a different person which they claim to represent, for thereby they add a fourth person to the Trinity....[72] *The only true image of Christ is the bread and wine of the Eucharist as He Himself indicated.*[73] On the other hand, the images of false and evil name have

66 *Ibid.,* 245 D.

67 There is an untranslatable pun here: *skaiographos* (painter of stupid things) instead of *skiagraphos.*

68 Mansi XIII, 248 E.

69 The terms "circumscribable" (*perigraptos*) and "uncircumscribable" (*aperigraptos*) have a technical meaning in the Iconoclastic controversy. The former is applied to anything that is finite, bounded and visible, hence admitting of representation; the latter to the infinite and invisible.

70 Mansi XIII, 252 A. The Acephali were rigid partisans of Eutyches who resisted the efforts at conciliation between the Monophysites and the Orthodox at the end of the 5th cenury.

71 *Ibid.,* 256 A.

72 *Ibid.,* 257 E–260 A.

73 *Ibid.,* 261–64.

no foundation in the tradition of Christ, the apostles and the Fathers, nor is there a holy prayer that might sanctify an image, and so transform it from the common to a state of holiness; nay, it remains common and devoid of honor, just as the painter has made it.[74]

If the above is acceptable insofar as it applies to Christ, in whom two natures were united, a man might still object that the same reasoning was not applicable to the Virgin Mary, the prophets, apostles, and martyrs who were "mere men." To this it may be retorted that once the image of Christ has been abolished, there is no need for the others. In general, Christianity steers a middle course between Judaism and paganism and does not borrow the ritual of either; it abhors the bloody sacrifices and burnt offerings of the Jews as well as the idol-making and idol-worship of the pagans. Men who have no hope of resurrection vainly attempt to represent what is not present as if it were present, but the Church of Christ, which contains no alien elements, rejects such satanic inventions. The saints live with God after their death on earth; to represent them by means of a dead art is to insult them.[75]

How indeed do they dare depict through the gross art of the pagans the all-praised Mother of God who was overshadowed by the plenitude of divinity, through whom an unapproachable light did shine for us, who is higher than the heavens and holier than the cherubim? Or [the saints] who will reign with Christ, and sit beside Him to judge the world, and share in His glory (of whom Scripture says that the world was not worthy of them)[76]—are they not ashamed to depict them through pagan art? For it is not lawful to Christians who believe in the resurrection to adopt the customs of demon-worshipping gentiles, and to insult by means of inglorious and dead matter the saints who will be adorned with so much glory. Indeed, we do not accept from aliens the proofs of our faith: yea, when the demons addressed Jesus as God, He rebuked them, because He deemed it unworthy that demons should bear testimony concerning Him.[77]

The Horos proceeds to adduce a number of passages from the Bible and from the Fathers (Epiphanius, Gregory Nazianzen, John Chrysostom, Basil, Athanasius, Amphilochius of Iconium, Theodotus of Ancyra, Eusebius) in support of iconoclastic doctrine. This is followed by a number of resolutions:

Let no man dare to pursue henceforth this impious and unholy practice. Anyone who presumes from now on to manufacture an icon, or

[74] *Ibid.,* 268 B–C.
[75] *Ibid.,* 272–76.
[76] Hebr. 11:38.
[77] Mansi XIII, 277 C–E. (Cf. Mark 1:25; Luke 4:41.)

to worship it, or to set it up in a church or in a private house, or to hide it, if he be a bishop or a presbyter or a deacon, he shall be deposed; if he be a monk or a layman, he shall be anathematized and deemed guilty under imperial law as a foe of God's commands and an enemy of the doctrines of the Fathers.[78]

This we also decree that no man who has charge of a church of God or a pious establishment shall, on the pretext of diminishing this error of icon [-worship], lay his hands on holy vessels consecrated to God for the purpose of altering them if they happen to have pictures on them,[79] or on altar-cloths (*endutai*) or other veils or any other object consecrated to the holy ministry lest these be put to waste.[80] If, however, a man receives from God such ability, and wishes to alter the aforesaid vessels or altar-cloths, he shall not presume to do so without the consent and knowledge of the most-holy and blessed Ecumenical Patriarch and permission of our most-pious and Christ-loving Emperors, lest under this pretext the devil dishonor God's churches; nor shall any dignitary or any of his subordinates, i.e., a member of the laity, under the same pretext lay his hands on the holy churches and sack them, as has been done in the past by certain individuals acting in a disorderly manner.[81]

The Horos *concludes with a string of anathemas in which the argument against icons is recapitulated.*

Definition (Horos) *of the Iconoclastic Council of 815*[82]: [5] This Council,[83] having confirmed and fortified the divine doctrines of the holy Fathers and followed [the lead of] the six holy Ecumenical Councils, formulated [a set of] most pious canons; [6] wherefore the Church of God remained untroubled for many years and guarded the people in peace; [7] until it chanced that the imperial office passed from [the hands of] men into [those of] a woman, and God's Church was undone by female frivolity: for, guided by most ignorant bishops, she convened a thoughtless assembly,[84] [8] and put forward the doctrine that the incomprehensible Son and Logos of God should be painted [as He was] during the Incarnation by means of dishonored matter. [9] She also heedlessly stated that lifeless portraits of the most-holy Mother of God and the saints who share in His [i.e., Christ's] form should be set up and worshipped, thereby

78 *Ibid.*, 328 C.
79 *Ibid.*, 329 D.
80 *Ibid.*, 332 B.
81 *Ibid.*, 332 D.
82 Preserved in fragments in a treatise of the Patriarch Nicephorus known by the title *Refutatio et eversio*. Ed. P. J. Alexander, *Dumbarton Oaks Papers*, VII (1953), 58 ff.
83 The Iconoclastic Council of 754.
84 The Seventh Ecumenical Council of 787.

coming into conflict with the central doctrine of the Church.[85] Further, she confounded our worship (*latreutikê proskunêsis*)[86] by arbitrarily affirming that what is fit for God should be offered to the inanimate matter of icons, [10] and she senselessly dared state that these were filled with divine grace, and by offering them candlelight and sweet-smelling incense as well as forced veneration, she led the simple-minded into error. . . . [14] Wherefore, taking to heart the correct doctrine, we banish from the Catholic Church the unwarranted manufacture of the spurious icons that has been so audaciously proclaimed, [15] impelled as we are by a judicious judgment; nay, by passing a righteous judgment upon the veneration of icons that has been injudiciously proclaimed by Tarasius,[87] and so refuting it, we declare his assembly invalid in that it bestowed exaggerated honor to painting,[88] namely, as has already been said, the lighting of candles and lamps and the offering of incense, these marks of veneration being those of worship. [16] We gladly accept, on the other hand, the pious council that was held at Blachernae, in the church of the all-pure Virgin, under the former pious Emperors Constantine and Leo,[89] a council that was fortified by the doctrine of the Fathers, and in preserving without alteration what was expressed by it, we decree that the manufacture of icons is unfit for veneration and useless. We refrain, however, from calling them idols since there is a distinction between different kinds of evil.

The Orthodox Position

St. John Damascene, *De fide Orthodoxa* IV, 16:[90] Inasmuch as some people blame us for reverencing and honoring the images of the Saviour, of our Lady and furthermore of the other saints and servants of Christ, they should hearken to [the statement] that in the beginning God made man in His own image.[91] Why is it indeed that we revere each other, if we had not been made in God's image? As the God-inspired Basil, who was learned in things divine, says, "The honor [shown] to the image is conveyed to its prototype."[92] The prototype is the subject represented

85 This repeats the formulation of 754: see p. 165.
86 This is the technical term for the veneration that is due only to God. The defenders of icons claimed for the latter a "relative veneration" (*schetikê proskunêsis*) as distinct from the "veneration of worship."
87 Patriarch of Constantinople (784–806) under whom the Council of 787 was held.
88 Literally "to colors."
89 The Council of 754.
90 PG 94, 1158 ff.
91 Gen. 1:26.
92 See p. 47.

from which the derivative (*paragôgon*) is made.[93] Why is it that the Mosaic people worshipped the Tabernacle all round, which contained the image and pattern (*tupos*) of heavenly things, or rather of the whole creation? For God said to Moses, "Look that thou make everything after the pattern which was shewed thee in the mount."[94] And the cherubim that overshadowed the mercy-seat,[95] were they not made by human hands? And what of the famous temple of Jerusalem? Was it not constructed by human hands and skill?

Divine Scripture condemns those who worshipped works of carving, but also those who sacrificed to the demons. The pagans offered sacrifice, and so did the Jews; but while the pagans sacrificed to demons, the Jews sacrificed to God. And whereas the sacrifice of the pagans was rejected and condemned, that of the righteous was acceptable to God. For Noah offered sacrifice and God smelled a sweet savor,[96] i.e., He accepted the fragrance of Noah's good will and love towards Him. Thus, the carvings of the pagans are rejected and prohibited because they represented demons.

Furthermore, who is capable of making a likeness of God who is invisible, incorporeal, uncircumscribable and without form? It is an act of extreme folly and impiety to figure God. Hence, the use of images was not practised in [the times of] the Old Testament. But since God, out of His innermost mercy, became truly man on account of our salvation, not as He had been seen in human form by Abraham and the Prophets, but verily a man in substance who lived on earth, conversed with men, worked miracles, suffered, was crucified, arose [from the dead] and was carried up [to heaven]; since all of these things happened truly and were seen by men, they were written down for the remembrance and instruction of us who were not present at the time, so that, though we had not seen, but have heard and believed, we may be deemed worthy of the Lord's blessing.[97] Since, however, not everyone knows how to read or has leisure for reading, the Fathers saw fit that these things should be represented in images, like deeds of prowess, to serve as brief reminders; for often, when we are not thinking of the Lord's passion, we see the image of the Crucifixion and, being reminded of that salutary passion, we fall to our knees and revere, not the matter, but the One represented; just as we do not adore the matter of the Gospel book or the matter of the cross, but that which is expressed (*ektupôma*) by them. For what is the difference between the cross that does not bear the Lord's representation (*ektupôma*)

[93] I.e., the image. In grammatical terminology *prôtotupon* (root word) was the opposite of *paragôgon* (derivative). See, e.g., Dionysius Thrax, *Ars grammatica*, ed. G. Uhlig (Leipzig, 1883), p. 25.
[94] Exod. 25:40.
[95] Exod. 25:18.
[96] Gen. 8:21.
[97] Cf. John 20:29.

from the one that does? And the same applies to the Mother of God, since the honor done to her is transmitted to Him who took on flesh from her. And likewise the valiant deeds of saints[98] incite us to courage and zeal and the imitation of their virtue for the glory of God. . . . The tradition is unattested (*agraphos*),[99] just as that of praying towards the east, adoring the cross and many other similar things.

A story is told that Abgar, the King of Edessa, sent a painter to make a likeness of the Lord and this painter was unable to do so because of the splendor that shone from His face, whereupon the Lord placed a cloth upon His divine and life-giving countenance and impressed upon it His image which he sent to Abgar [to satisfy the latter's] desire.[100]

St. John Damascene, *De imag. orat.* III, 16 ff.[101] 16. First, what is an image? An image is a likeness, an exemplar or a figure (*ektupôma*) of something, such as to show in itself the subject represented. Surely, the image is not in all respects similar to its prototype, i.e., its subject; for the image is one thing and the subject another, and there is necessarily a difference between them. . . . For example, the image of a man represents the characteristics of his body, but is not endowed with his spiritual faculties: it does not live or think or speak or feel or move a limb. And a son, who is the natural image of his father, is in some ways different from the latter, for he is the son and not the father.

17. Secondly, what is the purpose of an image? Every image is declarative and indicative of something hidden. I mean the following: inasmuch as a man has no direct knowledge of the invisible (his soul being covered by a body), or of the future, or of things that are severed and distant from him in space, being as he is circumscribed by place and time, the image has been invented for the sake of guiding knowledge and manifesting publicly that which is concealed. . . .

18. Thirdly, how many different kinds of images are there? The different kinds of images are these: The first kind is the natural. . . . Thus the first, natural and identical image of the invisible God is the Son of the Father, who exhibits the Father within Himself. . . .

19. The second kind of image is God's knowledge of what will be done by Him, i.e., His will that precedes time. . . . For his notion concerning each particular thing that will occur at His bidding is an image or exemplar of that thing. . . .

20. The third kind of image is the one made by God in the way of imitation, i.e., man. . . .

98 I.e., pictures of the deeds of martyrs.

99 I.e., the tradition of Christian painting has no scriptural authority.

100 On the famous Abgar legend, which took shape in the second half of the 6th century, see esp. E. von Dobschütz, *Christusbilder* (Leipzig, 1899), pp. 102 ff.

101 PG 94, 1337 ff.

21. The fourth kind of image is when Scripture invents figures, forms and symbols for invisible and incorporeal things, and the latter are represented in bodily form for the sake of a faint understanding of God and the angels, inasmuch as we are unable to contemplate incorporeal beings without figures that correspond to our comprehension, as stated by Dionysius the Areopagite, a man learned in divine things.[102] It is indeed with good reason that forms of the formless and figures of the figureless have been set before us, namely that our condition is unable to rise directly to the contemplation of intelligible things and is in need of aids appropriate to our nature so as to guide us upwards. . . .

22. The fifth kind of image is said to be the one which represents and delineates the future in advance, as the [burning] bush,[103] and the dew upon the fleece,[104] and the rod,[105] and the pot [of manna[106] represented] the Virgin who is also the Mother of God; and as the [brazen] serpent[107] [represented] Him who by means of the cross was to heal the bite of the [other] serpent, the originator of evil; and as the sea, the water and the cloud[108] [represented] the Spirit of baptism.

23. The sixth kind of image serves to record events, be it a miracle or a virtuous deed, for the glorification . . . of men who have excelled and distinguished themselves in virtue. . . . This is of two kinds: in the form of speech that is written in books . . . and in the form of visual contemplation. . . . So, even now, we eagerly delineate images of the virtuous men of the past for the sake of love and remembrance.

Acts of the Seventh Ecumenical Council (787):[109] The making of icons is not the invention of painters, but [expresses] the approved legislation of the Catholic Church. Whatever is ancient is worthy of respect, saith St. Basil, and we have as testimony [first] the antiquity of the institution and [second] the teaching of our inspired Fathers, namely that when they saw icons in holy churches they were gratified, and when they themselves built holy churches they set up icons in them. . . . The conception and the tradition are therefore theirs and not of the painter; for the painter's domain is limited to his art, whereas the disposition manifestly pertains to the Holy Fathers who built [the churches]. The name "Christ" is indicative of both divinity and humanity—the two perfect natures of the Saviour. Christians have been taught to portray this image in accordance with His visible nature, not according to the one in which He was

102 E.g., *De ecclesiastica hierarchia,* I, 2, PG 3, 373; *De divinis nominibus,* I, 1, *ibid.,* 588, etc.
103 Exod. 3:2.
104 Judges 6:40.
105 Aaron's rod which budded: Num. 17:8.
106 Exod. 16:33.
107 Num. 21:9.
108 Exod. 14:20 ff.
109 Mansi XIII, 252.

invisible; for the latter is uncircumscribable and we know from the Gospel that no man hath seen God at any time.[110] When, therefore, Christ is portrayed according to His human nature it is obvious that the Christians, as Truth has shown, acknowledge the visible image to communicate with the archetype in name only, and not in nature; whereas these senseless people [the Iconoclasts] say there is no distinction between image and prototype and ascribe an identity of nature to entities that are of different natures. Who will not make fun of their ignorance?

St. Theodore the Studite, *Epist. ad Platonem*:[111] Every artificial image is a likeness of that whereof it is the image, and it exhibits in itself, by way of imitation, the form (*charaktêr*) of its model (*archetupon*), as expressed by Dionysius, learned in divine things: the truth in the likeness, the model in the image, the one in the other, except for the difference of substance. Hence, he who reveres an image surely reveres the person whom the image shows; not the substance of the image, but him who is delineated in it. Nor does the singleness of his veneration separate the model from the image, since, by virtue of imitation, the image and the model are one. . . .

A natural image is one thing, an imitative image is another. The former has no natural difference with respect to its cause, but a difference of person, as the Son with respect to the Father: for the person (*hupostasis*) of the Son is not the same as that of the Father, while their nature is one and the same. The latter, on the other hand, has a difference of nature, but not of person, e.g., the image of Christ with respect to Christ. For the nature of painting (*hulographia*) is different from that of Christ, whereas the person is one and the same, i.e., that of Christ, even when it is delineated in an image. . . . Now, observe the distinction. In the case of the natural image and its cause, i.e., the Son and the Father, granted that their nature is one and the same, the reverence [due to them] is also one because of the identity of their nature, but not of their person. . . . Whereas in the case of the imitative picture and its model, i.e., of Christ and Christ's image, granted that the person of Christ is one and the same, the reverence is here, too, the same, because of the identity of person, without regard to the difference of nature between Christ and the image. If, however, we acknowledged that the reverence towards image and model was one, not only because of the identity of person, but also that of nature, we would be disregarding the difference between the image and the person represented . . . and falling into pagan polytheism by deifying every kind of material which is fashioned into the image of Christ. Thereby we would be giving the iconoclasts an opportunity to accuse us . . . of revering and honoring many gods, and this with good reason. If,

110 John 1:18.
111 PG 99, 500 ff.

on the other hand, we affirmed that the reverence towards image and model rested neither on identity of nature nor of person, we would clearly be severing from the image the might and glory of the model, and so in revering the image of Christ, we would be guilty of manifest idolatry by offering not one reverence, but two. This is what the iconoclasts seek to demonstrate, and by denying that Christ can be circumscribed in the flesh, they are proved to be as impious as those who believed that God came down to earth only by way of appearance and illusion....[112] Now a man might also say this: Granted that reverence is adoration (*latreia*), it follows that the image of Christ is adored together with the holy Trinity. This man would appear not to know the different nature of reverence (*proskunêsis*), inasmuch as we revere the saints, but do not adore them, neither do we adore those who rule by God's dispensation. Furthermore, he should learn that the reverence is not [directed] to the substance of the image ... but towards Christ who is revered in His image, while the material of the image remains altogether unrelated to Christ who is revered in it by virtue of similitude.... I think that the example of the mirror is appropriate, for in it, too, the spectator's face is, as it were, represented, but the similitude remains outside the material ... and when he moves away from the mirror, the reflection is simultaneously removed since it has nothing in common with the material of the mirror. The same applies to the material of the image: once the likeness that is visible upon it and towards which the veneration is directed has been obliterated, the material remains without veneration inasmuch as it has no connection whatever with the likeness. Or take the example of a signet ring engraved with the imperial image, and let it be impressed upon wax, pitch and clay. The impression is one and the same in the several materials which, however, are different with respect to each other; yet it would not have remained identical unless it were entirely unconnected with the materials.... The same applies to the likeness of Christ irrespective of the material upon which it is represented....

Such, as far as I know, basing myself on the doctrine of the holy Fathers, is the reverence towards the image of Christ. If it is subverted, Christ's incarnation is also subverted; and if the image is not revered, our reverence towards Christ is likewise destroyed.

St. Theodore the Studite, Epist. I, 17.[113] *Addressed to the spatharius*[114] *John.* We have heard that your Lordship had done a divine deed and we have marvelled at your truly great faith, O man of God. For my informer tells me that in performing the baptism of your God-guarded child, you had recourse to a holy image of the great martyr Demetrius instead of a

112 Referring to the Docetist heresy.
113 PG 99, 961.
114 A court dignity.

godfather. How great is your confidence! "I have not found so great faith, no, not in Israel"[115]—this I believe Christ to have said not only at that time to the centurion, but even now to you who are of equal faith. The centurion found what he sought; you, too, have won what you trusted in. In the Gospel the divine command took the place of bodily presence, while here the bodily image took the place of its model; there the great Logos was present in His word and invisibly wrought the incredible miracle through His divinity, while here the great martyr was spiritually present in his own image and so received the infant. These things, being incredible, are unacceptable to profane ears and unbelieving souls, and especially to the iconoclasts; but to your piety clear signs and tokens have been revealed.

St. Theodore the Studite, *Epist*. I, 19.[116] *Addressed to Theodoulos the stylite.* Forgive me, Father, for what I am about to say in all simplicity and sincere love.... Some persons have charged... that your Holiness had been acting in an improper manner.... And they have accused you both of certain words and deeds. To give one example, they alleged that you had represented in the windows angels crucified in the form of Christ, and that both Christ and the angels were shown aged.[117] Much as I questioned them, I could not contradict them. They said that you had done something foreign and alien to the tradition of the Church, and that this deed was inspired not by God, but surely by the Adversary [i.e., the Devil], seeing that in all the years that have passed no examples of this peculiar subject (*idiôma*) have ever been given by any one of the many holy Fathers who were inspired by God.

Nicephorus, *Antirrh*. III, 3:[118] Furthermore, we affirm that the delineation or representation of Christ was not instituted by us, that it was not begun in our generation, nor is it a recent invention. Painting is dignified by age, it is distinguished by antiquity, and is coeval with the preaching of the Gospel. To put it briefly and emphatically, these sacred representations, inasmuch as they were tokens (*sumbola*) of our immaculate faith, came into existence and flourished as did the faith from the very beginning: undertaken by the apostles, this practice received the approval of the Fathers. For just as these men instructed us in the words of divine religion, so in this respect also, acting in the same manner as those who represent in painting the glorious deeds of the past, they represented the

115 Matt. 8:10.

116 PG 99, 957.

117 For the identification of Christ with an angel in the Patristic period see J. Barbel, *Christos Angelos* (Bonn, 1941). Reflections in Byzantine art: J. Meyendorff, "L'iconographie de la Sagesse Divine," *Cahiers archéologiques*, X (1959), 266 ff.; S. Der Nersessian, "Note sur quelques images . . . du Christ-ange," *ibid.*, XIII (1962), 209 ff.

118 PG 100, 380.

Saviour's life on earth, as it is made manifest in evangelical Scripture, and this they consigned not only to books,[119] but also delineated on panels. . . . Therefore, he who accepts the written account will necessarily accept the pictures (*historia*) as well. . . .

Nicephorus, *Antirrh*. III, 36:[120] And what are we to say concerning the sign of the cross? The very prototype of the cross, if one may so call it, i.e., the venerable and life-giving wood, which is revered by us faithful, they shamefully insult and dishonor. And what do these impious men think of the so-called phylacteries, i.e., the gold and silver objects which have been made by Christians from the very beginning, and which we Christians wear suspended from the neck and hanging down over the breast for the protection and security of our lives . . . for which reason they have received their name . . . and upon which the passion and miracles of Christ and His life-giving resurrection are often represented, which objects are found in countless number among Christians? Instead of preserving them, they abominate them; instead of seeking them, they avoid them.

***Epist. synod. patr. Orient.* 6:**[121] The holy apostles, who "from the beginning were eyewitnesses and ministers of the Word,"[122] even as they had heard and seen and their hands had handled the Word of life,[123] so they adorned the holy Church with painted pictures and mosaics representing the likeness of Christ, the God-man, and this before they had written the God-inspired Gospels. *The Gospel of Matthew was written eight years after the Ascension; that of Mark ten years after, that of Luke fifteen years after, that of John sixty-two years after.* Hence the custom of making pictures in churches is earlier [than the Gospels] and, using the painter's colors as a book,[124] they delineated the heavenly salutation of the archangel Gabriel to the holy Virgin Mary at Nazareth; the Saviour's holy Nativity at Bethlehem; the angelic vision accorded to the shepherds who beheld with their eyes the incarnate God; the Infant, wrapped in swaddling clothes, reclining in the manger, with animals standing by; the star guiding the Magi versed in astronomy; the royal gifts[125] brought by them to the new-born babe; Symeon receiving Him in his holy arms and the testimony of the righteous Anna; the Saviour's holy Baptism by the angelic John; the descent of the Holy Ghost in the form of a dove

119 Referring presumably to illuminated manuscripts of the Gospels.
120 PG 100, 433.
121 Ed. Duchesne, pp. 273 ff. Cf. the Life of St. Pancratius of Taormina (p. 137) which also claims an apostolic origin for the New Testament picture cycle.
122 Luke 1:2.
123 I John 1:1.
124 The Greek text, as printed, is ungrammatical and possibly corrupt.
125 Emending *doruphorian*, as printed in the edition, to *dôrophorian*.

upon the one baptized; the manifestation of the wondrous and divine miracles of the Saviour; His willing and salutary sufferings; the supernatural and life-giving Resurrection after three days, the slaying of Death, the destruction of Hades and the fall of the devil; the holy women who brought unguents seeing the Saviour with their eyes and touching His immaculate feet; His apparition to the disciples who witnessed God; Thomas touching the divine chest from which life flowed forth, the immaculate hands and feet, and offering homage [to the Lord]; the Saviour's Ascension on the holy Mount of Olives; and likewise the subsequent incredible miracles of the apostles performed thanks to the visitation upon them of the Holy Ghost in the form of fiery tongues.

6

The Middle
Byzantine Period
(843–1204)

The reestablishment of icon worship, coupled with a favorable political (and hence economic) situation, led to a vigorous artistic activity that seems to have lasted about a century. The most urgent artistic task facing the government in 843 was the redecoration of the churches that had been stripped of their religious images by the iconoclasts. This was no small matter considering the immense size of some of these earlier churches, like St. Sophia and the Holy Apostles. Teams of artists had to be organized and they had to be furnished with the necessary materials, such as mosaic tesserae which were evidently in short supply.[1] We must not imagine, therefore, that new mural decorations sprang up everywhere like mushrooms; it was a slow process that was spread over several decades. The earlier churches were not only "unsightly" in the sense of being bare of religious images; they were also falling apart as a result of age, neglect, and earthquakes. An emperor like Basil I, who saw himself as the renovator of the Roman Empire, considered it his duty to "rejuvenate" these churches. The catalog of his works preserved in the Vita Basilii *is concerned much more with restoration than with new buildings.*

The concept of "renovation" was, understandably, of prime importance in the 9th century, and it meant not the creation of something new, but the regaining of what had been lost. Hence old models dating back to the time when the Christian Empire had been great (especially models of the 6th century) were sedulously copied, with this difference, however, that the economic resources of the Empire had drastically shrunk in the meantime. The domed building, already dominant at the time of Justinian, remained the norm, but it had to be made smaller, which led to the adoption of the cross-in-square, domed church supported on four columns or piers. In the case of exceptionally ambitious projects, like Basil's Nea Ekklêsia (the ancestor of a considerable progeny both in Byzantium and in Russia), subsidiary domes were placed over the four corners, thus producing a five-domed church. The scheme of internal decoration remained, however, unchanged: the vertical surfaces of the walls up to the springing of the arches were covered with a marble revetment, everything above that with mosaic or fresco. In view of the fact that most of the exotic quarries that had supplied Justinian's constructions were no longer operative, we may imagine that the slabs and columns of colored marble that we find in buildings of the 9th and subsequent centuries were to a large extent reused. The only art form that was not continued (but it was already falling into desuetude in the 6th and 7th centuries) was that of the mosaic pavement: its place was taken by opus sectile *resembling the later work of the Cosmati.*

[1] We have direct proof of this. For the decoration of the Nea Ekklêsia Basil I removed the mosaic tesserae and marble slabs from Justinian's mausoleum at the church of the Holy Apostles: *Patria*, ed. Preger, p. 288. Cf. Leo Grammaticus, p. 257: "The Emperor Basil took away many pieces of marble and mosaic cubes from many churches on account of the Nea Ekklêsia."

In painting, too, we find not invention, but imitation, contraction and standardization. The smaller dimensions of the churches necessitated a reduction of the pictorial programs which became limited to the basic New Testament cycle of "major feasts" and a number of single figures placed in hierarchical order. Painting (or mosaic) and architecture achieved a perfect balance which has been called the "classical Byzantine system,"[2] and is today known to us chiefly from monuments of the 11th century, such as Hosios Loukas, Nea Moni, and Daphni.

The period of artistic activity inaugurated under Michael III (842–67) appears to have continued until the reign of Constantine VII Porphyrogenitus (913–59). It may be said in passing that the concept of a 10th century "Macedonian Renaissance," which figures so prominently in the cogitations of modern scholars, finds little support in Byzantine sources devoted to art. The military emperors who held sway in the latter part of the 10th and the first quarter of the 11th century—Nicephorus Phocas (963–69), John Tzimiskes (969–76), Basil II (976–1025)—were not active patrons of the arts. A second period of activity set in, however, in the period which historians today call that of the "rule of the civil aristocracy" (1025–81). This period ended in disaster, the conquest of the greater part of Asia Minor by the Seljuq Turks, and the consequent shift of the center of the Empire's gravity to its Balkan possessions. The 11th century witnessed a number of lavish imperial foundations, such as St. Mary Peribleptos, St. George of the Mangana and Nea Moni on Chios, and is relatively well represented in extant monuments, but it cannot be said to have introduced any interesting artistic innovations. It may be worth noting, however, that epigrams devoted to works of art reappear at this time. They are admittedly rather tedious, and many of them are buried in inaccessible publications; yet, starting with the poems of Christophoros Mitylenaios and John Mavropous, and continuing until those of Manuel Philes and Nicephorus Callistus Xanthopoulos in the 14th century, they provide an abundant and almost unexploited source of information for art historians.

The next significant period of artistic endeavor, following the débacle of Mantzikert (1071), the First Crusade, and the consolidation of the Byzantine state under Alexius I Comnenus (1081–1118) falls toward the middle and second half of the 12th century, particularly in the reign of Manuel I (1143–80). Manuel was a gallant knight, and admirer of western customs and himself married first to a German and next to a French princess—in short, a European monarch.[3] It seems that in his reign the

2 See the stimulating book by O. Demus, Byzantine Mosaic Decoration (London, 1948).

3 See the lively sketch by Ch. Diehl, La société byzantine à l'époque des Comnènes (Paris, 1929).

closed circle of Byzantine art began to open up to outside influences, both from the West and from the East: in this connection the written sources are much more explicit than the preserved monuments. On the one hand, we hear of a building in pure Seljuq style erected in the Great Palace of Constantinople; on the other, we have the description of a painting(?) representing a tournament in which the Emperor took a prominent part.[4] The pictorial repertory of imperial exploits and conquests which, of course, had had a long ancestry in Byzantine art, enjoyed a great vogue in Manuel's reign both in mural decoration and metalwork. It is also in this period that the personality of the individual artist begins to emerge somewhat from its previous anonymity. Artists' names are recorded in inscriptions, e.g. those of Ephraem and Basil in the church of the Nativity at Bethlehem (1169) or that of Theodore Apseudes in the humble cell of St. Neophytos in Cyprus (1183). The painter Eulalios was highly esteemed at the court of Constantinople and took the unprecedented liberty of including his own portrait in a New Testament scene. The art of sculpture in the round, which had been abandoned since before the period of Iconoclasm, makes a fleeting reappearance in the reign of Andronicus I (1183–85) who also departed from tradition by having himself represented not in imperial vestments, but in those of a farm laborer. All these phenomena indicate a considerable artistic ferment in the second half of the 12th century, a wave of innovation that was broken by the collapse of 1204. There is a complementary facet of 12th century art that is also worth mentioning. Society under the Comneni had a quasi-feudal character and was completely dominated by a number of inter-married family clans. This encouraged the production of dynastic portrait series, such as the one, made up of seven images, in the monastery of the Grand Hetaeriarch George Palaeologus. In the following century the Serbian kings continued the tradition of dynastic "galleries."[5]

One of the main achievements of the Middle Byzantine period was the Christianization of the eastern Slavs, which was accompanied by a great geographical extension of Byzantine art forms. For Bulgaria, the first Slav country to have been converted, we unfortunately lack pertinent texts, except for the rather dubious story about the painter Methodius. For Kievan Russia, on the other hand, we do have literary evidence. Of particular interest is the Paterikon of the Cave Monastery which records the arrival of mosaicists from Constantinople, equipped with a stock of tesserae, and tells us how they trained a local man, Alimpij, the first Russian painter known to us by name.

[4] I have omitted it from this book for reasons of space. The text is published by S. Lampros, *Neos Hellênomnêmôn*, V (1908), 3–18.

[5] Cf. A. Grabar, "Une pyxide en ivoire à Dumbarton Oaks," *Dumbarton Oaks Papers*, XIV (1960), 131 ff.

Michael III (842–67)

Funerary Portraits

Translatio S. Theodori Studitae, 14.[6] *The bodies of St. Theodore Studite and of his brother Joseph, bishop of Thessalonica, were brought to Constantinople in 844 and buried in the monastery of Studius, in the same tomb that contained the remains of their uncle Plato.*

And now their tomb ... provides abundant grace and benefit to those that approach it. When, by night or day, we draw nigh to their remains, when we gaze at their sacred images which are depicted at the tomb, it is as if we were seeing the holy Fathers themselves. . . .

The Chrysotriklinos

Anthol. graeca I, 106. [Inscription] in the Chrysotriklinos of the Great Palace, round the ceiling:[7] The ray of Truth has shone forth again and has dimmed the eyes of the impostors.[8] Piety has grown, error has fallen, faith blooms and Grace spreads out. For behold, once again the image of Christ shines above the imperial throne[9] and confounds the murky heresies; while above the entrance is represented the Virgin as divine gate[10] and guardian. The Emperor and the Bishop[11] are depicted close by along with their collaborators inasmuch as they have driven away error, and all round the building, like guards, [stand] angels, apostles, martyrs, priests. Hence we call "the new Christotriklinos" that which aforetime had been given a golden name,[12] since it contains the throne of Christ, our Lord, the forms of Christ's Mother and Christ's heralds, and the image of Michael whose deeds are filled with wisdom.

6 Ed. Van de Vorst, p. 60.

7 The Chrysotriklinos was the principal throne room of the Great Palace. The decoration described in this epigram must have been executed between 856 and 866 because no reference is made, on the one hand, to the Empress Theodora who was expelled from the palace in 856, and, on the other, to Basil I, crowned coemperor in 866.

8 The Iconoclasts.

9 The emperor's throne was placed in the eastern apse of the Chrysotriklinos. The image of the enthroned Christ was probably in the semidome of the apse.

10 The Gate was a standard symbol of the Virgin Mary with reference to Ezek. 44:2.

11 The Patriarch Photius.

12 A pun on Chrysotriklinos (Golden Hall) and Christotriklinos (Christ's Hall).

The Church of the Virgin of the Pharos

Photius, *Homil*. X, 4 ff.[13] *The following description has long been considered to refer to the New Church (Nea Ekklêsia) built by Basil I and inaugurated in 880. In fact, it concerns the church of the Virgin of the Pharos situated very close to the Chrysotriklinos in the Imperial Palace.*[14] *This was the palatine chapel* par excellence, *and the repository of the most precious relics of Christendom.*

4. The atrium of the church is splendidly fashioned: for slabs of white marble, gleaming bright and cheerful, occupy the whole façade (*prosopsis*), and by their evenness and smoothness and close fitting they conceal the setting of one to another and the juncture of their edges, so that they suggest to the beholder's imagination the continuousness of a single [piece of] stone with, as it were, straight lines ruled on it—a new miracle and a joy to see. Wherefore, arresting and turning towards themselves the spectator's gaze, they make him unwilling to move further in; but taking his fill of the fair spectacle in the very atrium, and fixing his eyes on the sight before him, the visitor stands as if rooted [to the ground] with wonder. Legends proclaim the lyre of Thracian Orpheus, whose notes stirred inanimate things. If it were our privilege also to erect truth into legends and make it awe-inspiring, one might say that visitors to the atrium were turned with wonder into the form of trees: so firmly is one held having but seen it once.

5. But when with difficulty one has torn oneself away from there and looked into the church itself, with what joy and trepidation and astonishment is one filled! It is as if one had entered heaven itself with no one barring the way from any side, and was illuminated by the beauty in all forms shining all around like so many stars, so is one utterly amazed. Thenceforth it seems that everything is in ecstatic motion, and the church itself is circling round. For the spectator, through his whirling about in all directions and being constantly astir, which he is forced to experience by the variegated spectacle on all sides, imagines that his personal condition is transferred to the object.

Gold and silver cover the greater part of the church, the one smeared on tesserae, the other cut out and fashioned into plaques, or otherwise applied to other parts. Over here are capitals adorned [with gold], over there are golden cornices. Elsewhere gold is twined into chains,

13 Ed. Laourdas, pp. 100 ff.; trans. Mango, pp. 185 ff.
14 See R. J. H. Jenkins and C. Mango, "The Date and Significance of the Tenth Homily of Photius," *Dumbarton Oaks Papers*, IX–X (1956), 123 ff.

but more wonderful than gold is the composition of the holy table. The little doors and columns of the sanctuary together with the peristyle[15] are covered with silver; so also is the conical roof set over the holy table with the little pillars that support the canopy. The rest of the church, as much of it as gold has not overspread or silver covered, is adorned with many-hued marble, a surpassingly fair work. The pavement, which has been fashioned into the forms of animals and other shapes by means of variegated tesserae, exhibits the marvellous skill of the craftsman, so that the famous Pheidias and Parrhasius and Praxiteles and Zeuxis are proved in truth to have been mere children in their art and makers of figments. Democritus would have said, I think, on seeing the minute work of the pavement and taking it as a piece of evidence, that his atoms were close to being discovered here actually impinging on the sight. So full of wonder is everything. In one respect only do I consider the architect of the church to have erred, namely that having gathered into one and the same spot all kinds of beauty, he does not allow the spectator to enjoy the sight in its purity, since the latter is carried and pulled away from one thing by another, and is unable to satiate himself with the spectacle as much as he may desire.

6. But something has escaped me, although it should have been said first (for the wonder of the church does not permit the orator to do his own task fairly in words), so it shall be said now. On the very ceiling is painted in colored mosaic cubes a man-like figure bearing the traits of Christ. Thou mightest say He is overseeing the earth, and devising its orderly arrangement and government, so accurately has the painter been inspired to represent, though only in forms and in colors, the Creator's care for us. In the concave segments next to the summit of the hemisphere[16] a throng of angels is pictured escorting our common Lord. The apse which rises over the sanctuary glistens with the image of the Virgin, stretching out her stainless arms on our behalf and winning for the emperor safety and exploits against the foes. A choir of apostles and martyrs, yea, of prophets, too, and patriarchs fill and beautify the whole church with their images. Of these, one,[17] though silent, cries out his sayings of yore, "How amiable are thy tabernacles, O Lord of hosts! My soul longeth, yea, even fainteth in the courts of the Lord";[18] another,[19] "How wonderful is this place; this is none other but the house of God. . . ."[20]

[15] Referring to the chancel-screen with its peristyle of little columns.
[16] This suggests that the dome was gored.
[17] David.
[18] Ps. 83:2–3.
[19] Jacob.
[20] Gen. 28:17.

An Image of the Virgin in St. Sophia

Photius, *Homil.* **XVII, 2 ff.**[21] *The image in question, inaugurated on March 29, 867, is in all probability the mosaic still extant in the apse of St. Sophia.*[22]

With such a welcome does the representation of the Virgin's form cheer us, inviting us to draw not from a bowl of wine, but from a fair spectacle, by which the rational part of our soul, being watered through our bodily eyes, and given eyesight in its growth towards the divine love of Orthodoxy, puts forth in the way of fruit the most exact vision of truth. Thus, even in her images does the Virgin's grace delight, comfort and strengthen us! A virgin mother carrying in her pure arms, for the common salvation of our kind, the common Creator reclining as an infant —that great and ineffable mystery of the Dispensation! A virgin mother, with a virgin's and a mother's gaze, dividing in indivisible form her temperament between both capacities, yet belittling neither by its incompleteness. With such exactitude has the art of painting, which is a reflection of inspiration from above, set up a lifelike imitation. For, as it were, she fondly turns her eyes on her begotten Child in the affection of her heart, yet assumes the expression of a detached and imperturbable mood at the passionless and wondrous nature of her offspring, and composes her gaze accordingly. You might think her not incapable of speaking, even if one were to ask her, "How didst thou give birth and remainest a virgin?" To such an extent have the lips been made flesh by the colors, that they appear merely to be pressed together and stilled as in the mysteries, yet their silence is not at all inert neither is the fairness of her form derivatory, but rather is it the real archetype.

3. Seest thou of what beauty was the face of the Church bereft?[23] Of what splendor was it deprived? Over what graces did gloomy dejection prevail? That was the daring deed of a wretched Jewish hand,[24] lacking in no insolence. This is a most conspicuous token of a heart seized by God and of the Lord's love, whereby the initiated band of the apostles were led to perfection, through which the martyrs' winged course sped to the crowns of victory, and the prophets, God's tongues, with knowledge of future things and truthful foretelling, came unto men [bringing] undoubting belief. For verily are these things the prizes and gifts of a

21 Ed. Laourdas, pp. 166 ff.; trans. Mango, pp. 290 ff.

22 See C. Mango and E. J. W. Hawkins, "The Apse Mosaics of St. Sophia at Istanbul," *Dumbarton Oaks Papers*, XIX (1965), 113 ff.

23 I.e., during the period of Iconoclasm.

24 The iconoclasts, because of their rejection of images, were often likened to the Jews.

most sincere and divine love, from which depends likewise the veneration of holy images, just as their destruction [comes] from an irrepressible and most foul hatred. Those men, after stripping the Church, Christ's bride, of her own ornaments, and wantonly inflicting bitter wounds on her, wherewith her face was scarred, sought in their insolence to submerge her in deep oblivion, naked as she was, so to speak, and unsighty, and afflicted with those many wounds—herein, too, emulating Jewish folly. Still bearing on her body the scars of those wounds, in reproof of their Isaurian[25] and godless belief, and wiping them off, and in their stead putting on the splendor of her own glory, she now regains the ancient dignity of her comeliness, and sheds the rude mockery of those who have insulted her, pitying their truly absurd madness. If one called this day the beginning and day of Orthodoxy (lest I say something excessive), one would not be far wrong. For though the time is short since the pride of the iconoclastic heresy has been reduced to ashes, and true religion has spread its light to the ends of the world, fired like a beacon by imperial and divine command, this too is our ornament; for it is the achievement of the same God-loving reign.

4. And so, as the eye of the universe, this celebrated and sacred church, looked sad with its visual mysteries scraped off, as it were (for it had not yet received the privilege of pictorial restoration),[26] it shed but faint rays from its face to visitors, and in this respect the countenance of Orthodoxy appeared gloomy. Now, casting off this sadness also, and beautifying herself with all her own conspicuous ornaments, and displaying her rich dowry, gladly and joyously she hearkens to the Bridegroom's voice, Who cries out saying, "All fair is my companion, and there is no spot in her. Fair is my companion."[27] For, having mingled the bloom of colors with religious truth, and by means of both having in holy manner fashioned unto herself a holy beauty, and bearing, so to speak, a complete and perfect image of piety, she is seen not only to be fair in beauty surpassing the sons of men,[28] but elevated to an inexpressible fairness of dignity beyond any comparison beside. . . .

5. We, too, with gladness and joy in our souls, join the choir of this festival, and sharing today in the celebration of this restoration, we exclaim those prophetic words, saying, "Rejoice greatly, O daughter of Sion; cry aloud, O daughter of Jerusalem. The Lord has taken away thine injuries; He has delivered thee from the hand of thine enemies.[29] Lift up

[25] Referring to Leo III the Isaurian and his descendants.

[26] The Virgin in the apse was apparently the first image to have been set up in St. Sophia after the suppression of Iconoclasm. At the time when Photius was speaking the rest of the church would thus have been devoid of religious images.

[27] Cf. Solomon's Song 4:7.

[28] Ps. 44:3.

[29] Zeph. 3:14-15.

thine eyes round about, and see thy children gathered. For behold, all thy sons have come from far, yea and thy daughters,[30] bearing unto thee not gold and frankincense[31] and stones, all begotten of the earth and by human custom adorning what is precious, but purer than all gold, and more precious than all stones, the ancestral faith unadulterated. Rejoice and delight thyself with all thine heart,[32] for behold, the Lord is coming, and He shall fix His tabernacle in thy midst."[33] What could be more agreeable than this day? What could be more explicit than this feast to give expression to gladness and joy? This is another shaft being driven today right through the heart of Death, not as the Saviour is engulfed by the tomb of mortality for the common resurrection of our kind, but as the image of the Mother rises up from the very depths of oblivion, and raises along with herself the likenesses of the saints.[34] Christ came to us in the flesh, and was borne in the arms of His Mother. This is seen and confirmed and proclaimed in pictures, the teaching made manifest by means of personal eyewitness, and impelling the spectators to unhesitating assent. Does a man hate the teaching by means of pictures? Then how could he not have previously rejected and hated the message of the Gospels? Just as speech [is transmitted] by hearing, so a form through sight is imprinted upon the tablets of the soul, giving to those whose apprehension is not soiled by wicked doctrines a representation of knowledge concordant with piety. Martyrs have suffered for their love of God, showing with their blood the ardor of their desire, and their memory is contained in books. These [deeds] they are also seen performing in pictures, as painting presents the martyrdom of those blessed men more vividly to our knowledge. Others have been burnt alive, a sacrifice sanctified by their prayer, fasting and other labors. These things are conveyed both by stories and by pictures, but it is the spectators rather than the hearers who are drawn to emulation. The Virgin is holding the Creator in her arms as an infant. Who is there who would not marvel, more from the sight of it than from the report, at the magnitude of the mystery, and would not rise up to laud the ineffable condescension that surpasses all words? For even if the one introduces the other, yet the comprehension that comes about through sight is shown in very fact to be far superior to the learning that penetrates through the ears. Has a man lent his ear to a story? Has his intelligence visualized and drawn to itself what he has heard? Then, after judging it with sober attention, he deposits it in his memory. No less—indeed much greater—is the power of sight. For surely,

30 Isaiah 60:4.
31 Isaiah 60:6.
32 Zeph. 3:14.
33 Zeph. 3:15.
34 This may mean that mosaics representing various saints were then in the process of execution.

having somehow through the outpouring and effluence of the optical rays touched and encompassed the object, it too sends the essence of the thing seen on to the mind, letting it be conveyed from there to the memory for the concentration of unfailing knowledge. Has the mind seen? Has it grasped? Has it visualized? Then it has effortlessly transmitted the forms to the memory.

6. Is there one who rejects the holy writings on these matters and, in spite of the fact that all lies are dispelled by them, considers them to be not above dispute? Then this man has long since transgressed by scorning the veneration of holy images. Does he, on the contrary, reverence the latter, and honor them with proper respect? Then he will be disposed likewise towards the writings. If he treats either one with reverence or with contempt, he necessarily bestows the same on the other, unless, in addition to being impious, he has also abandoned reason, and is not only irreverent, but also preaches things which are in conflict with his own position. Those, therefore, who have slipped into assailing the holy images are proved not to have kept the correctness of doctrine either, but with the one they abjure the other. They do not dare confess what they believe, chary, not of being impious, but of appearing so; and they avoid the name whereof they willingly pursue the actions. Abominable in their misdeeds, they are more abominable in their impiety. Their whole off-shoot has perished, branches, roots and all, even as the wondrous David in his canticles sings of the memorial of the impious being destroyed with a noise,[35] and it is He Whom they have set at nought through His picture Who has passed righteous judgment on them. But before our eyes is set up motionless the Virgin carrying the Creator in her arms as an infant, [depicted] in painting as she is in writings and visions,[36] an interceder for our salvation and a teacher of reverence to God, a grace of the eyes and a grace of the mind, carried by which the divine love in us is uplifted to the intelligible beauty of truth.

A Picture of the Last Judgment

Theophanes Continuatus, pp. 163–64. *This is a legendary account of the conversion to Christianity of King Boris of Bulgaria (in 864).* The following is said to have happened, namely that the ruler Bogoris [Boris], who was consumed by a great passion for hunting, wished to represent subjects of that kind in one of his houses that he used to frequent, so that he might enjoy their sight both by day and by night. Seized by this desire, he summoned one of our Roman[37] monks, a painter called Methodius, and when the latter came into his presence, he commanded him (through

35 Ps. 9:7.
36 On the identity of icon and vision see p. xv.
37 I.e., Byzantine.

some divine inspiration) to paint not the killing of men in battle or the slaughter of wild beasts, but anything he might wish, on condition that the sight of the painting should induce fear and amazement in its spectators. The painter, who did not know of any subject more apt to inspire fear than the Second Coming of the Lord, depicted it there, with the righteous on one side receiving the reward for their labors, and the sinners on the other, reaping the fruit of their misdeeds and being harshly driven away to the punishment that had been threatened to them. When he [Boris] had seen the finished painting, he conceived thereby the fear of God, and after being instructed in our holy mysteries, he partook of divine baptism in the dead of night.

Illuminated Manuscripts

Nicetas Paphlago, *Vita S. Ignatii*, col. 450 f. *Upon the accession of Basil I on September 24, 867, the patriarch Photius was deposed and banished to a monastery, while his rival Ignatius was reinstated as patriarch.*

He [Basil] sent an emissary to Photius and requested him to surrender without delay all the documents he had, on his departure, removed from the Patriarchate. Photius lied under oath that he had taken nothing of the kind from there because he had left hurriedly. While, however, he was saying this to the *praepositus* Baanes,[38] his servants, bewildered as they were, stole to a nearby reed-bed with a view to hiding there six bags sealed with lead. The bags were seen by the men of the *praepositus* who snatched them away and brought them before the Emperor. Having opened these, they found two volumes adorned on the outside with gold, silver and silken cloth, while inside they were elegantly and carefully written in beautiful lettering. One of them contained seven synodal Acts against Ignatius, which in fact had never taken place—Acts which had been concocted in vain by an evil mind. At the beginning of each Act Ignatius was represented in colored painting, this being the handiwork of the Syracusan Asbestas[39] (for the splendid fellow was also a painter in addition to his other vices). At the head of the First Act—O his ungovernable rage, O his unsurpassable madness!—he portrayed Ignatius being dragged and beaten, and above his head he wrote "The Devil." . . . At the Second Act he showed him being spat upon and violently pulled about, and the inscription [said]: "The Origin of Sin." At the Third he was being deposed and [it was written]: "The Son of Perdition." At the Fourth Act he portrayed him being fettered and banished, and he wrote:

[38] The Emperor's emissary.

[39] Gregory Asbestas, bishop of Syracuse, a supporter of the patriarch Photius. The miniatures described here were evidently a parody of a martyrdom cycle.

"The Greed of Simon the Sorcerer." At the beginning of the Fifth he represented him wearing a prisoner's collar with this abusive inscription: "He who raises himself above God and above worship." At the Sixth he depicted him already condemned and there was this empty dictum against Ignatius: "The Abomination of Desolation."[40] At the Seventh and last he painted him being dragged along and beheaded (?), and the inscription he wrote was "The Antichrist."

Basil I (867–86)

Building at Constantinople

Vita Basilii, pp. 321 ff. 78. Between his warlike endeavors which he often, for the sake of his subjects, directed to a good end like a president of athletic contests, the Christ-loving emperor Basil, by means of continuous care and the abundant supply of all necessary things, raised from ruin many holy churches that had been rent asunder by prior earthquakes or had entirely fallen down or were threatening immediate collapse on account of the fractures [they had sustained], and to solidity he added [a new] beauty. . . . Of this we shall give a detailed account.

79. The western arch of the famous holy church that has received the name of God's Wisdom[41]—I mean the great one high up in the air—which arch had been considerably cracked and was threatening imminent collapse, he tightened up and restored, thanks to the skill of his craftsmen, and so made it secure and steadfast. In it he depicted an image of the Mother of God holding in her arms her Son, born without seed, and on either side he set up the chiefs of the apostles Peter and Paul. He also repaired most liberally the other fractures of this church both as regards building and expenditures, and not only did he correct the unsound walls, but he also increased by his own donations the diminished income [of the church]. . . .

80. Likewise the famous great church of the Holy Apostles, which had lost its former beauty and firmness, he fortified by the addition of buttresses and the reconstruction of broken parts, and having scraped off the signs of old age and removed the wrinkles, he made it once more beautiful and new. Also the holy church of the Mother of God at the Pêgê [Source][42] that had decayed and shed its pristine beauty he renewed and wrought more splendid than before. And similarly the other church of the Mother of God called the Sigma[43] that had suffered a grievous collapse he rebuilt from the foundations and made it more solid than the

40 Matt. 24:15.
41 St. Sophia.
42 Cf. p. 103.
43 In the western part of Constantinople. See Janin, *Églises*, pp. 239 f.

previous one. He furthermore rebuilt from the foundations the church of the first martyr Stephen at Aurelianae[44] that had fallen to the ground. As for the holy churches of the Baptist who was also the Forerunner, the one at Strobylaea[45] he rebuilt from the foundations, while that at Makedonianae[46] for the greater part. So also the fane of the apostle Philip and that of the Evangelist Luke,[47] lying to the west of it, he purged of their old damage and made new. 81. And furthermore he deemed worthy of his solicitude and raised entirely from ruin the big church of the martyr Mocius[48] which had suffered many fractures and whose sanctuary part had fallen down and crushed the altar table. And the church of Andrew,[49] the first-called among the apostles, which stands close to St. Mocius in a westerly direction, and which had crumbled to pieces from neglect, he raised to its ancient beauty by means of proper measures. Furthermore, the church of St. Romanus,[50] which, too, had fallen down, he rebuilt from the foundations; and those of St. Anna in the Deuteron[51] and of Christ's martyr Demetrius[52] he made new and comely. And as for that of the martyr Aemilianus,[53] which adjoins the church of the Mother of God at Rhabdos, perceiving it to be disfigured by old age, he renewed and fortified on either side by means of buttresses. 82. Furthermore, the holy church of the martyr Nazarius,[54] which had not only fallen down a long time previously, but had entirely disappeared, he built anew far surpassing its prior form in nobility and beauty. He also repaired and beautified the handsome church at the Portico of Domninus—the one that is dedicated to the Resurrection of Christ our God and to the martyr Anastasia[55]—by substituting a stone for a wooden roof and adding other admirable adornments. Seeing likewise that the church of Plato,[56] great among martyrs, had a damaged roof, he made it new and repaired the walls wherever necessary. And the church of the glorious martyrs Hesperus and Zoe,[57] which had been almost levelled to the ground, he rebuilt in a form corresponding to its old one. In addition, the holy church of the martyr Acacius at Heptascalon,[58] which was on the point of

[44] See *ibid.*, pp. 488 f.
[45] *Ibid.*, p. 455.
[46] *Ibid.*, p. 432.
[47] *Ibid.*, pp. 322, 508 f.
[48] *Ibid.*, pp. 367 ff.
[49] *Ibid.*, pp. 32 ff.
[50] *Ibid.*, pp. 463 ff.
[51] *Ibid.*, pp. 39 ff.
[52] *Ibid.*, p. 94.
[53] *Ibid.*, pp. 16 f.
[54] *Ibid.*, pp. 372 f.
[55] *Ibid.*, pp. 26 ff.
[56] *Ibid.*, p. 418.
[57] *Ibid.*, pp. 119 f.
[58] *Ibid.*, pp. 18 f. This church was attributed to Constantine I.

dissolution and collapse, he strengthened by means of various reinforcements and so saved it from ruin and caused it to stand solid. As for the church of the prophet Elijah at the Petrion,[59] which was, so to speak, expiring, he nursed it back to health and rebuilt it splendidly, having furthermore freed it from the constriction of surrounding houses.

83. But why do we dwell on his lesser achievements, great as they are, and not include that admirable work of his which he built in the very imperial palace, himself supervising it and creating it—which work is in itself sufficient to express his piety towards the Godhead and the wonderful grandeur of his undertaking? For repaying, as it were, for their benevolence on his behalf, Christ, our Lord, and Gabriel, primate of the angelic host, and Elijah, the zealous Tishbite (who had announced to his mother her son's elevation to the throne), he built in their name and to their eternal memory—of them and, furthermore, of the Mother of God and Nicholas, chief among bishops—a holy and beautiful church[60] in which art, riches, an ardent faith and a bountiful zeal were all combined and the most beautiful materials were gathered together from every quarter which have to be seen (rather than heard of) to be believed. This church, like a bride adorned with pearls and gold, with gleaming silver, with the variety of many-hued marble, with compositions of mosaic tesserae and clothing of silken stuffs, he offered to Christ, the immortal Bridegroom. 84. Its roof, consisting of five domes, gleams with gold and is resplendent with beautiful images as with stars, while on the outside it is adorned with brass that resembles gold. The walls on either side are beautified with costly marbles of many hues, while the sanctuary is enriched with gold and silver, precious stones and pearls. The barrier that separates the sanctuary from the nave, including the columns that pertain to it and the lintel that is above them; the seats that are within [the sanctuary] and the steps that are in front of them, and the holy tables themselves—all of these are compacted of silver suffused with gold, of precious stones and costly pearls. As for the pavement, it appears to be covered with silken stuffs of Sidonian workmanship: to such an extent has it been adorned all over with marble slabs of different colors enclosed by tessellated bands of varied aspect, all accurately joined together and abounding in elegance. . . .

85. Such is the church with regard to its interior. . . . But how marvellous, too, is it on the outside! On the western side, in the very atrium, stand two fountains, the one to the south, the other to the north. . . . The southern one is made of Egyptian stone which we are wont to call Roman,[61] and is encircled by serpents excellently carved. In the middle

59 *Ibid.*, pp. 144 f.
60 The Nea Ekklêsia.
61 Porphyry.

of it rises a perforated pine-cone supported by hollow white colonnettes disposed in circular dance formation,[62] and these are crowned by an entablature that extends all round. From all of these [elements] water spouted forth and innundated the underlying surface of the trough. The fountain to the north is made of so-called Sagarian stone (which resembles the stone called Ostrites)[63] and it, too, has a perforated pine-cone of white stone projecting from the center of its base, while all round the upper rim of the fountain the artist has fashioned cocks, goats and rams of bronze, and these, by means of pipes, vomit forth jets of water onto the underlying floor. Also to be seen there are cups, next to which wine used to spout up from below to quench the thirst of passers by. 86. As you go out the northern door of the church, you encounter a long barrel-vaulted portico whose ceiling is adorned with painting representing the feats and struggles of the martyrs, thereby both pleasing the eye and rousing the spirit to a divine and blessed love.... If, on the other hand, you go out the southern door facing the sea, and wish to proceed eastward, you will find another portico of equal length to the northern one and likewise extending as far as the imperial courtyard wherein it has become customary for emperors and young noblemen to play ball on horseback;[64] which courtyard the same glorious Emperor laid out, having bought up the houses that had previously been there and demolished them to the ground and cleared the area. He also built the beautiful structures on the seaward side of this courtyard which he appointed to be the treasury and sacristy of the aforesaid church. The expropriation of the houses and laying-out of the courtyard were motivated by the fact that the space previously used by emperors for this sport had been taken up by the construction of the holy church. As for the space enclosed between the two porticoes to the east of the church, he turned it into a garden, one that was "planted eastward"[65] of the new Eden, abounding in every kind of plant and irrigated with abundant water; which, on account of its position, we are wont to call Mesokêpion.

But enough has been said of the above, lest we be accused of tastlessness. 87. We may now steer our discourse to the remaining works of the industrious Emperor who was the provider of all good things. In the palace itself, did he not indeed surpass anyone else previously recorded ... not only with regard to [the construction of] churches ... but also of imperial residences? ... Since these beautiful things are not accessible to everyone, ... it is necessary to describe them in writing.... Directly in the

62 The "dance" of columns is a literary cliché. Cf. p. 74.
63 See p. 63, n. 43.
64 This court was called Tzykanistêrion and was used for some kind of polo game imported from Persia (Persian *tshu-qan*). See Ebersolt, *Le Grand Palais de Constantinople*, pp. 14 f., and cf. above, p. 163.
65 Gen. 2:8.

eastern part of the palace is the church of Elijah the Tishbite that was built by him, filled with all manner of magnificence and beauty not only within but also without. For its entire ceiling, compacted of well-joined mosaic cubes, shone with gold, even if much of its beauty has since been destroyed by excessive rainfall as well as wintry snow and ice. Adjoining this church he built a chapel dedicated to Clement, martyr of great suffering and endurance, wherein he deposited the latter's head and the holy relics of many other martyrs from which he himself and his successors have received both spiritual and bodily healing. Close to the above churches is the house of prayer he constructed in honor of our God, the Saviour, and those who have not seen it will find its costly magnificence altogether incredible; so great a mass of silver and gold, of precious stones and pearls has been expended for its adornment. Indeed, the entire pavement is made of solid beaten silver with niello (*enkausis*) exhibiting the perfection of the jeweler's art; the walls on right and left are also covered with an abundance of silver, picked out with gold and studded with precious stones and gleaming pearls. As for the closure that separates the choir from the nave, by Hercules, what riches are contained in it! Its columns and lower part are made entirely of silver, while the beam that is laid on top of the capitals is of pure gold, and all the wealth of India has been poured upon it. The image of our Lord, the God-man, is represented several times in enamel (*chumeusis*) upon this beam. As for the choir, speech is unable to express all the beautiful and sacred objects that are treasured therein. . . . Such then are the adornments of the eastern part of the palace that have come into being thanks to the piety of the illustrious emperor Basil.

88. His remaining works are in other parts [of the palace], among them the holy chapel of the preacher Paul, built with equal lavishness by the same creator. In its pavement are circular marble slabs bordered with silver, and it does not yield to the other [churches] with respect to magnificence and beauty. The same holds true of the holy church he constructed in honor of the highest apostle, Peter, like a corner tower at the end of Marcian's portico, to which church he joined a chapel of the Chief of the heavenly host. And as for the chapel of the Mother of God placed directly above the latter, it abounds in all manner of comeliness and beauty. . . .

89. As for the beautiful residences which the emperor Basil built— emperors' palaces in the midst of the palace—a description of them would require more eloquent speech and a more accomplished hand [than ours] to express in words what is inimitable in fact. Indeed, this building of novel aspect called Kainourgion which he built from the foundations, does it not strike spectators with amazement? It is supported on sixteen columns standing in a row, eight of them being of green Thessalian

stone, while six are of onychite (as it is proudly called)[66] decorated by the stone-carver with the shape of a vine and, within the latter, the forms of various animals.[67] The remaining two columns are likewise of onychite, but they have been carved into a different configuration in that the smoothness of their surface has been furrowed by twisted lines;[68] in this way did the craftsman choose to decorate them, seeking, as he did, beauty and delight through variety. From the columns up to [the top of] the ceiling as well as in its eastern dome the entire building has been beautified with gold mosaic cubes; it exhibits the originator of this work seated aloft, escorted by the subordinate generals who fought on his side, the latter offering him in gift the towns they have captured.[69] In addition, high up in the ceiling are depicted the Emperor's Herculean labors, his toils on behalf of his subjects, his warlike exertions and the prize of victory bestowed by God. Illuminated by these [deeds] as the sky is by stars, there opens up a bedchamber (?)[70] cunningly wrought by the same Emperor—a beautiful and variegated [work] that surpasses nearly all others. In the very center of its pavement by means of the stonecutter's art is represented the Persian bird, i.e., the peacock, all of gleaming tesserae, enclosed in an even circle of Carian stone[71], from which spokes of the same stone radiate towards a bigger circle. Outside the latter there extend into the four corners of the building streams, as it were, or rivers of Thessalian stone (which is green by nature) encompassing within their banks four eagles made of fine, variegated tesserae, so accurately delineated that they seem to be alive and anxious to fly. The walls on either side are reveted with many-colored plaques of glass that appear to be adorned with the forms of various flowers. Above these there is a different decoration blooming with gold[72] which separates the lower parts from the upper. This is followed by another adornment of golden tesserae exhibiting the Emperor, who is the creator of this work, enthroned together with his wife Eudocia, both clad in imperial costume

66 The sarcophagus of the Emperor Heraclius was, according to the catalog of tombs contained in the *Book of Ceremonies*, CSHB, I, 644, made of "white Docimian onychite." The marble of Hierapolis also looked like onyx: see above, p. 92.

67 I.e., an "inhabited scroll." It is interesting to find this Late Antique form revived in the 9th century (unless the columns were reused).

68 Presumably spiral fluting.

69 Cf. p. 109.

70 The text is unsatisfactory as it stands. A few words may have dropped out.

71 See p. 63, n. 43.

72 The may refer to a gilded cornice (*kosmitês*) evoked by the more classical word *kosmos* (decoration). The text appears, however, to be in need of some correction.

and wearing crowns. The children they had in common[73] are represented round the building like shining stars, they, too, adorned with imperial vestments and crowns. The male ones among them are shown holding codices that contain the divine commandments (which they were taught to follow), while the female ones also carry books of the divine laws; in this way the artist wished to show that not only the male, but also the female progeniture had been initiated into holy writ and shared in divine wisdom, even if their father had not at first been familiar with letters on account of the circumstances of his life, and yet caused all his children to partake of learning. This is what he wanted to show by the painter's art independently of [the witness of] history. Such beauties then are contained in the four walls up to [the height of] the ceiling; and as for the ceiling of this chamber, it is not raised to a great height, but rests upon the walls in four-square form,[74] being entirely decorated with gleaming gold and exhibiting in its center the victorious Cross made of green glass. All round the latter, like stars shining in the sky, you may see the illustrious Emperor himself, his wife and all their children raising their arms to God and the life-giving sign of the Cross and all but crying out that "on account of this victorious Symbol everything that is good and agreeable to God has been accomplished and achieved in our reign." There is furthermore an inscription of thanksgiving addressed to God by the parents on behalf of their children, and of the children on behalf of their parents. The one addressed by the parents is conceived in more or less the following words: "We thank Thee, O God most kind and King of them that reign, that Thou hast surrounded us with children who are grateful for the magnitude of Thy wonders. Guard them by Thy will lest any of them transgress Thy commandments, and so that, in this also, we may give thanks for Thy goodness." The children's [prayer] is expressed as follows: "We thank Thee, O Word of God, that Thou hast raised our father from Davidic poverty and hast anointed him with the unction of Thy Holy Ghost. Guard him and our mother by Thy hand, while deeming both them and ourselves worthy of Thy heavenly Kingdom." So much for the beauties of the said chamber.

90. Another work of the same hand and mind is the great hall by the portico of Marcian—the one called Pentakoubiklon, which also takes

[73] This expression may be deliberate because some doubt was entertained concerning the legitimacy of some of the children of Basil and Eudocia. There were the following sons: Constantine (d. 879; not by Eudocia), Leo VI, Stephen (these two were said to have been fathered by Michael III) and Alexander who was emperor in 912–13; and the following daughters: Anastasia (possibly not by Eudocia), Anna, Helena and Maria.

[74] In other words, the ceiling was not domed, but consisted of a vault of square plan which could have been either a barrel vault or a cross-groined vault.

the prize as regards all kinds of beauty. Next to it stands the chapel of the heavenly Paul that has already been mentioned, joined to another of the martyr Barbara, built by Leo, the most wise.[75] And furthermore, the other imperial residences—the ones that are situated eastward of the Chrysotriklinos and on a higher level than the latter, while being to the west of the New Church, and are called Aetos [the Eagle] because they rise to a great height in the air (wherein also is the most beautiful and agreeable church of the Mother of God)—are works of the same Emperor. ... Likewise the pyramidal residences to the west of the latter as well as another chapel of the Mother of God, the Word, which, by the sumptuousness and novelty of their construction surpass many other buildings, boast him as their creator. Below these, at the very gate called Monothyros, is the very pleasing chapel of John the Evangelist which the same Emperor built along with the sun-bathed walk that is paved with marble and extends as far as the Pharos; and likewise the very solid buildings that are to the east of it, one of which is used as a treasury and the other as a *vestiarium,* both of them combining attractiveness with security. He, too, it was that elegantly built that very beautiful, large and well-illuminated bath of the palace which is above the so-called Phialê [Fountain]— a name left over by the stone fountain of the Blue faction that formerly stood there....[76] As for the fountain of the other faction, I mean of the Greens, it used to stand in the eastern court of the palace, but was moved when the holy church that is there was built, and so the attendance of the factions at these [fountains] ceased and the ceremonies performed there were discontinued.[77]

The Decoration of the Church of the Holy Apostles

Constantinus Rhodius, *Descr. of Church of Holy Apostles.* *The date of this mosaic decoration has been much disputed. Some scholars suppose that it went back in whole or in part to the reign of Justin II (565–78).*[78]

[75] Leo VI.

[76] See p. 131.

[77] The text goes on, without, however, providing any interesting details regarding either architecture or decoration, to enumerate further constructions of Basil I under the following headings: (1) Palaces other than the Great Palace that were either built *de novo* or added to, namely those of the Mangana, Pêgae, and Hiereia; (2) Churches at Constantinople, namely those of the Virgin at the Forum of Constantine, of the Chalkoprateia (heightened and given better illumination), of St. Michael in the quarter of Tzêros (restored), of St. Laurence at Pulcherianae (rebuilt), and "about a hundred other churches," as well as hospices for the poor, the sick and the aged, and monasteries; (3) Churches rebuilt in the suburbs of Constantinople, namely those of St. John the Evangelist and St. John the Baptist at the Hebdomon, of St. Peter at Rhêgion, of St. Callinicus by the stream Bathyrsus, of St. Phocas and St. Michael on the Bosphorus.

[78] For the relevant bibliography see V. Lazarev, *Storia della pittura bizantina* (Turin, 1967), p. 35, n. 2.

I tend to to believe that it dated from the restoration of the building by Basil I.[79] *Constantine's description which stops with the Crucifixion is evidently incomplete. For a later account see p. 232 f.*

[626] The craftsman has piously ordained that the central [dome] should be elevated and rule over the others,[80] destined as it was to be the Lord's great throne, and to protect His precious image which has been delineated in the middle of the famous church. . . .

[737] In the middle of the costly ceiling, it [the church] bears a representation of Christ as if He were the sun, a wonder exceeding all wonders; next, like the moon, that of the stainless Virgin, and, like the stars, those of the wise Apostles. The whole inner space has been covered with a mixture of gold and glass,[81] as much as forms the domed roof and rises above the hollowed arches, down to [the revetment of] multicolored marbles and the second cornice.[82] Represented here are the deeds and venerable forms which narrate the abasement of the Logos and His presence among us mortals.

[751] The first miracle[83] is that of Gabriel bringing to a virgin maiden [the tidings of] the incarnation of the Logos and filling her with divine joy. . . .

[760] The second[84] is that of Bethlehem and the cave, the Virgin's giving birth without pain, the Infant, wrapped in swaddling clothes, reclining—O wonder—in a poor manger, the angels singing divine hymns, . . . the rustic lyre of the shepherds sounding the song of God's nativity.

[771] The third[85] is the Magi hastening from Persia to do homage to the all-pure Logos. . . .

[780] The fourth[86] is Simeon, the old man, bearing the infant Christ in his arms. . . . And that strange old prophetess Anna foretelling for all to hear the deeds which the infant was destined to accomplish. . . .

[792] The fifth is the Baptism received from the hands of John by the stream of the Jordan; the Father testifying to the Logos from above, and the Spirit coming down in the guise of a bird. . . .

[804] Sixth, you may see Christ ascending that thrice-glorious mount of Tabor together with a chosen band of disciples and friends,[87] altering His mortal form; His face shining with rays more dazzling than those of

[79] Another Gospel cycle was put up by Basil I in the church of the Virgin of the Source (Pêgê): *Anthol. graeca*, I, 109 ff.

[80] I.e., the central dome, placed over the crossing, was higher than the other four. For the architectural form of the church see p. 103.

[81] I.e., gold mosaic.

[82] The upper cornice at the springing of the arches.

[83] The Annunciation.

[84] The Nativity.

[85] The Adoration of the Magi.

[86] The Presentation in the Temple.

[87] The Transfiguration.

the sun, His garments a luminous white; the great Moses as well as Elijah standing by Him with pious reverence;...the disciples, upon hearing the thunderlike voice, falling, face down, to the ground....

[829] Next, you may see the widow's son, who had been brought on a bier to his tomb, returning alive and joyful to his house....[88]

[834] Then again, Lazarus, who had been laid in his grave and had rotted four days long...leaping out of his tomb like a gazelle and returning once more to mortal life after escaping corruption.

[844] Next, Christ mounted on a colt proceeding to the city of the God-slayers;[89] the crowds, with branches and palm leaves acclaiming Him as the Lord when He arrives at the very gates of Zion....

[858] In addition to all the above wonders, you will see, O excellent reader, this further astounding spectacle, an altogether exceptional one, which the artist has painted better than anything else in the church so as to move to tears and heart-felt pity those who behold this image of the Passion: ... Judas, that wretched man, betraying his Lord and teacher to be murdered...by an evil and abominable people...a countless rabble armed with swords, staffs, clubs and sticks.... The artist has painted his very manner, the savage cast of his face, his pale countenance, clenched jaws, hateful eyes filled with murder, nostrils as of an asp, breathing anger.... His feet, set wide apart, hasten with big strides on their wicked path, and his two hands strive to catch the Lord....

[916] The seventh[90] spectacle you may see among all these wonders is Christ's Passion ... painted with feeling.... What man, even if he had a heart of stone, upon seeing the image of the Passion, would not be amazed in his spirit as he beholds this altogether astonishing event: Christ, naked, stretched out on the cross between two condemned criminals,...his hands and feet pierced with nails, his side disfigured by the blow of a lance after He had tasted vinegar and gall, hanging dead upon the wood of the cross...and this in sight of His mother, the pure Virgin, and the disciple who was present at the Passion....

The Church of the Virgin at Pêgê

De sacris aedibus Deiparae ad Fontem, p. 882: After the disaster[91] the Christ-loving Emperor Basil who was then ruling the Roman state wished to pull the church down to its foundations and to rebuild it in a larger and more imposing form. He was, however, prevented from so doing by some dignitaries, and so he restored only those parts that had fallen down, namely the dome which he rebuilt starting from the upper

[88] The raising of the widow's son at Nain (Luke 7:11 ff).
[89] The Entry into Jerusalem.
[90] In fact, the eleventh.
[91] I.e., the earthquake of 869.

fastenings that join together.[92] When the ladders were set up so that the men who were going to execute the holy images in mosaic might climb to a sufficient height—it was the holy feast of the Descent of the Ghost that was being represented by the application of various colors and lineaments —it happened that the scaffolding and the ladders began to collapse in the direction of the ambo, so that those painters and artists were thrown into confusion as they bewailed the danger that was upon them. As the men quite naturally were seized by lamentation . . . one of them sees the Mother of God standing on top of the ambo and supporting the ladders. Then little by little, she gave way to their weight so as not to allow them to collapse all of a sudden. . . .

The following [incident], too, is not unlike the others.[93] The images of the All-pure one and of the archangel Gabriel—the ones that are set up to the right of the altar and constantly perform miracles—were, before the disaster, depicted high up in the right-hand arch. At that time they fell to the ground like all the rest, but they were not at all damaged, and are still to this very day seen to be intact. *There follows an anecdote about one Helena Artavasdina who removed these icons to her home and was then, by a supernatural agency, obliged to return them to the church.*

Leo VI (886–912)

The Church in the Monastery of Kauleas at Constantinople[94]

Leo VI, *Sermon 28:*[95] It [the church] is paved with white slabs [which form] a continuous translucent [surface], uninterrupted by any other color: the craftsman has preferred this pure splendor to a variegated composition such as is often to be seen in pavements. However, a boundary,[96] as it were, made of a stone of a different color, surrounds the white surface, and by slightly varying the spectacle, makes the white translucence, pleasing as it is, even more agreeable. . . . Now the [structure] which is above the beautiful pavement and forms the roof is raised in the shape of a half-sphere.[97] In the midst of it is represented an image of Him to whom the craftsman has dedicated the church. You might think you were beholding not a work of art, but the Overseer and Governor of the universe Himself who appeared in human form, as if He had just ceased

92 I.e., probably the pendentives.

93 I.e., it is as wonderful as the other miraculous incidents recorded in the text.

94 Founded or restored by the Patriarch Antony II Kauleas (893–901). See Janin, *Églises,* pp. 44 ff.

95 Ed. Akakios, pp. 245 f. On this and the following text see A. Frolow, "Deux églises byzantines," *Études byzantines,* III (1945), 43 ff.

96 I.e., a border of colored marble.

97 Literally "half-circle" (*hêmikuklion*), but this surely denotes the dome.

preaching and stilled His lips. The rest of the church's hollow and the arches on which the roof is supported have images of [God's] own servants, all of them made of mosaic smeared with gold. The craftsman has made abundant use of gold whose utility he perceived: for, by its admixture, he intended to endow the pictures with such beauty as appears in the apparel of the emperor's entourage. Furthermore, he realized that the pallor of gold was an appropriate color to express the virtue of [Christ's] members. Along with them is represented in a certain place[98] the Virgin Mother holding the infant in her arms and gazing upon Him with a mixture of maidenly composure and motherly love: you can almost see her opening her lips and addressing motherly words to the child, for to such an extent are the images endowed with life.[99] The remainder of the church, i.e., as much as is not covered with holy figures, is adorned with slabs of many colors. These have a beauty that corresponds exactly to that of the rest of the edifice.

The Church built by Stylianus Zaoutzas[100]

Leo VI, Sermon 34:[101] In the center [of the church], i.e., in the segment of a sphere that rises at the summit, is an image that lacks the lower part of the body.[102] I think that the artist wished, by means of this treatment of the picture, to offer a mystical suggestion of the eternal greatness inherent in the One represented, i.e., that His incarnation on earth did not detract from His sublimity, and even when He submitted to the ultimate humiliation, He retained the majesty He had previously enjoyed with His Father.... This is how I understand the artist's intention, namely why he excised from the image the lower members of the body. In this way, then, has the Creator of the universe been delineated at the summit. And, at the springing of the hemisphere (*hêmikuklion*) are represented, all round, His servitors whose being is higher than that of matter. They are the messengers (*angeloi*) of God's communications to men, and are named accordingly. Some of them ... are called *polyommata*[103] because of the multitude of their eyes.... And others are named after the number of wings, namely six, which they have.[104] The disposi-

98 Doubtless in the apse.

99 Leo is here plagiarizing Photius's sermon on the image of the Virgin in St. Sophia (p. 187).

100 Stylianus was Leo's father-in-law. The church was built after 886 and before c. 893.

101 Ed. Akakios, pp. 275 ff. Important textual corrections by D. Serruys, *BZ*, XII (1903), 169 f.; A. Syndikas, *Epistêm. Epetêris Philosoph. Scholês*, Univ. of Thessaloniki, VII (1957), 209 ff.

102 I.e., a half figure of Christ of the type usually known as Pantocrator.

103 Cherubim, whose bodies were covered with eyes.

104 Seraphim (*hexapteryga*).

tion of their wings is indicative of the mysterious hiddenness and folding in upon itself of the Godhead . . . while the veiling of their faces and feet[105] teaches us that the Godhead is altogether incomprehensible and invisible. . . . Next to these [the artist] has placed another category of servitors who are agreeable to God; these, although beings of a material composition, have nevertheless surpassed the bounds of matter and attained to the immaterial life. Some of them foresaw from afar the events which at a later time would be enacted for the salvation of the world;[106] while others took part in these very events—here you may see kings and priests—so that the universal King receives universal homage.[107] With these images is the summit of the church decorated, while the remainder contains the events of the Incarnation.

Here a winged being who has just descended from heaven converses with a virgin.[108] You might say that this picture was not devoid of speech, for the artist has infused such natural color and feeling (*êthos*) into the faces, that the spectator is forced to assume that they are so colored because of their awareness of what is being said. There, a mother who has just given birth, yet not by the laws of childbearing, turns towards the infant with maternal care and love.[109] Now men are hastening with precious objects to do homage to the infant.[110] Now a man afflicted by old age receives the babe in his arms;[111] as you behold this, you may perceive a contest between age and the youthful ardor that seizes the old man through his joy: trying to forget the burden of his years he quickly stretches out his arms to pick up the babe, but they prove weaker than his desire. Here the stainless One, desirous of washing off our filth, is being cleansed with purifying water;[112] there His form shines forth as His mortal appearance is removed.[113] In this place the friend who had rotted in the grave throws off corruption and leaps to life at [the sound of] a word.[114] Over there, submitting to His ordeal on

[105] In fact, in Byzantine art cherubim and seraphim (the distinction between them is seldom observed) are entirely covered by their wings *except* for their faces and feet.

[106] The Old Testament prophets. These were presumably placed in the drum of the dome.

[107] This passage is not entirely clear. Leo is drawing a distinction between personages of the Old Testament and those who took part in the events of the New (apostles?). In the latter group he places kings and priests. While the priests Zacharias and Simeon are conceivable candidates, we can think of no kings who were concerned with the story of the Incarnation. We suspect that the orator became confused, and that both the kings (David and Solomon) and priests referred to the Old Testament.

[108] The Annunciation.

[109] The Nativity.

[110] The Adoration of the Magi.

[111] The Presentation in the Temple.

[112] The Baptism.

[113] The Transfiguration.

[114] The Raising of Lazarus.

behalf of the world, He is Himself affixed to the wood.[115] Elsewhere, he is housed in a tomb,[116] and in another place He is seen trampling on corruption. Elsewhere again He rises and raises Adam along with Himself,[117] and makes His way to heaven, to ascend together with His human body (*proslêmma*) to the Paternal throne.[118] His Mother, who has transformed motherhood, and His disciples are standing there, fashioned with such lifelike character by the painter, that they seem indeed to be seized by the various emotions of living persons. One of them gives the impression of following the ascending [Christ] with his eyes; another is seen to be all ears, attempting to capture the meaning of the words that are uttered above (for, indeed, a number of winged beings are assisting in the ascension and seem to be conversing with them); another is pensive because of his astonishment; another is filled with wonderment and fear.

Such, then, are the upper beauties of the church, and they are all made of mosaic smeared with gold. But what of the lower part? Four columns adorned with the green color, such as the earth puts forth at the end of winter, . . . support the pendent arches.[119] The ground is covered all over with the hues of various flowers. In places the surface is traversed by white [patches], in others the white is framed by a composition of other hues, consisting of multicolored marble cut into tesserae, and this, in turn, is surrounded by purple slabs as if by rivers; the latter, too, are enclosed by a contexture imitating the different flowers of the earth.[120]

The Church of the Virgin of Pêgê

De sacris aedibus Deiparae ad Fontem, p. 884. *The monk Matthew,* oikonomos *of the monastery of Pêgê, won the friendship of Leo VI.* Out of respect for him [Matthew] he [Leo VI] laid the foundations of the church of St. Anne which he made extraordinarily beautiful. He also adorned the porch of the big church—what is called the narthex—after it had been damaged by the Bulgarians who at that time had invaded Thrace, and he made more attractive the so-called Kataphygê (which is

115 The Crucifixion.

116 The Burial.

117 If the text is interpreted strictly, there must have been two separate scenes of the Anastasis: Christ trampling on Hades (representing death or corruption), and Christ raising Adam.

118 The Ascension.

119 The church must have been of the inscribed cross type, supported by four columns, like the south church of the monastery of Lips at Constantinople (907).

120 The floor probably consisted of slabs of Proconnesian marble enclosed, individually or collectively, by frames of *opus sectile*. There was an outer border of purple marble and a further band of *opus sectile* all round. The 10th century Theotokos church of the monastery of Hosios Lukas gives an approximate idea of this type of pavement.

indeed a refuge from every kind of affliction) by means of fine mosaics and the blending of paints.

The Ciborium of St. Demetrius at Thessalonica[121]

Nicetas, archbishop of Thessalonica, *Miracula S. Demetrii,* § 6:[122] Likewise the holy ciborium which contains the miraculous grave has been given suitable decoration and a suitable place: it may be seen in the middle of the left side of the church, small in size, yet a great ornament set within the enormous [church]. Of the columns that contain it, some have the exact color of rue (*pêganon*),[123] and these are joined to white columns so as to produce a hexagonal shape, all of marble. Upon them rest arches, also of shining stone, adorned with a hexagonal collar (*sphendonê*) and, by means of further slabs of brilliant marble, contracting the roof to a narrow point. These are joined at the very top by [an element] which has the shape of a lily and a stone sphere upon which is set the holy, life-giving cross, all gleaming.

Regulations governing Craftsmen

Book of the Prefect, **XXII.** *Concerning contractors of all kinds, i.e., joiners, plasterers,*[124] *marbleworkers, locksmiths, painters, etc.* 1. Artisans, i.e., joiners, plasterers and the rest, whatever work they have contracted to do and received a deposit for, are not to abandon it and embark on another until they have completed the same. If, however, a delay occurs because of lack of material or the malice of the client, i.e., if the craftsman does not receive the necessaries for the completion of the task, then let him, of whatever craft he may be, give notice to the client by means of verbal statement or affidavit, and if the latter delays, the case should be referred to the Prefect, and, with his consent, the craftsman may take on other work.

2. Whenever the said contractors out of cupidity or malice abandon the work which they undertook to do and embark on another, the client shall have leave to make a deposition against them before assessors and to remind them of the written or verbal agreement that was made, and if they neglect to fulfil the said contract, let the client refer the case to the Prefect and then let him engage another contractor. The contractors

121 The ciborium described here may have been made after the sack of Thessalonica by the Arabs in 904. It followed fairly closely the form of the earlier, silver ciborium, on which see p. 129. For a reconstruction of the marble ciborium see G. A. and M. G. Sôtêriou, work quoted on p. 129, n. 29, p. 180.
122 Ed. Sigalas, pp. 332 f.
123 This was the so-called *pêganousian* marble on which cf. p. 164.
124 Rather than gypsum workers.

who have contravened the agreement shall be punished by flogging, tonsure and banishment, and shall refund whatever fees they have received from the client; in other words, they shall be removed from the task without compensation. But if the client happens to be short of materials, the craftsmen may, after warning him, undertake other work, lest they remain idle and lack sustenance.

3. If a craftsman undertakes many tasks so as to be in general demand, and sometimes he entices one man and at other times deceives another, urging them by his mischievous loquacity to increase his fees on the pretext that they had been unjustly determined; if then, by decision of the Prefect, the work is indeed found to have expanded in scope and to be causing loss to the craftsman, or if the contract having been made in one way, the client has decided that the work should be done differently, either better or worse, or if the nature of the work was not clearly defined, then, by decision of the Prefect, let this work be evaluated by experienced craftsmen, i.e., if it has been altered or affected by unforeseen circumstances. The provisions of the law on buying and selling shall also apply to contracts, namely that if it is ascertained that the contract has been complied with, yet the fee is less than one half [of the fair price], then the agreement shall be dissolved and the work evaluated, but if more than half, the fees shall be paid as agreed. If there has been addition to or alteration of the work, the addition or alteration shall be evaluated.

4. Those who build walls and domes or vaults of brick must possess great exactitude and experience lest the foundation prove unsound and the building crooked or uneven. For if a collapse occurs without act of God within ten years, the builder shall be liable [to replace the building] at his own expense. If it is a great work that exceeds one pound of gold [in value,] the contractor who has built it and his fellow-workers shall rebuild it free of charge, while the client shall provide the materials. Buildings of mud-brick must endure six years, and if within these six years the work collapses because of the craftsman's incompetence, he shall renew it without charge. The same shall apply to all contractors, and if any of them are found acting contrary to regulations, they shall be flogged, tonsured and suffer confiscation.

Constantine VII Porphyrogenitus (913–59)

Theophanes Continuatus, pp. 447 ff: 15. Furthermore, he restored the imperial vestments as well as the crowns and diadems that had been damaged for a long time. He also embellished the Bucoleon[125] with statues which he gathered from different places, and he installed a fish-

125 Enclosed within the complex of the Great Palace, the Bucoleon was a group of buildings comprising a harbor, a quay, and a palace overlooking the Sea Walls.

pond there.... 20. We ought also to mention the roof of [the hall of] the Nineteen Couches.[126] For perceiving it to be rotten, altogether unsightly and about to collapse, he restored it, and chose to make new and splendid the gilded ceiling which had fallen apart with the passage of time. He contrived in it octagonal cavities which he embellished with perforations and various carved shapes resembling the tendrils and leaves of the vine and the form of trees, and these he sprinkled with gold, making [the ceiling] so beautiful as to amaze the beholder. 21. And for his son, the Emperor Romanus, he built more palaces than previous emperors had done.... At the Tetraconch of the apostle Paul[127] which had lost its ancient beauty, he, with a view to instilling a new beauty into it, set up various golden figures and images.

22. This man [Constantine] was, I believe, more thoroughly versed in the art of painting than anyone before him or after him.[128] He often corrected those who labored at it and appeared to be an excellent teacher —indeed, he not only appeared as such, but was universally admired as a prodigy in an art that he had never learned. Who could enumerate all the instances in which the Porphyrogenitus set craftsmen right? He corrected stone carvers and builders, workers in gold leaf, silver-smiths and iron-smiths and in every case he showed his excellence. 23. Being a lover of beautiful things, the same Constantine constructed the silver doors of the Chrysotriklinos; furthermore, with much industry, he made a silver table for the reception of guests and the adornment of the dining-room, which table, in addition to its natural color, he beautified with materials and plaques of various other hues, thus affording a greater pleasure to his guests than they would have derived [solely] from the savor of the repast.

24. He also built a guardhouse of porphyry in front of his chamber, wherein he contrived a receptacle of water surrounded by marble columns shining smooth. And what else did his noble mind [invent]? He set upon the water pipe a silver eagle, looking not ahead but sideways, his neck high and proud as if he had caught a prey, while stifling a serpent that was coiled round his feet. In the vestibule of the imperial chamber he also put up artful mosaic images, a spectacle of divers colors, materials and forms....[129]

126 A ceremonial dining hall in the Great Palace.

127 The same as the Pentacubiculum (see p. 198) which ought to be imagined as a cruciform building with a central bay (probably domed) surrounded by four semicircular lobes.

128 Constantine's skill as a painter is also mentioned by Liudprand, *Antapodosis*, III, 37; Sigebertus Gemblacensis, *Chronica*, s.a. 918, Monumenta Germaniae historica, *Scriptores*, VI, 346.

129 The author goes on to speak in rather vague terms of the additions made by Constantine to the suburban palace of Hiereia which was somehow supported on four arches and had a building at each corner; and then of another palace constructed by Constantine (location not specified) next to which there was a church dedicated to the Holy Apostles (§§ 26–27).

28. Who would be able to describe the sacred objects and hangings[130] which he presented to the common propitiatorium (I mean the great and admirable one)?[131] Each time he came, he wished not to appear empty-handed in the sight of God, and so repaid his debt by lavish offerings of objects wrought in gold, of pearls, precious stones and cloths. These adorn the holy of holies and proclaim [the name of] Constantine who offered them....

33. It is also fitting that we should speak of the Chrysotriklinos which the ingenious Emperor turned into a blooming and sweet-smelling rose-garden by means of minute, variegated mosaic cubes imitating the colors of freshly opened flowers. Enclosed by spiral convolutions and shaped by the composition itself, these (?) are altogether inimitable.[132] He girded [the hall] with silver, encompassing it as with a border (*antux*),[133] and so offered the spectator a source of inexhaustible delight.

Liudprand, *Antapodosis* VI, 5, 8. *This passage describes an ambassador's audience with Constantine VII in 949 and a banquet in the palace.*

5. There is at Constantinople, next to the palace, a building of extraordinary size and beauty which the Greeks call Magnavra (the letter *V* taking the place of the digamma), i.e., "strong breeze" (*magna aura*).[134] For the sake of some Spanish envoys who had recently arrived as well as of myself and Liutefred,[135] Constantine gave orders that this building should be decked out in the following manner. In front of the Emperor's throne was set up a tree of gilded bronze, its branches filled with birds, likewise made of bronze gilded over, and these emitted cries appropriate to their different species. Now the Emperor's throne was made in such a cunning manner that at one moment it was down on the ground, while at another it rose higher and was seen to be up in the air. This throne was of immense size and was, as it were, guarded by lions, made either of bronze or wood covered with gold, which struck the ground with their tails and roared with open mouth and quivering tongue. Leaning on the shoulders of two eunuchs, I was brought into the Emperor's presence. As I came up, the lions began to roar and the birds to twitter, each according to its kind, but I was moved neither by fear nor astonishment.... After I had done obeisance to the Emperor by prostrating myself three times, I lifted up my head, and behold! the man whom I had just

130 The author uses the term *peplos* which may refer to any kind of cloth, veil or garment.

131 I.e., St. Sophia.

132 Text unclear and grammatically incorrect.

133 Probably referring to a cornice or entablature sheathed in silver that went round the interior of the building.

134 On the Magnaura, a building of basilical shape, see Ebersolt, *Le Grand Palais de Constantinople*, pp. 68 ff.; C. Mango, *The Brazen House* (Copenhagen, 1959), pp. 57 f., where it is suggested that it may have been the same as the Senate House, on which see above p. 108.

135 Envoy of Otto, King of Saxony.

seen sitting at a moderate height from the ground had now changed his vestments and was sitting as high as the ceiling of the hall. I could not think how this was done, unless perhaps he was lifted up by some such machine as is used for raising the timbers of a wine-press. . . .

8. Next to the Hippodrome, in a northerly direction,[136] is a hall of remarkable height and beauty called Decanneacubita. It obtained this name not from its nature (*ab re*),[137] but for an apparent reason: for "deca" is Greek for "ten," "ennea" is "nine," and "cubita" means couches that are flat for lying down on, and have curved ends. This is so because on the day when Christ was born according to the flesh nineteen tables are set up there. The Emperor and his guests do not sit up at dinner, as they do on other days, but recline, and on this occasion they are served not in silver vessels, but only in gold ones. After dinner fruit is brought in three golden vessels which are so immensely heavy that they are carried not by hand, but on trolleys covered with purple cloth. Two of them are put on the table in the following manner. Three ropes covered with gilded leather and provided with golden rings are let down through apertures in the ceiling and are inserted into the handles that project from the platters. With the help of four or more men stationed below, these are swung on to the table by means of a rotating device that is above the ceiling, and are then removed in the same manner.

Icons and Iconography

Vita S. Theodorae Thessal. § 52 ff:[138] 52. . . . Inasmuch as the Lord had seen fit, through these miracles,[139] that she [Theodora] should be praised and glorified by everyone, it became appropriate for her image, too, to be set up in holy fashion within the sacred precincts [of the monastery]. . . . A certain painter John, who had never seen St. Theodora in the flesh and had never entered the holy monastery wherein she dwelled, had the following dream. He saw himself lying in the narthex of the church of her monastery, and in the middle of the right-hand aisle (*stoa*) of this church (which is a chapel of the holy Theotokos), at the spot where the Saint's sacred tomb is placed, [he saw] a hanging lamp gushing oil. Below this was an earthenware vessel to receive the oil that was dripping down from the lamp.[140]

136 The Hall of the Nineteen Couches was actually south of the Hippodrome.

137 The meaning of this distinction is not entirely clear to me.

138 Ed. Arsenij, pp. 31 f.

139 Various posthumous miracles of St. Theodora are related in the preceding paragraphs.

140 A few days after Theodora's death the lamp that was hanging over her tomb was found to be miraculously overflowing with oil and never had to be refilled.

53. After awakening in the morning, he went walking in the town. He was met by a friend who said to him: "Let us go to the church of the First Martyr [Stephen],"[141] [meaning] that he should paint his [Stephen's] icon. So they proceeded to the monastery and knocked on the gate. Their presence was announced to the abbess, and they entered the church. As soon as they crossed its threshhold, the painter recognized the narthex ... and said to his companion: "Indeed, brother, last night I dreamt I was lying in this very church." And he related everything he had seen [in his dream], namely the form of the church, and of the lamp and of the earthenware vessel, exactly as he had seen them. After they had finished their prayers ... he [John] diligently enquired of the nun who happened to be then in the church the reason why the vessel was placed underneath that lamp; for at the moment when he entered the church, it chanced that the oil was not gushing forth as he had seen it in his dream. The nun explained everything in detail, but was not able to convince them since they had not seen with their own eyes the lamp overflowing. . . . So, after collecting in their minds everything that had been said about the Saint, they went home.

54. That night again the painter dreamt that he was sketching (*skiagraphounta*) the image of a nun at the very spot where the holy likeness of St. Theodora is today placed. What her name was he did not know, as he told me under oath; he had, however, the impression of sketching the image of the person of whom the nun had spoken the previous day. And likewise the following day he had exactly the same dream and, being assured of God that this was a holy vision, he proceeded to the monastery and, after relating to the abbess what he had seen, he painted the image of St. Theodora, although he had not been informed by anyone of the height of her stature or the nature of her complexion or her facial traits. Assisted by God's guidance and the Saint's prayers, he depicted her in such a form that those who had known her well asserted that she looked like that when she was young. After a given time a sweet-smelling oil was seen to exude from the palm of the right hand of that holy icon, and to this day it pours forth in a stream, so that it has washed off [some of] the colors of the icon. It was therefore found necessary to affix a lead vessel at the foot of the icon lest the oil that was gushing forth be lost on the ground.

***Vita S. Mariae iunioris*, § 18, p. 699:** At that time she [St. Mary] appeared in a dream to a painter who was a recluse at Rhaedestus.[142] She was wearing a white robe and had a red veil over her head. In her right hand she held a lighted lamp upon which was inscribed "The lamp of charity." She was preceded by two handsome youths and followed by a

141 Theodora's monastery was dedicated to St. Stephen.
142 Modern Tekirdağ in European Turkey.

maiden of pleasing aspect. When she had appeared, the painter asked her who she was and whence she had come to him. She answered in a cheerful voice, smiling, "I am Mary from the city of Bizye,[143] concerning whom you have heard many things, although until now you have not seen me. So, as you see me now, paint my image together with my servants Orestes and Bardanes and my maid Agatha who is following me, and send this image to the city of Bizye." When he awoke and perceived that this was the wish of the Blessed one, he gladly made the icon in conformity to his dream and sent it from Rhaedestus to Bizye, to the church that had been built by Mary's husband. When those who had known her in her lifetime saw the icon, they were filled with astonishment and acknowledged that this was indeed her appearance and that of her servants.

***Vita S. Niconis Metanoeite*, pp. 124 ff:** Some time elapsed and, while Malakênos[144] was still living at Constantinople, the Saint departed [this life] to the ageless blessedness that was allotted to him. Having heard of this, Malakênos deemed that he was going to be cheated of that sweet and fair hope, namely that of seeing once again, as had been prophesied, the Saint's much-longed-for face. . . . Finally, spurred on by faith, . . . what does he think of doing? Having summoned a skilled painter, he described to him in detail the Saint's visage and appearance, the [color of his] hair and his costume; and he enjoined [the artist] to paint the Saint's likeness on a board. As for the painter, he returned home and set about fulfilling the order by means of his own skill, but he found the task most difficult, and all his toil proved useless: for, excellently trained as he was in his art, he was unable to portray with all exactitude a man he had never seen on the basis of a [verbal] account alone. As he was thus perplexed . . . he suddenly sees a monk entering his house, a man of tall stature, eremitic in appearance, wearing an old garment; a man having an unkempt head, black hair and a black beard and, in a word, resembling the Saint in all particulars. He even carried in his hand a staff surmounted by a cross. Having greeted the painter as was fitting, he asked the reason why the latter appeared idle and worried. The painter disclosed the reason and explained the difficulty of his task. Whereupon he who appeared to be a monk said in a calm voice: "Observe me, brother, for the man to be painted is in all respects similar to me." Indeed, when the painter looked at him intently, he had the conviction that it was the same man as had been described by Malakênos; and as he turned his gaze to the board he was holding, he saw that the likeness of the thrice-Blessed one had been automatically impressed upon it. He turned towards the Saint in amazement, crying out in great fear, "Lord, have mercy!" but he saw him no

143 Modern Vize.
144 A Peloponnesian nobleman who had been unjustly accused of treason, but, thanks to the saint's prayers, succeeded in proving his innocence before the Emperor Basil II.

more; for the Saint had immediately vanished. So the painter applied the remaining colors to the lineaments that had been impressed, and having completed the icon—such as it can still be seen suspended in the Saint's holy church and worshipped there—he brought it to the most excellent Malakênos and announced to him all that had happened. The latter, when he had heard this and been convinced, by the exact likeness of the saint he was now seeing, that the righteous man's prediction had been accomplished even in this respect, was filled with joy, and from that time on he proclaimed in a loud voice God's wondrous deeds and the grace that the Holy Ghost had bestowed upon the Saint.

Vita S. Athanasii Athonitae, § 254: The time has come to mention also a miracle which I witnessed with my own eyes. I am sure that all of you, brethren, have known Cosmas the former *ecclesiarch* of the monastery [the Lavra] either by hearsay or by sight. This man used to put in at my father's whenever he had need to come to the capital. Arriving on one occasion and seeing at our house an icon of the Saint [Athanasius] which my father had recently had made, he acknowledged it to be an exact likeness—the very man himself—and he demanded to have it as something indispensable to him. My father would not consent on the grounds that he did not have another one that was equally well made. Cosmas replied that a man who was as much of a connoisseur as my father would be able to obtain one that was just as good; by way of supplication he invoked the Saint himself as intercessor, and finally prevailed upon my father. The latter, in part willingly (because of the man's great faith) and in part against his will, agrees to the request, adding, "If you wish to attain your goal, stay here another three days during which I shall have this icon copied and then give it to you without regret." The old man consented to await the appointed time; as for my father, he arose at the hour of matins and went to see the painter of the icon, named Pantoleon,[145] to whom he explained the matter and pressed the work upon him, for Pantoleon was a friend of ours and would do anything for us. "If you wish to do me a favor," said my father (Pantoleon happened at the time to be engaged on an imperial commission), "make me with all speed an icon just like this one. But do not delay the favor, if it is to be a favor." Pantoleon complained of the untimely vexation, saying, "What need was there to remind me once again when I have already been reminded?" Whereupon he showed his paints which were in readiness along with all the other materials necessary for the work. "For late yesterday evening," he added, "I was notified of this through your servant

145 Doubtless the same as the painter Pantoleon, the chief illuminator of *Cod. Vaticanus graecus* 1613, who signed 79 of its miniatures. See I. Ševčenko, "The Illuminators of the Menologium of Basil II," *Dumbarton Oaks Papers,* XVI (1962), 245 ff.

so-and-so, and requested to present myself in the morning [equipped] with these materials." Unable to understand the meaning of these words, my father was seized with astonishment and wonder, and he called for the testimony of the servant, who happened to be present. The latter expressed similar surprise. Most astonished of all, however, was Cosmas when the news was brought to him, for he knew that the servant had been with us all that day and had not gone out of the room, and said that he preferred to do so(?)[146] than to watch the painter paint. So, we all concluded that this had been a clear manifestation on the part of the Saint. . . .

"Ulpius (or Elpius) the Roman" ***Concerning Bodily Characteristics:***[147]
The blessed *Dionysius*[148] had this physical appearance: of medium stature, thin, white complexion, sallow skin, somewhat flat-nosed, puckered eyebrows, hollow eyes, [an air of] continual concentration, big ears, long grey hair, fairly long beard of sparse growth, slightly corpulent, long fingers.

Gregory of Nazianzus:[149] not a tall man, somewhat sallow but pleasing, flat-nosed, straight eyebrows, gentle and kindly expression, although one of his eyes, namely the right one, was rather stern, being contracted in the corner by a scar; beard not long but fairly thick, bald, white-haired, the tip of his beard having a smoky appearance.

Basil the Cappadocian[150] was a tall man, straight of build, lean, swarthy, his complexion having an admixture of pallor; long nose, arched eyebrows, contracted brow, severe and anxious expression, forehead lined with a few wrinkles, elongated cheeks, concave temples, hair somewhat in need of clipping, rather long beard, half-grey.

Gregory of Nyssa:[151] in all respects similar to the former except for being grey-haired and slightly more pleasing [in appearance].

Athanasius of Alexandria:[152] a man of medium stature, fairly broad, stooped, pleasing countenance, healthy complexion, receding hair, hooked nose, his jaw covered with a wide but not very long beard, big mouth, very grizzled, [his hair] not pure white but of a yellowish cast.

John of Antioch:[153] a very short man carrying a big head on his shoulders, extremely thin, having a long nose, wide nostrils, and a very pale whitish complexion. The sockets of his eyes were hollow and con-

146 The text is unclear.
147 Ed. Chatzidakis, pp. 393 ff.
148 Presumably the Areopagite, converted to Christianity by St. Paul, first bishop of Athens.
149 Patriarch of Constantinople (379–81), d. 389 or 390.
150 Bishop of Caesarea (370–79).
151 Bishop of Nyssa, appointed in 371, d. after 394.
152 The great opponent of the Arian heresy, patriarch of Alexandria (328–73).
153 John Chrysostom, patriarch of Constantinople (398–404).

tained big eyeballs which sometimes glinted pleasantly, although the rest of his expression was that of a man in grief. He had a bald, high forehead marked with many wrinkles. His ears were big, his beard short and very sparse, of a light color due to grey hairs.

Cyril of Alexandria:[154] of a stature a little lower than normal, his appearance fairly healthy, forehead marked by big, bushy eyebrows of an arched shape; long nose, nostrils divided by a projecting partition, taut cheeks, rather thick lips, forehead slightly bald; adorned with a dense and long beard, curly hair of a light, half-grey color.

Cyril of Jerusalem:[155] of middle stature, sallow, long-haired, flat-nosed, square-faced, straight eyebrows, jaw covered with a white beard divided into two strands; the expression, as a whole, being of an uncouth kind.

Eustathius of Antioch:[156] tall, thin man with a long face, stern gaze, hair receding on his forehead, thin, straight eyebrows, long neck, cheeks covered with a medium-length black beard having a few grey hairs.

Our father *St. Tarasius*[157] was in bodily appearance similar to Gregory Theologos, setting aside [the latter's] grey hair and injured eye, for he was not completely grizzled.

Our father *St. Nicephorus*,[158] bishop of the Imperial City, was in all respects similar to Cyril of Alexandria except for [the latter's] curly hair and beard and his being half-grey—for Nicephorus had altogether grey, straight hair. Furthermore, the partition between his nostrils did not project, nor were his lips thick.

An Imaginary Palace

Digenes Akrites, VII, 42 ff. *Digenes Akrites constructed his palace on the Euphrates. The description opens with an account of the garden.* In the midst of this wonderfully pleasant garden the noble Akrites erected a big square house of cut stone having stately columns and windows up above. He adorned all the ceilings with mosaic, he decorated the pavement with precious gleaming marbles and tesserae of stone. Inside he made upper chambers on three floors having sufficient height and decorated ceilings; [he also made] cruciform halls, strange *pentacubicula*,[159] containing shining marbles reflecting shafts of light. So beautiful was the

[154] Patriarch of Alexandria (412–44).
[155] Patriarch of Jerusalem (350 or 351–86).
[156] Patriarch of Antioch (324 or 325–30).
[157] Patriarch of Constantinople (784–806).
[158] Patriarch of Constantinople (806–15).
[159] Like the *pentacubiculum* built by Basil I in the Great Palace: see p. 198. The words "strange *pentacubicula*" are probably placed in apposition to "cruciform halls": we may visualize a tetraconch which, counting the central space, would have been divided into five bays.

artist's work that the gay, many-figured aspect of the stones made one think of a woven tapestry. He paved the floor with onyx so smoothly polished that those who saw it mistook it for water congealed to ice. On either side he set up long, wondrous reclining-rooms having golden ceilings upon which he represented in mosaic the victories of all those men of yore who shone in valor, beginning with Samson's fight against the gentiles, how with his hands he strangely rent a lion, how, when he was imprisoned, he carried up the hill the city gates together with their bolts, how the gentiles mocked him and how they were destroyed; finally, how in those days of old, he utterly overthrew the Temple and himself perished together with the gentiles. He also showed David without any weapons except for the sling and the stone he held in his hand, and Goliath, tall in stature, terrible of aspect and mighty in strength, encased in iron from head to toe, and bearing in his hand a spear like a weaver's beam[160] of iron color portrayed by the painter's art. His warlike movements he also represented, and how Goliath, struck by a well-aimed stone, at once fell wounded to the ground, and David, rushing up and raising his sword, cut off his head and won the victory; after that, the fear of Saul, the flight of the meek one, the thousand plots and God's vengeance.

He also represented the fabled wars of Achilles, the beauty of Agamemnon[161] and the disastrous flight of Helen; the wise Penelope and the slain suitors; the wonderful daring of Odysseus in the face of the Cyclops; Bellerophon killing the fiery Chimaera; the victories of Alexander and the defeat of Darius; the wise Candace in her palace; the wise Alexander's arrival among the Brahmans and again among the Amazons and his remaining feats,[162] and many other marvels and courageous deeds of all kinds. Then again the miracles of Moses, the Egyptians scourged, the exodus of the Jews, the murmurs of the ungrateful, God's vexation, His servant's prayers, and the glorious deeds of Joshua, the son of Nun. These and many more did Digenes depict in the two halls with golden mosaic, and they provided infinite pleasure to those that saw them. Within the courtyard of the dwelling was a level space of great extent both in length and width; in the midst of this he erected a church in the name of the saintly martyr Theodore, a glorious work, and within it he buried his own honored father, whose body he had brought from Cappadocia, in a tomb decorated, as was fitting, with gleaming stones.

160 Cf. 2 Sam. 21:19.

161 The text is obviously corrupt at this point. H. Grégoire in *Byzantion,* II (1925), 544 proposes a correction which instead of the beauty of Agamemnon and the flight of Helen, would yield the translation, "the disastrous flight of the unfortunate Hector."

162 These details were drawn from the *History of Alexander* by Pseudo-Callisthenes.

The Eleventh Century

St. Mary Peribleptos

This monastery was built by Romanus III (1028–34) who was buried in it, and restored by Nicephorus III Botaniates (1078–81). It is said to have remained in Greek hands until 1543, when it was taken over by the Armenians. The ancient buildings were burnt down in 1782 and have disappeared except for some substructures.[163]

Clavijo, pp. 37 ff.: Then, the same day, they went to see another church of St. Mary which is called Parabilico [*sic*], and at the entrance of this church is a great courtyard in which are cypresses, walnut-trees, elms and many other trees. And the body of the church is on the outside completely decorated with pictures of different kinds, rich in gold and azure and many other colors. And further, as one enters the body of the church, on the left-hand side, are represented many images, among them one of St. Mary, and next to it, on one side, is an image of an emperor, and on the other side, the image of an empress,[164] and at the feet of the image of St. Mary are represented thirty castles and towns, the name of each one being written in Greek. And they said that these towns and castles belonged to the domain of this church and had been granted to it by an emperor called Romanus who lies buried at the foot of this image.[165] Here are placed certain privileges on leather,[166] sealed with wax and lead seals, which are said to be the privileges received by this church over the aforesaid towns and castles. In the body of the church are five altars, and the body itself is a round hall, very big and tall, and it is supported on jasper [columns] of different colors; and the floor and the walls are likewise covered with slabs of jasper. This hall is enclosed all round by three aisles which are joined to it, and the ceiling of the hall and the aisles is one and the same, and is completely wrought in rich mosaic. And at the end of the church, on the left side, was a big tomb of colored jasper wherein lies the said Emperor Romanus. And they said that this tomb

163 See Janin, *Églises*, pp. 227 ff.

164 These may have been, in fact, the portraits of Michael VIII Palaeologus (1259–82), his wife Theodora and his son Constantine, reproduced by Du Cange, *Familiae augustae byzantinae* (Paris, 1680), p. 233. See also J. Leunclavius, *Annales sultanorum Othmanidarum*, 2nd ed. (Frankfurt, 1596), ch. 51, p. 137, who says that this picture was *versus occidentalem templi partem*. Some uncertainty remains, however, because two 17th-century travellers speak of an imperial group portrait (which appears to be the same one) as being in the refectory.

165 This appears to be incorrect since the tomb of Romanus is mentioned further down as being in a different part of the church.

166 Presumably parchment.

was once covered with gold and set with many precious stones, but that when, ninety years ago [*sic*], the Latins won the City, they robbed this tomb. And in this church was another big tomb of jasper in which lay another emperor.[167] Also in this church was the other arm of St. John the Baptist. . . .

Outside the body of the church was a cloister beautifully adorned with different pictures, among which was represented the Tree of Jesse, of whose line the Holy Virgin Mary was descended;[168] and this was of mosaic work so marvellously rich and well wrought that he who has seen it will not see anything so marvellous elsewhere. In this church there were many monks who showed to the said ambassadors . . . a refectory that was very broad and very tall, and in the middle of it was a table of polished white marble, beautifully made, and it was 35 palms long. The floor was paved with white slabs. At the far end of the refectory there were two other small tables of white marble. The ceiling was of gold and mosaic, and on the walls was represented in mosaic work the angel's Salutation to the Virgin Mary; next, the Nativity of Jesus Christ, and then how He went about the world with His disciples, and the whole story of His blessed life until His Crucifixion. And in this refectory there were many benches made of white slabs, set apart, and these were meant for placing dishes and meats upon them.

St. George of the Mangana[169]

Michael Psellus, *Chronogr.* VI, 185 f:[170] My indictment of his [Constantine IX's] excesses now comes to its principal point, namely the church he founded in honor of the martyr George, which he then entirely destroyed and wiped out, and [after rebuilding it] reduced it once again to ruin. This matter was undertaken by him not from the best of motives, but I need say nothing of that.[171] At first, it seemed that the church was not going to attain great size, since the foundations that had been laid were rather modest, the superstructure was in the same proportion, and the height was not excessive. Later on, however, he became consumed by the passion of rivalling all the buildings of the past and even surpassing them by far. Accordingly, a vaster outer wall was thrown round the church, the foundations were partly raised on heaped up earth, partly

167 Probably Nicephorus III.

168 This subject became current in Byzantine painting only in the Palaeologan period. The mosaic in question may have dated, therefore, from the time of Michael VIII.

169 On the remains of this church see R. Demangel and E. Mamboury, *Le quartier des Manganes* (Paris, 1939), pp. 19 ff. and pl. V.

170 Ed. Renauld, II, 61 ff.

171 The motive was that Constantine's mistress, Skléraina, lived close by, and the Emperor sought an excuse for visiting her frequently.

dug deeper into the ground,[172] and upon them were set bigger and more varied columns. Everything was made more artful, the ceiling was covered with gold, slabs of a verdant color were laid in the pavement and affixed to the walls, and each kind of marble bloomed next to another which was either of the same or of contrasting hue. And gold flowed in a torrential stream from the public treasury as from an inexhaustible source.

186. Yet, before the church was completed, everything was once more altered and re-arranged: the exact joining of the stones was disrupted, walls were pulled down and everything laid bare. The reason for this was that the Emperor had not quite succeeded in his contest with the other churches, and having vied with one in particular,[173] had won second prize. So another wall was built and an exact circle was described using the third church as center,[174] and this, as it were, with greater art, and everything was splendid and heavenly. Indeed, the church was like the sky adorned on all sides with golden stars; to be more exact, the heavens are gilded only at intervals, while here the gold, flowing, as it were, from the center in a copious stream, has covered the entire surface without interruption. All round were buildings bordered with porticoes on four or two sides (*oikoi peridromoi kai amphidromoi*) and all [the grounds] as far as the eye could see (for their end was not in sight) were fit for horse-riding, and the next [buildings] were greater than the first; and in addition there were meadows full of flowers, some extending all round, others in the middle; there were water conduits that filled fountains; there were groves, some on high ground, others sloping down towards the plain; there were baths of indescribable charm.

Clavijo, pp. 48 f.: The same day they went to see another church which is called St. George. In front of its first gate is a great court in which are many houses and orchards, and the main building of the church is beyond these orchards. On the outside, before the church door, is a bathing font, very big and beautiful, and above it is a cupola supported on eight pillars of white marble carved with many figures. The main body of the church is very lofty and is entirely covered with mosaic work. There is a representation of Jesus Christ as He ascended up to heaven. And the floor of the church is marvellously wrought, being covered with slabs of porphyry and jasper in many colors, and they form many an interlace. The walls are wrought in the same fashion. In the middle of the ceiling of this church is represented God the Father[175] in mosaic work. And above the entrance door is figured the True Cross which an angel points to [as it appears] among the clouds of heaven to the apostles, and the Holy Ghost

172 The vast substructures of the monastery have survived: Demangel and Mamboury, pl. III.

173 Presumably St. Sophia.

174 Meaning unclear to me.

175 I.e., Christ Pantocrator.

descends upon them in the form of flames.[176] All this is done in marvellously wrought mosaic. In this church was a great tomb of jasper covered with a pall of silk, and here lies buried an empress.[177]

Imperial Images

Christophoros Mitylenaios, *Poem* 112.[178] *On the painter Myron painting the image of Michael:*[179] If you are painting only Michael's appearance, then mix your ochre and grind the other colors, but if, together with his appearance [you include] all his virtues, set him up alive, if you can do so; for you cannot paint him without his virtues, him who is an animate catalog (*puxion*) of virtues.

Joannes Mavropous, *Poems* 57, 75, 80, 87.
On the Emperor's image at Euchaita:[180]

A pious deed does here portray the mighty lord Constantine,[181] the great Monomachus, the wonder of the earth. Seeing that the gifts of the emperors before him have been, through spite, severely undermined, he has propped them up with a golden pillar in erecting a chrysobull ordinance like a mighty buttress against violence. By this means he offers a more secure future to the Martyr's city and to the diocese, and so he receives in return a just honor by being inscribed among our benefactors.

On the supplicatory image (deêsis) *of the Emperor lying at Christ's feet. The Emperor is speaking:*

It is Thou who hast appointed me lord of Thy creatures and master of my fellow-slaves, but having proved to be the slave of sin, I tremble before thy scourge, O Lord and Judge.[182]

176 This was clearly a picture of the Pentecost, and the True Cross must have belonged to the central medallion containing the Etimasia. The presence of an angel is, however, abnormal in this composition. Furthermore the Pentecost was usually represented in the area of the *bêma* rather than above the entrance.

177 In the church were buried Constantine IX and his mistress Sklêraina. After 1204 the latter's tomb was reused to bury Count Hugues de Saint-Pol. The memory of Sklêraina must have remained alive, however, until 1403.

178 Ed. Kurtz, p. 75.

179 Probably the Emperor Michael IV (1034–41).

180 Euchaita, the cult center of St. Theodore, was situated near Amaseia in the Pontus.

181 Constantine IX.

182 Poems 76–79, which are purely rhetorical in content, refer to the same image: the Virgin Mary and St. John the Baptist intercede on the Emperor's behalf, Christ accepts their petition, and then the Emperor utters a further prayer. The picture consisted, therefore, of Christ flanked by the Virgin Mary and St. John the Baptist, with the Emperor prostrate at Christ's feet. The mosaic above the Imperial Door of St. Sophia provides an obvious analogy.

On the image at Sosthenion:

Thy mighty hand, O Christ, has crowned the mighty emperors and given them their kingdom; Thy goodness has made them an inexhaustible fount[183] of rich gifts. The entire earth is bounteously filled with these gifts and gives glory to Thee, the giver of kingdom; she implores Thee, the assister of kingdom, to be ever present, to fight along, to strengthen the emperors, to grant them long life and joy. In testimony thereof this image has been painted: for the monks of this venerable monastery of the First Angel at Sosthenion,[184] having been favored with many rich gifts, give this reward to their kindly benefactors by artfully depicting Thee, O Christ, in the act of crowning them here.

On the image of the Emperor and the Patriarch:

Those who have been selected as our masters by God's wise judgment should also be honored in painting; for the one rules over men's bodies, while the other has been chosen shepherd of [men's] souls. Both have their authority from above and both rule their subjects well; hence on their picture are also represented the originators and protectors of their powers.[185]

Byzantine Artists at Kiev

Russian Primary Chronicle, sub anno 6497: Thereafter Vladimir lived in the Christian faith and he bethought himself of building a church of the most-holy Mother of God,[186] and so he sent [emissaries] and brought masters from Greece.[187] So he began building it, and when he had finished, he adorned it with images and entrusted it to Anastasius of Cherson. He appointed priests from Cherson to officiate in it and bestowed upon it everything he had taken at Cherson, namely icons, vessels and crosses.

Paterikon of the Cave Monastery, Kiev, ch. 4:[188] Here is another wonderful miracle which I am going to tell you. There came to the abbot Nikon icon-painters from that same God-guarded city of Constantinople, and they said to him: "Set before us the men who negotiated with us: we wish to bring suit against them. They indicated to us a small church,

183 Literally "sea."

184 The same as St. Michael's at Anaplous on the Bosphorus, on which see p. 115.

185 I.e., Christ and, probably, some other heavenly patrons were portrayed in the upper part of the image.

186 The so-called Tithe Church (Desjatinnaja Cerkov'), destroyed in 1240. Its foundations have been excavated.

187 I.e., from the Byzantine Empire.

188 Ed. Abramovič–Tschiževskij, pp. 9 ff.

and so we made an agreement with them before many witnesses, whereas this church is very big. So take back your gold, and we shall return to Constantinople." The abbot replied: "Who was it that negotiated with you?" The painters mentioned the names of Antony and Theodosius,[189] and described their appearance. And the abbot said to them: "O my children, we cannot produce these men since they left this world ten years ago, and now they are constantly praying on our behalf, are perpetually guarding this church, preserving their monastery and caring for those that live therein." When the Greeks heard this answer, they were frightened. They brought many merchants, both Greeks and Abkhazi,[190] who had travelled with them from there [Constantinople], and they said: "We made our agreement in the presence of these men, and we received gold from the hand of the two [monks], and now you do not wish to show them to us. And if they have died, show us the image of the two, so that these men, too, may see if they are the same." Then the abbot brought out the images in front of everyone, and when the Greeks and the Abkhazi saw them, they bowed down and said: "Truly, it is they; and we believe that they are alive even after death, and are able to help, save and protect those who have recourse to them." And they gave away the mosaic [cubes] which they had brought for sale, and it is with them that the holy chancel is now adorned.

The Greeks go on to relate that they were brought to Kiev by supernatural force, and that, in spite of their resistance, their boat travelled with unusual speed up the Dnieper to the very monastery. Then, all together, the monks and the Greeks, craftsmen (*masteri*) and painters, gave glory to the great God, to His immaculate Mother, to her miraculous icon, and to the holy Fathers Antony and Theodosius. And so both the builders and the painters ended their lives in the Monastery of the Caves having taken the monastic habit, and they are buried in a special chapel (*pritvor*). And their cloaks (*svity*)[191] and Greek books are to this day preserved in the sacristy (*polaty*) in remembrance of so great a miracle.

Paterikon of the Cave Monastery, Kiev, ch. 34:[192] The blessed Alimpij was given by his parents to study icon-painting. When the Greek painters were forcibly brought from Constantinople by the will of God and of His all-pure Mother to paint the church of the Caves (in the days

[189] Founders of the Cave Monastery (shortly after 1051).

[190] *Obezi* in the text. These were a Georgian people, called Abasgians by ancient authors, who dwelled on the west coast of the Caucasus.

[191] Some commentators have translated this term as "scrolls" and have understood it to refer to model books; *svita*, however, means regularly a garment.

[192] Ed. Abramovič–Tschiževskij, pp. 172 ff.

of the pious prince Vsevolod Jaroslavič[193] and of the blessed abbot Nikon), as has been said. . . . God performed and manifested a stupendous miracle in His church. For while the craftsmen were laying mosaic in the chancel, the image of our all-pure Lady the Mother of God, Mary for ever virgin, appeared all by itself. All these men were within the chancel setting the mosaic, and Alimpij was helping them and receiving instruction, and they all saw the wondrous and amazing miracle: as they were gazing at the image of Our Lady. . . , it suddenly shone brighter than the sun. Unable to look at it, they fell to the ground in fear, then, rising a little, they tried to see the miracle that had occurred, and, lo, out of the lips of the all-pure Mother of God flew a white dove and it soared up to the image of the Saviour and hid there. . . .

When they had finished decorating the church, the blessed Alimpij received the tonsure, which was at the time of the abbot Nikon. He learned well the painter's craft and was very expert at painting icons. This skill he decided to acquire not for the sake of riches, but he did it for the sake of God, and he worked so hard at painting icons that they sufficed for everybody—the abbot and all the brethren—and he took no remuneration. And when this blessed man had nothing to do, he borrowed gold and silver, such as are needed for icons, and he would make an icon and give it to the person who had made him the loan in repayment thereof. And he often begged his friends that whenever they saw in the church icons that were decayed, they should bring them to him, and he would renew them and put them back in their places. He did all of this so as not to be idle. . . . *There follow several anecdotes concerning the miracles performed by Alimpij. We reproduce one of them.*

A certain pious person engaged this blessed man to paint a fixed (*naměstnaja*)[194] icon. A few days later, however, the blessed man fell ill, and the icon remained unpainted. The pious layman began to importune him, and the blessed man said to him: "Do not come and trouble me, but entrust your concern for the icon to the Lord, and He shall do as He pleases. And the icon shall be set up in its place on its own feast day." The man was pleased that the icon would be painted before the feast day and, trusting in the blessed man's words, he went joyfully home. He came again on the eve of the Dormition[195] wishing to take the icon, and he saw it unpainted, and the blessed Alimpij very ill indeed, and he reproached him, saying: "Why did you not inform me of your sickness? I would have engaged another to paint the icon so that the

193 Grand Prince of Kiev (1078–93). Nikon was abbot from 1077 until 1088. The consecration of the church is dated by the Russian Primary Chronicle to 1089.

194 I.e., an icon that had a fixed place in the chancel screen.

195 The feast of the Assumption (August 15).

feast day might be glorious and joyful. As it is, you have put me to shame
by withholding the icon." The blessed man replied to him meekly: "My
son, is it out of idleness that I have done so? And is it impossible for God
to paint His Mother's icon by His word alone? I am about to leave this
world, as the Lord has revealed to me, but after my departure God will
fully console you." So the man returned sorrowfully to his house. And
after his departure there entered a resplendent young man and, taking
up the brush (vapnica), he began painting the icon. Alimpij thought
that the owner of the icon was angered with him and had sent another
painter, for at first he seemed to be a man, but the swiftness of his work
proved him to be an incorporeal being. Now he laid gold on the icon,
now he ground the pigments on a stone and painted with them; and in
three hours he completed the icon, and said: "O monk, is anything lack-
ing, and have I made any mistake?" The blessed man replied: "You
have made it well. God has helped you to paint this icon so skilfully and
has worked through you." When evening came [the young man] dis-
appeared together with the icon.

The owner of the icon spent a sleepless night in sorrow because
there was no icon for the feast day, and he kept calling himself a sinner
unworthy of such grace. And he arose and went to the church to lament
his trespasses, and when he opened the doors of the church, he saw the
icon shining in its proper place. . . .

The Comneni (1081–1185)

Manuel I (1143–80)

Nicetas Choniates, p. 269: This Emperor's love of magnificence is
evidenced by the immensely long colonnaded halls which he erected in
both palaces,[196] and which, resplendent with gold mosaics, portray in
diverse colors and by means of wonderful handicraft the brave deeds he
accomplished against the barbarians and the other benefits he conferred
on the Romans. It was he, too, who erected or further adorned the
greater number of those splendid buildings at the Strait of the Pro-
pontis[197] wherein the emperors of the Romans spend their summers,
seeking as they do a temperate climate, as the ancient rulers of the
Persians did at Susa and Ecbatana.

Joannes Cinnamus, VI, 6, p. 266 f. *This passage concerns Alexius Axouch,*
one of the generals of Manuel I. Alexius was made Governor of Cilicia
(1165) and was believed to have conspired with Kīlīç-Aslan II, Sultan of

[196] I.e., the Blachernae Palace on the Golden Horn and the old Imperial
Palace next to the Hippodrome.
[197] I.e., the Bosphorus.

Iconium, to dethrone Manuel. When, some time later, he returned to Byzantium [from Cilicia] and determined to decorate with painting one of his suburban houses, he did not include among the subjects any ancient deeds of the Hellenes, nor did he represent, as is the custom among men placed in authority, the emperor's achievements both in war and in the slaying of wild beasts: for, indeed, the emperor had fought more wild beasts of different kinds than any other man we have heard of. . . . Omitting such subjects, Alexius depicted the Sultan's campaigns, thus foolishly exhibiting in his house matters that he ought to have kept in the dark.

Eustathius of Thessalonica, *Speech addressed to the Emperor Manuel I.*[198] *This passage concerns Stephen Nemanja, Grand Župan of Rascia who, after being defeated by Manuel in 1172, was brought to Constantinople as an imperial vassal.* He [Nemanja] surveys with his eyes those decorations that represent your [Manuel's] feats, cunningly wrought for the sake of remembrance by the hands of painters—those that concerned himself as well as the other [paintings]. Here [he was represented] arousing his people to rebellion, elsewhere as a man-at-arms or a horseman, elsewhere placing his hand upon his sword, repeatedly ranging his army in the open, planting ambuscades, being defeated by your forces, filling the hard-trodden plain with his fugitives, and finally being enslaved. Seeing these paintings, he agrees with everything and approves of the visual feast. In one respect only does he chide the painter, namely that the latter has not called him a slave in all the scenes of triumph, that the appellation "slave" has not been coupled with the name Neeman [Nemanja].

Cod. Marc. Gr. 524,* fol. 22v***.[199]** On the newly built house of Leo Sikountênos at Thessalonica that contains various pictures from olden times as well as that of the Emperor, the Lord Manuel Comnenus:

Wondrous is the foundation of this house, O stranger, in that its lower part receives support from above, for it is upheld by the symbols of virtue that are represented both inside and out.[200] The artist has painted these virtues both by themselves[201] and in various forms that express them in action, namely by delineating venerable men who excelled in virtue: Moses, the witness of God, striving out of true love to toil together with his kindred people, bravely slaying the Egyptians, and gently feeding the mouths of those that murmured; and the military

198 Ed. T. L. F. Tafel, *De Thessalonica eiusque agro* (Berlin, 1839), p. 419; German trans. by Tafel, *Komnenen und Normannen* (Ulm, 1852), p. 222. The speech was composed in 1174 or 1175.

199 Ed. S. Lampros, *Neos Hellênomnêmôn* VIII/1 (1911), 29 f.

200 I.e., this house, instead of being supported from below, receives supernatural support from above on account of the paintings it contains.

201 Referring, presumably, to personifications of the virtues.

deeds of Joshua, son of Nun, who captured that great city of Jericho, being endowed both with wisdom and courage. To these ancient [subjects] he has added those of the present time by painting alongside the soldiers of the heavenly King the crowned Emperor of the earth, the pillar of New Rome shining in the purple, Manuel, the descendant of the Comnenes, slayer of alien peoples. . . .

Cod. Marc. Gr. 524, fol. 36[r].[202] On the gate of a house whereon was represented the Emperor, and above him the most-holy Mother of God having Christ in her bosom (*enkardion*)[203] [in the act of] crowning the Emperor, an angel preceding him, St. Theodore Tiro handing him the sword, and St. Nicholas following behind:

Behold, O Manuel, unshakable pillar of Rome, Comnene, born in the purple, Emperor, the Highest is looking upon you from heaven . . . and crowning you through your victories with the crown of Empire as the Maiden, the husbandless Mother, intercedes on your behalf. Behold, an angel precedes you in your path. . . . Also present is the horseman Tiro, Christ's martyr, who rides in front of you when you battle the enemy, who instructs your hands in military contest and places in them a whetted sword. Nicholas, the fount of holy oil,[204] accompanies you, fortifies your kingdom and protects your back. . . . These things are proclaimed by the *sebastos* Andronicus, a Kamatêros by his father, a Doukas by his mother,[205] who has painted you, slave as he is, before the gate that he may lovingly adore even your picture.

Cod. Marc. Gr. 524, fol. 46[r].[206] On a hall newly built by the Emperor, the Lord Manuel, to serve as a monk's refectory, wherein were represented, along with himself, his grandfather, the Emperor, the Lord Alexius, and his father, the Emperor, the Lord John, and the Lord Basil, the Bulgar-slayer:[207]

If buildings were naturally endowed with a voice, then surely the monastery of Mocius[208] . . . would have said that it had been fashioned by imperial hands. Indeed, the foursome of Emperors represented here reminds the spectators that the Emperor Basil first made it into a

202 Ed. Lampros, pp. 43 f.

203 I.e., a bust of Christ in a circular medallion painted over the Virgin's breast.

204 The epithet *muroblutês* was applied to saints, especially Demetrius and Nicholas, whose relics exuded oil.

205 On this person see D. I. Polemis, *The Doukai* (London, 1968), pp. 126 f.

206 Ed. Lampros, pp. 127 f.

207 Basil II (976–1025).

208 On the monastery of St. Mocius, situated in the western part of Constantinople, see Janin, *Églises*, pp. 367 ff., who misinterprets the present document.

habitation of monks,[209] . . . that Alexius Comnenus, the slayer of the Persians,[210] instituted for them a communal life[211] and furnished them most abundantly with every necessity; that his son John . . . ceaselessly poured out his benefactions in countless ways; while their descendant, the Emperor Manuel . . . increases these donations many times more. . . . He props up the enormous roof of the church that was all rent asunder at the cost of a hundred pounds of gold, and erects this hall from the foundations so that [the monks] . . . may set up therein a common table. . . .

Cod. Marc. Gr. 524, fol. 108ʳ.[212] On the monastery newly built in honor of the most-holy Mother of God by the *pansebastos,* the Grand Hetaeriarch;[213] in the vestibule (*pronaos*)[214] of which were represented the emperors from whom his family line is descended as well as certain feats of the Emperor born in the purple, the Lord Manuel Comnenus:

As you behold the beauty of this church, O stranger, your heart is filled with splendid joy, for it shines with the variegated radiance of marble and gleams with the gold that covers it all round . . . George the Grand Hetaeriarch of the Palaeologus family,[215] the *sebastos,* a scion of emperors' grandchildren, of Comnenes and Doukai, dedicates it to the Maiden who was a mother without a husband. . . . And to indicate the origin of his family, he has represented a holy group of seven emperors, heads of clans who support him like pillars:[216] Constantine Doukas[217] and his son Michael,[218] Romanus of the family of Diogenes,[219] and next Nicephorus Botaniates,[220] then the great Alexius Comnenus,[221] John, the shining star of the purple,[222] and Manuel, the beacon of a doubly royal Kingship. These are his lords, these are his benefactors inasmuch as he is descended from their family tree. Yet he lauds above all others the mightiest among emperors, Manuel, the terror of barbarian chieftains, the ocean of liberality, whom he considers to be the dispenser of his

209 I.e., it was Basil II who turned the church of St. Mocius (built in the 4th century) into a monastery.
210 I.e., the Seljuq Turks.
211 I.e., made the monastery coenobitic.
212 Ed. Lampros, pp. 148 ff.
213 Captain of the imperial guard. The titles *sebastos* and *pansebastos* were equivalent and indicated the bearer's rank in the palatine hierarchy.
214 Perhaps the narthex.
215 On this person see D. I. Polemis, pp. 155 f.
216 This alludes to the seven pillars in the house of Wisdom (Prov. 9:1).
217 Constantine X (1059–67).
218 Michael VII (1071–78).
219 Romanus IV (1068–71).
220 Nicephorus III (1078–81).
221 Alexius I (1081–1118).
222 John II (1118–43).

very life. His [Manuel's] countless feats are known throughout the earth's orb, and a few of them have been represented here: how he set on fire the environs of Iconium after forcing the entire Persian army to flee together with the chief satrap;[223] how, while hunting unarmed, he chanced upon armed Saracens . . . and was wounded in the heel, yet turning round captured his assailant, but refrained from killing him; how, with a small army of Romans, he took countless captives when he joined battle with numerous attacking Ishmaelites and, all alone, put them to flight, not afraid of all their swords, arrows and spears; next, how, on setting forth to punish the insolent Dalmatians, he chances upon the Paeonians,[224] and shows his prowess in single combat by capturing the Župan who has come out against him with bared sword; how before conquering the land of Sirmium, he inflicts in an incredible manner a suitable punishment on Serbia which he enslaves; finally, taking Sirmium, too, he shares the power of the Paeonian ruler and celebrates a great triumph in the City. . . .[225]

Cod. Marc. Gr. 524, fol. 180[r].[226] On a gold vessel upon which was represented our holy Emperor routing the Sultan:[227]

The vessel is of gold whose brilliance seems to glisten in an unusual manner: for represented on it are the feats of Manuel, Emperor of New Rome, who is himself like gold, both in mind and body. What the entire orb of the earth is insufficient [to contain] has been delineated round this vessel: the Emperor of the Romans who shines in the purple [in the act of] frightening, pursuing and utterly defeating the chief of the Persians, armed for battle, together with the countless host of the Iconians; and how it was that having chanced upon untold thousands invisibly hidden in mountain ravines, he alone cut through their line by manfully wielding his spear here and there. Thus is the golden one [Manuel] adorned all the more.

Nikolaos Mesarites, *Account of the Usurpation of John Comnenus "the Fat"* (1201):[228] The Mouchroutas[229] is an enormous building adjacent

223 Manuel marched against Iconium in 1146, but did not, in fact, achieve any marked success.

224 I.e., the Hungarians.

225 Manuel's triumphal entry into Constantinople, after the defeat of the Serbian Grand Župan Stephen Nemanja, took place in 1172. Cf. p. 225.

226 Ed. Lampros, p. 172.

227 This refers to Manuel's expedition against Sultan Masud of Iconium in 1146. The same events were represented on a "golden veil" (so says the *lêmma,* but it seems that, once again, a vessel or plate is meant), the subject of another epigram (Lampros, pp. 176 f.). Manuel's exploits in Hungary were also pictured on a gold plate (Lampros, pp. 175 f.).

228 Ed. Heisenberg, pp. 44 f.

229 From the Arabic *mahrúta* (also used in Persian and Turkish) = "cone," probably with reference to the conical domes of the building.

to the Chrysotriklinos,[230] lying as it does on the west side of the latter. The steps leading up to it are made of baked brick, lime and marble; the staircase, which is serrated [?] on either side and turns in a circle, is colored blue, deep red, green and purple by means of a medley of cut, painted tiles of cruciform shape. This building is the work not of a Roman, nor a Sicilian, nor a Celt-Iberian, nor a Sybaritic, nor a Cypriot, nor a Cilician hand, but of a Persian[231] hand, by virtue of which it contains images of Persians in their different costumes. The canopy of the roof, consisting of hemispheres[232] joined to the heaven-like ceiling, offers a variegated spectacle; closely packed angles project inward and outward;[233] the beauty of the carving is extraordinary, and wonderful is the appearance of the cavities which, overlaid with gold, produce the effect of a rainbow more colorful than the one in the clouds. There is insatiable enjoyment here—not hidden, but on the surface. Not only those who direct their gaze to these things for the first time, but those who have often done so are struck with wonder and astonishment. Indeed, this Persian building is more delightful than the Laconian ones of Menelaus.[234]

So, this Persian stage, the work of his grandfather's kindred hand,[235] had upon it the actor John,[236] crowned, but not arrayed like an emperor, sitting on the ground . . . acting agreeably to the Persians represented in the building and drinking their health. . . .

The Painter Eulalios

There has been endless discussion about the painter Eulalios: did he live in the 6th century or in the 12th?[237] To my mind, there can be no doubt whatever that he was active in the reign of Manuel I, as the following texts demonstrate. That was precisely the time when Byzantine

230 The principal throne room of the Imperial Palace.

231 I.e., Seljuq.

232 I.e., domes.

233 This surely refers to stalactite decoration.

234 Homer, *Od.*, IV:43 ff.

235 Or "a hand [i.e., a person] related to his grandfather." John Comnenus was of Turkish lineage, being the son of the protostrator Alexius Axouch (on whom see p. 224) and the grandson of John Axouch, a Seljuq Turk captured as a boy by the Byzantines in 1097. The latter reached the rank of grand domestic and enjoyed the favor of Emperors John II and Manuel I. The Mouchroutas would thus appear to date from about the middle of the 12th century.

236 An untranslatable pun on *skênê* (stage, tent, house) and *skênikos* (theatrical, an actor).

237 For the bibliography see V. Lazarev, *Storia della pittura bizantina* (Turin, 1967), p. 95, n. 2. The correct solution was first put forward by N. Bees, "Kunstgeschichtliche Untersuchungen über die Eulalios-Frage," *Repertorium für Kunstwissenschaft*, XXXIX (1916), 97 ff., 231 ff.; XL (1917), 59 ff.

painters began to emerge from their anonymity and to sign their works: we should not be so surprised, therefore, that Eulalios, the most famous artist of his period, should have gone one step further and included his own portrait in a Biblical scene. With regard to the mosaic decoration of the Church of the Holy Apostles, all we can say with certainty is that parts of it were redone in the 12th century. The Pantocrator in the central dome and the Women at the Sepulchre were works of Eulalios. Several other scenes described by Mesarites, judging by their iconography, appear to have been made at the same time.[238] The earlier ekphrasis by Constantine the Rhodian, which is certainly incomplete, alludes to eleven New Testament scenes (see pp. 199 ff); Mesarites describes twenty-two. The two accounts have only seven scenes in common, but we cannot draw any inference from this, since the two authors may have simply chosen to describe different compositions. Thus, Mesarites omits the Presentation in the Temple and the Entry into Jerusalem, which certainly made part of the main cycle.

In view of the fact that the full text of Mesarites is now available in English translation, we have excerpted from it only those passages that relate to the two mosaics attributable to Eulalios. There is much else in Mesarites that is of interest, e.g., the scenes depicting the preaching of the Gospel by the apostles.

Theodore Prodromos, *Supplicatory poem addressed to Emperor Manuel* I, v. 37 ff.[239] If Prodromos were to die of penury, and this in your reign and days, where would Your Majesty find another Prodromos like me? Even if perchance you told your buffoon to impersonate me, to become my double, exactly as I am, you would not recognize, my Lord, the Prodromos you have in me. Even if Eulalios himself were to come, and that famous Chênaros and the well-known Chartoularis, who are the foremost painters,[240] they could not reproduce—let no one deceive you —a man like me, a man of such choice learning and wisdom, the greatest teacher of grammar and eloquence, the greatest poet, the greatest prose-writer.

[238] See N. Malickij, "Remarques sur la date des mosaïques de l'église des Saints-Apôtres," Byzantion, III (1926), 123 ff.

[239] Ed. A. Maiuri, "Una nuova poesia di Teodoro Prodromo," BZ, XXIII (1920), 399 f.

[240] The meaning of this sentence has been misunderstood by previous commentators, who thought that Prodromos was comparing his art or fame to that of Eulalios, a celebrated painter of a bygone age. What Prodromos is saying to the Emperor is, however, quite different: "Even if you are to call in Eulalios, he would not be able to paint a man of my accomplishments." It follows that Eulalios, Chênaros and Chartoularis (the latter two are otherwise unknown) were contemporary artists.

Theodore Prodromos.[241] These verses were written for the Annunciation in the church of the *pansebastos prôtosebastos*,[242] the son of the *sebastokratôr* Isaac:

Either the spirit has here taken on the grossness [of matter], or the colors have been altered in relation to the subject, and the brush, as if it were made of some fine substance, delineates the incorporeal; for the spirit[243] that has been represented seems to be somehow addressing Gabriel's words to the Maiden, reverently and gently (since it is a mystery), yet he does not part his lips.

On the same [subject]: How reverent are your colors, O painter! For you are giving speech to the angel you have delineated, having dipped your brush in immateriality.

On the same [subject]: The image is animated, for indeed you are being painted alive, or else you are present alongside the painter as he has been delineating you and have let fall upon his brush a drop of breath: it is a live painting, for verily you live, O Virgin.

On the same [subject]: The colors are those of flesh for they represent a live Maiden; or else so great is the art of Eulalios as to make paintings worthy of his name[244] and to mix colors that are endowed with speech. Yet, O stranger, this is not so because of the art of painting, but the Maiden who is celebrated among men has directed the brush of Eulalios and made his colors so expressive (*eulalon*).

Nicephorus Callistus, On the archangel Michael, a work of art by the famous painter, master Eulalios:[245]

It seems either that the painter has dipped his brush (*skariphos*) in immateriality to delineate a spirit, or else the spirit remains unobserved in his picture, hiding in colors his incorporeal nature. How is it that matter can drag the spirit down and encompass the immaterial by means of colors? This is [a work] of ardent love (as shown by the facts), and it kindles the heart.

Nicephorus Callistus, Other [verses] on the Lord Christ whom Eulalios has masterfully depicted in the central dome of the Holy Apostles:[246]

Either Christ Himself came down from heaven and showed the

241 Ed. E. Miller, "Poésies inédites de Théodore Prodrome," *Annuaire de l'Assoc. pour l'encouragement des études grecques,* XVII (1883), 32 f.

242 The editor prints *prôtosebastôr*, which is a nonexistent title. Bees, pp. 113 ff., has attempted to identify this church with that of the monastery of Christ Evergetês.

243 I.e., the angel.

244 I.e., expressive or endowed with speech, a pun on the name Eulalios.

245 Ed. A. Papadopoulos-Kerameus, "Nikêphoros Kallistos Xanthopoulos," BZ, XI (1902), 46 f., No. 16.

246 *Ibid.,* 46, No. 14.

exact traits of His face to him who has such eloquent hands,[247] or else the famous Eulalios mounted up to the very skies to paint with his skilled hand Christ's exact appearance.

Nicholas Mesarites, *Description of the Church at the Holy Apostles*, XIV: This dome, starting at its very base,[248] exhibits an image of the God-man Christ looking down, as it were, from the rim of heaven towards the floor of the church and everything that is in it. He is not [represented] full-length and entire, and this, I think, is a very profound conception that the artist has had in his mind and has expressed by means of his art to the unhurried spectator: first, methinks, because at present our knowledge of things concerning Christ and His ways is but partial, as in a riddle or in a glass;[249] second, because the God-man is going to appear to us from heaven once again at the time of His Second Coming to earth, and the time until that happens has not yet entirely elapsed, and because He both dwells in heaven in the bosom of His Father,[250] and wishes to associate with men on earth together with His Father, according to the saying, "I and my Father will come and make our abode with him."[251] 2. Wherefore He may be seen, to quote her who sings [in the Canticle],[252] looking forth through the windows, leaning out down to his navel through the lattice which is near the summit of the dome,[253] after the manner of irresistibly ardent lovers. 3. His head is in proportion to His body that is represented down to the navel, His eyes are joyful and welcoming to those who have a clean conscience.... 5. Such are His eyes to those who are not reproached by their conscience, but to those who are condemned by their own judgment, they are wrathful and hostile.... 6. The right hand blesses those who walk a straight path, while it admonishes those who do not and, as it were, checks them and turns them back from their disorderly course. 7. The left hand, with its fingers spread as far apart as possible, supports the Gospel of Him who holds it, while pressing it and resting it somewhat on the left side of the breast, and by means of supporting it there procures considerable

247 The same pun on the name Eulalios.

248 Strictly speaking, this could not have been so, since we know that the central dome of the church had windows at its base. Mesarites probably means to say that the circular medallion containing the Pantocrator occupied the greater part of the curvature of the dome.

249 Cf. 1 Cor. 13:12.

250 John 1:18.

251 John 14:23.

252 Solomon's Song 2:9.

253 The reference to the "lattice" (*diktuôton*) is borrowed from the Septuagint version of Solomon's Song which has *dia tôn diktuôn*, "through the lattice." It is not quite clear to me what element of the dome Mesarites has in mind here. He may be thinking of the rainbow border of the medallion which is often rendered in a diaper pattern suggestive of a lattice or net.

relief from the burden. . . . 8. The God-man's raiment has more blue color than gold, thereby admonishing us through the painter's hand not to wear splendid apparel, not to seek purple and silk, scarlet and hyacinth. . . .

Nicholas Mesarites, *Description of the Church of the Holy Apostles,* XXVIII, 10 ff: They [the women] have already come to the tomb without shouts, noise and loud cries. . . . 13. First, they see that the stone has been rolled away from the tomb not by human hand . . . and then the angel himself seated, all bright, on the stone of the tomb. 14. Once more they are seized by fear and trepidation. . . . 15. And the tears which were gushing noiselessly from their eyes as from a fountain are immediately congealed. . . . 16. Like statues of wood and stone stand the women bearing unguents, and a deep pallor has spread over the surface of their faces. . . . 18. But [the angel] whom they have seen revives them . . . and raises them from their collapse by the good tidings of the resurrection: "Why seek ye, weeping, Him who lives among the dead?[254] . . . Verily, the Life of all men has been called back to life, and the Resurrection of all men has arisen. 19. My words are witnessed by these seals of the tomb that have been loosed, by the bars and nails that have been torn out and knocked down, by the towel and the winding cloths that have remained in the tomb, by the watchless guards who have fallen into a deathlike and, as it were, unwaking sleep. . . . 21. For all of their senses and energies have ceased to function. Some of them are seen stretched out snoring, others are bowing down their heads upon their own or their fellows' shoulders, others are pressing their arms against their knees and supporting their chins on the palm of their hands. . . . 22. But leave them here at this spot, sleeping their well-nigh unwaking sleep, and go quickly to the friends and disciples of Him who has arisen. . . ."

23. Thus did the angel speak to the women. But our discourse, in looking and gazing round curiously hither and thither, has recognized the man who with his own hand has depicted these things,[255] as he may be seen standing upright by the Lord's tomb like a watchful guard, dressed in the same robe and other garments which he wore to adorn his outer appearance when he was living and painting these things and succeeding admirably [in the representation] both of himself and of all the other [particulars]. 24. And our discourse might well have spent more time in praising this man, and this with good reason, were it not obliged to accompany the women, hastening with them as they hasten to the disciples in accordance with the angel's command.

254 Luke 24:5.
255 A marginal note in the manuscript says, "He means Eulalios."

Secular Art

Theodore Balsamon, *Scholion on Canon 100 of the Quinisext Council (692)*[256] The foremost sense is that of sight, and we ought to be guided by it towards everything that is good. . . . In view of the fact that certain persons who were consumed by erotic desires and were indifferent to their manner of life represented cupids (*erôtidia*) and other abominable things on panels and on walls and in other media, so that they might satisfy their carnal desires by the sight of them, the holy Fathers ordained . . . that such things should fall utterly into abeyance. . . . Note this also: in the houses of some of the rich, not only are such paintings (even gilded ones) indecorously represented, but human forms made of stucco are also set up.

Andronicus I (1183–85)

Nicetas Choniates, pp. 431–34: Intending to have himself buried at the church of the holy Forty Martyrs, inasmuch as it was of great beauty and size and stood at the very center of the city, he zealously repaired those parts of the church that were injured and restored their vanished splendor. He also adorned with great magnificence the icon of Christ our Saviour, through which the latter is said to have spoken once to the Emperor Maurice,[257] and he moved from the garden of the Great Palace into the courtyard of the church that enormous porphyry basin whose rim is encircled by the coils of two monstrous serpents—a marvellous sight. Thither, too, he transferred the remains of his wife[258] from the monastery of Angourion[259] where she had been previously buried. Outside the north door of the church of the Forty Saints that faces the public square, he had himself represented on a large panel, not arrayed in golden imperial vestments, but in the guise of a much-toiling laborer, dressed in a dark parted cloak that reached down to his buttocks, and having his feet shod in knee-high white boots.[260] In his hand he held a

256 Ed. G. A. Rhallès and M. Potlês, *Suntagma tôn theiôn kai hierôn kanonôn*, II (Athens, 1852), 545 f. The text of the canon (Mansi, XI, 985 D) is in part as follows: "We ordain that paintings such as bewitch the sight, corrupt the mind and lead it to the temptations of shameful pleasures, be they on panels or set up in any other form, shall not henceforth be represented in any manner whatever. Whoever attempts to do such a thing shall be excommunicated."

257 On this image see C. Mango, *The Brazen House* (Copenhagen, 1959), pp. 109 ff.

258 Andronicus's first wife, whose name is not recorded.

259 On the Asiatic shore of the Bosphorus.

260 A slightly different description of the Emperor's costume is given in

curved reaping-hook—a heavy, big, sturdy [implement]—whose bent line encompassed and entrapped the figure of a young man represented down to his neck and shoulders. By means of this image he clearly informed and instructed the passers-by . . . of his own unlawful deeds, namely of having murdered the successor [to the throne] and having appropriated to himself both the latter's kingship and the latter's wife.[261] He also intended to set up his own effigy in bronze on top of a pillar—the so-called Anemodoulion, a tall four-sided monument of bronze upon which [are represented] naked Erotes pelting one another with apples;[262] and this although he altered the images of the Empress Xenê (the mother of the Emperor Alexius) whom he killed by suffocation, and had her face repainted to look old and shrivelled because he suspected the pity felt by spectators upon seeing her most beautiful appearance that was truly worthy of admiration.[263] And most [other imperial images] he allowed to be defaced and repainted to represent himself, in imperial attire, standing next to the bride of Alexius, or else alone. Finally, he erected magnificent quarters for his own use at the church of the Forty Martyrs, wherein he was to dwell whenever he visited the shrine. Not having any recent actions suitable to be depicted in these buildings either in blended paints or fine mosaic cubes, he had recourse to his deeds prior to his becoming emperor; and so were represented here horse-races and hunts, birds clucking, dogs barking, the capture of deer and hares, wild boar with projecting tusks being transfixed, and the *zubros*[264] being pierced with a spear (this is a beast larger than the mythical bear and the spotted leopard and is reared especially among the Tauroscythians), a rustic life under tents, the informal consumption of the hunted game, Andronicus himself cutting up with his own hand the flesh of deer or solitary boar and cooking it skilfully on the fire, and other such things indicative of the life of a man trusting in bow and sword and swift-footed steeds, a man who had fled his country whether from senselessness or virtue.

the demotic version of Nicetas's History: the cloak reached down to the knees, while the feet and lower legs had strips of white cloth wound round them after the manner of puttees. Curiously enough, this portrait of Andronicus is reflected in the illustrations of the Oracles of Leo the Wise which may have originated in the 12th century. See C. Mango, "The Legend of Leo the Wise," *Zbornik radova Vizant. Instituta,* VI (1960), 64 and figs. 4, 5.

[261] Andronicus married the eleven-year-old Agnes (Anna), daughter of Louis VII of France, who had been espoused to the child emperor Alexius II.

[262] On the Anemodoulion see p. 44.

[263] Mary of Antioch, second wife of the Emperor Manuel I, who on her husband's death assumed the monastic name Xenê. She was renowned for her beauty.

[264] Nicetas uses here the Slavonic name (*zubr*) of the aurochs or urus, the extinct wild ox of Europe.

The Angeli (1185-1204)

Isaac II Angelus (1185-95)

Nicetas Choniates, pp. 580 ff.: Above everything else, he [Isaac] was very eager to erect enormous buildings. . . . In both palaces[265] he built most splendid baths and apartments. He also constructed sumptuous houses along the Propontis and made little islands to rise in the sea. Having decided to build a tower at the palace of Blachernae both for its protection and support, as he claimed, and to serve as his dwelling-place,[266] he demolished a number of churches that had long stood neglected along the shore as well as many famous buildings of the Imperial City which, to this day, exhibit their foundations, a lamentable sight to all that pass by; among these, he tore down the splendid build-ing of the Genikon[267] which was all of baked brick. He also destroyed, along with many others, the celebrated palace (*oikos*) of the Mangana,[268] showing no respect for the beauty and great size of the building, nor yet fearing the victorious Martyr [St. George] to whom it was dedicated. Wishing, furthermore, to restore the church of Michael, chief of the heavenly host, at Anaplous,[269] he transferred thither all the marble slabs, beautifully polished and mottled with many-colored spots, that were used for floor paving and wall revetment in the imperial palace.[270] He also collected in the same church as many images of the archangel, both painted and in mosaic, as the City contained and those that were set up as phylacteries in villages and in the country—works of ancient and quite wonderful art. This Emperor's eagerness to bring from Monem-basia, as it is now called, the image of Christ led to the cross (an admira-ble and most elegant work of art) did not fall short of being a consum-ing passion. He was entirely gripped by this desire until he succeeded in removing the image thence by stealth, for to have done it openly would have been an operation not devoid of danger.[271] Furthermore, he trans-

265 I.e., in the old imperial palace next to the Hippodrome and in the palace of Blachernae.

266 On the tower of Isaac Angelus see A. van Millingen, *Byzantine Con-stantinople. The Walls of the City* (London, 1899), pp. 131 ff.

267 The Public Treasury. Its exact situation is unknown. See Janin, *CP byzantine*, pp. 173 f.

268 Cf. R. Demangel and E. Mamboury, *Le quartier des Manganes* (Paris, 1939), p. 42.

269 On this church see p. 115.

270 I.e., the old palace next to the Hippodrome. Ms B of the Bonn ed. specifies that the slabs in question were taken from the Nea church.

271 This icon has given its name (*Helkomenos*) to the largest church of Monembasia which in its present form dates from the end of the 17th century. It contains a much restored icon portraying Christ, his hands tied, wearing the

ferred thither [i.e., to Anaplous] the bronze doors which, being wide and exceedingly high, formerly closed the entrance of the Imperial Palace, while, in our time, they barred the prison called on their account the Chalkê.[272] He also denuded of all its sacred furniture and vessels the famous church in the palace which is called the Nea monastery.[273] He was as proud and conceited over these deeds as if he had done something worthy of admiration.

Paintings in St. Sophia

Antony of Novgorod, pp. 15–16, 17, 23. On the same side [274] is placed a big icon of Saints Boris and Gleb which painters have [as a model]. . . .[275]

There, too,[276] is a baptistery with water, and in it is painted the Baptism of Christ by John in the Jordan together with the [whole] story: namely, how John taught the people and how small children and men cast themselves into the Jordan. All of this was painted by the artist Paul in my lifetime, and there is no painting like this elsewhere. There, too, are wooden [supports] and on them the patriarch places an icon of the holy Saviour at a height of thirty cubits. Paul at first painted Christ with precious stones and pearls; in one place he rubbed off the paints(?). This icon stands in St. Sophia to this very day. . . .[277]

In the gallery are painted all the patriarchs and emperors, as many of them as there have been at Constantinople, and [it is indicated] which ones among them were heretics.

Inventories

There exists a group of inventories, mostly monastic, containing lists of icons, liturgical vessels and vestments, holy relics, manuscripts, etc. These texts are of considerable interest for the study of the minor arts, but their technical terminology often presents difficulties of interpretation. In addition to the Patmos inventory, an excerpt of which is reproduced below, the following are of interest: 1. A list of donations made in

crown of thorns and a purple robe. Reproduced in *Eleutheroudaki Enkyklopaidikon Lexikon*, IX (Athens, 1930), pl. facing p. 512, fig. 4.

272 The Chalkê (on which see p. 109) is said to have been turned into a prison in the 7th century.

273 On the Nea, see p. 194.

274 I.e., on the right hand side of St. Sophia, close to the altar.

275 Note variant reading *i tu menjajut piscy*, which presumably means "copies of which are sold by painters."

276 I.e., at St. Sophia.

277 It is not clear why Antony should make this remark if the painter Paul was his contemporary. It should be borne in mind that Antony's text has come down to us in a highly corrupt condition.

the late 10th century to the monastery of the Grand Lavra and to Karyes, the administrative center of Mount Athos.[278] 2. The will of Eustathius Boilas (1059).[279] 3. The rule (diataxis) of Michael Attaliates (1077).[280] 4. The inventory of the Bačkovo monastery in Bulgaria (1083).[281] 5. That of the monastery of S. Pietro Spina in Calabria (c. 1135).[282] 6. That of the monastery of Xylourgou on Mt. Athos (1143).[283] 7. That of the monastery of the Virgin Eleousa (Veljusa), near Strumica in Yugoslav Macedonia (1449).[284]

Inventory of the Monastery of St. John the Evangelist, Patmos (1200):[285]

A big holy icon of the Evangelist [John] with a gilded silver border; halo and Gospelbook of silver with gold and enamel. —An *enkolpion*[286] of the Crucifixion. —Another round [*enkolpion*] of the Virgin and Child, both silver with gold and enamel. —Another icon of the holy apostles Peter and Paul, entirely reveted with gilded silver. —Another icon of [John] Chrysostom having the halo, Gospel book, cuffs (*epimanika*) and three crosses,[287] all of gilded silver. —Another icon of the holy Virgin having a border. —Another icon of the three Saints, Theodore, Demetrius and George, entirely plated (? *holotzapôtos*).[288] —Another icon of St. Nicholas of copper (*sarout*) with a border. —Another icon of the holy Virgin with border and halo, having also a small pearl on the forehead. —Another icon [in the form of a] diptych, having on one side six images, inside of which are relics of those same saints. —Another entirely reveted icon of St. Athanasius and St. Cyril. —Another icon, a processional one (? *signon*),[289] of the holy Virgin holding the Child with a border having ten [inset] images with [decorated] haloes; in the Child's halo are two [precious] stones and one pearl. —Another icon of St. Paul of Latros[290]

[278] Contained in the Georgian Life of Sts. John and Euthymius. Latin trans. by P. Peeters, *Analecta Bollandiana*, XXXVI–XXXVII (1917–19), 25 ff.

[279] English trans. and commentary by S. Vryonis, Jr., *Dumbarton Oaks Papers*, XI (1957), 263 ff.

[280] K. N. Sathas, *Mesaiônikê bibliothêkê*, I (Venice, 1872), 47 ff. Cf. W. Nissen, *Die Diataxis des Michael Attaleiates* (Jena, 1894), pp. 69 ff.

[281] Ed. L. Petit, *Vizant. Vremennik*, XI, Suppl. 1 (1904), 12, 52 ff.

[282] B. de Montfaucon, *Palaeographia graeca* (Paris, 1708), pp. 403 ff.

[283] *Akty russkago na svjatom Afone monastyrja* (Kiev, 1873), pp. 50 ff.

[284] Ed. L. Petit, *Izvestija Russk. Arkheol. Instituta v Konstantinopole*, VI (1900), 118 ff.

[285] Ed. C. Diehl, BZ, I (1892), 511 ff.

[286] I.e., a small medallion such as was worn round the neck. See article "Enkolpion" by K. Wessel, *Reallexikon zur byzant. Kunst*, II (1967), 152 ff.

[287] These must have been represented on the Saint's *ômophorion* (humeral).

[288] The adj. *tzapôtos* appears in Ducange's *Glossarium mediae graecitatis* and in the inventory of Xylourgou, but its exact meaning is not clear.

[289] The term *signon* denoted a banner. Cf. Petit (above, n. 284), p. 131 (Eleousa inventory). In this context it refers, I think, to a processional icon rather than to an image painted on a banner.

[290] Mount Latmos or Latros near Miletus. St. Paul died in 955.

containing relics of this Saint. —Another entirely plated (?) icon of Christ and the two Evangelists Luke and John. —The following are in the cell of the aforementioned abbot: an *enkolpion* entirely decorated with silver and enamel of the Virgin and Child. —Another icon entirely reveted of St. George and St. Demetrius containing [a particle of] the True Cross. —Another entirely plated (?) icon of the Virgin and Child. —Another small *enkolpion* [representing] the Dormition. —One great cross[291] of gilded silver. —Two other big crosses plated (?) with silver. —Another processional (? *signon*) cross with enamel icons. —Another reveted icon of the Dormition of the holy Mother of God. —Another reveted icon of St. Mercurius (these two are the gift of . . .[292] from Crete). Another icon of the holy Mother of God, carved and reveted. —Another reveted one of St. Panteleêmôn. *The iventory continues with the enumeration of saints' relics, liturgical vessels and veils and, finally, manuscripts.*

Deed of Concession to the Genoese of Certain Areas of Constantinople (October 13, 1202):[293] The particulars of the so-called Palace of Botaniates[294] that has been handed over to them [the Genoese], which is close to the place called Kalubia, are as follows. The holy church is domed, has a single conch and four columns, one of them being of white Bithynian marble. The face of the arch (? *epilôros*) and the curve (? *diastrophê*) of the conch (*muakion*) are reveted with marble, as are the vaults (*kamarai*).[295] The revetment of the gamma-shaped spaces (? *gamatismata*)[296] on the west side are of Nicomedian tiles (?*tanstria*)[297] as is the cornice, and above that are images in gold and colored mosaic, as also in the dome and the four vaults,[298] three of which have glass [windows]. The

291 This and the following items were, I presume, not in the abbot's cell, but in the main church or the sacristy.

292 The donor's name has been left blank in the manuscript.

293 Ed. F. Miklosich and J. Müller, *Acta et diplomata graeca medii aevi*, III (Vienna, 1865), 55.

294 On the palace of Botaniates see Janin, *CP byzantine*, pp. 251, 326. The Genoese concession was situated near the modern quarter Sirkeci on the Golden Horn. Attached to the palace was a church which is described in this document. It was of the four-column, cross-in-square type, and may have dated from the 10th or 11th century.

295 These vaults must have been in the area of the apse. Since the vaults themselves could not have been reveted with marble, some kind of a marble surround is probably meant.

296 The term *gammation* was applied to gamma-shaped ornaments on vestments, usually ecclesiastical. In this context it may denote the wall space on either side of the west doors.

297 Cf. D. Talbot Rice, *Byzantine Glazed Pottery* (Oxford, 1930), p. 15. These were presumably decorated glazed tiles, such as the well-known fragments from Patleina in Bulgaria. Nicomedia was presumably the place of their manufacture. The use of such tile revetments in Constantinople was quite widespread, and they were applied not only to flat surfaces, but also to moldings and cornices. Cf. C. Mango and E. J. W. Hawkins in *Dumbarton Oaks Papers*, XVIII (1964), 310 f. and figs. 47–58.

298 The four barrel vaults on which the dome rested.

partition of the *bêma* consists of four posts (*stêmonoroi*) of green [marble] with bronze collars, two perforated closure slabs, a marble entablature and a gilded wooden *templon*.[299] The marble canopy (*katapetasma*) of the holy table, the latter having four straight moldings (?*riglia*),[300] is [supported] on four reed-like [columns] and is enclosed by means of two railings (*sustematia*) and two closure slabs (*stêtha*) as well as railing doors and [other] little doors. Above the west railing is a carved marble icon. The pavement consists of an interlace (*plokê*) of green slabs and *opus sectile* (*sunkopê*) and a border of Phlegmonousian marble.[301] To the south is an adjunct (*parapterugon*) having an arch (*tropikê*) adorned with paintings and a little conch with mosaics. The latter is screened off by means of three reed-like [columns], a *harmosphênion*[302] and a marble entablature. The two entrances into it have marble railings, a third is closed. The floor is of white marble with *opus sectile* and roundels. The outer semi-circular terrace (*hêliakos*), which is decayed, has two reed-like columns and a marble floor. The north adjunct has an arch adorned with paintings, a little conch that is not enclosed, and a floor of plain marble....

299 This passage is of interest for the history of the Byzantine chancel-screen on which see esp. V. Lazarev, "Trois fragments d'épistyles peintes et le templon byzantin," *Deltion tês Christian. Archaiol. Hetaireias*, Ser. 4, IV (1964), 117 ff. We have here a normal marble screen consisting of pillars, closure slabs, and entablature. The wooden *templon* was probably placed above the entablature and represents a step in the direction of the gilded wooden iconostasis which, from about the 14th century onward, begins to form a solid barrier between the nave and the choir.

300 The term *riglion* (from Latin *regula*) denoted any kind of straight rod or ruler.

301 Same as Sagarian marble.

302 The meaning of this term is unknown. It appears to be a compound of *harmozô*, "to join together" and *sphên*, "wedge." Perhaps a spandrel is meant.

7

The Late
Byzantine Period
(1204–1453)

In 1204 the Byzantine Empire was fragmented. While the Crusaders occupied Constantinople, part of Bithynia, Thrace, the eastern half of Greece and the Poloponnese, while the Venetians made themselves masters of the Aegean islands and of Crete, the Byzantine Greeks set up a number of independent principalities: the Empire of Nicaea, the Despotate of Epirus, and the far-away Empire of Trebizond which continued its existence until 1461. In 1261 the Emperor of Nicaea, Michael VIII Palaeologus, was able to recover Constantinople, and his descendants, hard pressed on all sides by the Bulgarians, the Serbians, the Latins, but especially by the rising tide of the Ottoman Turks, maintained an uncertain hold over gradually shrinking territories in the southern part of the Balkan peninsula. Under Michael VIII (1259–82) the Empire could still pass as a European power, but the reign of his successor Andronicus II (1282–1328) was marked by heavy losses and inaugurated a series of civil wars that reduced the state to complete exhaustion. By the middle of the 14th century the Turks began establishing themselves in Europe, and the Byzantine Emperor became an impotent vassal of the Sultan. When, at length, Constantinople fell in 1453, the political situation of eastern Europe was not greatly affected by this event.

Viewed against this gloomy background, the artistic achievement of the Palaeologan period is very impressive, at least until about 1325. The incomparable mosaics and frescoes of the monastery of the Chora (Kariye Camii) and St. Mary Pammacaristos (Fethiye Camii) at Constantinople, the churches of Mistra, Mount Athos, Thessalonica and Ohrid show us how much ostentation the richer Byzantines could still afford at the time; and the Serbian kings did their best to reproduce Byzantine models on their own territories.

The main artistic contribution of the Palaeologan period lay in the realm of painting. A distinctive new style came into being soon after the reconquest of Constantinople in 1261: lacking the monumentality of earlier Byzantine painting, it was marked by a multiplication of figures and scenes, by a new interest in perspective (however strangely rendered) and by a return to much earlier models such as illuminated manuscripts of the 10th century. The radiation of this new style was not quite as wide as that of Comnenian painting, being at first limited to the Balkans and the small section of Asia Minor that the Empire still controlled. But by the end of the 14th century Palaeologan painting was carried to Novgorod and Moscow and, thanks to the activity of that great master, Theophanes the Greek, produced a profound effect upon the subsequent development of Russian religious art.

The written sources bearing on the art of this period are disappointingly meager. The renewed interest in ancient monuments is documented in a letter of the Emperor Theodore Ducas Lascaris which we have included for its relevance to the history of taste; it is, however, rather an

exceptional document since there is little evidence of any widespread curiosity about the remains of classical art in the 13th and 14th centuries.[1] *Was it the influence of antiquity or that of western Europe that inspired that most remarkable monument of the reign of Michael VIII, the bronze statue of the Emperor kneeling in front of his namesake, the archangel Michael? Alas, we shall never know. Yet, whatever new forms were absorbed by Palaeologan art, the old Byzantine tradition remained dominant, and patronage continued to be vested in a small class of "feudal" aristocracy. Our chief literary source for the artistic production of the early 14th century, the poet Manuel Philes, poured out a stream of doggerel verse concerned with icons, liturgical and secular vessels, funerary portraits, etc., practically all of them commissioned by members of the aristocracy. The content of his poems is, however, seldom interesting to the art-historian, consisting as it does either of clichés or the praises and lineage of his noble patrons. Nor can we derive much benefit from the poems of the prime minister Theodore Metochites who, after his disgrace, described in labored hexameters the beauties of his former palace and of the monastery of the Chora which he had rebuilt.*[2]

Contact with western art must have been a fact of everyday occurrence in the Palaeologan period, and it produced a twofold reaction. The Byzantine churchman, such as Symeon of Thessalonica, was deeply shocked by the naturalistic images and statues of the Latins which he denounced as a breach of Christian tradition. But this same naturalism in secular art drew the admiration of a few educated Byzantines who, predictably yet curiously enough, expressed it in the form of ekphraseis of French or Flemish tapestries, such as the "Picture of Spring" by the Emperor Manuel II,[3] *the "Kings in a garden" and the "Plane tree" by Joannes Eugenikos.*[4]

[1] In addition to Lascaris, we may mention Maximus Planudes who, towards the end of the 13th century, visited the ruins of Cyzicus. See C. Wendel, "Planudea," BZ, XL (1940), 432 ff.

[2] We have omitted the latter for reasons of space. The two poems relevant to the monastery of the Chora have been edited by M. Treu, *Dichtungen des Gross-Logotheten Theodoros Metochites*, Programm des Victoria-Gymnasiums zu Potsdam (1895).

[3] Probably inspired by a tapestry at the Louvre. Text in PG 156, 577–80. Cf. J. von Schlosser, "Die höfische Kunst des Abendlandes in byzantinischer Beleuchtung," *Mitt. d. Inst. für österr. Geschichtsforschungen*, XVII (1896), 441 ff.; reprinted in *Präludien* (Berlin, 1927), 68 ff.

[4] Text in J. F. Boissonade, *Anecdota nova* (Paris, 1844; reprint, Hildesheim, 1962), pp. 331 ff., 340 ff. There is also an *ekphrasis* of the Dormition of St. Ephraem Syrus attributed to Markos Eugenikos which has been shown to describe an Italian rather than a Byzantine picture. See D. Pallas, "Eikona tou hagiou Eustathiou stê Salamina," *Charistêrion eis A.K. Orlandon*, III (Athens, 1966), 358 ff. Text in K. L. Kayser, *Philostrati libri de gymnastica* (Heidelberg, 1840), pp. 142 ff.

A Greek scholar has recently argued that a shift towards a more naturalistic appreciation of art occurred in Byzantium c. 1400.[5] It would be difficult to prove that this was a general phenomenon. What we can say, however, is that a few Byzantines who went to the West began to look on art with new eyes. Particularly interesting is the case of Manuel Chrysoloras who poses in Aristotelian terms the relation of art to nature and who, for the first time, evaluated the contribution of Byzantium in historical terms. But Chrysoloras was a widely travelled expatriate Greek and a man of the Renaissance.[6]

Attitude towards Antiquity

Theodore Ducas Lascaris, *Epist*. XXXII *ad* G. *Acropolitam*.[7] Pergamon . . . is full of monuments, grown old, as it were, and decrepit with age, showing as through a glass their former splendor and the nobility of those who built them. For these things are filled with Hellenic elevation of thought and constitute the image of that wisdom. Such things does the city show to us, the descendants, reproaching us with the greatness of our ancestral glory. Awesome are these compared to the buildings of today. . . . There are walls reared up, their construction as variegated as that of the "brazen heavens."[8] In between flows a river bridged by tall arches which (by the Maker of heaven!) you would not think to be composite, but rather to have grown up naturally as a single block of stone. If a sculptor like Pheidias were to see them, he would admire their exact evenness and lack of inclination. Between the buildings are low hovels, which appear, as it were, to be the remnants of the houses of the departed, and the sight of them causes much pain. For, as mouseholes are compared to the houses of today, so one might say are the latter compared to those that are being destroyed. . . . On either side of the circuit-wall of the great theatre stand cylindrical towers, vying with each other in the evenness of their stonework and girded with some kind of bands. They are not the work of a modern hand, nor the conception of a modern mind: for their very sight fills one with astonishment.[8a]

Michael VIII (1259–82)

Georgius Pachymeres, *Histor*., II, 234. *This passage refers to the earthquake of 1296.* The church of All Saints which had stood until that time

5 D. Pallas, "Hai aisthêtikai ideai tôn byzantinôn pro tês Halôseôs," *Epetêris Hetair. Byzant. Spoudôn*, XXXIV (1965), 313 ff.

6 On his career see G. Cammelli, *Manuele Crisolora* (Florence, 1941).

7 Ed. Festa, pp. 107 f.

8 *Iliad*, XVII, 425.

8a This refers not to a theatre, but to the so-called Serapaeum or Red Court.

in good condition suffered grievous damage, namely the collapse of its roof, both that part that was over the bema and the part that was in the middle. And likewise the bronze statue of the Archangel [Michael] that is there—the one that is set up on a column-like pedestal and represents the Emperor Michael at the Archangel's feet, offering to him the City which he holds [in his hands] and commending it to his protection—this statue, I say, lost its head and the City slipped out of the Emperor's hands, and both fell to the ground.[9]

Georgius Pachymeres, *Histor.*, I, 517: Wishing that these deeds[10] be immortalized, he [Michael VIII] ordered them to be painted on the walls of the palace, and not these only, but also those that by God's grace had been accomplished from the beginning [of his reign]. The former were immediately painted in the vestibule, while the latter were not executed, the Emperor having died in the meantime.

Andronicus II (1282–1328)

The Prime Minister's Palace

Theodore Metochites, *To himself, after the reversal of his fortunes*, vv. 165 ff.[11] *The dethronement of Andronicus II in 1328 brought about the fall of his all-powerful and wealthy prime minister Metochites. The latter's palace, described in this passage, was sacked by the populace.* Within it [the palace] was a chapel, a delightful sight.... It stood unshaken, resting on a solid construction of evenly dressed stones joined together. Inside, columns support the roof, and outside, too, all round the pleasant vestibule, they are set up in a circle, a joy to see as they glisten. The entire pavement, both inside and out, is composed of glorious many-colored marbles cut in twain, and these, too, are set upright all round. Such was the chapel in my palace.

Round about were houses such as befitted the condition of noble men, and very serviceable, too. There were also gardens of delightful beauty and ever-flowing fountains gushing forth, fed from the outside by well-built conduits. . . . Inside, underground reservoirs of water through hand-made founts relieved by their coolness the fiery heat. Also inside, abundant streams of water were channelled as necessary from a well-built bath, a pleasure to use and to see both within and without.

9 This monument is also mentioned by Buondelmonti in 1420: "Apud denique eclesiam sanctorium Apostolorum quinta insultat columpna; quo in capite Angelus eneus est, et Constantinus genuflexus hanc urbem in manu sua offert." Ed. G. Gerola, "Le vedute di Costantinopoli di Cristoforo Buondelmonti," *Studi bizantini e neoellenici*, III (1931), 275 f.

10 The Byzantine victory over the Angevins at Berat in Albania in 1281.

11 Ed. with many mistakes by R. Guilland, "Le palais de Théodore Métochite," *Rev. des études grecques*, XXXV (1922), 88 ff.

There was also a courtyard surrounded by a portico sheltered from the rays of the sun; it was a delight to walk through it. It was very large as befitted the buildings, and it was pleasant to behold its position and the proportion of its length to its width. It was paved with quarried stone besprinkled with old lime dust in a uniform, dry layer so as to afford easy passage to both men and horses, free from the hindrance of marshy ground....

Allegories

Manuel Philes, *Cod. Escur.*, Poem No. 237:[12] On the images of the Virtues in the palace: If you are expressing in colors the Emperor's character, why have you painted only four virtues? If it was not possible to represent [the other virtues that are begotten] of these [four,] why, instead of them all, have you not painted him in person...? *The same conceit is repeated in Nos. 238–40 and in* Cod. Paris., *No. 24.*[13]

No. 241. On Prudence who points her finger at her head: O maiden Prudence, is it on your own estimation that you are pointing your finger at yourself? Point it instead at the Emperor of the Roman country who has shown his head to be your instrument.

No. 243. On the image of Fortitude: In representing the soul's boldness in the face of the passions, the painter has given arms to Fortitude.[14]

No. 244. [On the image] of Justice: On seeing, O stranger, the image of the heavenly scales, weigh well your actions in this life.[15]

No. 245. [On the image] of Temperance: Not only her crown, but also her modest gaze and her garments that are drawn together adorn Temperance.

Manuel Philes, *Cod. Escur.*, Poem No. 248:[16] On a picture of Life which represents a tree, in which is a man gaping upwards and quaffing honey from above, while below, the roots [of the tree] are being devoured by mice:[17] On seeing this symbol of the shadow of [earthly] things, bear in mind, O man, the end that is hidden from you. Standing upright, you are enjoying the honey of pleasure, while a dragon with gaping mouth awaits your fall to destroy you. *Poems 246, 249–52 are devoted to the same picture.*

[12] Ed. Miller, I, 124 ff.

[13] *Ibid.*, II, 67.

[14] Fortitude was probably represented holding spear and shield. These attributes suggest western influence.

[15] Justice was traditionally represented holding a balance.

[16] Ed. Miller, I, 127.

[17] This composition is derived from the story of Barlaam and Joasaph. See S. Der Nersessian, *L'illustration du roman de Barlaam et Joasaph* (Paris, 1937), pp. 63 ff.

Painting of a Garden

Manuel Philes, *Cod. Paris*., Poem 62:[18] On the painted ceiling in the palace: Where has this luxurious garden been planted? Do you not see it above ground, O stranger? In what manner, being as it is suspended and stretched out under the roof, does it preserve so securely its interwoven contexture, lest its bond be disrupted by the breezes and so force the fruit to drop off before its time? What moisture have the roots absorbed to have produced such delicate shoots on the plants? For the painter, no matter how exactly he imitates nature, is unable to pour in water. Whence has the warmth of vegetation crept through to put forth flowers that adorn the boughs, to make leaves with their hidden shadows? Who has gone by and painted, next to the lilies, all those colors of the beautiful grove? Do you see the white, the dark green, the hue that grows pale as if from sickness, and the one that is adorned with purple, a purple that does not come from the sea-shell? Be mindful, O spectator, not to touch the lilies; for you are not permitted to use your knife here, lest any [plant] be stabbed and quickly fade away, and so deprive the birds of their food. See how the painter has shown himself an excellent caretaker of the grove: for he has depicted the carnivorous animals pursuing only those which by nature feed on herbs, so that the meadow should not be given over to grazing to be ravaged all too soon. And lest the fowl devour the grass, he has confined them in circular pens. And the foursome of hares, fashioned so fitly, he has gathered in a single group lest they be parted from one another, and one of them, rushing out into the meadow, be immediately seized by the jaws of those bloodthirsty animal-stalkers. And if, my good man, in some parts of the garden you chance to see a bird perched in the hollow of a lily, gathering the sperm of the flower, do not be astonished at the painter: for he provides food for the humble, and he makes the garden a place of strange and soft delight; otherwise one might have thought that the green grass was devoid of moisture and unsuitable for eating. As you can see, he has also painted a female lion and given her a fixed abode that she might feed her cubs, and fenced her with a woven barrier, lest she boldly sally forth and chase away the roe with her young.... *The poet goes on to refer to a pair of peacocks. The noisier birds, however, such as swallows, nightingales and swans have been banished from the garden lest their cries disturb the silence that is obligatory in an imperial chamber.*

18 Ed. Miller, II, 127 ff.

John V (1341–91)

The Mosaic of the Pantocrator in the Dome of St. Sophia

Nicephorus Gregoras, Hist., XXIX, 47 f.[19] *Part of the dome of St. Sophia collapsed in 1346. The repairs lasted several years, and shortly after 1355 an enormous mosaic of Christ Pantocrator in a circular medallion was made in the center of the dome, probably the last mosaic of any size to have been produced in the Byzantine Empire.*

Having reached this point, it would be fitting to set down the length and breadth of the holy image of the enhypostatic Wisdom of God, I mean Christ our Saviour, that was recently depicted on the inner curved surface of the roof. . . . It is worth reflecting, I think, that when one looks up [at the image] from below, one is unable [to apprehend] by means of sight its true proportions and transmit them to the mind, since sight is usually deceived by the interposition of distance between the spectator and the object seen. . . . The height [of the head] from its summit to the tip of the beard is 28 palms, its width 14, the first finger 8½ long and the others in proportion. Each eye is 3 palms, and the nose nearly 8.[20] Now that I have given these elements, the more accomplished painters will be able, by using proportional analogy, to reckon straightaway the length and breadth of the other members and parts as well as the conformation of the entire body of that holy image of the Saviour.

The Painter Gastreas

Manuel Raoul, Letter to the Painter Gastreas (c. 1360?):[21] Granted that a painter's hand possesses sagacity and is skilled in imitating truth, I, too, have need of Your Sagacity's hand for [an icon of] the venerable and glorious Dormition of the most-pure Mother of Christ Our Saviour; all the more so since I remember your very considerable zeal in this respect when, not less than twenty-six years ago, you sought an exact [picture] of this, and often repaired in the morning to Upper Tavia[22] in order to reproduce the ancient icons there (*tous archetupous . . . pinakas*). For

19 CSHB, III, 255 f.

20 These measurements do not appear to be altogether consistent. See C. Mango, *Materials for the Study of the Mosaics of St. Sophia* (Washington, D.C., 1962), pp. 87 f. The medallion enclosing the Pantocrator (now probably destroyed) has a diameter of 11 m.

21 Ed. S. Lambros, BZ, VII (1898), 310; ed. R. J. Loenertz, *Epet. Hetair. Byzant. Spoudón*, XXVI (1956), 162.

22 A locality in Arcadia.

this reason I request you to grant me what I am seeking at the appropriate [fee].

Constantinople in the Fifteenth Century

Manuel Chrysoloras, Epist. 1 *addressed to the prince John Palaeologus (later the Emperor John VIII).*[23] *In this letter Chrysoloras compares Rome, where he is then residing, to Constantinople. The Old Rome and the New Rome resemble each other as a mother resembles her daughter; but the latter is the more beautiful of the two.* Had I wished to enumerate the memorials, the tombs, the monuments and statues that are or have been in our city [Constantinople], I would not have been at a loss to do so. I might have had to acknowledge that there are fewer of them than there are here [in Rome], but some of them are much more beautiful and splendid. Take, for example, the tomb of the Emperor who is the founder and guardian of the city, and the other tombs that are round it in the imperial mausoleum—a wonder to behold—and many others that are preserved standing in a circle near the church of the Apostles,[24] in addition to those that have disappeared, and all those others that are in the vestibules of churches in different parts of the city. Or take the statue of the Emperor who made laws;[25] in front of it, if I remember correctly, to the east, there had been other statues upheld on enormous columns. Many other such statues used to be in the city as shown by their remaining pedestals and the inscriptions upon them; these were in different places, but especially in the Hippodrome. Many of these, which I now hear have been removed, I earlier saw myself. It is also said that the column on the Xêrolophos and the one facing it to the east, the one named after the bull (*tauros*),[26] on the other hill, once supported statues of beaten silver, the former of the elder, the latter of the younger Theodosius. How big, precious and beautiful these statues must have been may be surmised from the beauty, height, splendor and magnificence of the bases. In recalling these to my mind, I also remembered that in line with the same street, to the west, there was once a gate

[23] PG 156, 45 ff. The letter was written from Rome in 1411.

[24] Referring to the mausolea of Constantine and Justinian, on which see P. Grierson, "The Tombs and Obits of the Byzantine Emperors," *Dumbarton Oaks Papers*, XVI (1962), 20 ff.

[25] Justinian's equestrian statue in the Augustaion. Concerning the columns placed in front of it see C. Mango, *The Brazen House* (Copenhagen, 1959), pp. 174 ff.

[26] Referring to the "historiated" columns (i.e., columns whose shaft was covered with a spiral band of pictorial reliefs) of Theodosius I at the Forum Tauri and of Arcadius (not Theodosius II) on the seventh hill called Xêrolophos. The first of these was pulled down c. 1500, but a few fragments of its reliefs survive; the second was dismantled c. 1715, but its battered pedestal is still standing. See G. Becatti, *La colonna coclide istoriata* (Rome, 1960), 83 ff.

of the city big enough to let through entire towers and fortifications (if only these could move) and cargo-ships with all their sails and masts;[27] and [it was made] of great marble blocks, and above it was a portico (*stoa*) that shone from afar; and, furthermore, in front of it was a column which also supported a statue. And on another hill, the one above your residence,[28] there is a column, and others at the Stratêgion,[29] and another to the right of the church of the Apostles,[30] and many more —suitable pedestals for the statues [they supported]. And what of the porphyry column which is at the east end of the same street and raises a cross high in the air—the one that Constantine the Great himself set up in the court of his palace, and that surpassed all other statues and monuments?[31] We also have many works of sculpture as, for example, on those columns that are carved all round, exact imitations of the ones that are here [in Rome].[32] These, however, are surpassed by the statues of porphyry stone that are seated on thrones by the roadside between these [two columns] and which have received a name derived from the superintendence of the marketplace;[33] and that other small statue of white stone or marble that is on the same street at the head of the stream that flows through the city,[34] and seems to be reclining on its elbow. There are many others of the same kind which I did not happen to have seen myself; I have heard, however, that they exist in certain secret places. I pass over the ones in front of the Golden Gate (admirable as this gate is with its marble towers), namely the labors of Hercules and the punishment of Prometheus and other such [carvings] of marble.[35] The reason why that city [Constantinople] does not contain more works of

[27] This presumably refers to a monumental gate of the Constantinian walls which survived until 1508. See A. Van Millingen, *Byzantine Constantinople* (London, 1899), p. 21. The column outside the gate seems to be the one that supported a statue of Constantine: *Patria*, § 54, ed. Preger, p. 181.

[28] The emperor resided in the Blachernae palace. I do not know which column Chrysoloras is referring to.

[29] On the Stratêgion and its monuments see Janin, *CP byzantine*, pp. 431 f.

[30] Presumably the one that supported the statue of Michael VIII, on which see p. 246.

[31] The so-called Burnt Column which in fact had nothing to do with Constantine's palace. It originally supported a statue of Apollo-Helios in the guise of Constantine, but this fell down in 1106. Manuel I (1143–80) placed a cross at the summit of the column. See C. Mango, "Constantinopolitana," *Jahrb. d. Deutschen Archäol. Inst.*, LXXX (1965), 306 ff.

[32] The columns of Trajan and Marcus Aurelius.

[33] These statues, probably of the 4th century, were popularly known as the "True Judges." See C. Mango, "The Legend of Leo the Wise," *Zbornik radova Vizant. Instit.*, VI (Belgrade, 1960), 75.

[34] The Lycus.

[35] This was a set of twelve panels which survived until the 18th century. A few small fragments of them were found in 1927. See Th. Macridy and S. Casson, "Excavations at the Golden Gate, Constantinople," *Archaeologia*, LXXXI (1931), 63 ff.

this kind is that it was founded at a time when such things were being neglected even here [in Rome] on account of religion and, I suppose, men were averse to statues that were similar to idols. For why should they [the Byzantines] have been making them, when here [in Rome] the statues that had existed previously were being destroyed? Instead, they made and invented other [kinds of representation], namely on panels, images, paintings, and especially in mosaic, a most splendid and durable art. Such mosaics are rare here and, truly, pertain to Greece or even to that city [Constantinople], for even those that may be seen here or elsewhere derive their material and their art from there [Byzantium]. The same I believe to have happened in the case of sculpture, namely that it originated over there [in Greece] and, the principle having come thence, it reached a wonderful development here. One can probably say this of other things as well.

The Palace of Trebizond[36]

Bessarion, *Encomium of Trebizond*:[37] The dwelling of the emperors is set up in the present acropolis and is itself no less than an acropolis, surpassing as it does all other buildings by the strength of its walls and the variety, size and beauty of its construction. Its west wall is common to the acropolis and the palace, and serves the same purpose to both up to a height of two storeys; from there upward, it extends for the sake of the palace alone and towers above the wall of the acropolis by almost the same measure that the latter rises above the ground. The walls facing in other directions, being adequate in point of height, thickness and other respects, extend all the way down and, while they take away more than half of the acropolis, they add this area to the palace, and are by themselves sufficient to resist the oncoming enemy and to guard safely those that may be inside. They afford entrance by means of two gates and one postern, and for the rest are securely constructed so as to exclude and ward off attackers. On either side is left an open space for rooms and the quartering of the emperors' servants, while the palace rises in the middle and has one entrance provided with a staircase of steps, so that the entrance is also a way up. As one enters, one straightaway encounters on one side splendid vestibules and halls of sufficient beauty and size, capable of containing a great number of people, the halls being surrounded with

36 Some ruins of the palace of Trebizond are still in existence, but they have not been properly studied. See F. I. Uspenskij, *Očerki iz istorii Trapezuntskoj Imperii* (Leningrad, 1929), pp. 154 ff. and pls. 1–2. For the layout of the citadel see plan in Chrysanthos (Metropolitan of Trebizond), *Hê ekklêsia Trapezountos = Archeion Pontou*, IV–V (Athens, 1936). The Empire of Trebizond was set up in 1204, so that the palace must have been constructed, probably in stages, some time thereafter.

37 Ed. S. Lampros, *Neos Hellênomnêmôn*, XIII (1916), 188 ff.

balconies facing in all directions and exposed to all the breezes. On the other side is stretched out a very long and beautiful building, its floor entirely paved with white marble, while its ceiling shines with the blooms of painting, with gold and various colors. The entire hollow [of the ceiling] gleams with shining stars in imitation of the heavens and exhibits excellence and delicacy of painting. All round, on the walls, is painted the choir of the emperors, both those who have ruled our land and their ancestors;[38] also painted there are the dangers our city has undergone and those who in attacking it have done so to their own detriment. High up, at the end of the building, there appears a covered imperial dais (*bêma*) having a pyramidal roof supported on four columns. This, too, is screened all round with white marble, roof and all, and it separates the emperors from their subjects as with a barrier. It is there in particular that the emperor makes his appearance, that he conducts business with his ministers, converses with ambassadors, speaks and is spoken to. Farther on is another imperial hall (*bêma*) of outstanding height and width, covered with a roof and having columns all round. In this building, which is decorated with paintings, is a flight of steps so as to raise the emperor aloft, and it is here that he is wont to give splendid banquets for his ministers and other subjects. On the left hand side one encounters a suite of many rooms, including one that differs from the rest: this is fenced by four equal sides, like a frame, and contains memorials of the Creation of the world and of the origin and history of man.[39] On the right hand side are many halls, vestibules, terraces, chambers and rooms separated by colonnades running athwart one another, all of a measure that cannot be surpassed, each bigger than the next and all constructed with unutterable beauty and due harmony. There, too, is set up a church decorated with beautiful paintings and adorned with sacred offerings which, if not very numerous, are of outstanding beauty. What this church lacks in size it makes up in comeliness.

Attitude towards Latin Religious Art

Symeon of Thessalonica, *Contra haereses*, ch. 23:[40] What other innovation have they [the Latins] introduced contrary to the tradition of the Church? Whereas the holy icons have been piously established in honor of their divine prototypes and for their relative worship[41] by the faithful, . . . and they instruct us pictorially by means of colors and other materials

38 The imperial dynasty of Trebizond was descended from the Byzantine Emperor Andronicus I Comnenus (1183–85).

39 I.e., paintings illustrating the book of Genesis.

40 PG 155, 112.

41 See p. 169, n. 86.

(which serve as a kind of alphabet)—these men, who subvert everything, as has been said, often confect holy images in a different manner and one that is contrary to custom. For instead of painted garments and hair, they adorn them with human hair and clothes, which is not the image of hair and of a garment, but the [actual] hair and garment of a man, and hence is not an image and a symbol (*tupos*) of the prototype. These they confect and adorn in an irreverent spirit, which is indeed opposed to the holy icons.... *Symeon goes on to condemn the western custom of staging mystery plays with biblical subjects.*

Sylvester Syropoulos, *Vera historia*, p. 109. *At the Council of Ferrara (1438) the Patriarch of Constantinople, Joseph II, petitioned the Pope for the use of a church in order to celebrate the Easter services. This move was criticized by members of the Greek delegation, one of whom, Gregory Melissenus, the emperor's confessor, spoke as follows:*

When I enter a Latin church, I do not revere any of the [images of] saints that are there because I do not recognize any of them. At the most, I may recognize Christ, but I do not revere Him either, since I do not know in what terms he is inscribed (*ouk oida pôs epigraphetai*). So I make the sign of the cross and I revere this sign that I have made myself, and not anything that I see there.

Aesthetic Theory

Perspective

Nicephorus Gregoras, *Astrolabica*, p. 222: The delineation of a sphere on a flat plane is similar to painting. For just as the painters seek to imitate objects exactly, not according to their true properties, but so as to make them recognizable to the viewers within the capabilities of human nature, and they show the length or the breadth of lofty buildings contracting somewhat and sinking down according to the requirements of the art and so as to make them visually more plausible, so, too, the geometricians and astronomers delineate on a flat plane solid objects, such as octahedrons and cubes and all spherical bodies, like the stars, the heavens and the earth.

Nature and Art

Manuel Chrysoloras, *Epist.* 3.[42] Why is it that when we see a live horse or a dog or a lion (as we may do every day), we are not roused to admira-

[42] PG 156, 57 ff. Written from Rome in 1411. For a discussion of this text see M. Baxandall, "Guarino, Pisanello and Manuel Chrysoloras," *Journal of the Warburg and Courtauld Institutes*, XXVIII (1965), 197 ff.

tion, are not delighted by its beauty and attach little value to its appearance—and the same applies to a tree, a fish, a cock and even to human beings (indeed, some of them are displeasing to us)— but when we see the picture of a horse or a bull or a plant or a bird or a man, or even of a fly, a worm, a mosquito or some other foul animal, we are greatly moved by the sight of such pictures and make much of them? And yet the pictures are surely not more exact than their models since they are praised to the extent that they appear to resemble the latter. However, we neglect the existing models for all their beauty, while we admire their representations. We do not pay much attention to the graceful curve of a bird's beak or to the hoof of a live horse; but when the mane of a bronze lion is beautifully spread out, when the leaves of a stone tree show their ribs, when the leg of a statue suggests the sinews and veins upon the stone—this we find pleasing, and there are many men who would gladly exchange several live horses in perfect condition for one stone horse by Pheidias or Praxiteles, even if the latter happens to be broken and damaged. Furthermore, it is not considered shameful to gaze upon the beauty of statues and paintings (on the contrary, this indicates a certain nobility of spirit on the part of the admiring spectator), whereas to gaze upon beautiful women is a licentious and shameful act. What is the reason for this? It is that in images we are admiring the beauty not of bodies, but of the maker's mind. For, as it happens with well-molded wax, he receives through his eyes an image (*tupos*) onto the imaginative part of his soul (*to phantastikon tês psuchês*) and then imprints it on stone, wood, bronze or on pigments; for just as every man's soul disposes its body (which has many weaknesses) in such a way that its disposition— be it sorrow, joy or anger—is visible in the body; so does the artist by means of artful simulation fashion the stubborn and hard substance of stone, bronze or pigments—a substance that is alien and unrelated—and makes the emotions of the soul visible in these [materials]. Moreover, even if he is not himself laughing or, perchance, is not at all pleased, or angered or mournful or disposed in this or that way—indeed, his disposition may be quite the opposite—yet, he impresses these emotions upon his materials. This, then, is what we admire in images; just as in the case of natural beings, if we were to contemplate the Mind that has fashioned them and fashions them every day, . . . we would be filled with the greatest admiration.

Byzantine Artists in Russia

Novgorod

First Novgorod Chronicle, **Second Recension, s.a. 6846, p. 348:** In the same year [1338], May 4th, the feast of the bishop Silvan the martyr, the

prince Basil commanded Isaias the Greek and others to paint the church of Our Lord Jesus Christ [called] the Entry into Jerusalem, and on that very day he started painting.

Third Novgorod Chronicle, s.a. 6886, p. 243: In the same year [1378] was painted the church of Our Lord Jesus Christ on Iljina street at the behest of the noble and God-loving bojar Vasilij Danilovič and the dwellers of the street. It was the Greek master Theophanes who painted it at the time of the Grand Prince Dimitrij Ivanovič and Alexij, archbishop of Novgorod the Great and Pskov.

Moscow

Trojtskaja Chronicle, s.a. 6852, p. 366: In the same year [1344] two stone churches in Moscow began to be painted, that of the holy Mother of God and that of St. Michael. [The church of] the holy Mother of God was painted by Greeks, painters of the metropolitan Theognostos, and in the same year they started they also finished. As for St. Michael's, it was painted by Russian painters, men of the Grand Prince Semen Ivanovič, and the elders and chiefs among these painters were Zacharias, Joseph, Nicholas and their companions. However, they were unable that year to paint even half of the church on account of its great size.

Trojtskaja Chronicle, s.a. 6903, p. 445: In the same year [1395], on the 4th of June, a Thursday, at the time of mass, the new stone church of the Nativity of the holy Mother of God at Moscow began to be painted. The masters were the icon-painter Theophanes, who was a Greek philosopher, as well as Semen Černyj and their pupils.

Trojtskaja Chronicle, s.a. 6907, p. 450: In the same year [1399] was painted the stone church of St. Michael at Moscow by the Greek icon-painter Theophanes, who was the master, and by his pupils.

Trojtskaja Chronicle, s.a. 6913, p. 459: In the spring of that year [1405] the stone church of the holy Annunciation in the Grand Prince's palace —not the one that is standing now—began to be painted. The masters were the Greek icon-painter Theophanes, the elder monk Prokhor from Gorodets and the monk Andrej Rublev. They finished in the same year.

Epifanij the Wise, Letter to Cyril of Tver':[43] You saw at one time the church of St. Sophia of Constantinople painted in my book, namely the Gospels, which in Greek are called *Tetraevangelion*, while in our Russian tongue they are called Četveroblagovestie [the Four Gospels]. It happened in the following way that this building was painted in my book.

[43] Written c. 1415. Text in V. N. Lazarev, *Feofan Grek i ego škola* (Moscow, 1961), pp. 113 f.

While I was living at Moscow there also lived there a celebrated sage, a most cunning philosopher, the Greek Theophanes, a famous illuminator of books and an excellent religious painter who painted with his own hand more than forty stone churches in the cities of Constantinople, Chalcedon, Galata, Kaffa, Novgorod the Great and Nižnij Novgorod. In Moscow he painted three churches: that of the Annunciation of the holy Mother of God, that of St. Michael and one more. At St. Michael's, on the wall, he painted with colors a city with all its particulars; he likewise painted [a view of] Moscow itself on a stone wall at the prince's Vladimir Andreevič, and the palace of the Grand Prince he painted with a [previously] unknown and wondrous kind of painting, and in the stone church of the holy Annunciation he also painted the Tree of Jesse and the Apocalypse. While he delineated and painted all these things no one ever saw him looking at models as some of our painters do who, being filled with doubt, constantly bend over them casting their eyes hither and thither and instead of painting with colors they gaze at the models as often as they need to. He, however, seemed to be painting with his hands, while his feet moved without rest, his tongue conversed with visitors, his mind dwelled on something lofty and wise, and his rational eyes contemplated that beauty which is rational. This wondrous and famous man had a great love for my mediocrity, so that I, humble and foolish as I was, had the great temerity of often visiting him, for I was fond of conversing with him.

Whoever conversed with him either for a short or a long time could not but be struck by his intellect, his sayings and his wise mentality. When I perceived that he loved me and did not despise me, I added shamelessness to boldness and addressed to him the following demand: "I beg your Wisdom that you paint for me with colors a representation of that great church of St. Sophia at Constantinople, the one that was erected by the great emperor Justinian who emulated the wise Solomon. Some persons have related that with regard to quality and size it is like the Moscow Kremlin of the inner city—so great is the circuit of its foundations when you walk round it. If a stranger enters it and wishes to go about unaccompanied by a guide, he is unable to find an exit without losing his way no matter how clever he may be, and this on account of the multitude of columns and colonnades, ascents and descents, passages and corridors, and various halls, chapels, stairs, treasuries and sepulchres as well as divisions and appendages of different denominations, windows, ways, doors, entrances and exits and stone pillars. Delineate for me Justinian, as he is called, sitting on horseback and holding in his right hand a brazen apple which, they say, is so big and capacious that it would hold two and a half pails of water. Please represent for me all the aforementioned on the leaf of a book so that I may be able to place it at the beginning of my book and, as I recall your

handiwork and contemplate such a church, I may imagine myself being in Constantinople." He, being a wise man, answered me wisely: "It is impossible," he said, "for you to obtain this as it is for me to draw it; however, on account of your insistence, I shall draw for you a small part, and that not even a part, but, as it were, one hundredth—something small out of something great—so that thanks to this paltry representation of mine you may be able to imagine and understand the rest, great as it is." So he spoke, and boldly taking a brush and a leaf, he quickly sketched the picture of a church in the likeness of the one at Constantinople, and he gave this to me. This leaf proved of great benefit to the other icon-painters of Moscow inasmuch as many of them copied it for themselves, and they vied with one another and passed it from one to the next. Last of all, I, too, as a painter, allowed myself to paint it in four different forms, and I inserted this church in my book in four places, namely,

1. At the beginning of Matthew's Gospel, where [I placed] Justinian's pillar and the image of the Evangelist Matthew;
2. The church at the beginning of the Evangelist Mark;
3. The same at the beginning of the Evangelist Luke;
4. At the beginning of John's Gospel.

I painted four churches and four Evangelists which you saw yourself when I fled to Tver' from fear of Edegej[44] and rested from my tribulations at your house, and related my grief to you, and showed you all the books that I had saved from dispersal and destruction. At that time you saw the church as it was painted, and six years later, during the past winter, you reminded me of it in your kindness.

A Cretan Painter

Testament of the Painter Angelo Acontanto (1436):[45] Because of the transgression of our ancestor Adam, all of us have been given over to death and corruption, and there is no man who shall live and see not death. For this reason, I, too, Angelos Kotantos, the painter, being a mortal man and subject to death, and being about to sail to Constantinople, do so ordain and make my testament regarding my possessions as follows. . . . My child that is about to be born, if it is a male,[46] I wish him first to learn to read and write and thereafter the art of painting, and if he learns the latter, I bequeath to him my *disegni (teseniasmata)* and all the articles of the craft, but if he does not learn it—I mean

[44] Referring to the attack on Moscow by Edigü, Emir of the Golden Horde (1408–9).
[45] Ed. M. I. Manoussakas, *Deltion tês Christianikês Archaiologikês Hetaireias*, Ser. 4, II (1960/1), 146 ff.
[46] The painter was leaving behind his wife who was pregnant at the time. We happen to know from another document that she gave birth to a daughter.

the craft—then I bequeath my *disegni*, i.e., my drawings (*skiasmata*), and all the articles of the craft to my brother John. . . .[47] And my books I bequeath to my child, if it is male, so he may learn to read, and let them pass from father to son, but if he dies as a child, let the books be sold . . . I also wish that the head of St. Catherine, the round icon, should be given after my death to the monks of Sinai[48] who will expose it every year on the feast day of the Saint[49] in my memory. I wish furthermore that the two icons that are in my room, i.e., the Anastasis of Jesus Christ and the other, the Nativity of Christ, should after my death be taken to [the church of] Christos Kephalas[50] and set up in the middle [of the church] together with the veil[51] which I have for this purpose, namely the Anastasis on Easter day and the Nativity on Christmas . . . and then let them be brought back to my house. Let my child that is about to be born, whether male or female, observe this practice every year if it lives. But if the child dies, I bequeath these two icons, the Anastasis and the Nativity, to Christos Kephalas, and out of the alms I am leaving let them make two frames (?)[52] with doors for the safe keeping [of the icons] and hang them up high. . . . If the child that is about to be born dies, I bequeath to my brother John the big icon of Christ which hangs in the porch, opposite the door.

[47] Also a painter.

[48] The monastery of St. Catherine of Mt. Sinai had a dependency (*metochion*) at Candia.

[49] It is the practice of the Greek Church to expose the icon of the day to the veneration of the faithful upon a stand called *analogion*.

[50] A church at Candia.

[51] Angelo uses the word *pódas* (masc.) which seems to mean the same as *podéa* (fem.), a veil, sometimes richly decorated, that was laid under an icon.

[52] The meaning of *duo kléziolais skletais* is not clear to me.

BIBLIOGRAPHY

The following works, some of them obsolete, are either collections of excerpts or contain useful indications of source material:

Augusti, J. C. W., *Beiträge zur christlichen Kunst-Geschichte und Liturgik*, 2 v. (Leipzig, 1841–46).

Bayet, C. M. A. L., *Recherches pour servir à l'histoire de la peinture et de la sculpture chrétiennes en Orient avant la querelle des iconoclastes* (Paris, 1879).

Dobschütz, E. von, *Christusbilder*. Texte und Untersuchungen zur Geschichte der altchristlichen Literatur, N. F., III (Leipzig, 1899).

Downey, G., "Ekphrasis," *Reallexikon für Antike und Christentum*, IV (Stuttgart, 1959), 921–44.

Elliger, W., *Die Stellung der alten Christen zu den Bildern in den ersten vier Jahrhunderten* (Leipzig, 1930). Pt. 2: *Zur Entstehung und frühen Entwicklung der altchristlichen Bildkunst* (Leipzig, 1934).

Geischer, H.-J., *Der byzantinische Bilderstreit*, Texte zur Kirchen- und Theologie- Geschichte, 9 (Gütersloh, 1968).

Hennephof, H., *Textus byzantini ad iconomachiam pertinentes* (Leiden, 1969).

Hohlweg, A., "Ekphrasis," *Reallexikon zur byzantinischen Kunst*, fasc. 9 (Stuttgart, 1967), 33–75.

Kalokyrês, K. D., *Pêgai tês christianikês archaiologias* (Thessaloniki, 1967).

Koch, H., *Die altchristliche Bilderfrage nach den literarischen Quellen* (Göttingen, 1917).

Richter, J. P., *Quellen der byzantinischen Kunstgeschichte* (Vienna, 1897).

Unger, F. W., *Quellen der byzantinischen Kunstgeschichte* (Vienna, 1878).

INDEX OF AUTHORS AND ANONYMOUS WORKS

Bibliographic references that are given in the text are not repeated here.

Greek

Agathias (c. 531–c. 580), historian, poet and editor of the *Cycle*, a collection of epigrams by contemporary poets. *Historiarum libri quinque*, ed. R. Keydell (Berlin, 1967). Poems included in *Anthol. graeca*.

Agathon, deacon, early 8th century.

Anthologia graeca, a collection of about 3700 epigrams, both pagan and Christian, compiled in the 10th century on the basis of earlier collections and supplemented c. 1300 by Maximus Planudes. The so-called Planudean Appendix constitutes Bk. XVI. Standard ed. by F. Dübner and E. Cougny, 3 v. (Paris, 1864–90). Better, but incomplete ed. by H. Stadtmüller, 3 v. (Leipzig, Teubner series, 1894–1906). Ed. with English trans. by W. R. Paton, 5 v. (London-New York, Loeb Classical Library, 1916–18); unfinished ed. with French trans. by P. Waltz (Paris, Budé series, 1928–); ed. with German trans. by H. Beckby, 4 v. (Munich, 1957–58).

Asterius, bishop of Amaseia, d. c. 410. Description of martyrdom of St. Euphemia, ed. F. Halkin, *Euphémie de Chalcédoine* (Brussels, 1965).

Basil, St., bishop of Caesarea in Cappadocia (329–379).

Bessarion, bishop of Nicaea, later cardinal (1403–72).

Book of the Prefect, 10th century. A collection of regulations governing the conduct of the professional and trade guilds of Constantinople. Ed. J. Nicole, *Le Livre du Préfet* (Geneva, 1893). English trans. by E. H. Freshfield, *Roman Law in the Later Roman Empire* (Cambridge, 1938). Both reprinted in *To Eparchikon Biblion; the Book of the Eparch; le Livre du Préfet*, with introd. by I. Dujčev (London, 1970).

Choricius of Gaza, rhetorician, first half of 6th century. Ed. R. Foerster, *Choricii Gazaei opera* (Leipzig, 1929).

Christophoros Mitylenaios, poet, first half of 11th century. Ed. E. Kurtz, *Die Gedichte des Christophoros Mitylenaios* (Leipzig, 1903).

Chronicon Paschale, universal chronicle down to 627. Ed. L. Dindorf, CSHB.

Constantinus Rhodius, poet, first half of 10th century. Description of church of Holy Apostles, ed. E. Legrand, *Revue des études grecques*, IX (1896), 32 ff., and separately, *Description des oeuvres d'art et de l'église des Saints Apôtres....* (Paris, 1896).

Constitutiones apostolorum, a collection of ecclesiastical regulations, c. 375.

Cyril, St., patriarch of Alexandria, d. 444.

De sacris aedibus Deiparae ad Fontem, anonymous description of the church of the Virgin of Pêgê and of the miracles that took place in it; 10th century. ASS, Nov. III, 878 ff.

Digenes Akrites, a ballad of the 10th or 11th century. Ed. with English trans. by J. Mavrogordato, *Digenes Akrites* (Oxford, 1956).

Epiphanius monachus, first half of 9th century. *Vita S. Andreae*, PG 120.

Epiphanius, bishop of Salamis, d. 403. Fragments ed. G. Ostrogorsky, *Studien zur Geschichte des byzant. Bilderstreites* (Breslau, 1929).

Epistola synodica patriarcharum orientalium, a petition alleged to have been addressed to the Emperor Theophilus by a council held at Jerusalem in 836. Ed. with Italian trans. by L. Duchesne, *Roma e l'Oriente*, V (1912–13), 222 ff.

Eusebius, bishop of Caesarea, c. 265–340. *Historia ecclesiastica*, ed. E. Schwartz, *Eusebius Werke*, II in 3 pts. (Leipzig, 1903–9); ed. with English trans. by K. Lake, J. E. L. Oulton and H. J. Lawlor, 2 v. (London-New York, Loeb Classical Library, 1926–32); *Vita Constantini* (authorship doubtful), ed. I. A. Heikel, *Eusebius Werke*, I (Leipzig, 1902).

Eustathius, archbishop of Thessalonica, c. 1125–c. 1195.

Eustratius presbyter, hagiographer, disciple of Patriarch Eutychius of Constantinople (552–65, 577–82).

Evagrius, lawyer, 6th century. Ed. J. Bidez and L. Parmentier, *The Ecclesiastical History of Evagrius* (London, 1898).

Georgius Cedrenus, compiler of universal chronicle down to 1057. Ed. I. Bekker, 2 v., CSHB.

Georgius Pachymeres, historian, 1242–c. 1308. *Historiae*, ed. I. Bekker, 2 v., CSHB. *Ekphrasis* of the Augusteôn along with Nicephorus Gregoras, II, CSHB, 1217 ff.

Georgius presbyter, *Vita S. Theodori Syceotae* (d. 613), written soon after Saint's death. Ed. Th. Ioannou, *Mnêmeia hagiologika* (Venice, 1884), pp. 361 ff. Partial English trans. by E. Dawes and N. H. Baynes, *Three Byzantine Saints* (Oxford, 1948), pp. 85 ff.

Gregory of Nazianzus, St., c. 329–389/90.

Gregory of Nyssa, St., c. 335–c. 395. *Epistolae*, ed. G. Pasquali in *Gregorii Nysseni opera*, ed. W. Jaeger, VIII/2 (Leiden, 1959).

Historia mystagogica, an interpretation of the church building, priestly vestments and liturgy. Attributed to Germanus I, Patriarch of Constantinople (715–30). Ed. F. E. Brightman, *Journal of Theol. Studies,* IX (1908), 248 ff., 387 ff. Longer, contaminated version in PG 98, 384 ff.

Hypatius of Ephesus, first half of 6th century. Fragments of *Miscellaneous Enquiries*, ed. F. Diekamp, *Analecta Patristica*, Orientalia Christiana Analecta, CXVII (Rome, 1938).

Ignatius, abbot of monastery *tou Akapniou* at Thessalonica, 12th century or earlier. *Narratio de imagine Christi in monasterio Latomi*, ed. A. Papadopoulos-Kerameus, *Varia graeca sacra=Zapiski istor.-filol. Fakult. Imp. S. Petersb. Univ.*, XCV (1909), 102 ff.

Joannes Chrysostomus, St., Patriarch of Constantinople, c. 344–407.

Joannes Cinnamus, historian, second half of 12th century. *Epitome*, ed. A. Meineke, CSHB.

Joannes Damascenus, St., theologian, d. c. 750.

Joannes Diakrinomenos, author of Ecclesiastical History preserved only in paraphrased fragments. Late 5th century.

Joannes bishop of Gabala, author of a lost Life of Severus, Monophysite Patriarch of Antioch (512–38), a fragment of which is quoted in the Acts of the Seventh Ecumenical Council (787).

Joannes Lydus, civil servant, 6th century. *De magistratibus populi Romani,* ed. R. Wuensch (Leipzig, 1903).

Joannes Malalas, 6th century, author of a universal chronicle that has come down to us in an abridged form. *Chronographia,* ed. L. Dindorf, CSHB.

Joannes Mavropous, bishop of Euchaita, author of sermons, poems, etc.; first half of 11th century. Ed. P. de Lagarde and J. Bollig, *Johannis Euchaitarum metropolitae quae supersunt,* Abhdl. Göttinger Ges. Wiss. 28 (Berlin, 1882).

Joannes Moschus, hagiographer, d. 619.

Joannes, archbishop of Thessalonica, author of sermons, first half of 7th century.

Leo VI, Emperor, 866–912. Sermons ed. Akakios, *Leontos tou Sophou panégurikoi logoi* (Athens, 1868).

Leo grammaticus, early 11th century, redactor of the Chronicle of Symeon Logothetes (mid 10th century). *Chronographia,* ed. I. Bekker, CSHB.

Leontius scholasticus, mid 6th century, poet whose epigrams are included in the *Cycle* of Agathias.

Manuel Chrysoloras, philologist and diplomat, c. 1350–1415.

Manuel Philes, poet, c. 1275–c. 1345. Ed. E. Miller, *Manuelis Philae carmina,* 2 v. (Paris, 1855–57).

Manuel Raoul, author of letters, late 14th century.

Marcus diaconus, follower of Porphyrius, bishop of Gaza (d. 420). *Vita Porphyrii,* ed. with French trans. by H. Grégoire and M.-A. Kugener (Paris, 1930).

Michael Psellus, philosopher, historian and author of miscellaneous works, 1018–c. 1096. *Chronographia,* ed. with French trans. by É. Renauld, 2 v. (Paris, 1926–28).

Miracula SS. Cosmae et Damiani, a collection of miracle stories written at different times, probably in the 6th–7th centuries. Ed. L. Deubner, *Kosmas und Damian* (Leipzig-Berlin, 1907).

Miracula S. Demetrii, a collection of miracle stories in 3 books, the first by Joannes, archbishop of Thessalonica (early 7th century), the second of the end of the 7th century, the third of later date.

Narratio de S. Sophia, a legendary account of the construction of St. Sophia, 8th or 9th century. Ed. Th. Preger, *Scriptores originum Constantinopolitanarum,* I (Leipzig, 1901), 74 ff.

Nicephorus, Patriarch of Constantinople, 758–828. *Breviarium* (concise chronicle), ed. C. de Boor, *Nicephori opuscula historica* (Leipzig, 1880).

Nicephorus Callistus Xanthopoulos, author of saints' lives, a history of the Church, poems, etc.; *fl.* early 14th century.

Nicephorus Gregoras, historian, scientist and author of miscellaneous works, c. 1290–1360. *Historia,* ed. L. Schopen and I. Bekker, 3 v., CSHB; *Astrolabica,* ed. A. Delatte, *Anecdota Atheniensia,* II (Liège-Paris, 1939).

Nicetas Choniata, historian and theologian, d. 1213. *Historia* and *De Signis,* ed. I. Bekker, CSHB.

Nicetas magister, hagiographer, *fl.* early 10th century.

Nicetas Paphlago, author of saints' lives and sermons, first half of 10th century.

Nicetas, archbishop of Thessalonica, hagiographer, 10th or 11th century. *Miracula S. Demetrii,* ed. A. Sigalas, *Epetêris Hetaireias Byzantinôn Spoudôn,* XII (1936), 317 ff.

Nikolaos Mesarites, author of miscellaneous works, d. c. 1220. Description of the Church of the Holy Apostles (written 1198–1203), ed. with German trans. by A. Heisenberg, *Grabeskirche und Apostelkirche,* II (Leipzig, 1908); ed. with English trans. by G. Downey, *Trans. Amer. Philos. Soc.,* N.S., XLVII/6 (1957), 855 ff. Account of the usurpation of John Comnenus the "Fat" (1201), ed. A. Heisenberg, *Die Palastrevolution des Johannes Komnenos* (Würzburg, 1907).

Nilus of Sinai, St., ascetic, author of Epistles, d. c. 430.

Parastaseis syntomoi chronikai, a popular guidebook to the monuments of Constantinople, compiled in 741–75. Ed. Preger, *Scriptores originum* ... I, 19 ff.

Passio S. Procopii, earlier than the 8th century. Ed. A. Papadopoulos-Kerameus, *Analekta Hierosolymitikês stachyologias,* V (St. Petersburg, 1898), 1 ff.

Patria Constantinopoleos, a guidebook to the monuments of Constantinople, based partly on the *Parastaseis.* Compiled c. 995. Ed. Preger, *Scriptores originum* ... II (1907).

Paulus Silentiarius, poet, fl. c. 560. Description of St. Sophia and its ambo ed. P. Friedländer, *Johannes von Gaza und Paulus Silentiarius* (Leipzig-Berlin, 1912); obsolete English trans. in W. R. Lethaby and H. Swainson, *The Church of Sancta Sophia, Constantinople* (London-New York, 1894), pp. 35 ff.; Italian trans. by A. Veniero, *Paolo Silenziario* (Catania, 1916), pp. 233 ff.

Photius, Patriarch of Constantinople (858–67, 877–86), author of miscellaneous works. Homilies ed. B. Laourdas, *Photiou Homiliai,* Suppl. 12 to *Hellênika* (Thessaloniki, 1959); English trans. by C. Mango, *The Homilies of Photius* (Cambridge, Mass., 1958).

Procopius, historian, 6th century. *De aedificiis,* ed. J. Haury, *Procopii Caesariensis opera,* III/2 (Leipzig, 1913); ed. with English trans. by H. B. Dewing and G. Downey, *Procopius,* VIII (London-New York, Loeb Classical Library, 1940).

Scriptor incertus de Leone Armenio, fragment of a lost chronicle covering the years 811–20. Ed. I. Bekker along with Leo Grammaticus, CSHB, pp. 335 ff.

Sophronius, Patriarch of Jerusalem (634–38), author of sermons and saints' Lives.

Sozomen, jurist, d. c. 450. *Historia ecclesiastica,* ed. J. Bidez and G. C. Hansen, *Sozomenus Kirchengeschichte* (Berlin, 1960).

Sylvester Syropoulos, Patriarchal dignitary, first half of 15th century. *Vera historia unionis non verae,* ed. R. Creyghton (The Hague, 1660).

Symeon, archbishop of Thessalonica, theologian, d. 1429.

Theodoret of Cyrrhus, c. 393–c. 466. Epistles ed. Y. Azéma, *Théodoret de Cyr: Correspondance* (Paris, 1955=Sources chrétiennes, No. 40).

Theodorus Balsamon, Patriarch of Antioch, canonist. Second half of 12th century.

Theodorus Ducas Lascaris, Emperor of Nicaea (1254–58). *Epistulae CCXVII,* ed. N. Festa (Florence, 1898).

Theodorus Lector, author of an Ecclesiastical History preserved only in fragments. 6th century.

Theodorus Metochites, prime minister and author of miscellaneous works, 1270–1332.

Theodorus, bishop of Paphos, hagiographer. *Vita S. Spyridonis,* composed in 655, ed. P. Van den Ven, *La légende de S. Spyridon évêque de Trimithonte* (Louvain, 1953).

Theodorus Prodromos, court poet, 12th century.

Theodorus Studita, St., theologian, 759–826.

Theophanes, chronicler, c. 752–818. *Chronographia,* ed. C. de Boor, I (Leipzig, 1883).

Theophanes Continuatus, the continuation of the Chronicle of Theophanes compiled at the behest of the Emperor Constantine VII. Ed. I. Bekker, CSHB.

Translatio S. Theodori Studitae, written c. 850; ed. C. Van de Vorst, *Analecta Bollandiana,* XXXII (1913), 27 ff.

Ulpius (or Elpius) the Roman, *Concerning Bodily Characteristics,* an opuscule of the 9th or 10th century containing notes on the physical appearance of Adam, the Prophets, Christ, the apostles Peter and Paul and eleven Fathers of the Church. Ed. M. Chatzidakis, *Epetêris Hetair. Byzant. Spoudôn,* XIV (1938), 393 ff.

Vita S. Athanasii Athonitae (d. c. 1004), ed. I. Pomjalovskij, *Žitie prepodobnago Afanasija Afonskago* (St. Petersburg, 1895).

Vita Basilii, Life of the Emperor Basil I written by or under the supervision of Constantine VII. It constitutes Bk. V of Theophanes Continuatus.

Vita S. Mariae iunioris (d. c. 902), ASS, Nov. IV, 692 ff.

Vita S. Marthae, matris Symeonis stylitae iunioris (d. 551), ASS, May V, 399 ff.

Vita S. Niconis Matanoiete (d. 998), ed. M. Galanopoulos, *Bios, politeia ... tou hosiou ... Nikônos tou "Metanoiete"* (Athens, 1933).

Vita S. Pancratii, ep. Tauromenii, a legendary account, composed probably in the 7th century, purporting to refer to the time of the apostle Peter. Full text unpublished. Extracts ed. A. N. Veselovskij, *Sbornik Otdel. Russk. Jazyka i Slov. Imper. Akad. Nauk,* XL/2 (1886), 73 ff.; H. Usener, *Kleine Schriften,* IV (Berlin-Leipzig, 1913), 418 ff.

Vita S. Stephani iunioris (d. 764) by the deacon Stephen, written in 806.

Vita S. Symeonis stylitae iunioris (d. 592), ed. P. Van den Ven, *La Vie ancienne de S. Syméon Stylite le jeune* (Brussels, 1962).

Vita S. Theodorae Thessalonicensis (d. 892), ed. Bishop Arsenij, *Žitie i podvigi sv. Feodory Solunskoj* (Jur'ev, 1899).

Latin and Western

Agnellus, first half of 9th century. *Liber* (or *Codex*) *Pontificalis ecclesiae Ravennatis,* ed. O. Holder-Egger, Monumenta Germaniae hist., *Script. rerum Longob. et Ital.* (Hannover, 1878), pp. 265 ff.; ed. A. Testi Rasponi, *Rerum ital. scriptores,* fasc. 196–97, 200 (Bologna, 1924) down to ch. 104 only. The passages relevant to the history of art have been collected by H. L. Gonin, *Excerpta Agnelliana* (Utrecht, 1933).

Clavijo, Ruy González de, Spanish ambassador, visited Constantinople in 1403. Ed. F. López Estrada, *Embajada a Tamorlán* (Madrid, 1943); English trans. by G. le Strange, *Embassy to Tamerlane* (London, 1928).

Codex Justinianus, promulgated in 529. Ed. P. Krüger, *Corpus iuris civilis,* II, 10th ed. (Berlin, 1929).

Codex Theodosianus, promulgated in 438. Ed. T. Mommsen and P. M. Meyer,

I, 1, 2, II (Berlin, 1905); English trans. by C. Pharr, *The Theodosian Code* (Princeton, 1952).

Liudprand, bishop of Cremona and diplomat, 920–72. *Antapodosis,* ed. J. Becker (Hannover-Leipzig, 1915); English trans. by F. A. Wright, *The Works of Liudprand of Cremona* (London, 1930).

Oriental

John, bishop of Ephesus, 6th century. *Ecclesiastical History* (in Syriac), ed. with Latin trans. by E. W. Brooks, *Corpus script. Christ. orient., Script. Syri,* Ser. 3, III (Louvain, 1935–36); English trans. by R. Payne Smith (Oxford, 1860).

al-Maqdisī (or Muqaddasī), Arab geographer, second half of 10th century. Ed. M. J. de Goeje, *Bibliotheca geogr. Arab.,* III (Leyden, 1877; revised ed., 1906).

al-Ṭabari, Arab historian, d. 923. *Annales,* ed. M. J. de Goeje, 15 v. (Leyden, 1879–1901).

Testamentum Domini nostri Jesu Christi, 5th century. Syriac text ed. with Latin trans. by Patriarch Ignatius Ephraem II Rahmani (Mainz, 1899).

Zacharias rhetor, 5th–6th century, author of lost Ecclesiastical History in Greek, partly incorporated into an anonymous Ecclesiastical History in Syriac completed in 569. Ed. with Latin trans. by E. W. Brooks, *Corpus script. Christ. orient., Script. Syri,* Ser. 3, V–VI (Paris and Louvain, 1919–1924); English trans. by F. J. Hamilton and E. W. Brooks, *The Syriac Chronicle known as that of Zachariah of Mitylene* (London, 1899).

Slavic

Antonij, archbishop of Novgorod, pilgrim to Constantinople in 1200. *Kniga palomnik* (Pilgrim's Book), ed. Kh. Loparev, *Pravoslavnyj Palestinskij Sbornik,* No. 51 (St. Petersburg, 1899); unreliable French trans. by Mme B. de Khitrowo, *Itinéraires russes en Orient* (Geneva, 1889).

Epifanij the Wise, Russian hagiographer, d. 1420.

Novgorod Chronicle (First), 14th sentury with later additions; ed. A. N. Nasonov, *Novgorodskaja pervaja letopis'* (Moscow-Leningrad, 1950); English trans. by R. Michell and N. Forbes, *The Chronicle of Novgorod* (London, 1914; repr. Hattiesburg, Miss., 1970).

Novgorod Chronicle (Third), compiled in the 17th century, ed. A. F. Byčkov, *Novgorodskie letopisi,* 2nd ed., *Polnoe sobranie russkikh letopisej,* III (St. Petersburg, 1879).

Paterikon of the Cave Monastery at Kiev, a collection of edifying stories about monks, compiled c. 1220. Ed. D. Abramovič, *Kievo-Pečerskij Paterik* (Kiev, 1931); reprinted by D. Tschižewskij, *Das Paterikon des Kiever Höhlenklosters* (Munich, 1964).

Russian Primary Chronicle, early 12th century. Ed. D. S. Likhačev, *Povest' vremennykh let,* 2 v. (Moscow-Leningrad, 1950); English trans. by S. H. Cross and O. P. Scherbowitz-Wetzor, *The Russian Primary Chronicle* (Cambridge, Mass., 1953).

Trojtskaja Chronicle, composed in Moscow in 1408, ed. M. D. Priselkov, *Trojtskaja Letopis'* (Moscow-Leningrad, 1950).

GENERAL INDEX

(A) = architect; ch. = church; bp. = bishop; emp. = emperor; mon. = monastery; (P) = painter; patr. = patriarch; (R) = representation of; (S) = sculptor; w. = wife.

Abd al-Malik, Caliph, 132
Abgar, king of Edessa, 171
Abraham (R), 42 (see also Isaac, Sacrifice of)
acheiropoiêtos, 115
Achillean costume, 110, 113
Agathias of Myrina (R), 115, 132
Agnellus, bp. of Ravenna (R), 107 f.
Agnes, empress, w. of Andronicus I (R), 235
aithrion, 5
Alexander romance (R), 216
Alexander, patr. of Constantinople (R), 16
Alexandria, ch. of St. John and St. Dionysius, 27 n.21; Tetrapylon, 136
Alexius I, emp. (R), 226 f.
Alexius II, emp. 235
Alimpij (P), 222 ff.
Allegories of Life, 247; of virtues, 225, 247
altar, 25, 51, 142
altar cloth, see endutê
Amaseia, 115; ch. of St. Michael and Virgin Mary, 133
ambo, 24 f., 59, 79, 91 ff., 143, 202
Amphilochius, bp. of Iconium, 27
Anastasis (R), 259
Anastasius I, emp., 33, 35, 46 (R)
Anastasius II, emp., 141
Andrew, St. (R), 42, 153
Andronicus I, emp., 44 n.114, 234 f. (R)
Angelo Acontanto (P), 258
angels (R), 35, 43 f., 87, 140, 186, 203; crucified, 175
Annunciation (R), 231
Anthemius of Tralles (A), 72, 75, 77 f., 81, 84
Antioch, 31, 43 f., 113, 134; ch. of St. Barlaam, 37 n.68; of St. Michael, 44; Octagonal ch., 11; mon. of St. Symeon, the younger stylite, on Wondrous Mountain, 126 f.
Antony and Theodosius, Sts. of Kiev (R), 222
Apamea, 113 f., 135
Aphrodite (R), 133
Apocalypse (R), 257
Apostles (R), 87
apsis, 60, 97 n.207, 125
Arcadius, emp., 46
Ariadne, empress (R), 35
Arians, 16, 35 f., 107
artists' manuals, xii f.
Asaph and Addai (A), 58

Asbestas, Gregory, bp. of Syracuse (P), 191
Ascension of Christ (R), 219
Athanasius of Alexandria, St. (R), 214, 238
Athanasius of Athos, St. (R), 213 f.
Axouch, Alexius, 224, 229 n.235

Bačkovo, mon., 238
Baghdad, 160
Baptism of Christ (R), 237
baptisteries, 6, 25, 42, 61, 84
Barlaam, St. (R), 37
Basil I, emp., 103, 163 f., 191 ff., 197 f. (R), 201
Basil II, emp. (R), 226
Basil, St., 169, 172, 214 (R)
basilica, basileios naos, 5, 12 f., 21
Belisarius (R), 109
Bellerophon (R), 216
bêma, 35, 44, 143, 240, 253
Bethlehem, ch. of Nativity, 114
bishops, portraits of, 16, 39 f., 107, 133, 152, 237
Bizye, 212
Boris, king of Bulgaria, 190 f.

Caesarea in Cappadocia, 115
Camuliana, image of Christ, 114 f.
cancelli, 143
Candia, ch. of Christ Kephalas, 259
Carthage, 14
catechumens, 25
Catherine, St. (R), 259
centering, 98, 102
Chalcedon, ch. of St. Euphemia, 30, 37 ff.
chalice and paten (diskopotêrion), 100, 137, 144
charioteers, portraits of, 49 f., 153
Chartoularis (P), 230
Chênaros (P), 230
Cherson, 221
Cherubim, 203 (R); in Tabernacle, 117, 170
chorbanas, 25
chrism, vessels for, 106
Christ (R), 16, 18, 37, 40 ff., 71, 87 ff., 105, 114 f., 136 f., 139 f., 140, 155 f., 166 ff., 184, 186, 196, 200, 202, 221, 223, 234, 237, 239, 254, 259; led to Cross (R), 236; Pantocrator (R), 203, 219, 231 f., 249; miracles (R), 51, 89, 176
ciboria, 59, 79, 104 f., 129, 142, 186, 206
cochlias, 7

267

triconches, 160
Trimithous, 136
Trojan War cycle (R), 216
Twelve Feasts, 100 n.221
Tyche of Constantinople (R), 10
Tyre, cathedral, 4 ff.; ch. of Theotokos, 27
n.21

Vaulting, uncentered, 28
Verina, empress (R), 34 f.
Victor, bp. of Ravenna (R), 105
Virgin Mary (R), 16, 35, 40, 62, 87, 89,
152, 155, 167 ff., 184, 186, 187 ff., 192,

200, 202 f., 217, 223, 226, 238 f.; veil of,
34 n.53
Vladimir, prince of Kiev, 221

Wages (workers'), 28
Walid, Caliph, 132
Women at the Sepulchre (R), 233

Yazid II, Caliph, 151

Zacharias and companions (P), 256
Zeno, emp., 125
Zenobius (A), 14
Zeus (R), 40 f.